STAR **PRODUCT** DESIGNERS

STAR **PRODUCT** DESIGNERS

PROTOTYPES, PRODUCTS, AND SKETCHES FROM THE WORLD'S TOP DESIGNERS

Irene Alegre

HARPER
DESIGN

An Imprint of HarperCollins Publishers

STAR PRODUCT DESIGNERS
Copyright © 2013 by Harper Design and LOFT Publications

HarperCollins books may be purchased for educational, business, or sales promotional use.
For information, please write: Special Markets Department, HarperCollins Publishers,
10 East 53rd Street, New York, NY 10022.

First edition packaged in 2013 by:
LOFT Publications
Via Laietana, 32, 4th fl., of. 92
08003 Barcelona, Spain
Tel.: +34 93 268 80 88
Fax: +34 93 317 42 08
www.loftpublications.com

First edition published in 2013 by:
Harper Design
An Imprint of HarperCollins Publishers
10 East 53rd Street
New York, NY 10022
Tel.: (212) 207-7000
Fax: (212) 207-7654
harperdesign@harpercollins.com
www.harpercollins.com

Distributed throughout the world by:
HarperCollins Publishers
10 East 53rd Street
New York, NY 10022
Fax: (212) 207-7654

Editorial coordination:
Claudia Martínez Alonso

Assistant to editorial coordination:
Ana Marques

Editor and texts:
Irene Alegre

Translation:
textcase
www.textcase.nl

Art direction:
Mireia Casanovas Soley

ISBN: 978-0-06-221026-5

Library of Congress Control Number: 2013936187

Printed in China

CONTENTS

"Good design is making
something intelligible
and memorable. Great
design is making
something memorable
and meaningful."

Dieter Rams

Human beings started to design the day—or perhaps night—that they realized they had a problem and decided to solve it. At that moment, invention began: weapons for hunting, tools for cultivating crops, and containers for transporting water. At first, design had the simple goal of making everyday tasks easier. And then art arrived.

Art expressed ideas but at the same time was used to decorate people and spaces. And once basic needs were met, other needs appeared, relating to individuality—personal aesthetic expression. Human beings are not indifferent to sensory qualities; even the youngest children have individual preferences regarding colors, shapes, and textures. Design blends the functionality of objects with beauty and artistic expression. That is why we find vases with reliefs and balanced forms, jewelry, ornaments, and treated and dyed skins among archaeological remains.

The capacity to produce the same object an infinite number of times came with the Industrial Revolution. Henry Cole, the English designer who organized the Great Exhibition, which took place in 1851 in London, firmly believed in blending art and manufacture, promoting good taste among consumers. Industrial design is now defined as the process of creation and production targeted at mass consumption. This has brought about great social change

because, more than ever, it prioritizes usefulness over aesthetics. Its main objective is to produce inexpensive consumer goods.

In the twentieth century, the Bauhaus movement was known for absence of ornamentation and for harmony between function and the artistic and technical means of production: the form of a product must be consistent with its intended use. And in the 1930s, at the beginning of the Great Depression, designer Raymond Loewy proposed simplifying products and hiding their innards, adding a final touch to this emerging concept of design.

Today's consumers are not just looking for bargains; they are looking for products that are modern, sustainable, environmentally friendly, innovative, high-tech, and mobile. And these are just some of the many characteristics that lead consumers to buy. Industrial designers are increasingly focused on fulfilling these requirements, trying to satisfy more than one need with a single object. The results include phones with music players, music players with Wi-Fi and Internet, computers with their own video game graphics cards, and video game consoles that are used for playing sports. In the furniture market, we find tables that function as chairs, chairs that function as sofas, sofas that function as beds, and wardrobes hiding chairs, tables, beds, and sofas.

Industrial design is directly related to mass consumption. And mass consumption, somewhat paradoxically, is directly related to individuality. Increasingly, the entire world wears the same clothes, owns the same phone, and decorates with the same Swedish furniture, so now more than ever human beings need to express their uniqueness. In a world where everyone has the same things, we want to feel that nobody is like us. In a world where everyone's designs are the same, it is natural to want to underline that each individual is unique. And in order for designers to stand out from their competitors, they have to show that their creative processes are different.

How do we define an object? There are so many variables involved in the first sketch of an idea. What will it be? What will it be used for? How will it work? Who is it intended for? How long should it last? What materials will be used? How will it be made cost-effective? Will it be difficult to produce?

Each designer decides how to go about answering these questions. Some can convey an entire idea with four strokes of a pencil, while others strive to specify every detail, texture, and connection. Some work on computers, using digital design programs. In their sketches, all designers convey their style, their methodology, and their particular way of approaching the creative process, which is why we have chosen details from sketches to begin each presentation in this volume.

This is a compilation of various designers and their sketches. Our aim in bringing together these examples of functional art is to provide a wide view of the landscape of industrial design. This collection surveys production processes, the technological features displayed, cohesion between form and function that has been attempted, and the sustainable materials used. Modern design focuses on improving products and solving problems, while being conscious of environmental issues and trying to reduce production costs as much as possible.

The designers introduced here work in their own styles, following their own creative processes and developing their own dreams and ideas. They pay attention to the context of each thing to find a formula for efficiency without having to abandon their preference for moderation and simplicity. Above all, a design should be honest, clear, and sincere— transparent, not so much in the technology hidden inside but rather in the way that it is used. A good product communicates with the user without the need for an instruction manual. An object that speaks for itself is synonymous with success.

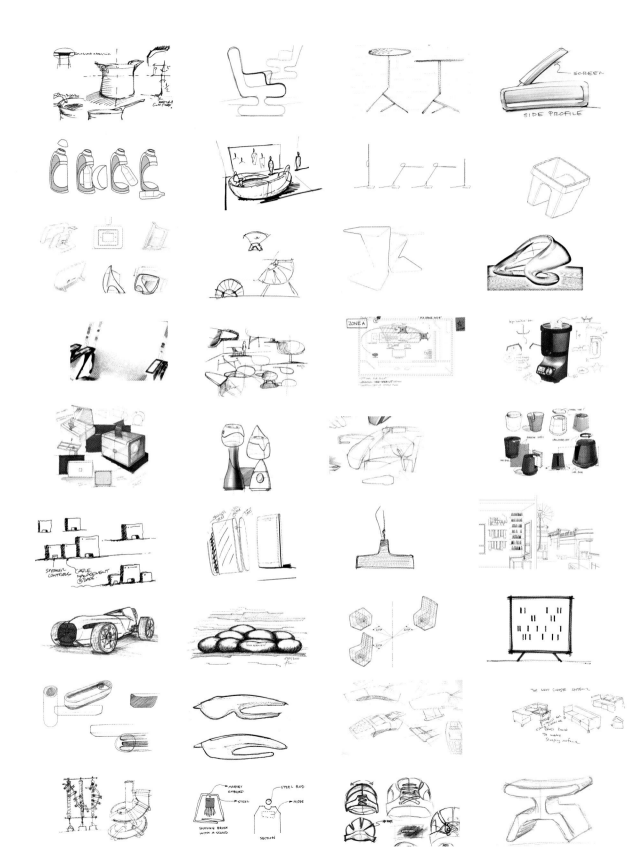

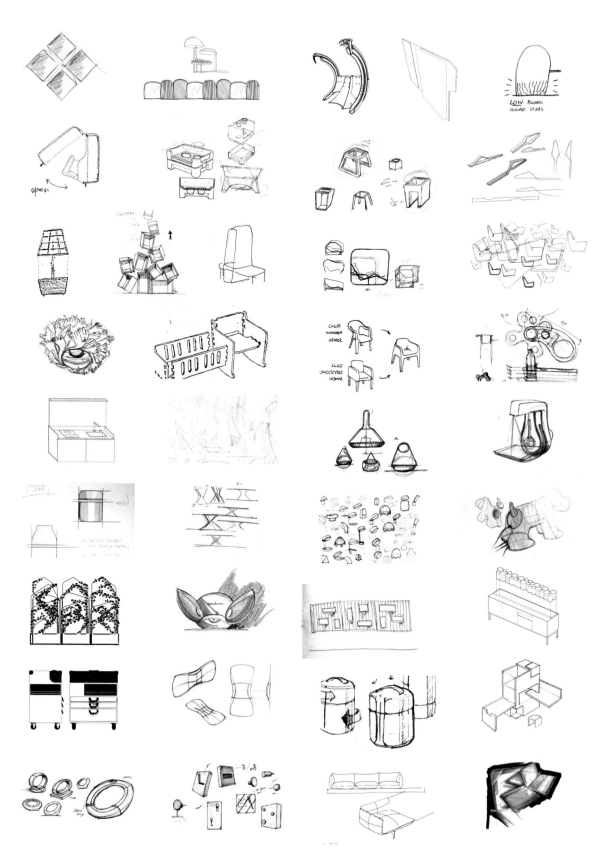

TANYA AGUIÑIGA

Los Angeles, CA, USA
www.aguinigadesign.com

Tanya Aguiñiga creates works of art that function as pieces of furniture. The designer, born in Tijuana, Mexico, holds a master's degree in furniture design from the Rhode Island School of Design and is currently part of the teaching staff at the Otis College of Art and Design in Los Angeles. Her work has been exhibited in Mexico City and Milan, and she was nominated to be a United States Artists Target Fellow in crafts and traditional art.

The design of CB2 chairs is somewhere between sculpture and furniture and was inspired by the organic shapes of nature and the animal world. With their different shapes and upholstery, no two CB2s are the same.

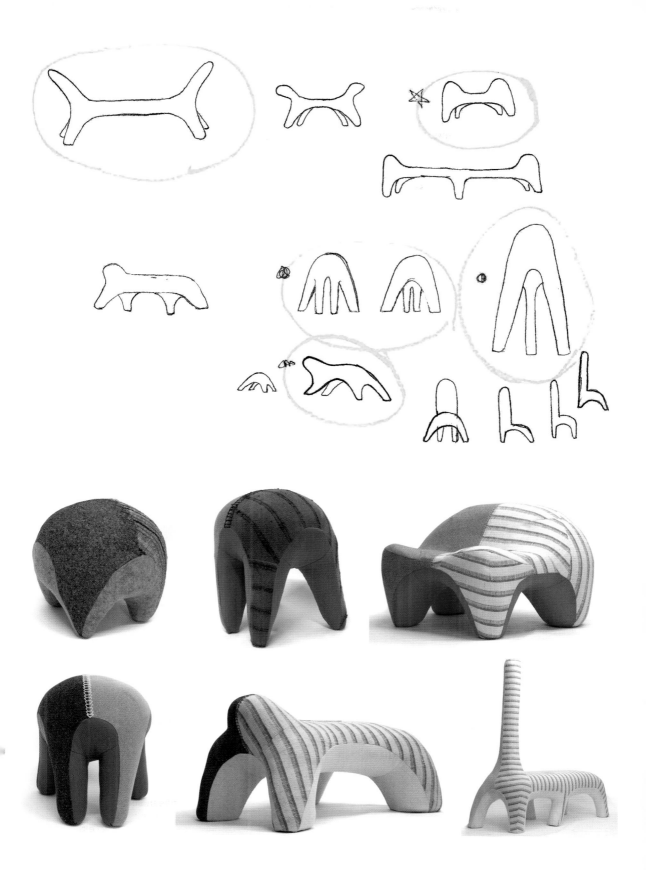

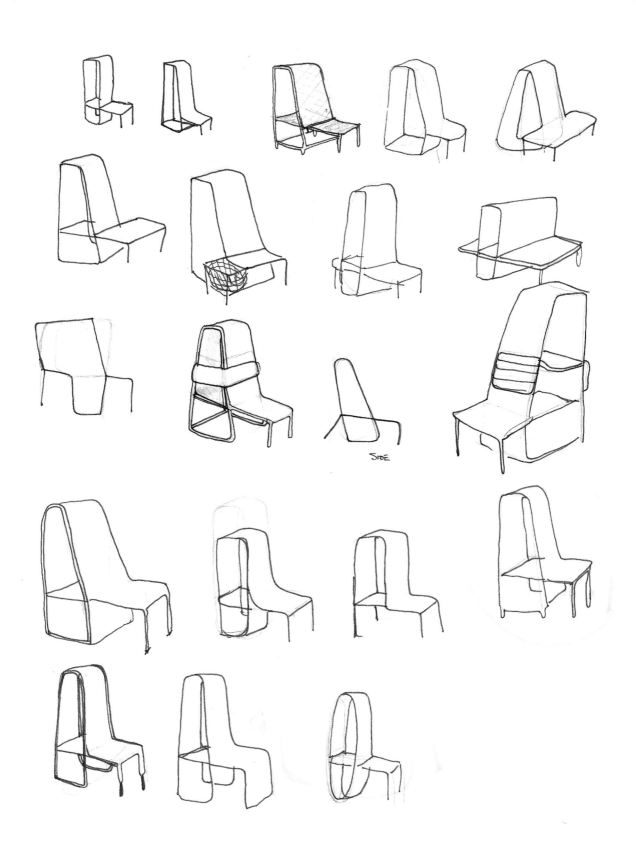

SIDE

14

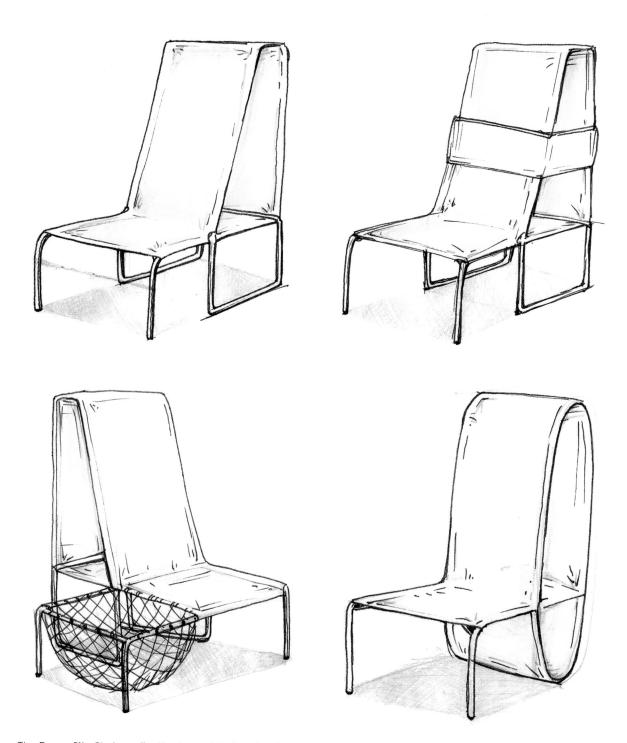

The Paper Clip Chairs collection has a tubular structure, alluding to the shape and ductility of a paperclip.

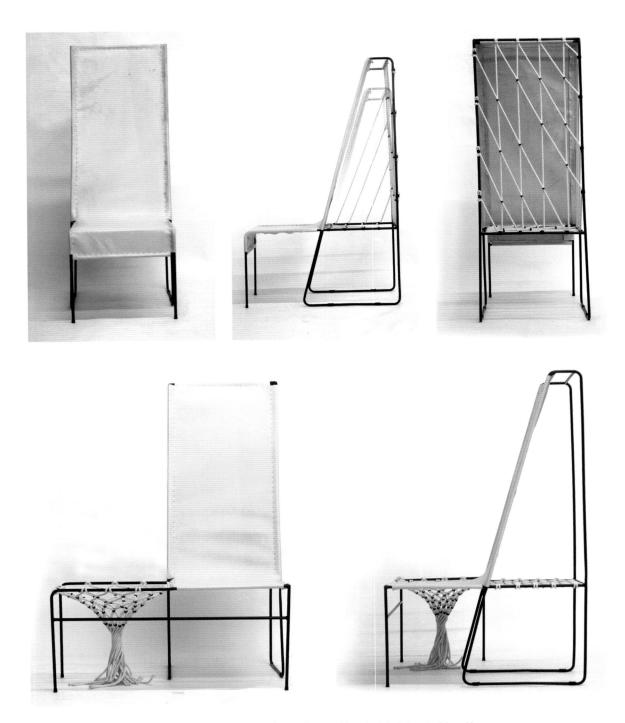

The design uses different fabrics and surfaces, depending on the chair's intended function.

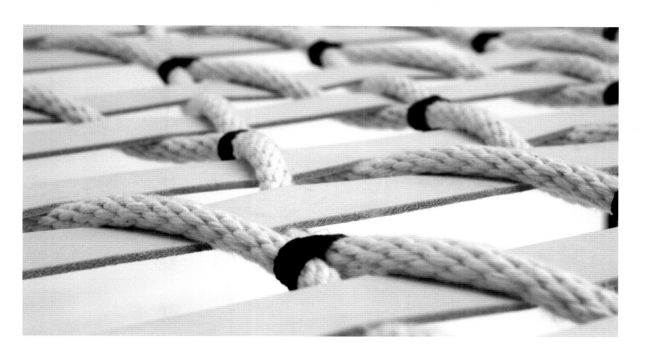

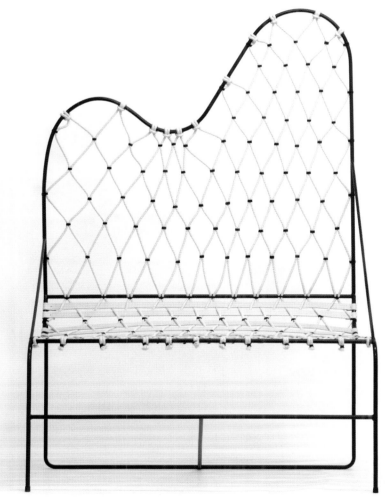

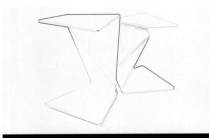

AQUILIALBERG

Milan, Italy
www.aquilialberg.com

Laura Aquili (born in 1973) and Ergian Alberg (born in 1972) have worked for companies such as Zaha Hadid Architects, OMA, UNStudio, ONL, and Fuksas. Their first job as independent designers was the VERTIGO coffee table, which was the beginning of their collaboration with Moroso. They have also participated in the design of Prada boutiques in New York, San Francisco, and Los Angeles. They work for many clients, including Moroso, Fiam, and Kundalini, as well as publishing articles in various Italian design magazines.

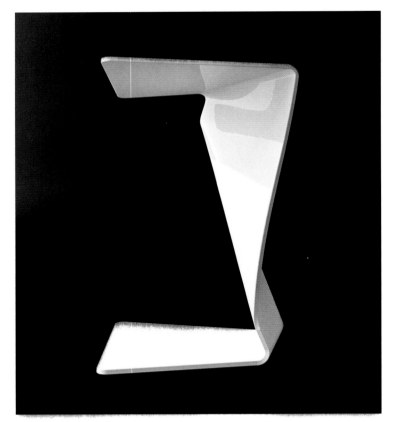

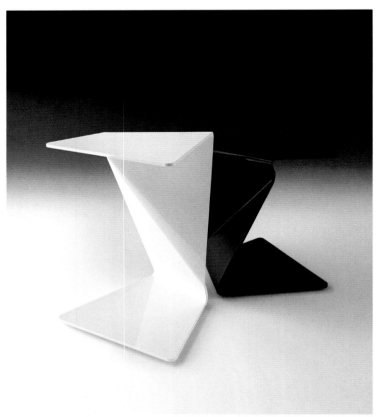

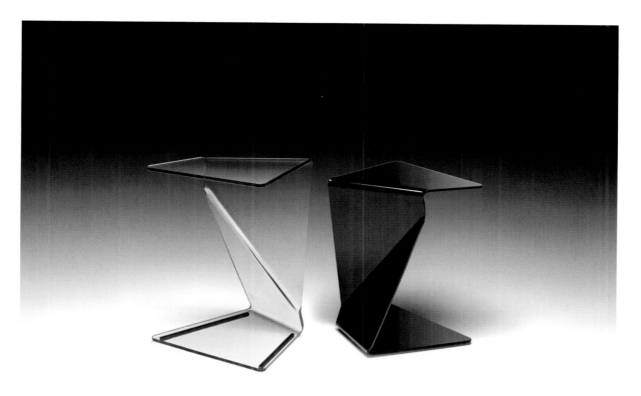

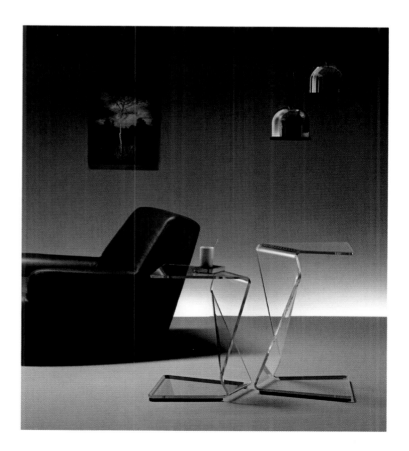

The outstanding design of the Sigmy was inspired by the perception of motion and the combination of lines, lightness, and buoyancy. Its form is reminiscent of the Greek letter sigma, which gives it its name.

ATELIER OPA

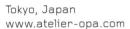

Tokyo, Japan
www.atelier-opa.com

The Atelier Opa team consists of three designers: Yuki Sugihara, Toshihiko Suzuki, and Munetaka Ishikawa. Suzuki is an architect and has participated in exhibitions in London and Milan; Sugihara is an artist who is passionate about languages; and Ishikawa is a designer who is also passionate about soccer. The company studies the constant evolution of international design and architecture and participated in the exhibition at the Asia Design Award in 2007.

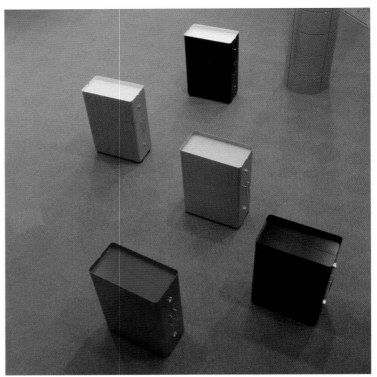

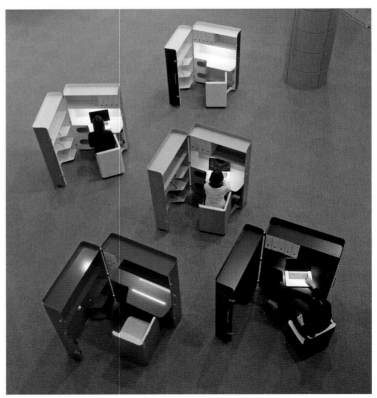

KENCHIKUKAGU

open

study Room Space

1000 500

1800

Foldaway office

shelf

desk

chair

When closed, this folding office occupies the space of a narrow closet and has a desktop that opens to 3.28 feet (1 meter) long and 19.7 inches (50 centimeters) deep. It also includes shelves and a chair connected to the structure.

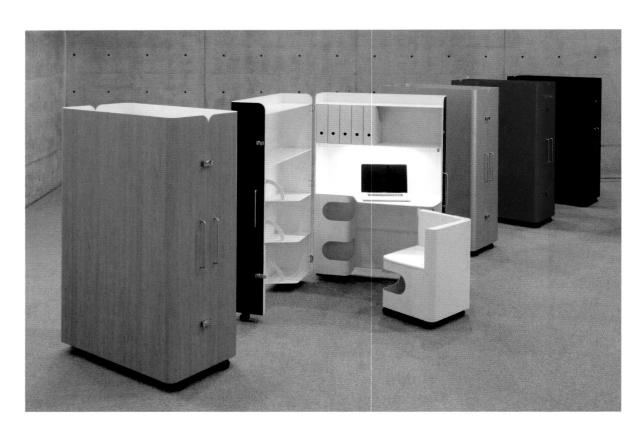

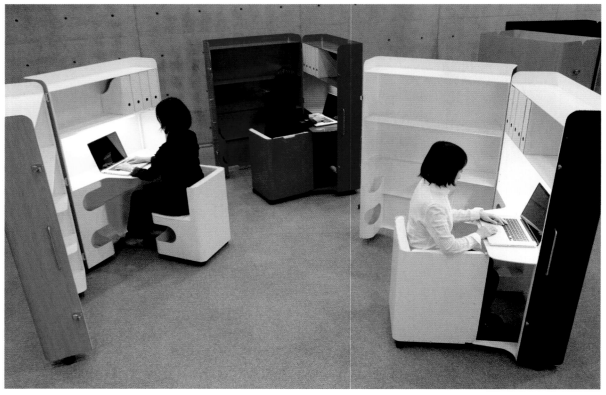

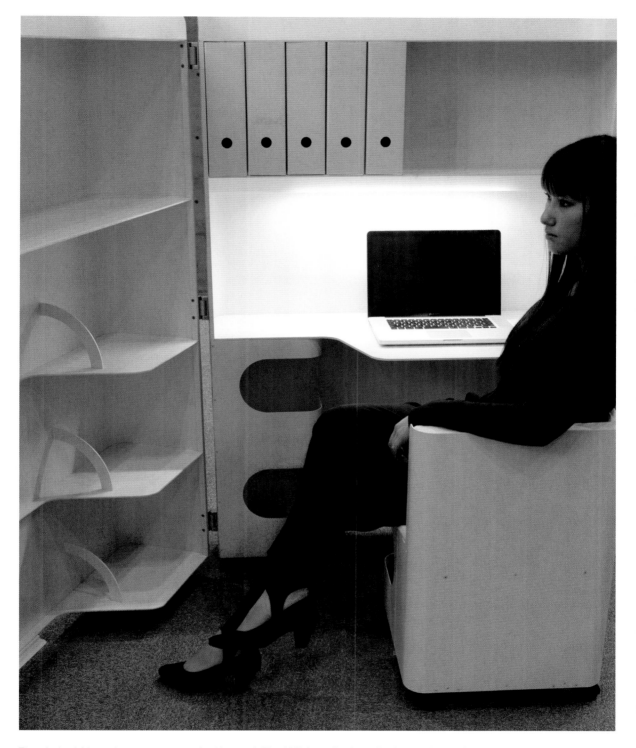

The chairs hide a storage space under the seat. The LED lamp is also attached to the table.

B.DNB DESIGNSTUDIO

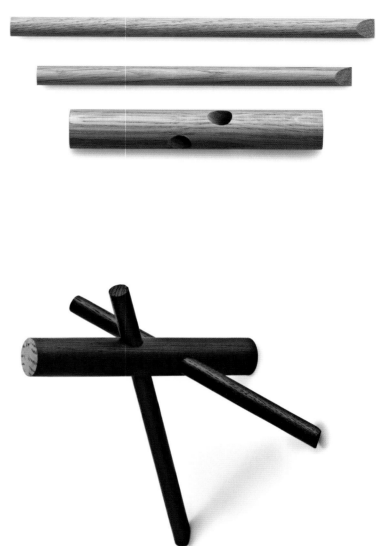

Brussels, Belgium
www.benoitdeneufbourg.com

B.dnb designStudio was founded in 2004 by Benoît Deneufbourg, whose training was in design and architecture. His work focuses on materials and manufacturing processes, from which arises a wide range of products, including furniture, lighting, and accessories. Deneufbourg would like to establish his own design language and has participated in exhibitions such as the Milan Furniture Fair, as well as appearing in publications such as *Victoire*.

The Sticks coat and hat stand has a simple and very functional structure consisting of three wooden bars that provide different options for hanging clothes.

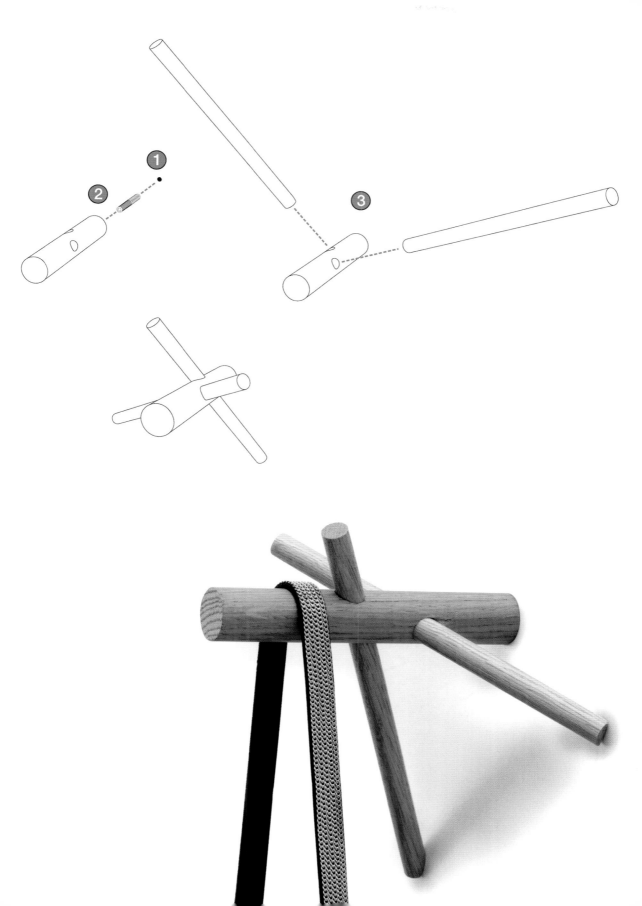

The Twist table was designed for Interni Edition. The original shape of the lacquered steel base was inspired by turbines and the movement of palm trees. The result is a stylish yet stable stand.

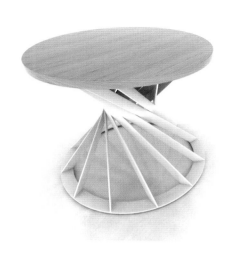

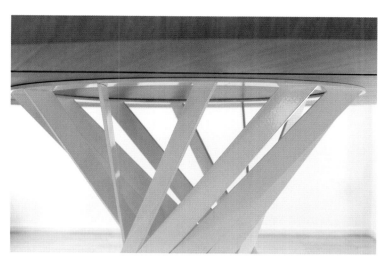

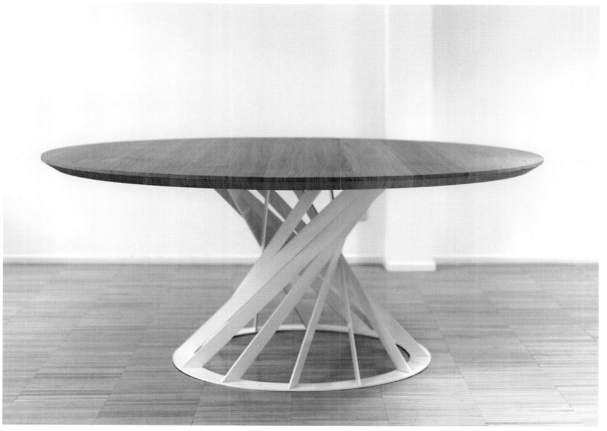

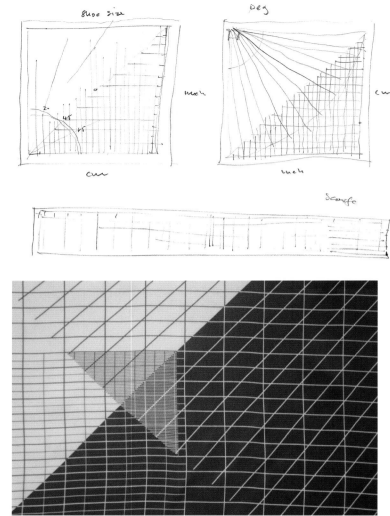

SEBASTIAN BERGNE

London, UK
www.sebastianbergne.com

Sebastian Bergne graduated from London's Royal College of Art in 1990 and founded his studio soon after. Since then, Bergne has accumulated an excellent and diverse portfolio. His work varies, although he usually focuses on household items such as teapots and frying pans. His designs are simple and efficient, and his work has been recognized with several international prizes, as well as by his participation in publications and exhibitions.

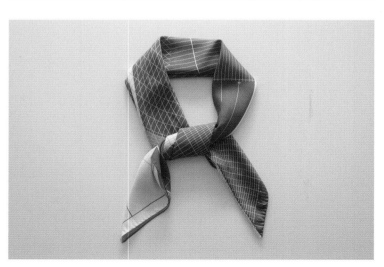

The Measuring Square is a silk handkerchief that can be used to measure surfaces. The fabric is stamped with a metric-unit grid, as shown in the sketch.

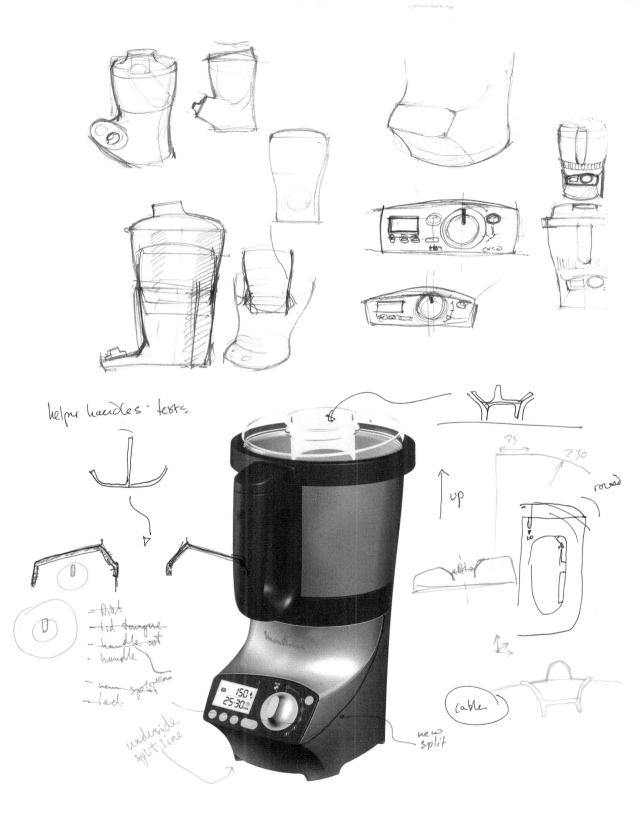

Soup & Co is a kitchen robot designed for Moulinex. With 1,100 watts and the capacity to reach a temperature of 100 °C, this machine comes with four installed programs and does not require supervision.

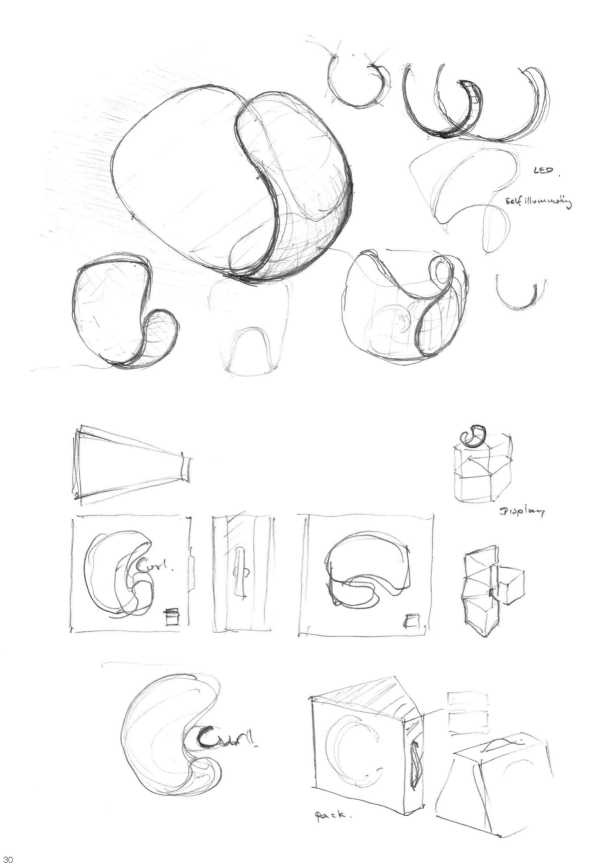

LED.

Self illuminating

Curl.

Curl.

Display

pack.

30

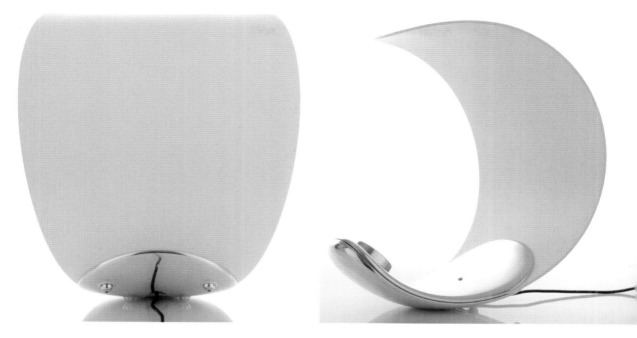

The Curl is a sculptural LED table lamp. Light is reflected on the curved white surface and can be directed toward various points.

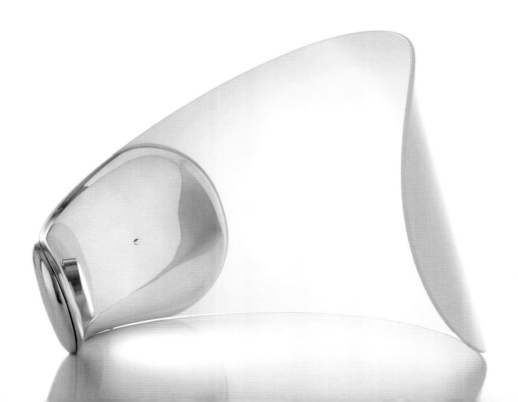

HOW TO CUT CHEESE ?

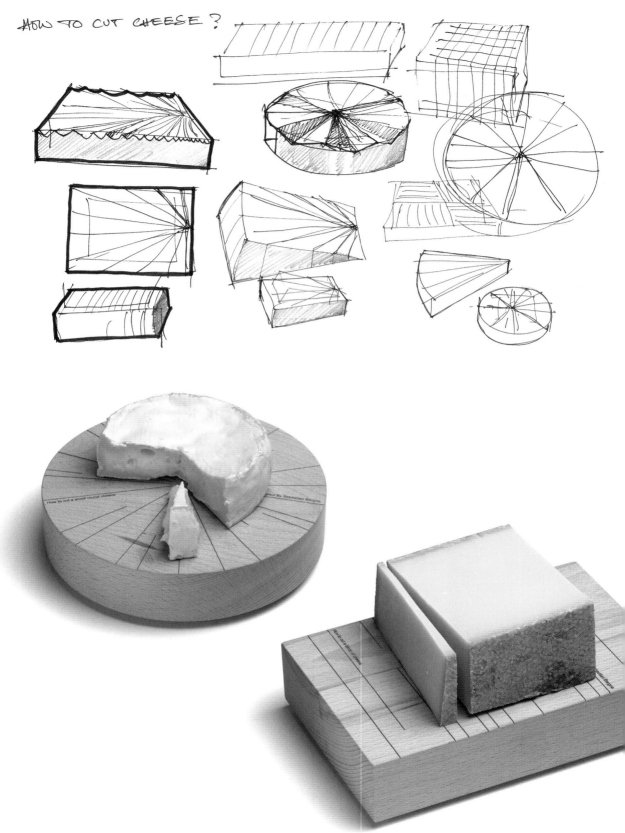

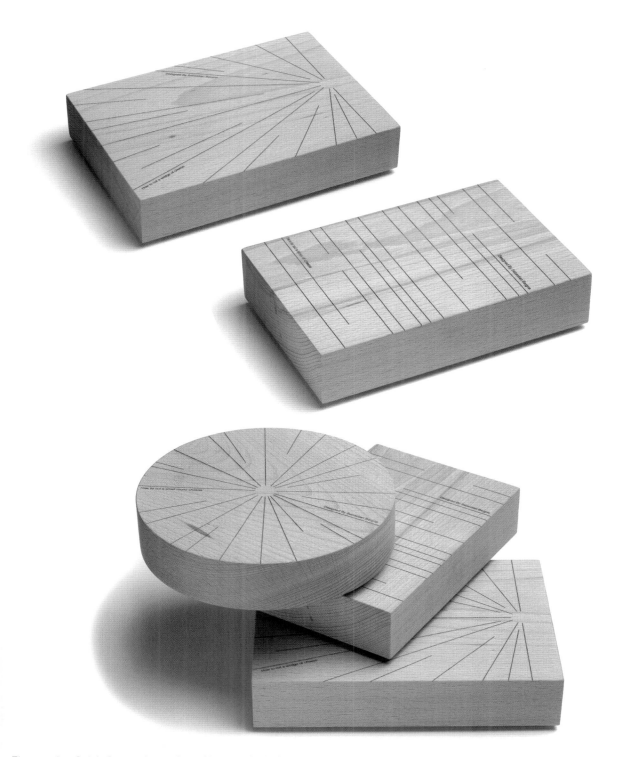

The wooden Cut & Serve cheese board has marks to indicate different portion sizes. It comes in different shapes.

SARAH BÖTTGER

Wiesbaden, Germany
www.sarahboettger.com

Sarah Böttger bases her ideas for products on her observations of daily activities and puts special emphasis on combining traditional materials with modern techniques, which produces interesting intersections between the two. Böttger earned a degree in industrial design in 2009 from the University of Offenbach am Main and aims to develop products with a unique identity that will prevail in the long term. Her work has been exhibited in Milan, Paris, Barcelona, and Shanghai.

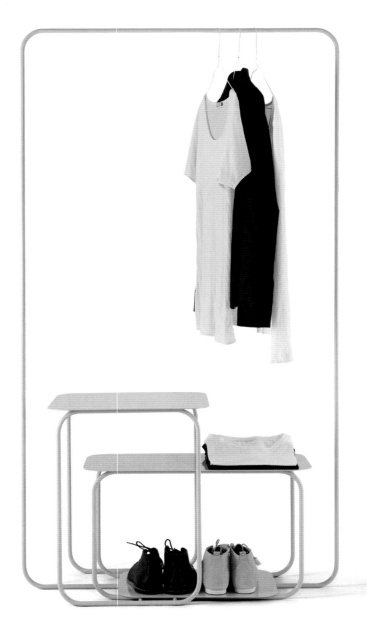

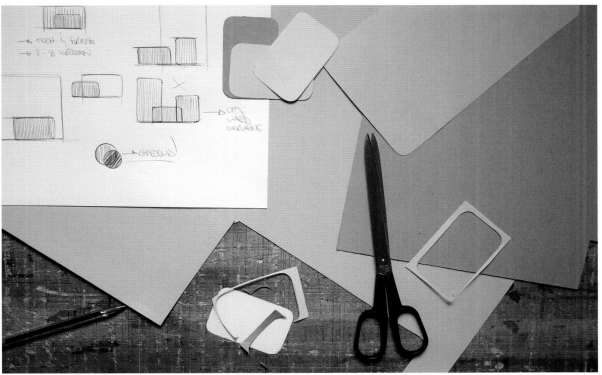

The Skale is a spatial collage comprising a set of metal structures with the same shape but various sizes. It can be used as a wardrobe, hanger, table, chair, or shoe holder.

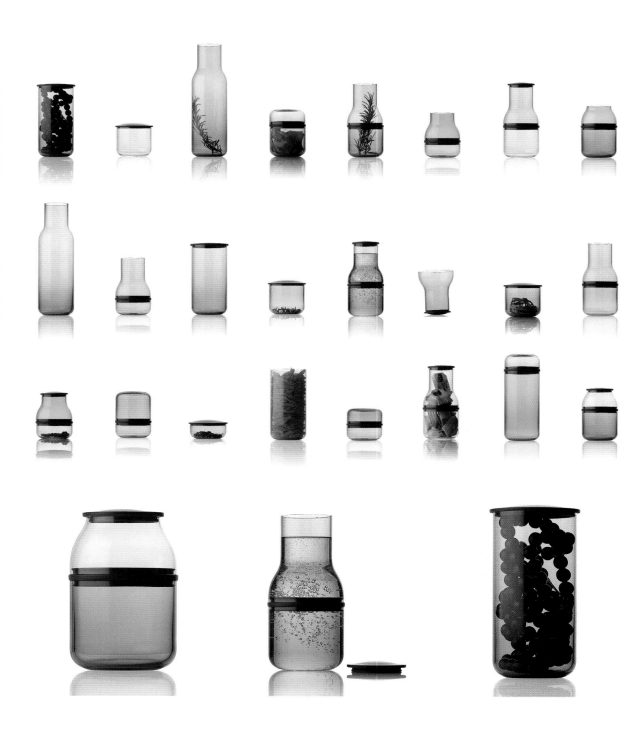

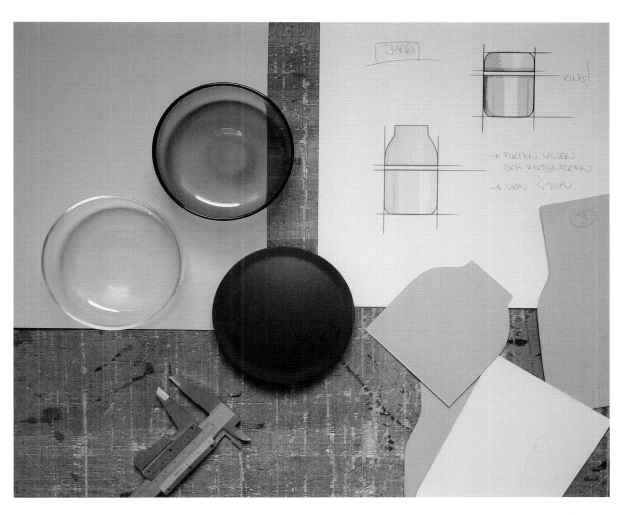

Juuri is a collection of jars of different heights. All are cut from the same container, so they share the same width. They can be closed or combined using a rubber ring and flexible plastic covers.

LOW BLOOD
SUGAR LEVEL

MICKAEL BOULAY

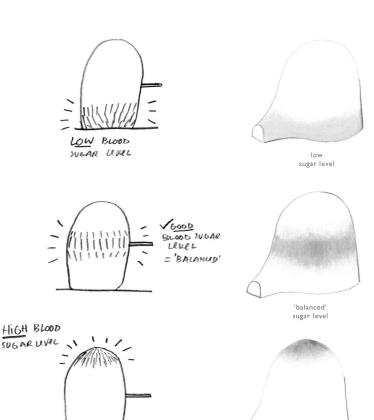

LOW BLOOD
SUGAR LEVEL

low
sugar level

✓GOOD
BLOOD SUGAR
LEVEL
= 'BALANCED'

'balanced'
sugar level

HIGH BLOOD
SUGAR LEVEL

high

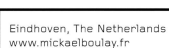

Eindhoven, The Netherlands
www.mickaelboulay.fr

The new generation of industrial de-
signers is interested in human prob-
lems and in their role as designers
in society as a whole. Mickael Boulay
is part of this group, investing time
and energy in humanitarian projects
that make people's lives easier. Bou-
lay studied industrial design at the
National School of Applied Arts and
Crafts in Paris (ENSAAMA) and then
continued his training in the Neth-
erlands at the Academy of Design in
Eindhoven.

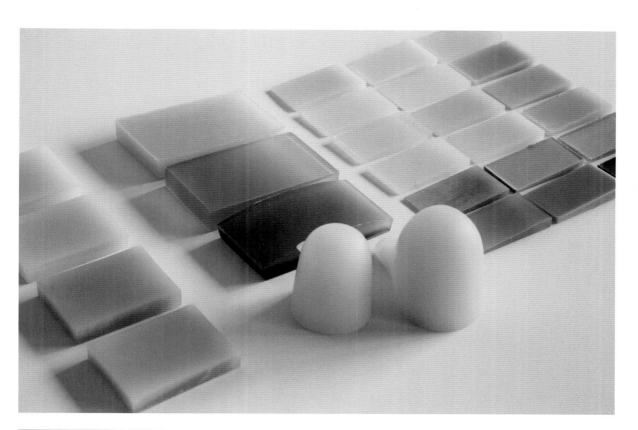

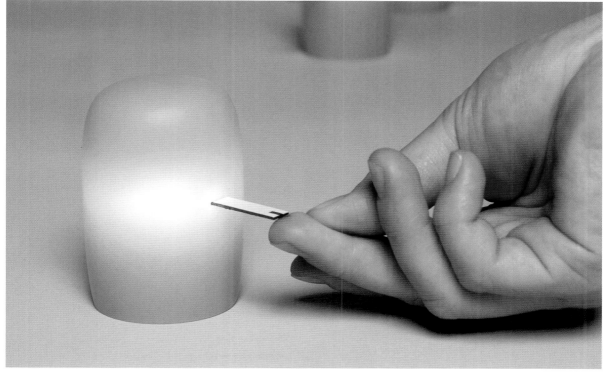

The Measuring Less to Feel More is a device for people with diabetes, enabling them to measure their glucose levels at home. The device changes color according to the levels of sugar in the body.

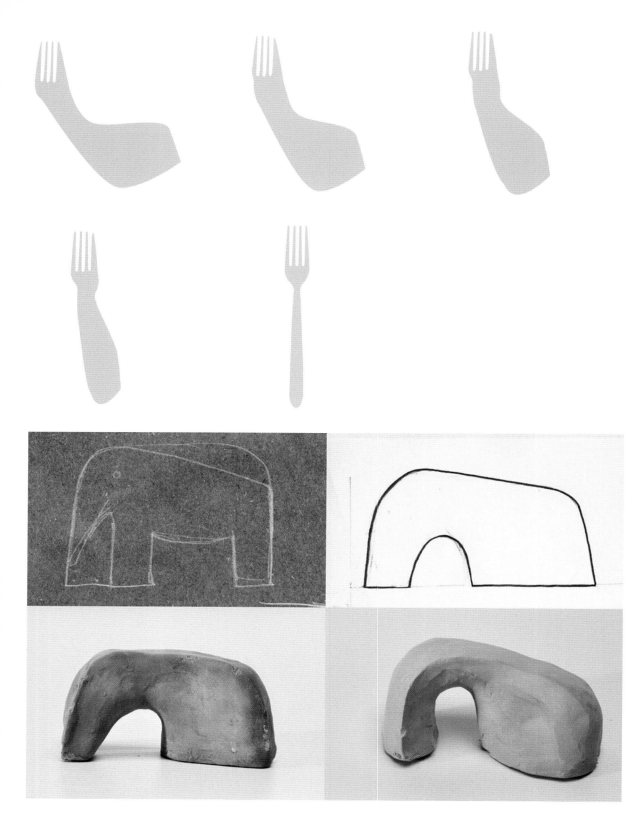

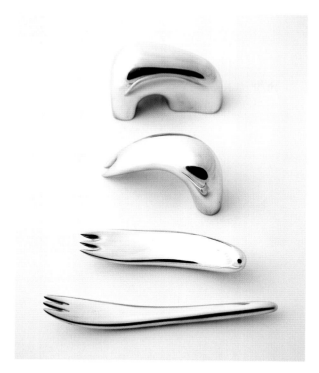

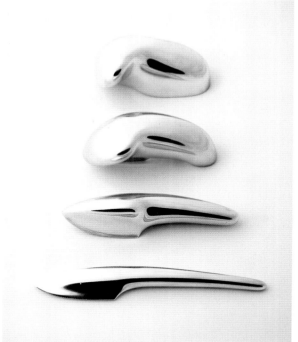

Transitions is a line of cutlery for people with reduced function in their wrists and hands. Thanks to its anatomical shape, the muscles work gradually and the patient can recover total mobility.

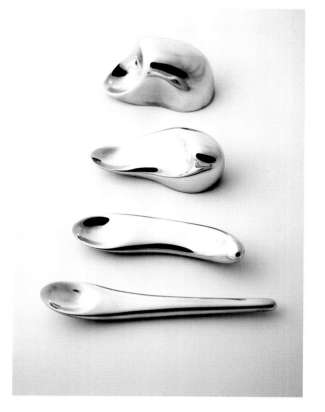

BRAD ASCALON STUDIO NYC

New York, NY, USA
www.bradascalon.com

Born in Philadelphia, Brad Ascalon specializes in furniture design, packaging, consumer goods, and environmental design, as well as participating in art installation projects. His work has been exhibited in Italy, Germany, the United Kingdom, and the United States. In 2007, his first designs were included in the ICFF Studio Bernhardt Design Exhibition, which promoted the work of designers around the world.

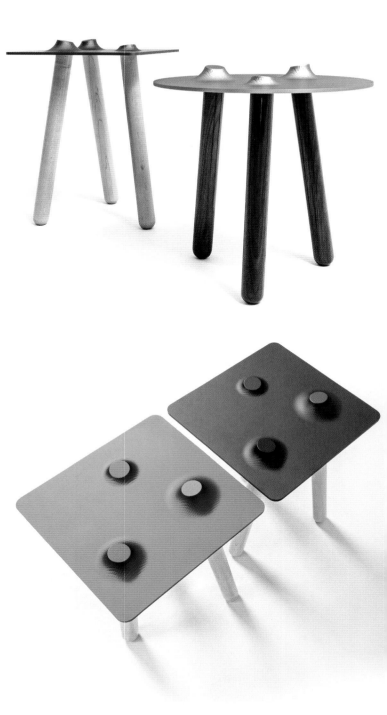

The natural wooden legs of Timber's design, inspired by rural furniture, penetrate the aluminum surface, creating an original and rustic relief. It was co-designed with Frederick McSwin for NFS.

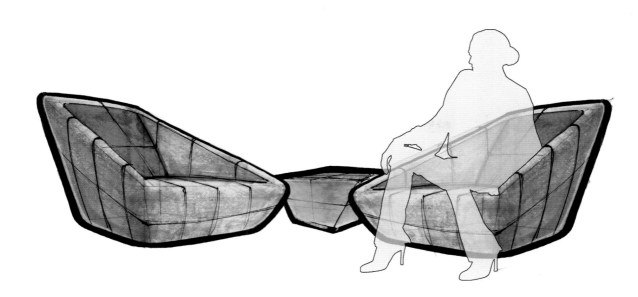

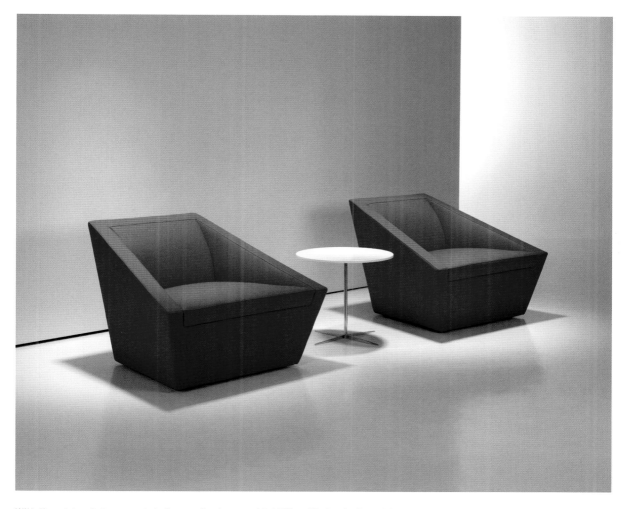

With its minimalist, geometric forms, the trapezoidal Pillar Chair, designed for Bernhardt Design, is upholstered in multiple vibrant colors and comes with the option of a swivel base.

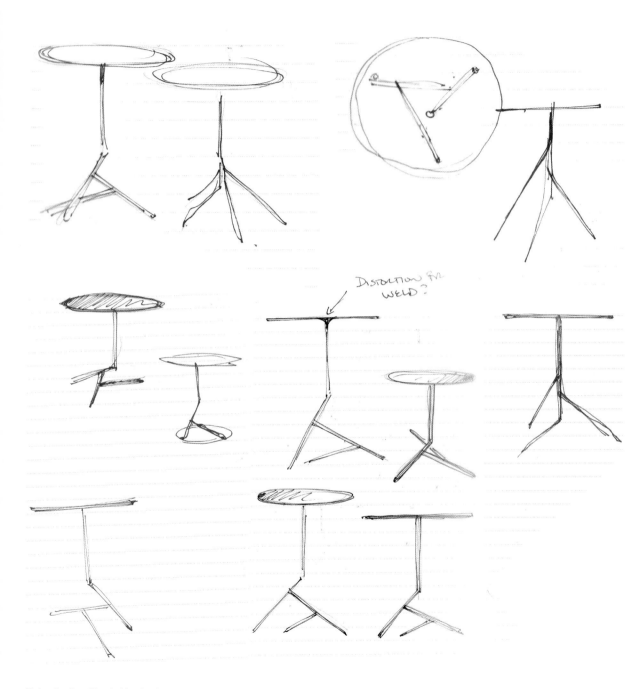

This steel coffee table designed for Ligne Roset is powder coated. The base of the Lovey Table consists of a metal support with three short legs reminiscent of tree branches. Walnut is used for the detailing.

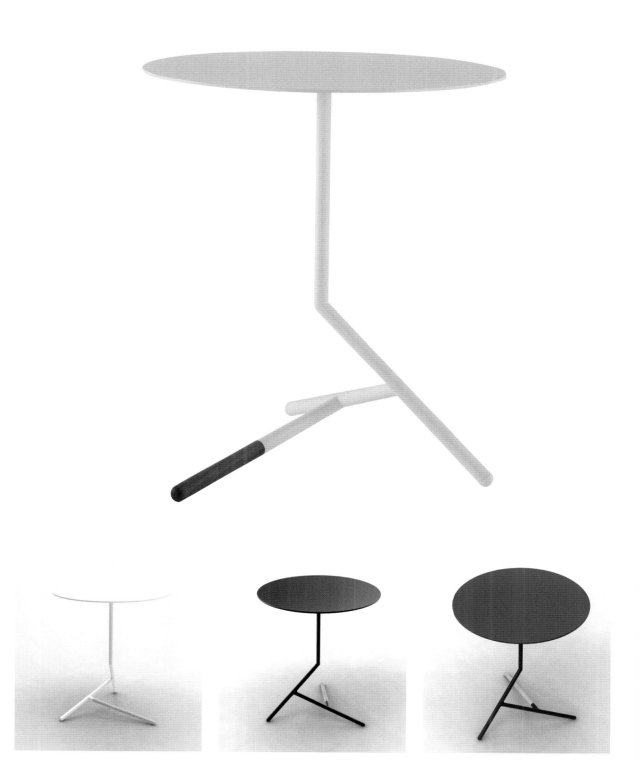

BRANCA-LISBOA

Porto, Portugal
www.branca-lisboa.com

Inspired by Lisbon's magical light, Marco Sousa Santos designs novel household products and accessories. His creations are the result of an exhaustive search for materials with good structural qualities and aesthetics that make them suitable for beautiful, practical, functional, long-lasting products. Sousa has worked in various design fields. He is a lecturer in industrial design in Lisbon, and he established his own studio in 1995.

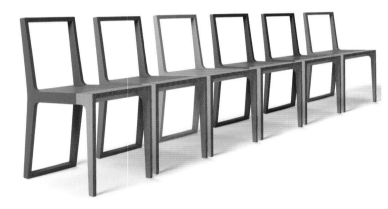

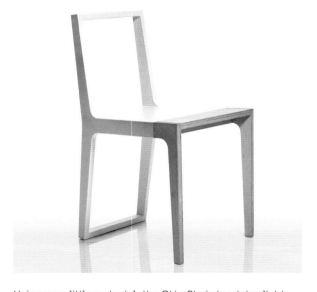

Using very little material, the Skin Chair is minimalist in both form and concept. The back and the rear legs are a single piece, making the chair stronger.

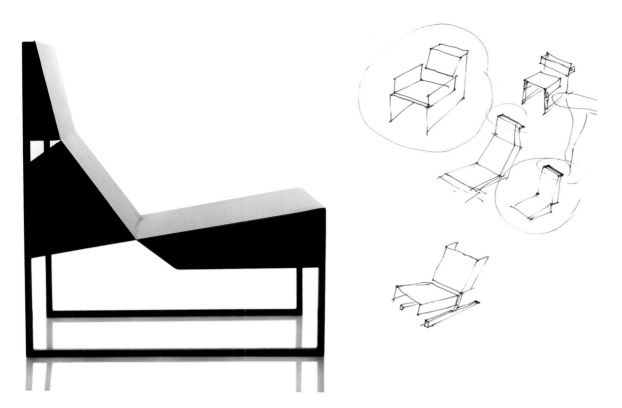

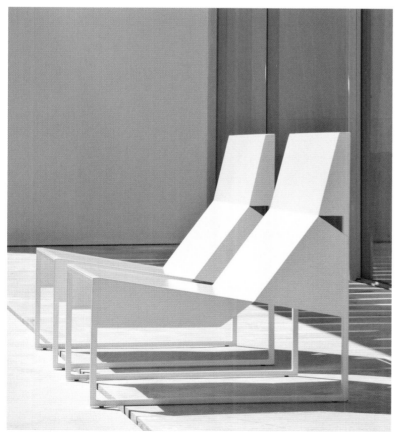

The lacquered water-resistant Paper Chair can be used in interior and exterior spaces. Its structure suggests a sheet of paper that acquires strength when folded.

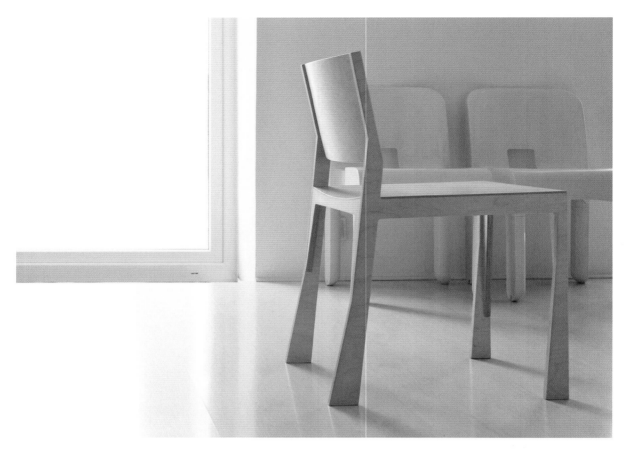

WR.03 is a simple chair of lightweight construction, with an ergonomic structure that helps to correct posture. It is made of birch plywood.

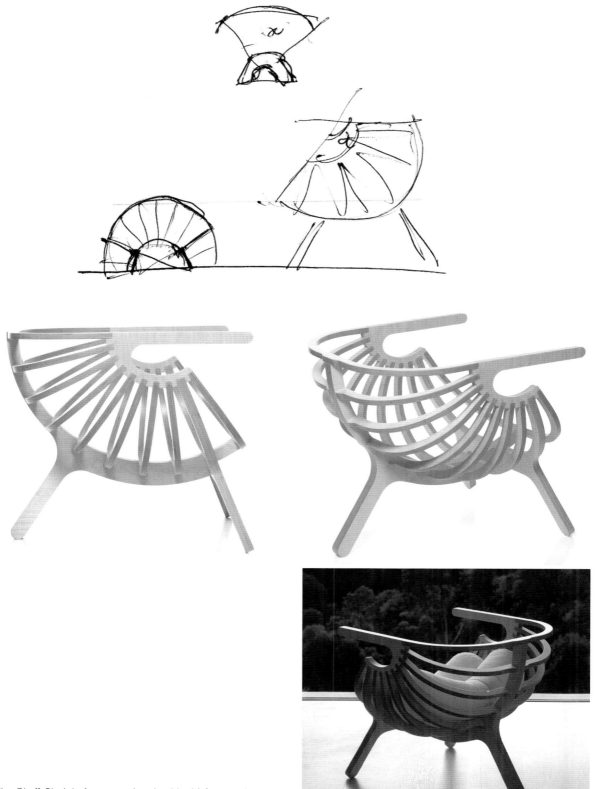

The Shell Chair's form was inspired by biology and the human body. Its ergonomic structure mimics the vertebrae; cushions can be inserted.

CARRASCOBARCELÓ
DESIGN STUDIO

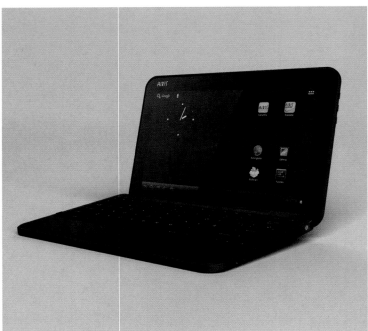

Barcelona, Spain
www.carrascobarcelo.com

Brothers Miguel and David Carrasco Barceló share something more than blood ties. Miguel, who graduated from the Elisava School in 1999, has worked for companies such as Faladesa and Infinity Systems. David graduated a year later from the same institution and completed a master's degree in transport design. In 2003 he joined Magma Design, where he carried out various projects until 2009. The studio is the personal project of the two designers.

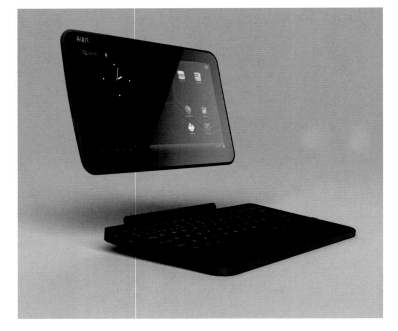

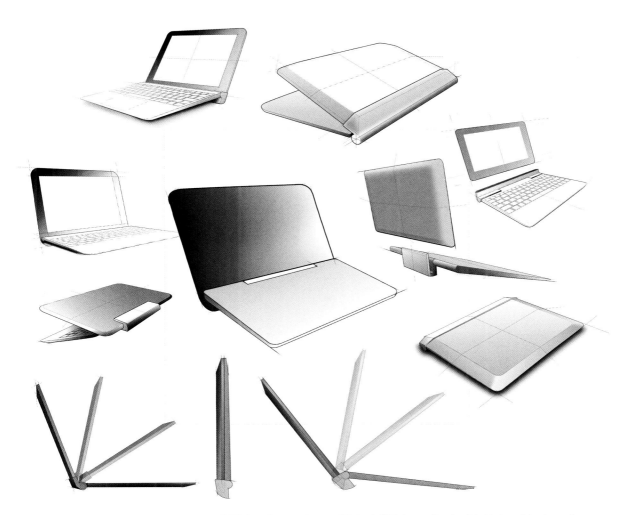

The TransBook is a netbook designed for AIRIS and comprises a 10-inch (25.4-centimeter) tablet and keyboard. The design perfectly integrates the two parts, with good interaction as well as an agreeable appearance.

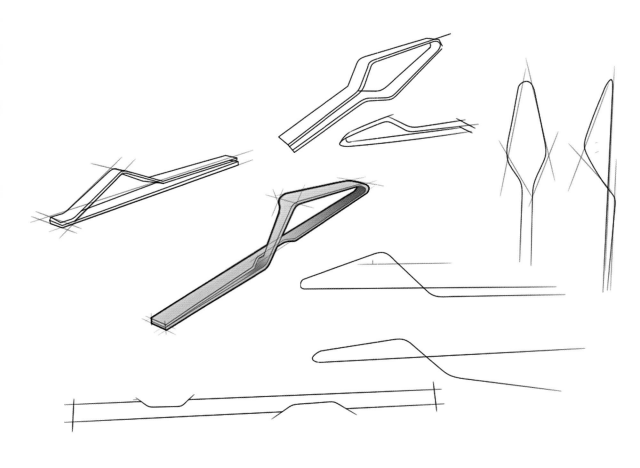

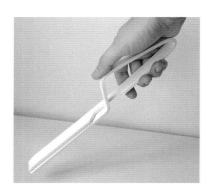

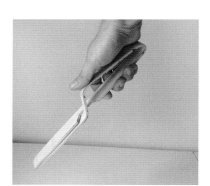

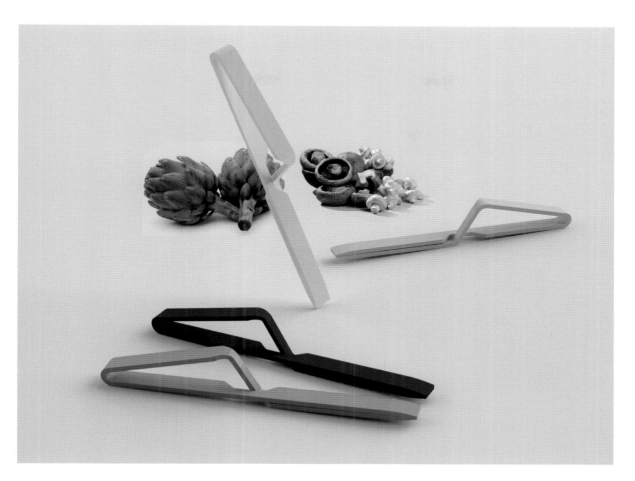

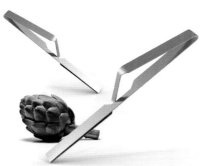

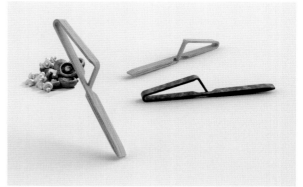

These kitchen tongs are a reinterpretation of an everyday object and are designed to stand out from others on the market. The product can be made from various materials, each one offering a different thickness and spring effect.

CHD INDUSTRIAL & PRODUCT DESIGN

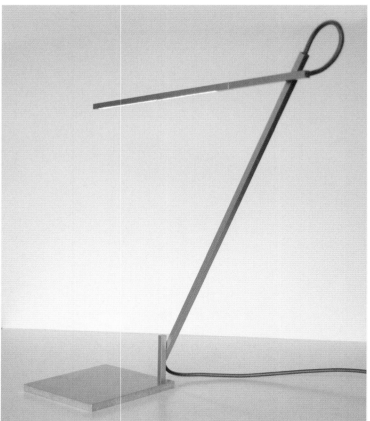

Geneva, Switzerland
www.chd.gr

Constantinos Hoursoglou is the director of CHD Industrial & Product Design. Born in Athens in 1972, Hoursoglou earned a degree in industrial design and a master's degree at the Royal College of Art in London. After working with Minale Tattersfield, Ayse Birsel, and Karim Rashid, he founded his own studio in 2002, and now designs products for large companies such as Swatch, Niedecker, and Prospers Japan. Hoursoglou has won a Red Dot Design Award and twice the Walker of Tomorrow Award, and currently lives in Geneva.

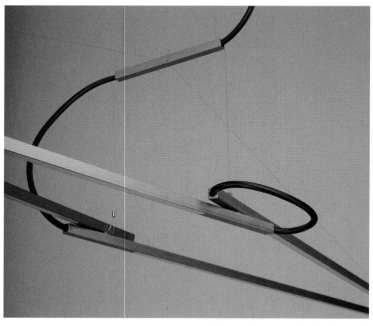

The Linelight is a flexible anodized aluminum LED lamp. The fabric-covered areas allow you to modify and combine colors, and the light direction can be adjusted as necessary by using the available different pivots and points of rotation.

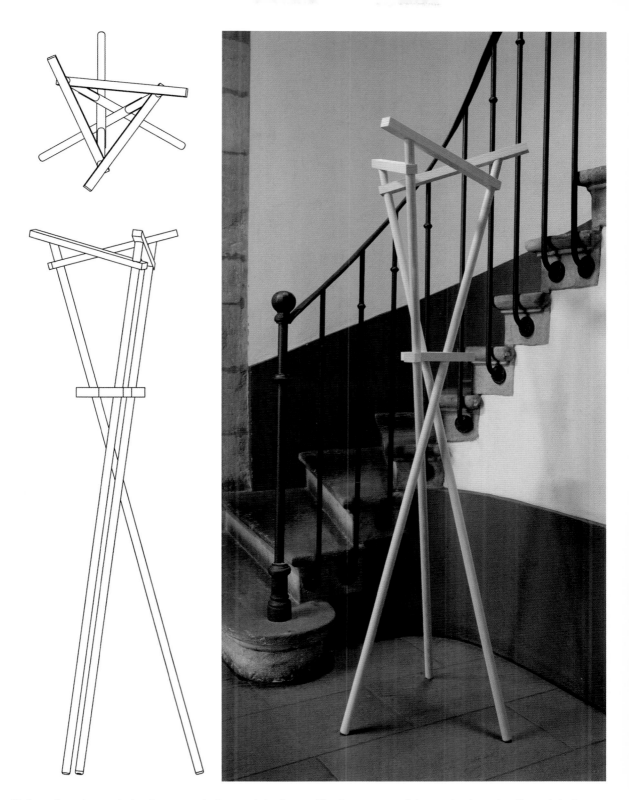

Sixthree is a pine coat stand composed of geometric shapes. The three upper slats create six protruding points for hanging clothes and folded shawls, and scarves can be hung on the sides of the hexagon.

CLAUDIO BELLINI
DESIGN + DESIGN

Milan, Italy
www.claudiobellini.com

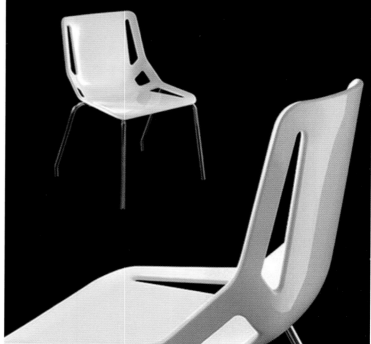

Son of the famous designer and architect Mario Bellini, Claudio was born in Italy in 1963. In 1990, after earning his degree in Milan, he began working in his father's studio. In 2006, he founded his own studio, where he focused on the application of new technologies and research into promising new materials. He is one of today's most influential designers and has been honored with the Good Design Award and the Red Dot Design Award.

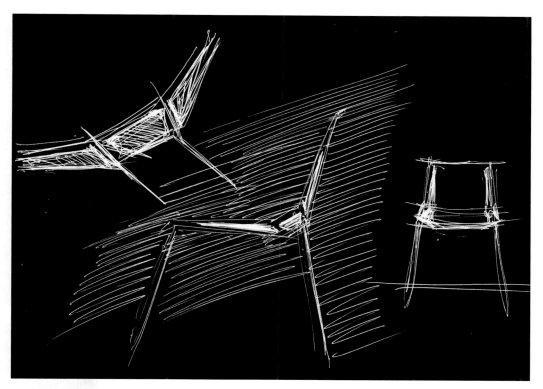

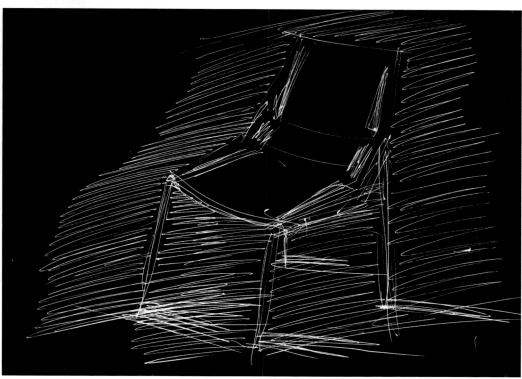

The CB chair seat is made from high-resistance polymer. Its structure is light, thanks to symmetrical openings.

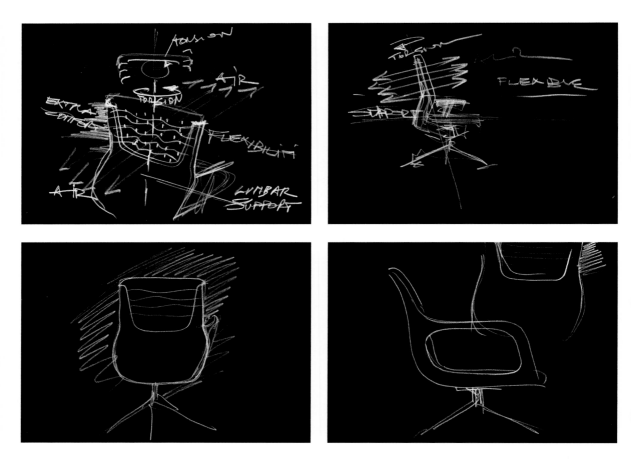

The Ega chair is designed with a flexible and breathable back that molds itself to the shape of the person sitting. The rotating structure is made of steel.

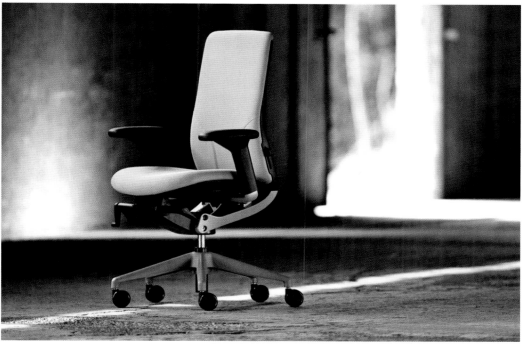

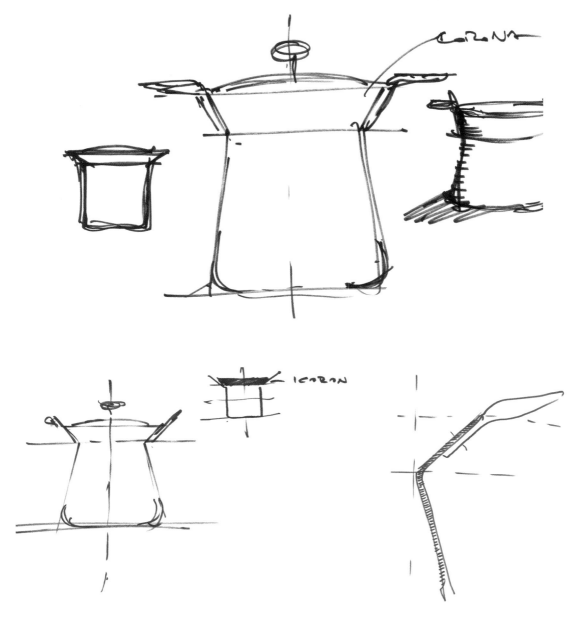

The My Lady cooking pot, designed for Barazzoni, remakes a classic, rounded design in a remarkable material: titanium.

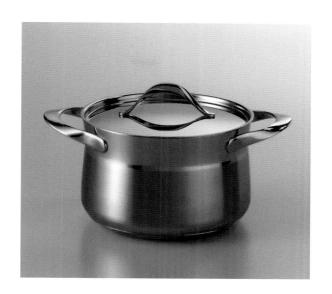

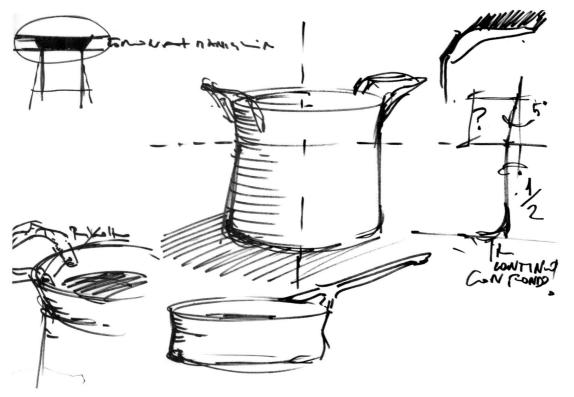

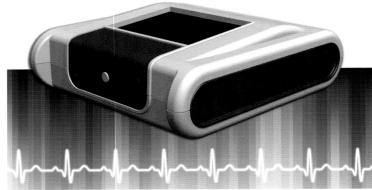

DESIGN DIRECTIVE

Ontario, Canada
www.designdirective.com
www.korzendesign.com

This multidisciplinary studio specializes in product design and development. Design Directive (where Tom Korzeniowski works) creates innovative, interactive solutions that aim to improve quality of life through consumer, industrial, and medical products. Design Directive's mission is to bring profitable, ecologically friendly, and functional products to market.

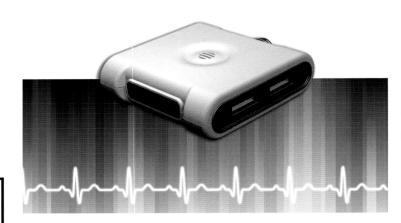

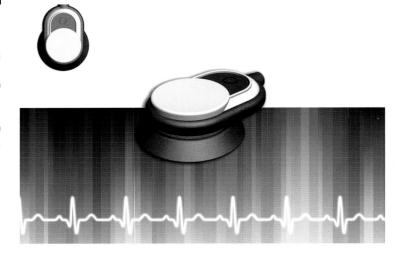

FRONT VIEW

SCREEN

SIDE PROFILE

AUDIO,
DC, OUTLET

LED TO
INDICATE
POWER.

OUTLETS

SIDE VIEW.

HARD-DRIVE
DEVICE
INSERTED IN
BACK.

HANDGRIP UNDERNEATH
HANDLE

ANGLED SCREEN
FOR OPTIMAL
VIEWING

RUBBER
SIDEGRIPS FOR
HANDLING &
GRIP

The Cardio Center is used for the diagnosis and treatment of cardiovascular illnesses. The system is composed of different devices, using software to analyze information gathered by the biometric sensors.

DESIGNNOBIS

Angora, Turkey
www.designnobis.com

As far as the Designnobis team is concerned, creativity is not just a tool; it is the foundation underpinning all of their activity. On the theory that the innovator is almost always competitive, this company, ran by Hakan Gürsum, develops distinctive ecological products that help their clients differentiate themselves from their competitors and find a strategic gap in the market.

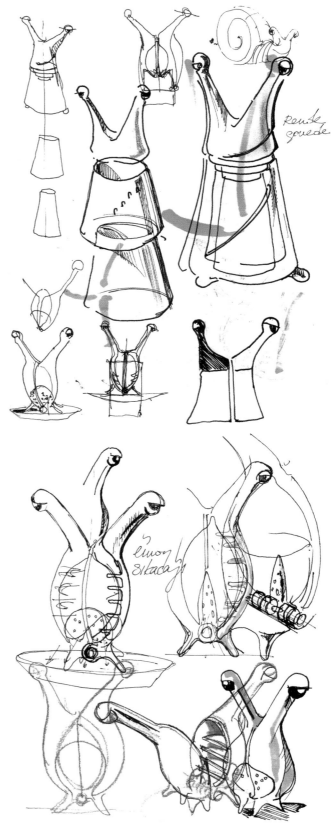

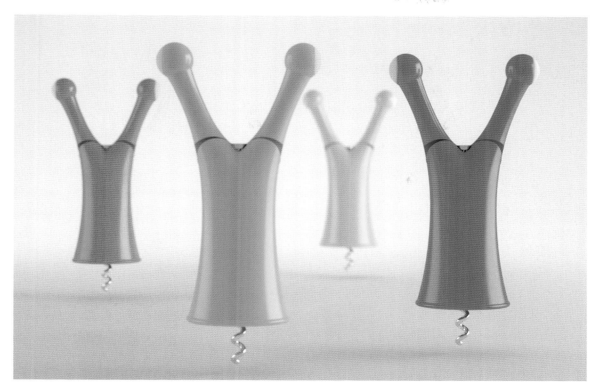

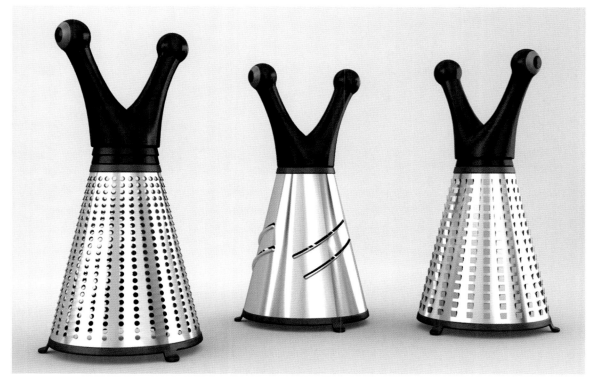

The Snail Series is a collection of small kitchen accessories designed to look like a snail's head. The set includes nutcrackers, a potato peeler, a grater, and a corkscrew.

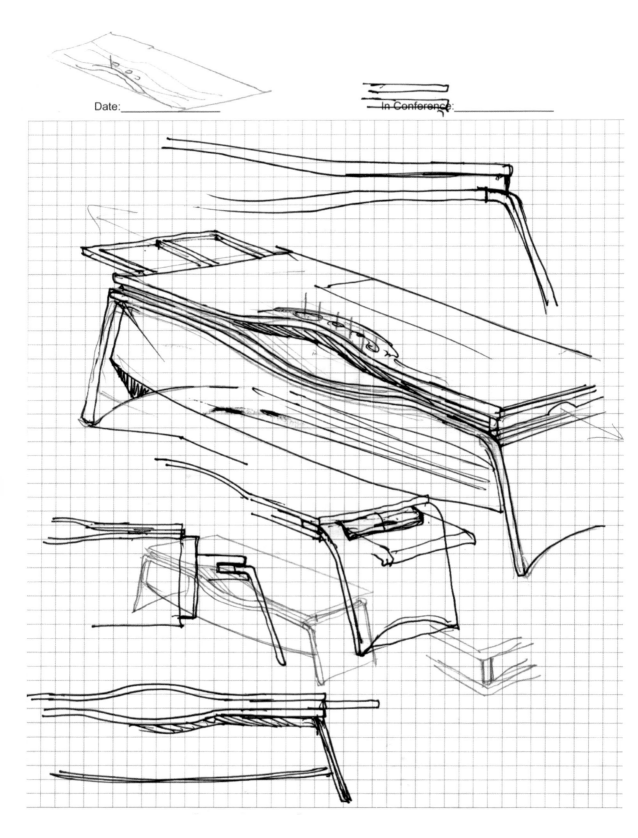

Date: _____

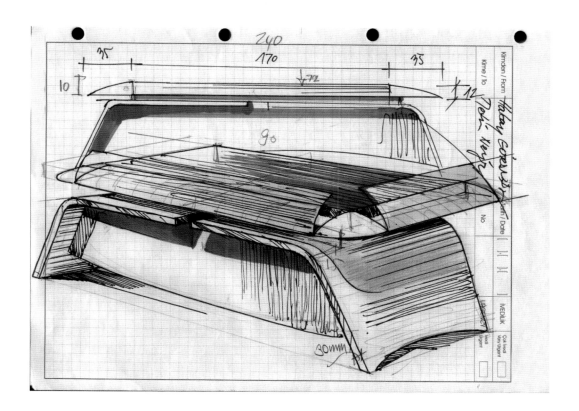

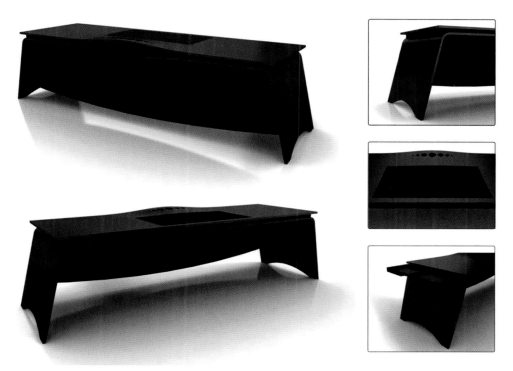

The Office is a desk designed with defined surfaces for storing different kinds of office equipment, including a side shelf that can be hidden like a drawer and used to organize pens and other items.

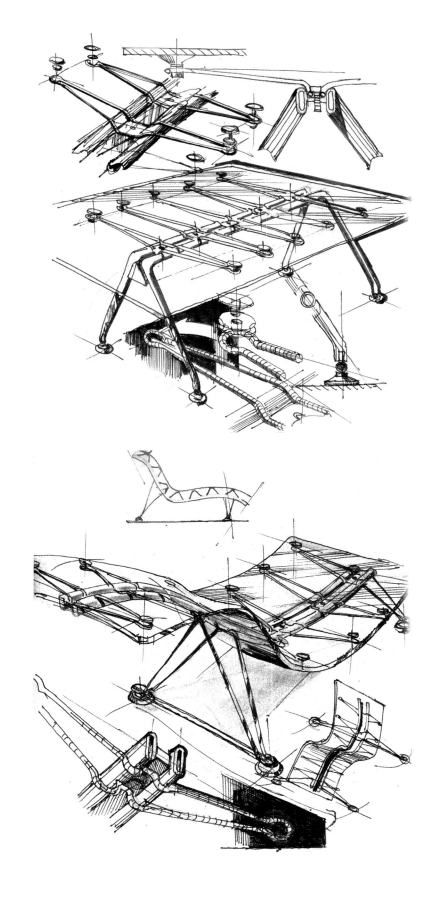

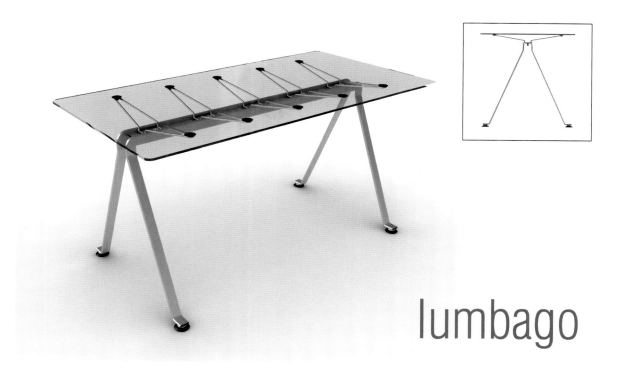

lumbago

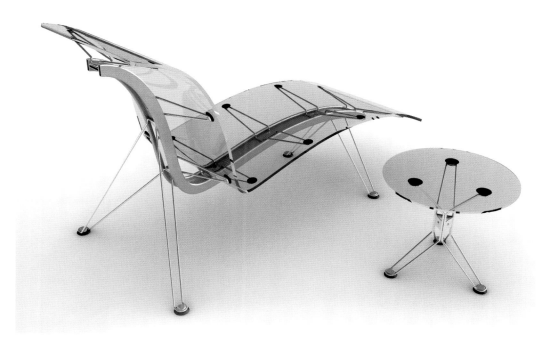

The Lumbago is a table and chair set with a metal frame inspired by the spine. Its design is simple and light, thanks to the supports used and their transparency.

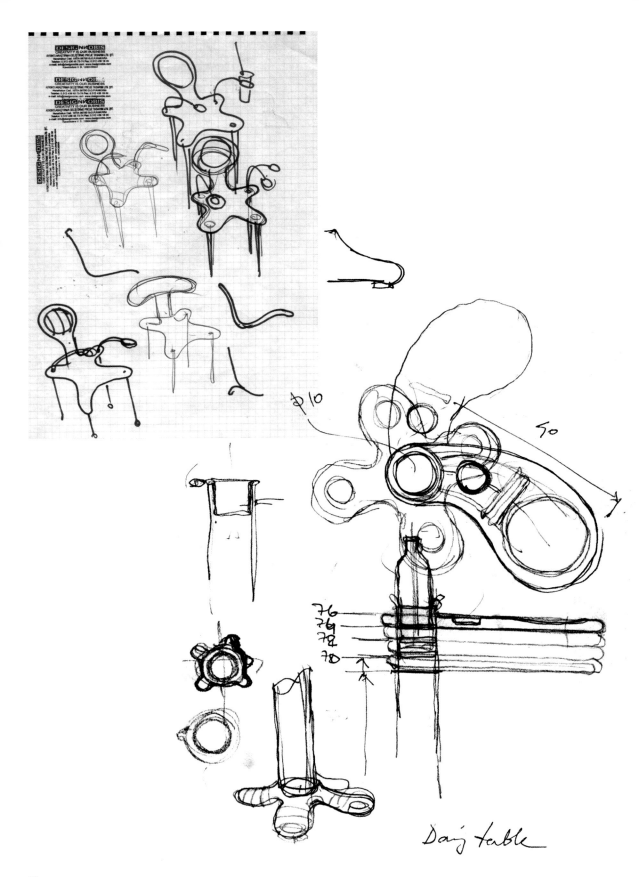

Dining table

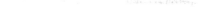

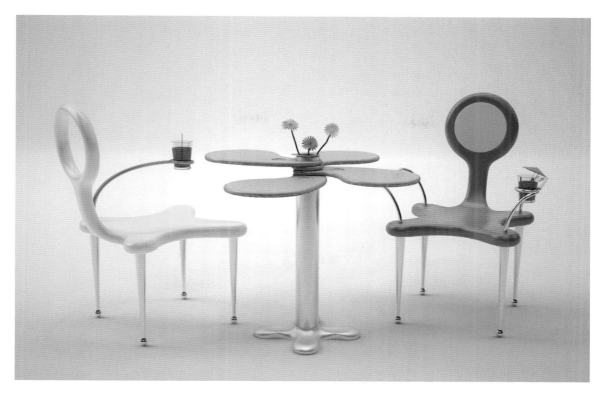

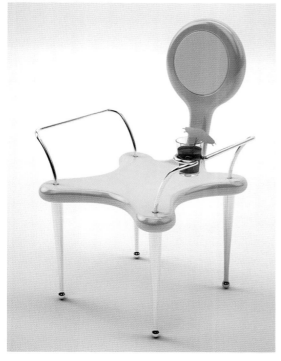

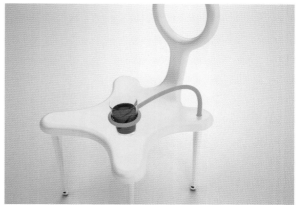

The Daisy and Margerite is a table and chair set in lively colors with an original design. Imitating the shape of a flower, the table has four folding petals and a hole in the middle that can be used as a vase. The chair has built-in cup holders.

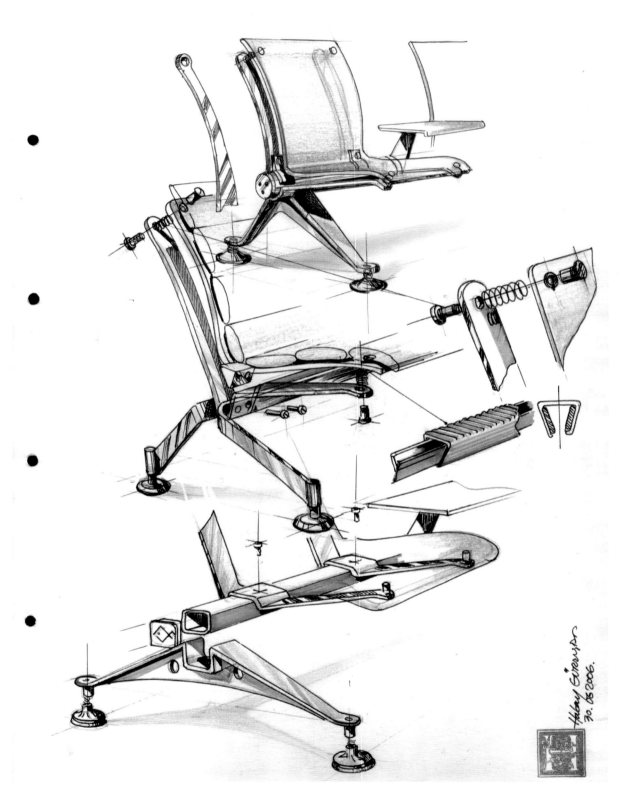

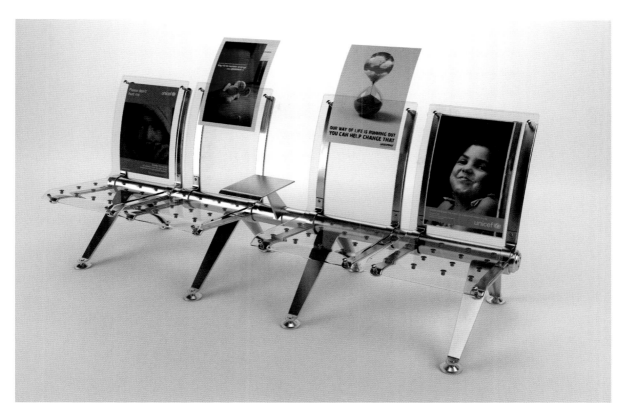

Beetling consists of a row of transparent indoor seats. Designed for public places, the backs have a space for advertisements and posters.

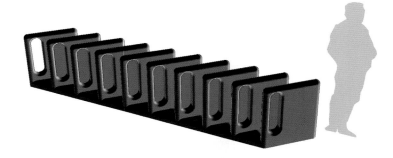

DÍEZ + DÍEZ DISEÑO

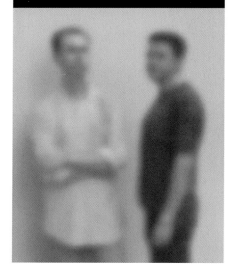

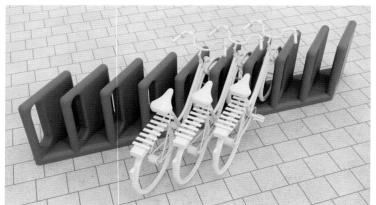

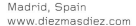

Madrid, Spain
www.diezmasdiez.com

Brothers Javier and José Luis Díez, industrial designer and interior designer respectively, run a studio specializing in product design. The team has developed projects for companies such as MiSCeLaNia, Escofet 1886, Gitma, Tecnología & Diseño Cabanes, and Ecoralia. Their studio won the 2005 Delta de Plata Award, and in 2010, they won an award in the industrial design category of the 13th Awards of the Association of Spanish Design Professionals.

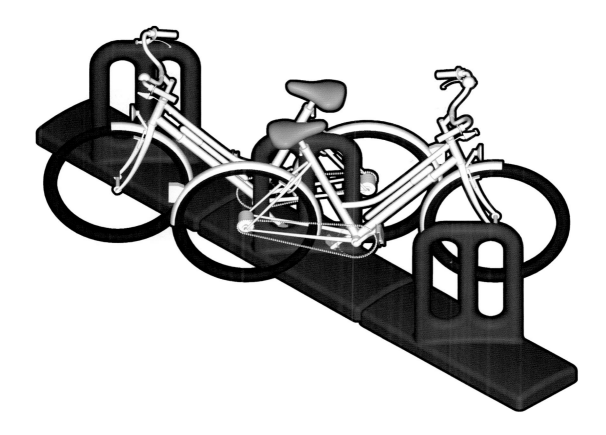

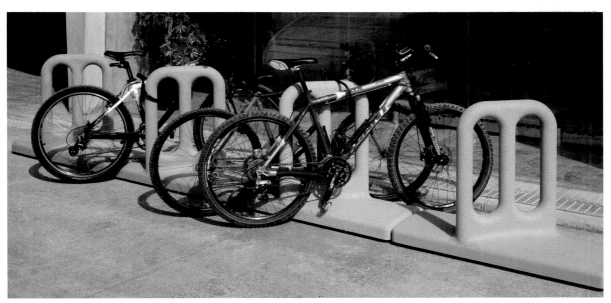

The concrete Cyclo is a structure for parking bicycles on the street. It is available in two varieties: battery, for large spaces; and free, perfect for smaller spaces, as it allows the bikes to be aligned lengthwise on narrow footpaths.

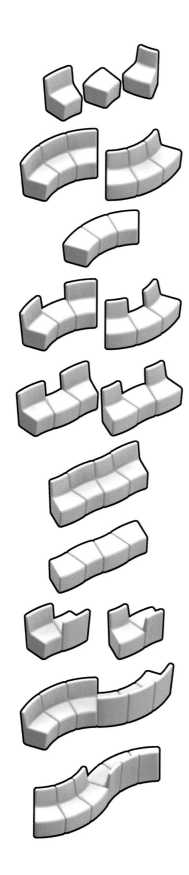

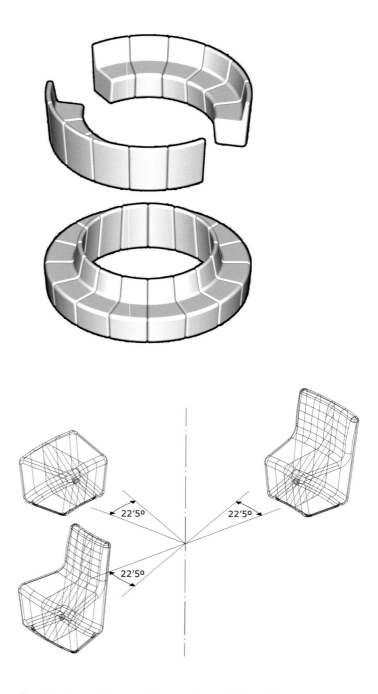

The Dove is a sofa comprising seating modules with a backrest. They can be concave or convex and join at the sides to form different combinations of dynamic curves.

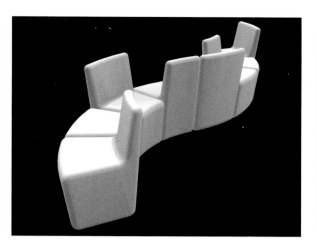
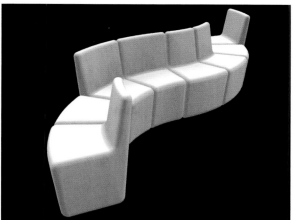
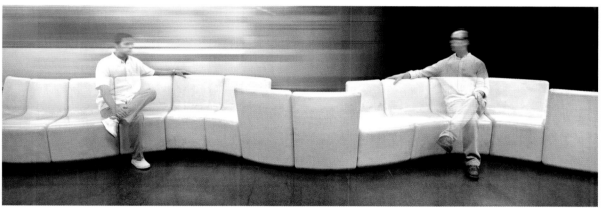
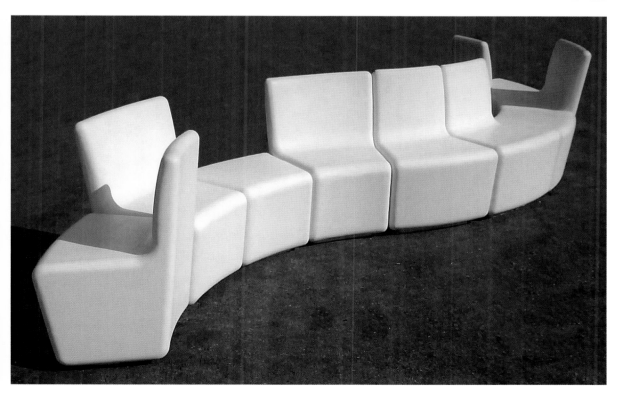

DING 3000

Hannover, Germany
www.ding3000.com

Designers Carsten Schelling, Sven Ru-
dolph, and Ralph Webermann opened
DING 3000 in 2005. The young com-
pany specializes in consumer-orient-
ed products that are simple, useful,
and fun, with a touch of magic. The
team has received more than thirty
awards, including the iF Product De-
sign Award, the Good Design Award,
the Red Dot Design Award, and the
Design Plus Award.

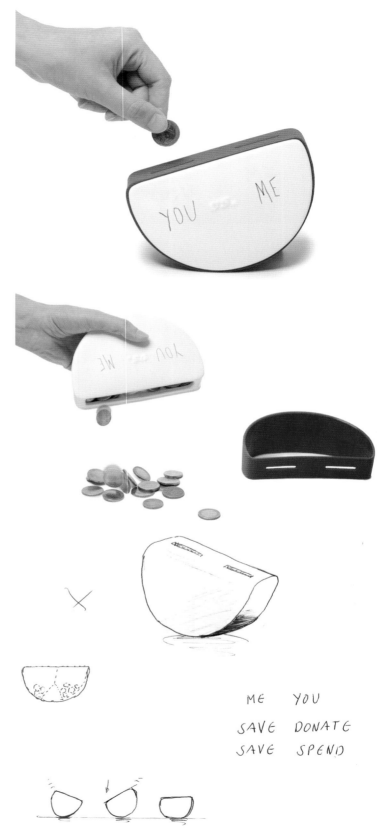

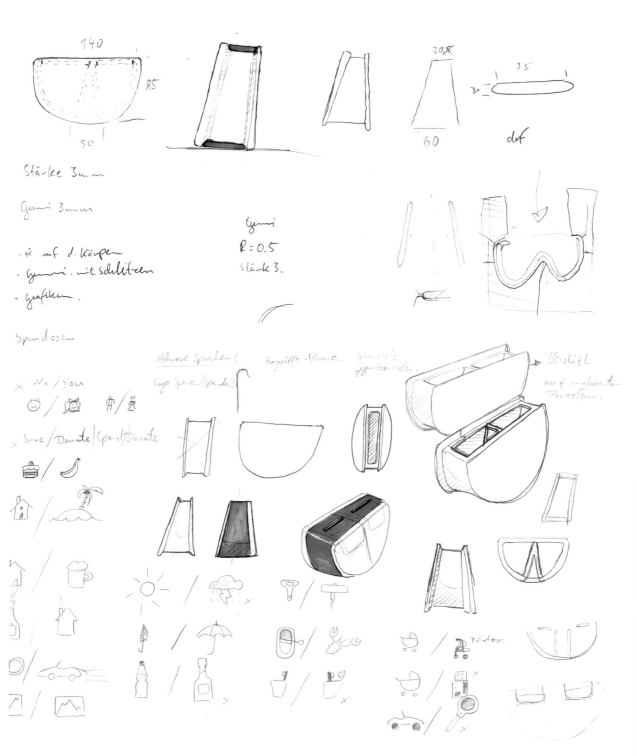

Duell is a money box with two compartments separated by a V-shaped part and two separate slots. It allows money to be saved for two different purposes, creating a "duel" between the two. It is opened by moving the red frame.

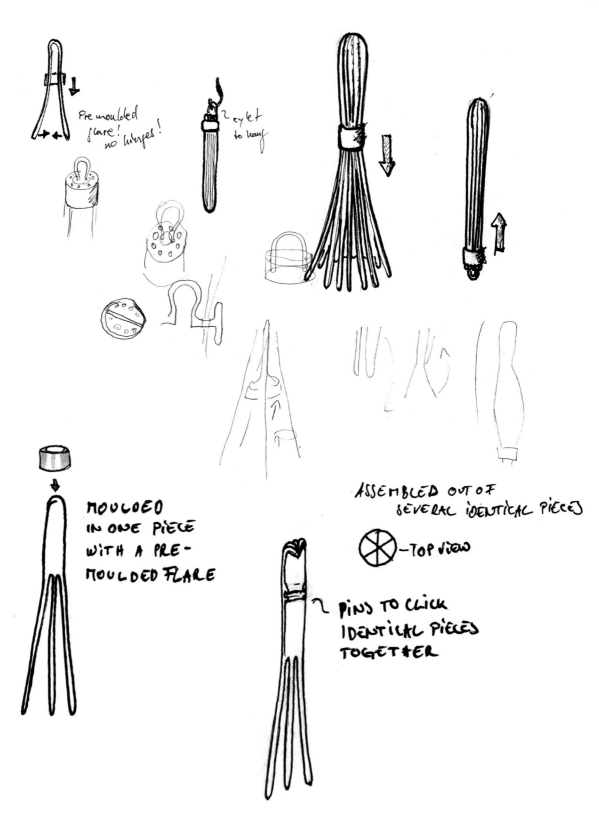

Pre moulded flare! no hinges!

eylet to hang

MOULDED IN ONE PIECE WITH A PRE- MOULDED FLARE

ASSEMBLED OUT OF SEVERAL IDENTICAL PIECES

—TOP VIEW

PINS TO CLICK IDENTICAL PIECES TOGETHER

The Beater is functional and attractive and takes up little space in the kitchen. Its design suggests a handful of straw held together by a central ring. Moving the ring opens and closes the utensil.

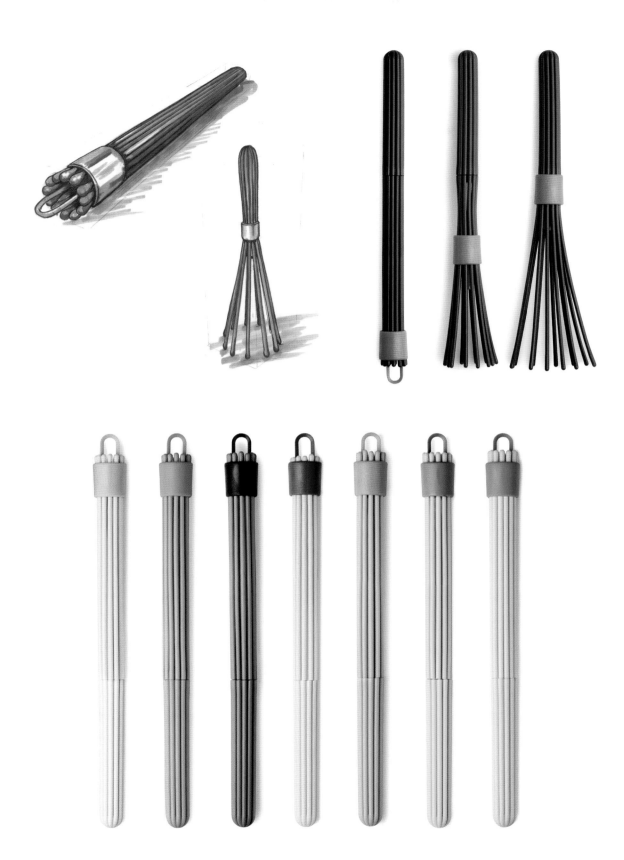

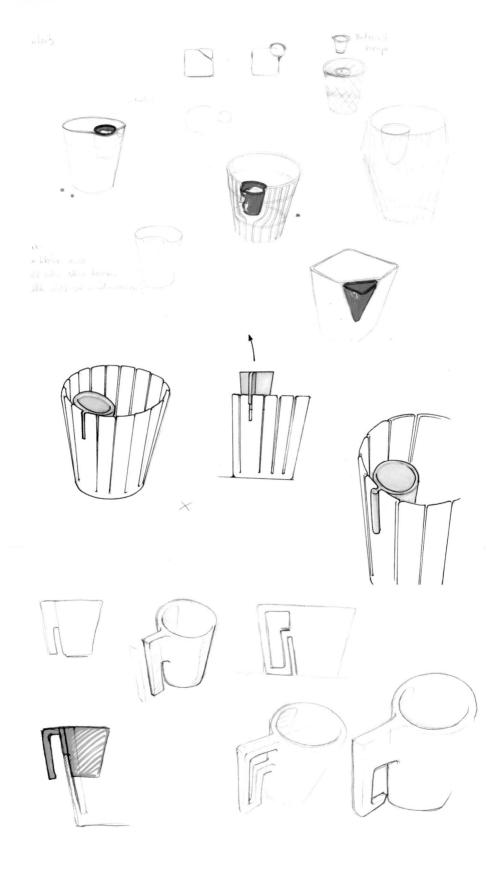

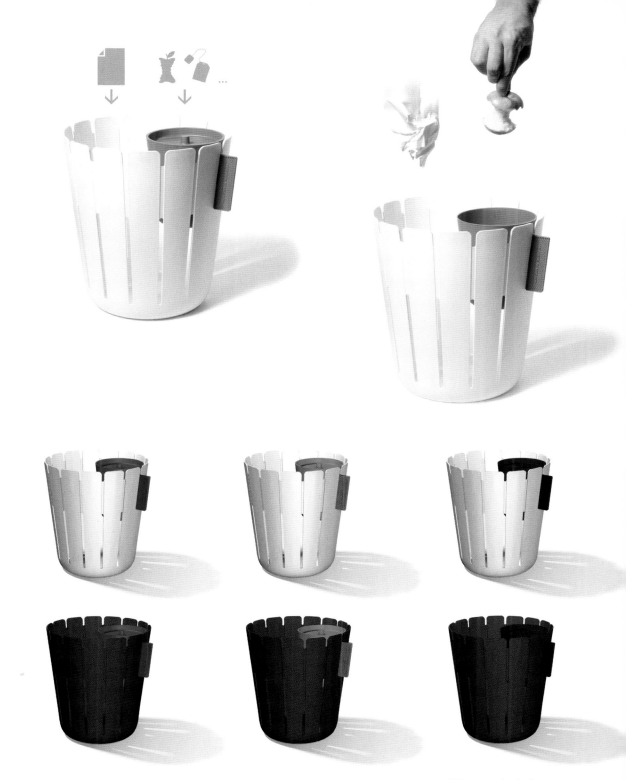

A small receptacle slips into the side of the Basketbin, perfect for liquid and food scraps. This receptacle is dishwasher-proof and comes in vibrant colors that contrast with the neutral tones of the wastepaper basket.

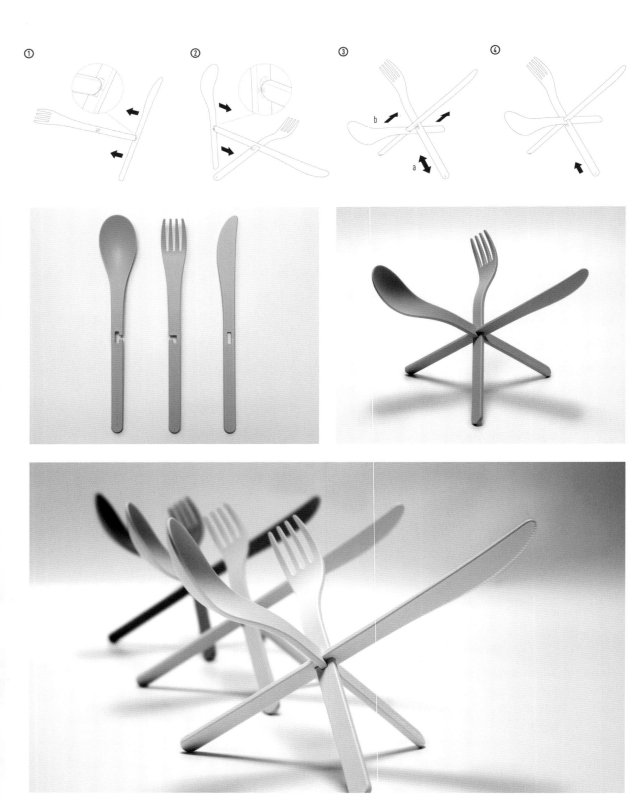

Join is a new take on the plastic flatware set. Designed for Konstantin Slawinski | housewarming objects, each eating utensil has a notch in a different shape that allows the user to assemble them. The set comes in various vibrant colors.

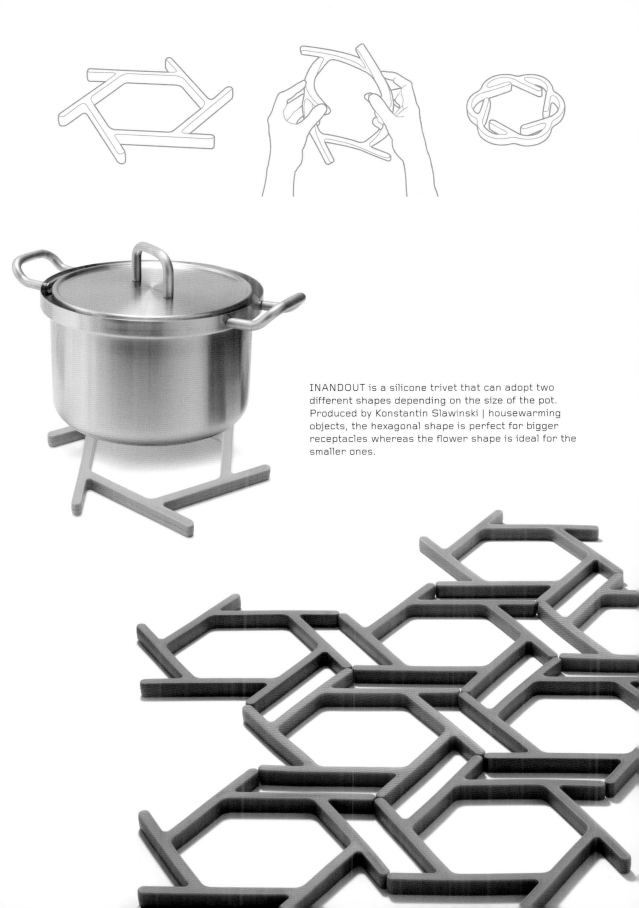

INANDOUT is a silicone trivet that can adopt two different shapes depending on the size of the pot. Produced by Konstantin Slawinski | housewarming objects, the hexagonal shape is perfect for bigger receptacles whereas the flower shape is ideal for the smaller ones.

FEIZ DESIGN STUDIO

Amsterdam, The Netherlands
www.feizdesign.com

Born in Iran in 1963, Khodi Feiz grad-
uated from Syracuse University with
a BA in industrial design in 1986.
In 1998, he founded the Feiz Design
Studio, where he worked alongside
graphic designer Anneko Feiz-van
Dorssen. The studio specializes in
product design, furniture, and com-
mercial branding, and has the Red Dot
Design Award 2010, the IDEA Award
2010, and the Toy of the Year 2010.

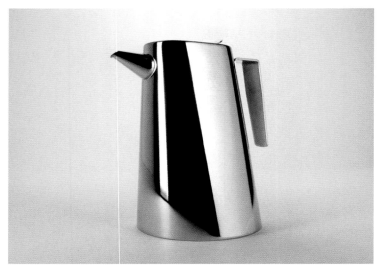

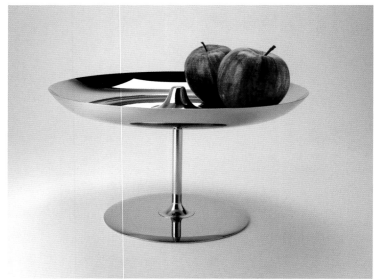

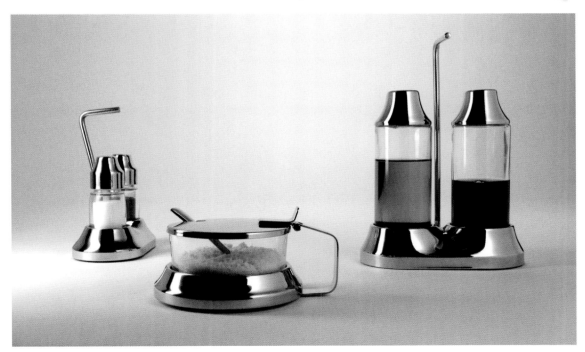

Steel is a collection of stainless steel objects for the table: oil and vinegar bottles and a saltshaker, among others. Not only do these products reflect light and enhance any space, they are also very strong and easy to keep in good condition. It was designed for Giannini.

Inspired by the experience of sitting, Moment is a round and generously shaped chair with an extra support that functions as a table. It is made of cold-molded foam; the covering forms an integral part of the structure. It was designed for Offecct.

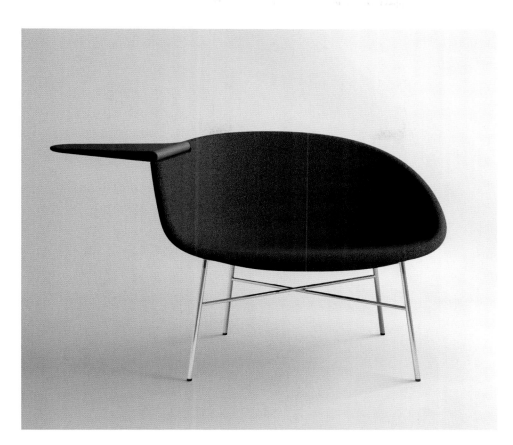

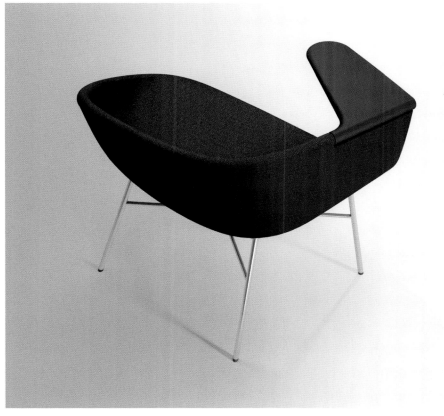

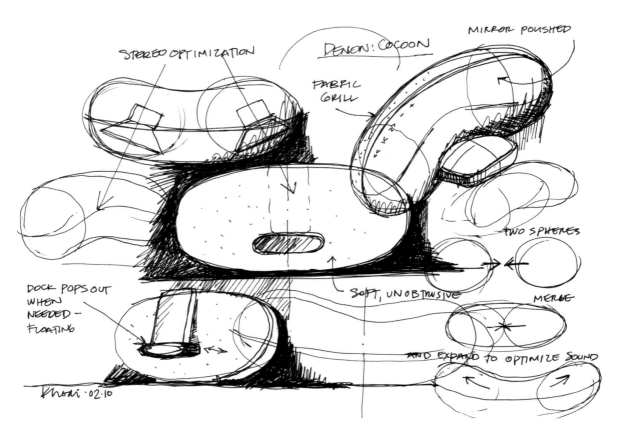

STEREO OPTIMIZATION

DENON: COCOON

MIRROR POLISHED

FABRIC GRILL

TWO SPHERES

MERGE

SOFT, UNOBTRUSIVE

DOCK POPS OUT WHEN NEEDED — FLOATING

AND EXPAND TO OPTIMIZE SOUND

Khodi · 02.10

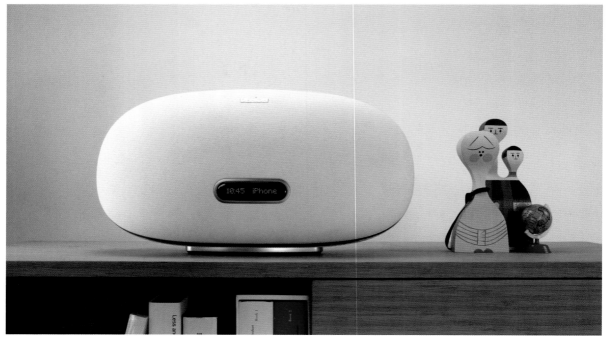

10:45 iPhone

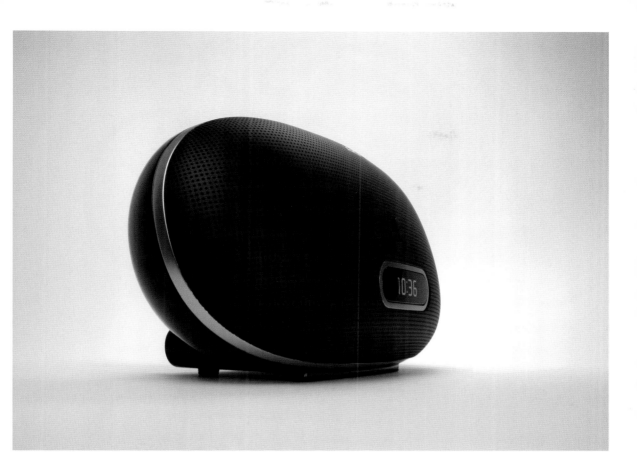

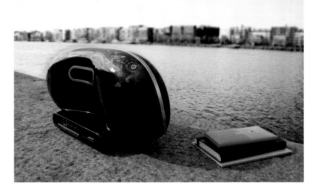

This wireless speaker, which comes either portable or fixed, has rounded shapes and a sealed acoustic chamber that guarantees 100 watts of power. The Cocoon was designed for Denon and is compatible with Apple, Android, and Windows devices.

FRANCESC GASCH

Barcelona, Spain
www.francescgasch.com

Francesc Gasch was born in 1986. He has a degree in design engineering and a master's degree in product design from Elisava, the Barcelona School of Design and Engineering. After spending seven months working for a French company, Gasch returned to Barcelona and established his studio in 2010. He has won several international prizes, such as the 5th Edition of Hi-cooking Castey Design Awards.

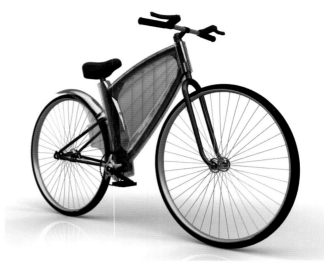

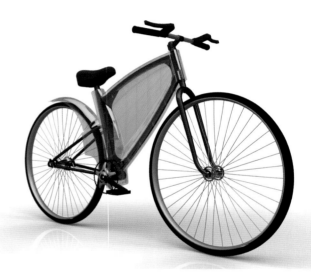

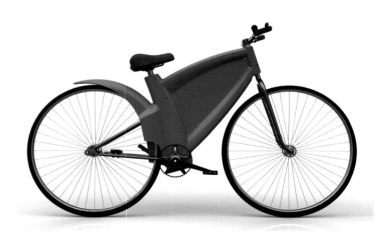

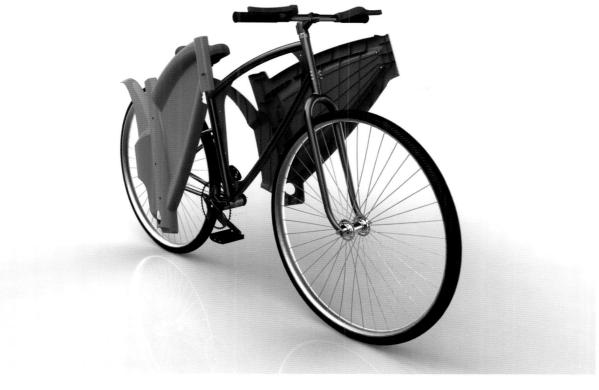

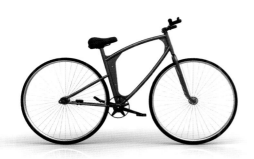

The U-Bike was planned for the bike hire system in Barcelona. The transparency of the structure confers a sensation of lightness, and it has a GPS for easy locating.

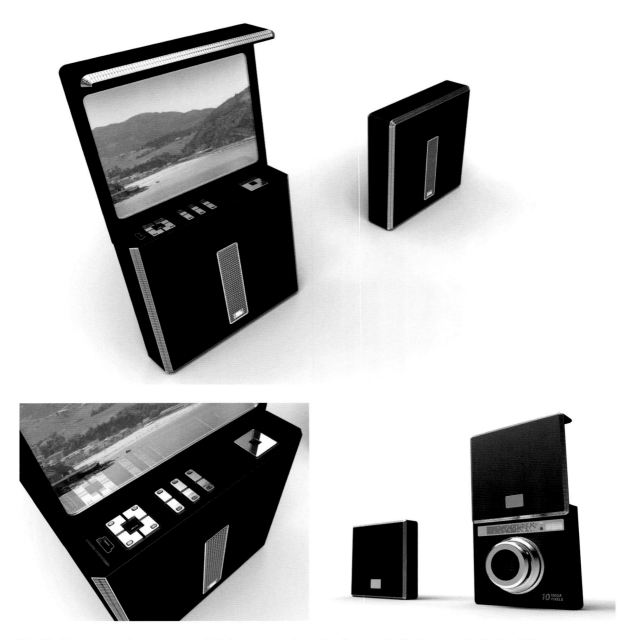

The Oled is a proposal of a compact digital camera designed for Swarovski. Its fine organic flexible LED screen makes its small size possible and has secured its place in the market as a camera with a difference. It also combines Swarovski jewels with a high-tech gadget.

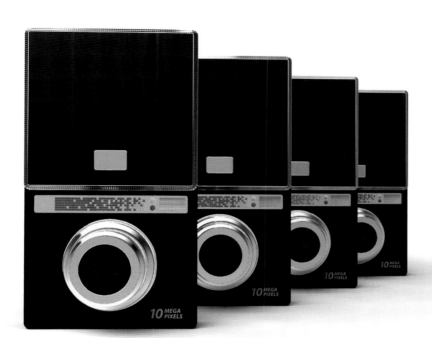

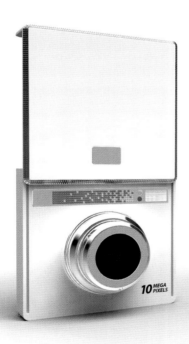

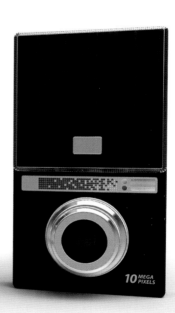

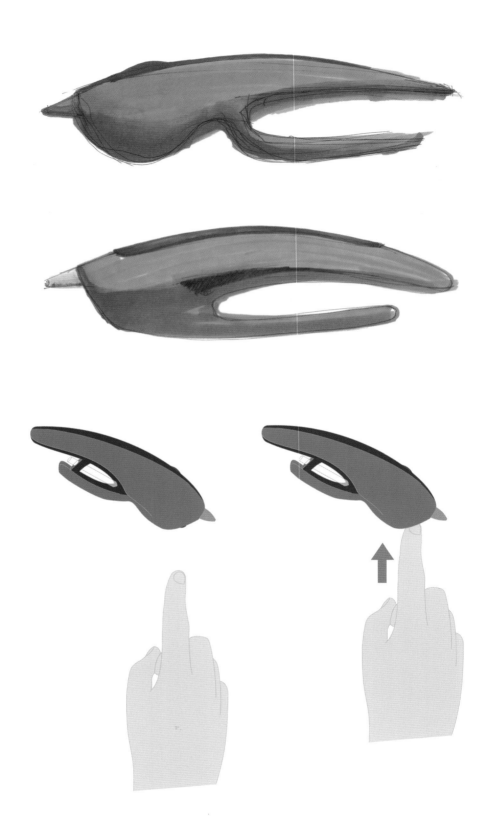

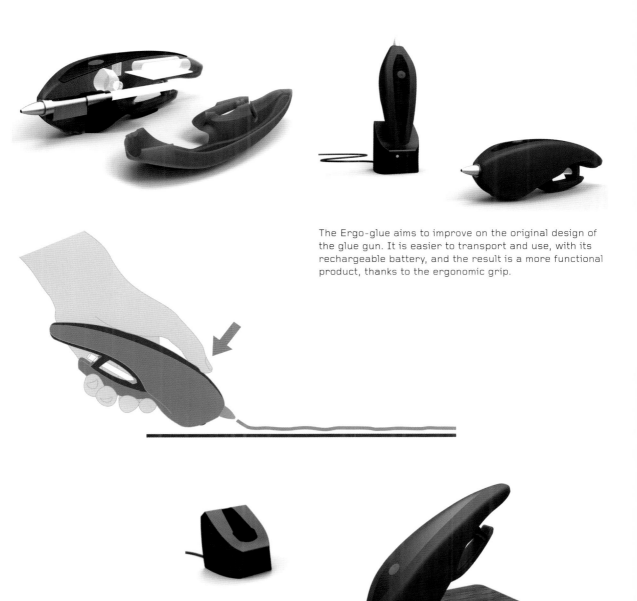

The Ergo-glue aims to improve on the original design of the glue gun. It is easier to transport and use, with its rechargeable battery, and the result is a more functional product, thanks to the ergonomic grip.

JOAN GASPAR

Barcelona, Spain
www.joangaspar.com

Joan Gaspar studied industrial design at School of Artes y Oficios in Barcelona. In 1998 he began working for VAPOR, creating minimalist lights and lamps. In 2002 Gaspar founded his own studio and began collaborating with various companies to design new products. He has been teaching at Barcelona's Eina, School of Design and Art, since 2003 and has won a Delta de Plata Award.

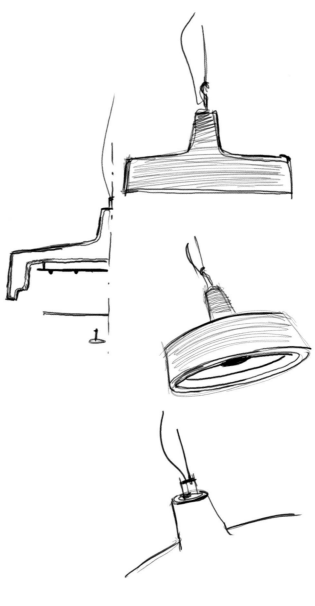

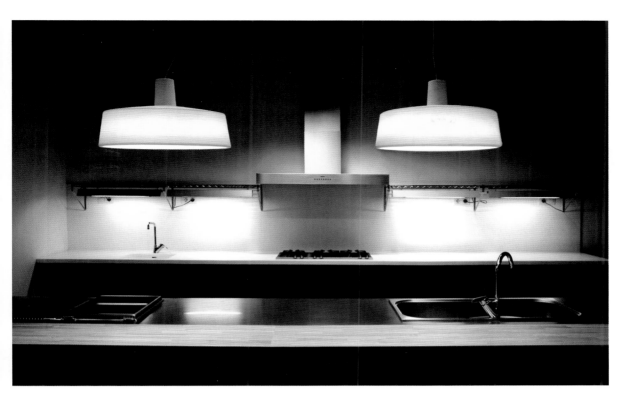

The Soho is a lamp designed for public spaces, although it is now available in a smaller size, making it perfect for the home. Its light is smooth because of its large screen.

The Polo is an LED lamp with a tubular screen that directs light with great precision. Note the detail in the joining mechanism.

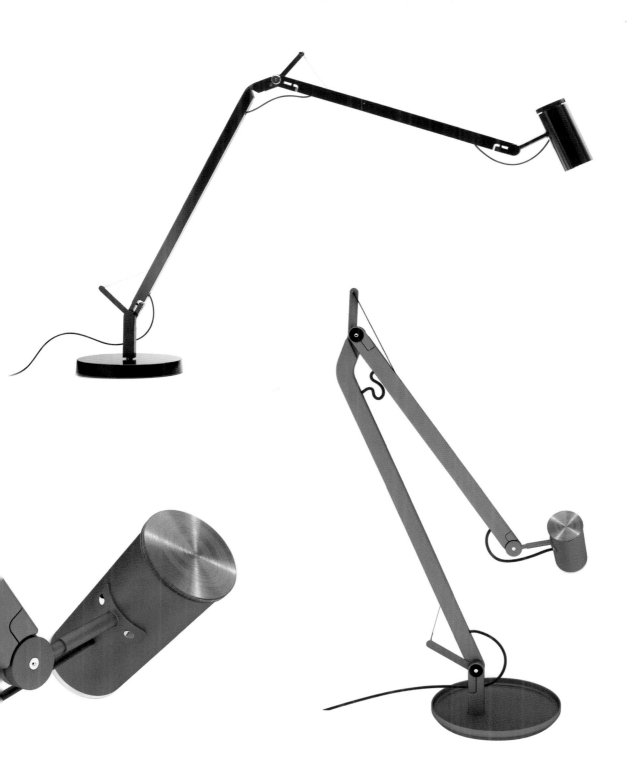

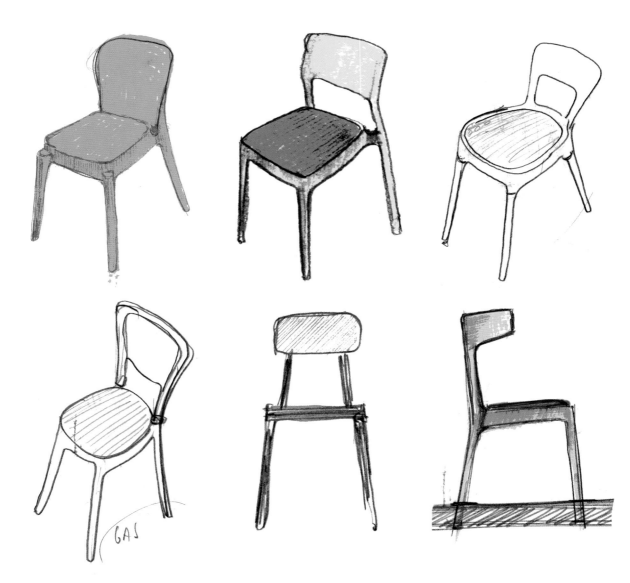

The outstanding Lisboa chair is injection molded using glass-fiber reinforced propylene, which creates surfaces of varying thicknesses, very thin walls, and a light design.

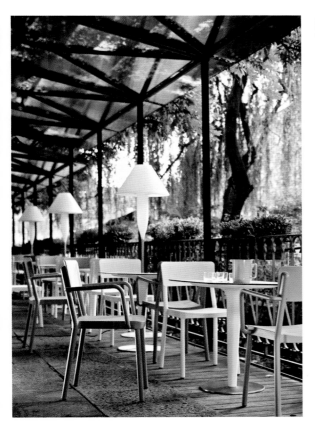

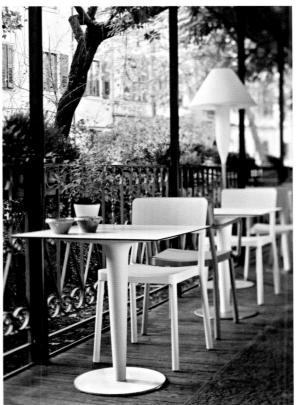

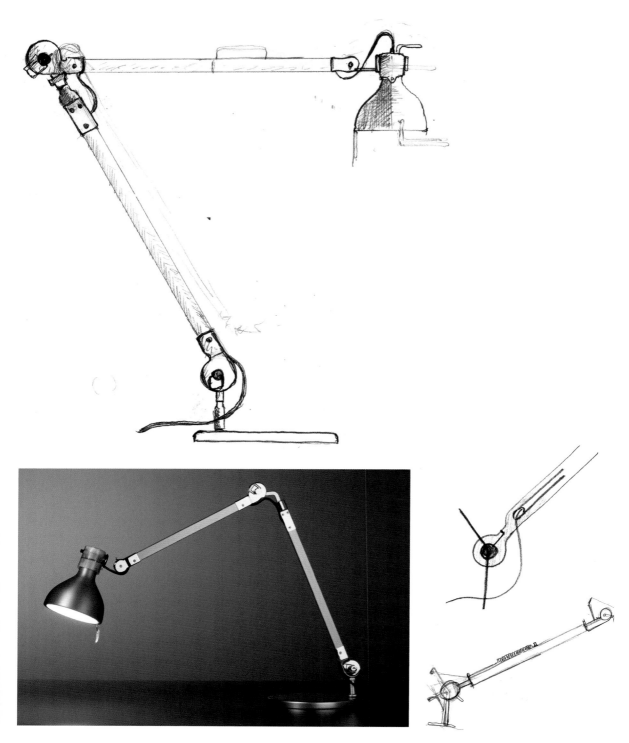

Atila is a desktop gooseneck lamp with a carefully designed mechanism that allows it to be adapted as needed. It can also be used as a standard or wall lamp.

TOMMY HAWES

Toronto, Canada
www.tommyhawes.com

As a child, Tommy Hawes used to take his toys apart to see what was inside. He would spend hours trying to figure out how a particular toy worked. This led to Hawes studying industrial design. Later he spent five years traveling around the world and working for studios in different countries. Hawes strives to exceed consumer expectations with his designs, making everyday activities interesting.

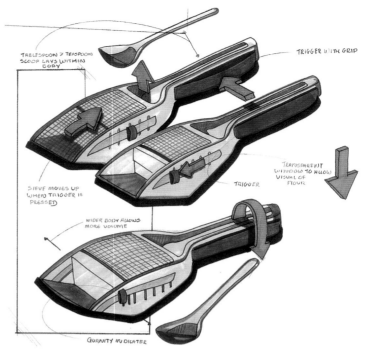

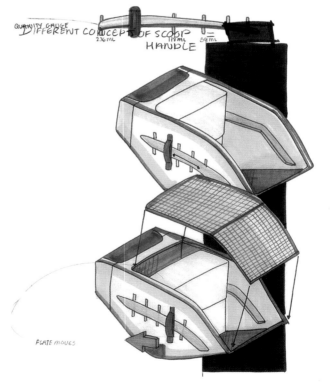

The body of this flour sieve is slender with beveled edges to make it handier. It can be used to measure different quantities; the handle contains smaller measures. The nylon material makes it easy to clean.

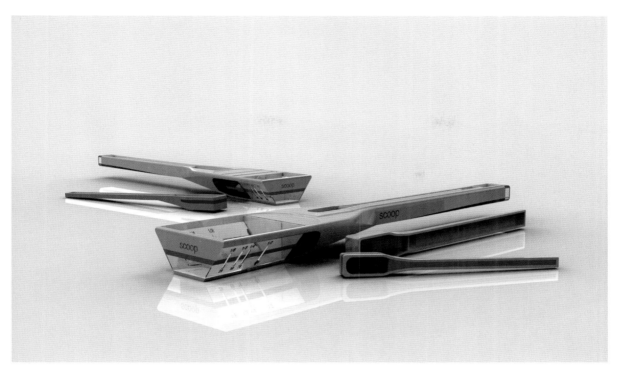

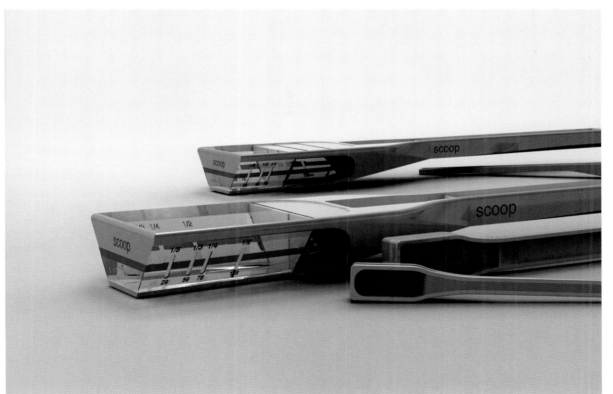

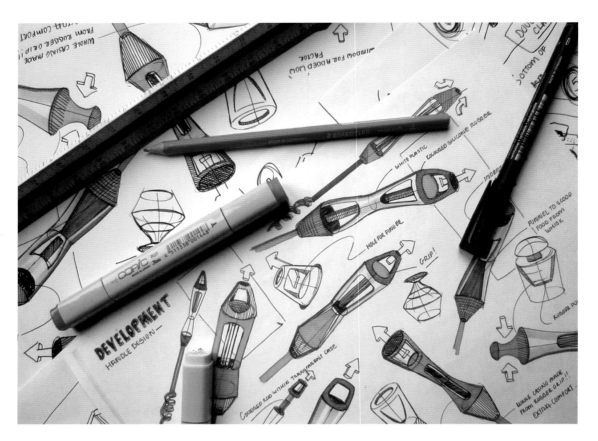

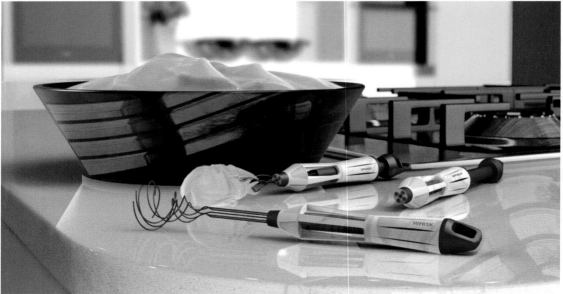

The Retractable Whisk was designed to reduce food waste. The whisk is drawn back into the levers of the handle, and the excess is left in the tip, ready to use. It is made of easy to clean nylon and silicone.

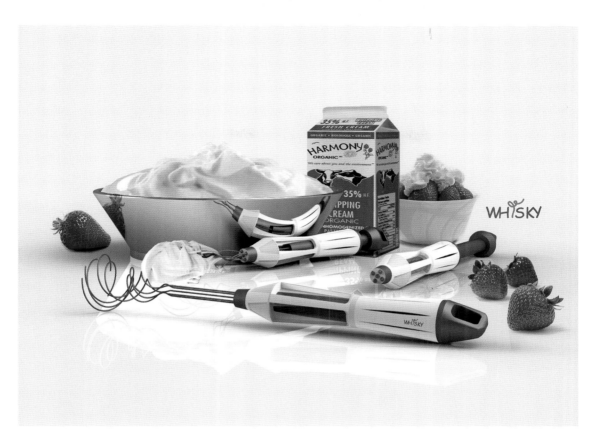

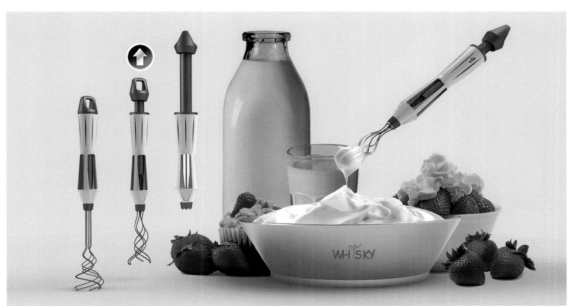

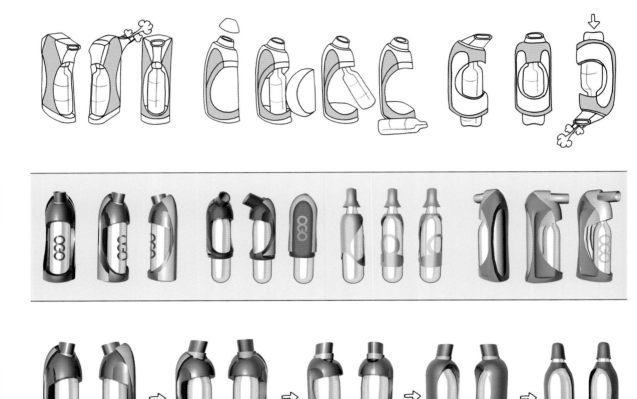

OGO is a university project in which Hawes was to design a new product for an already existent company. The inhaler is a solution for providing the oxygen a user would need in a reduced-oxygen environment.

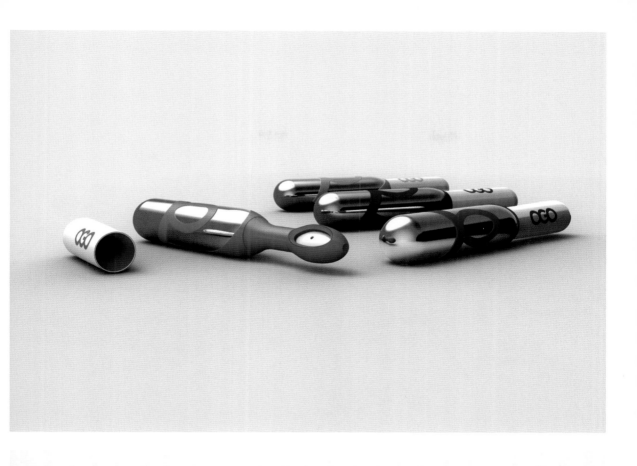

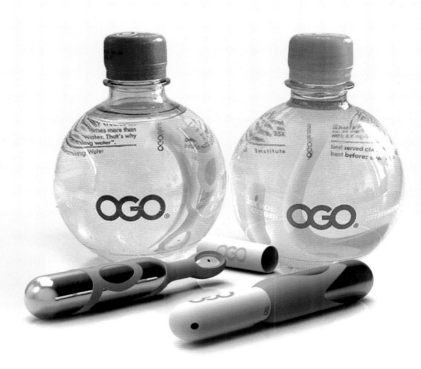

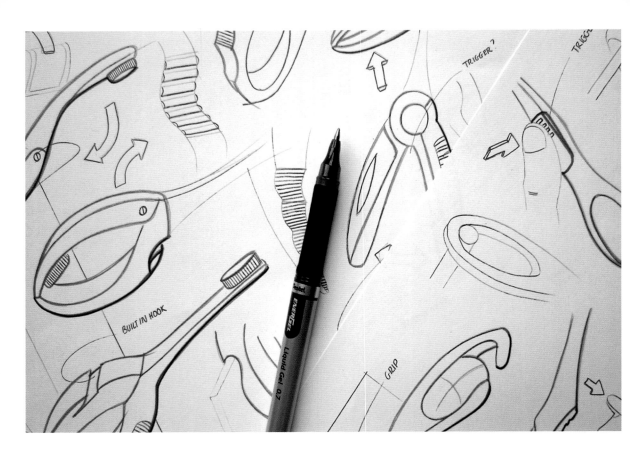

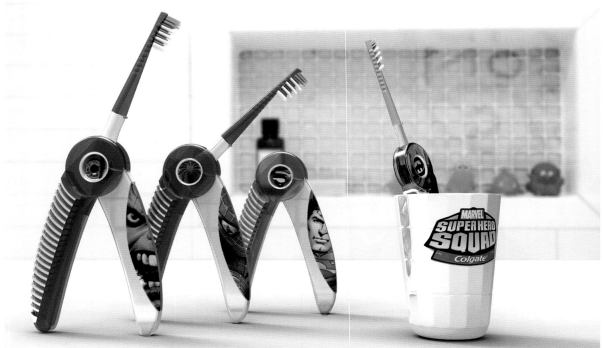

The Actuator Toothbrush is designed for children. Small, foldable, and decorative, this gadget automatically loads the correct amount of toothpaste.

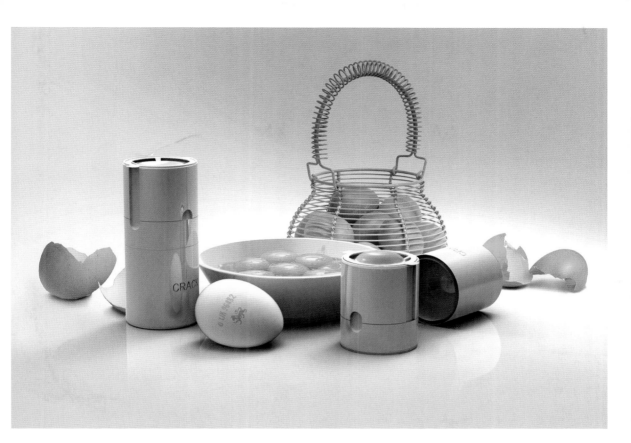

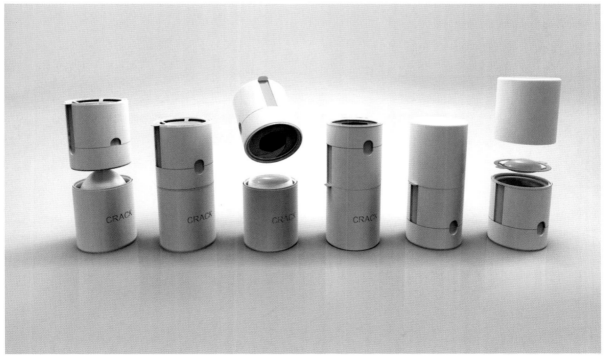

This device, aptly named Crack, is used for separating yolks from egg whites. The egg is placed in the central compartment, and with one turn, the shell, yolk, and white are separated.

LOUISE HEDERSTRÖM

Malmö, Sweden
www.louisehederstrom.com

A graduate of the Beckmans College of Design in Stockholm, Louise Hederström is inspired by the unexpected and seeks to design products that demand attention and communicate with the user. Hederström, born in 1973, therefore adds personality to her creations, and their function derives from the character that each object acquires. Her studio works for brands such as Maze Interior and Design House Stockholm.

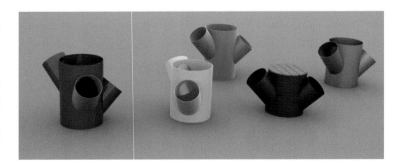

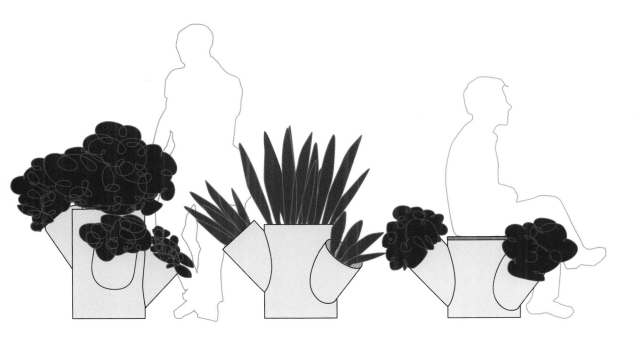

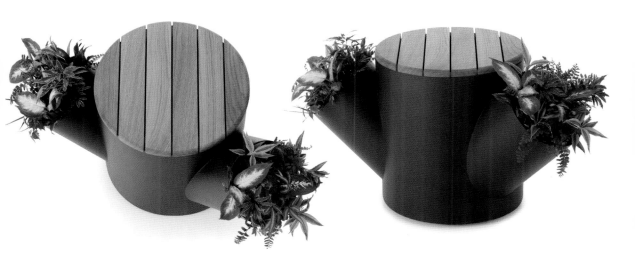

The Willow is a multifunctional plant pot inspired by the trunk of the willow tree. Manufactured from lacquered steel, a single pot can hold three species because of its branches. The oak seat is removable.

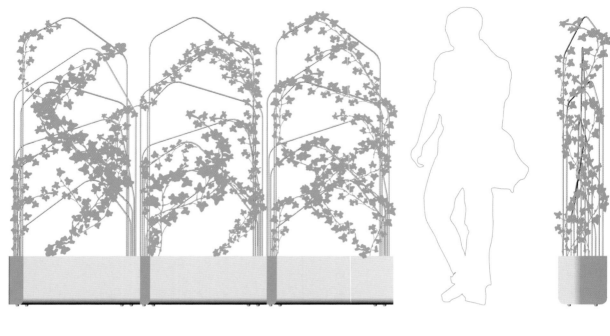

The Green Divider creates natural spaces in a room. With its lacquered steel frame and plastic plant pot, this folding screen allows you to grow plants in indoor spaces such as offices.

CHEAP
MONOCOQUE
OUTDOOR

HOLE DESIGNSTUDIO

Padua, Italy
www.alessandrobusana.it

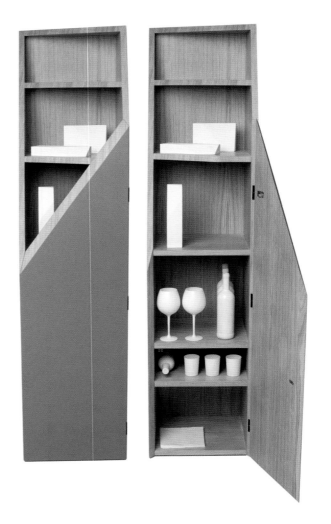

Alessandro Busana, born in 1977, is the founder of HOLE Designstudio, a research and prototype development firm. Busana studied at the School of Italian Design in Padua and graduated in 1999. During his period of specialization, he participated in workshops organized by various companies, including Rollerblade, Alfa Romeo, and Whirlpool. He has been working in creative product design since 2004. His work has been displayed in several international exhibitions and has been featured in industry magazines such as *Domus* and *Casa Viva*.

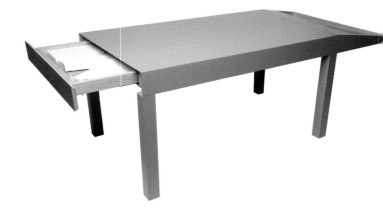

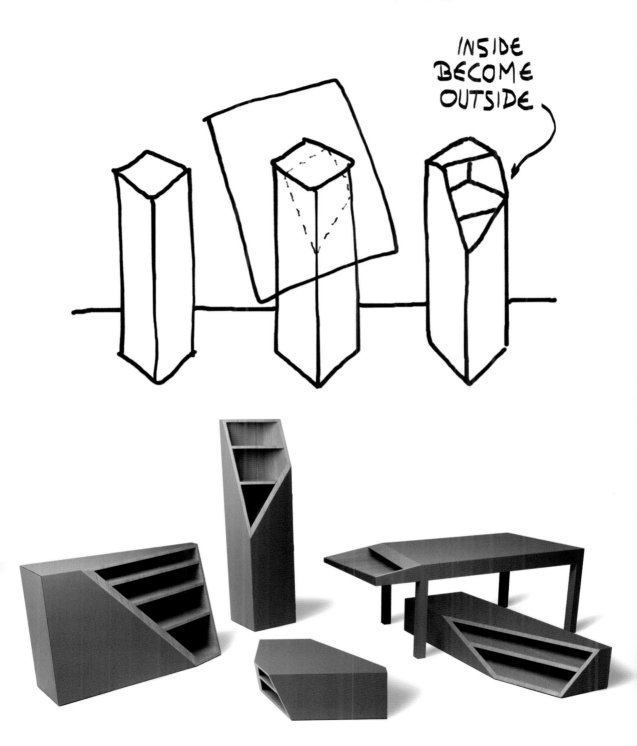

Cutline furniture defines the dynamism of its pieces with crosscuts that reveal what is inside. This original feature is not only distinctive but also provides useful storage spaces.

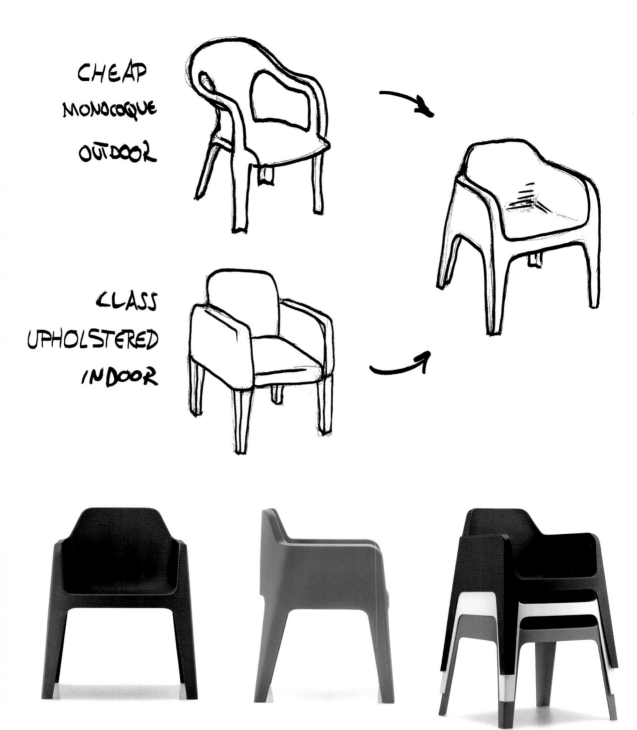

CHEAP
MONOCOQUE
OUTDOOR

CLASS
UPHOLSTERED
INDOOR

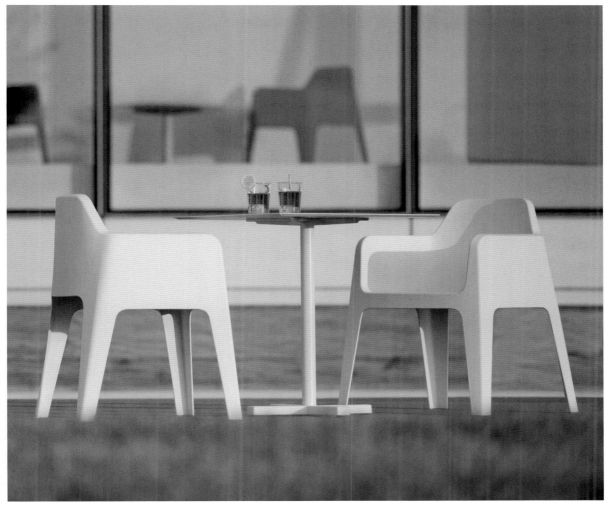

The Plus embraces two diametrically opposed conceptual designs. This chair defines a middle ground where a balance between practicality, formal identity, and accessibility becomes the perfect combination.

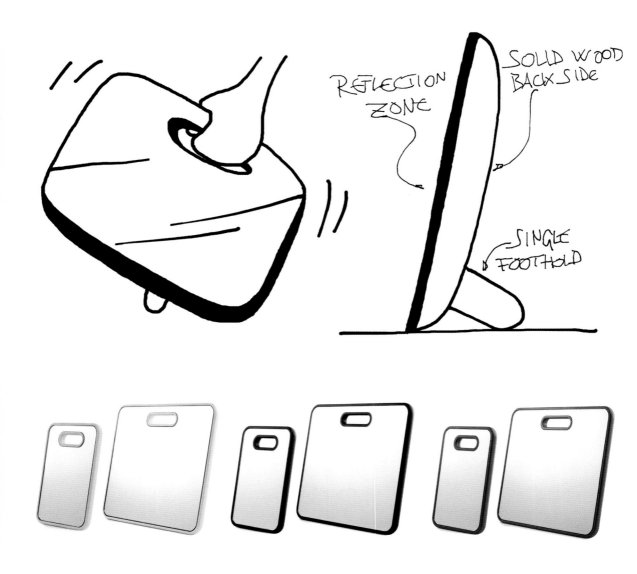

REFLECTION ZONE

SOLID WOOD BACKSIDE

SINGLE FOOTHOLD

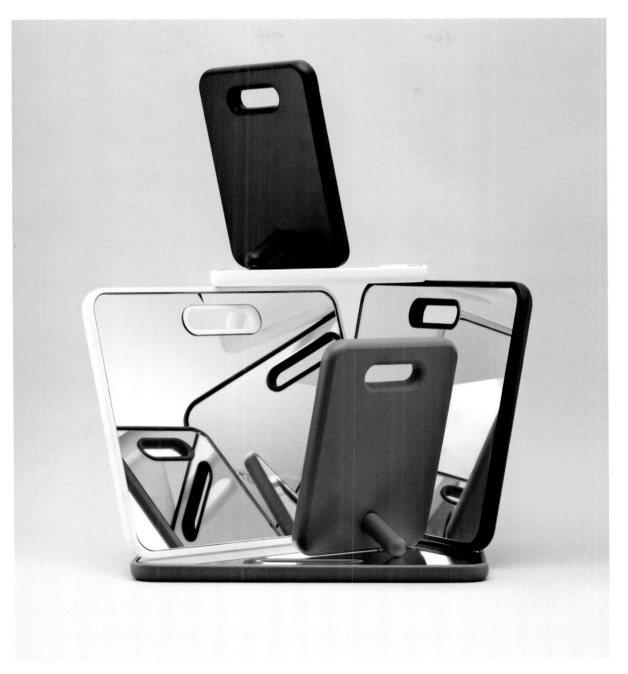

The Reflect is a mirror of elegant shapes and rounded angles. The handle, which makes it easy to transport, is incorporated into the design, and the rear support provides stability. Unlike most of its competitors, this mirror is sturdy and strong.

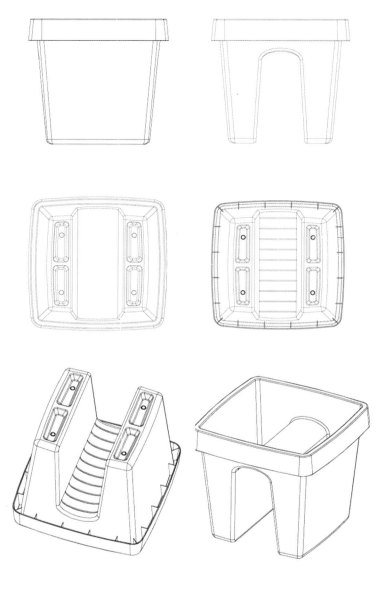

IGLOO DESIGN STRATEGY

Kfar Saba, Israel
www.igloo-design.com

Arik Yuval founded Igloo Design Strat-
egy in 2002, and Yariv Sade joined the
studio in 2005. Born in 1968, Yuval
studied industrial design technology
and worked for Vertex as a product
developer. Sade, born in 1967, stud-
ied industrial design and worked for
Source Ltd. and Plasson Ltd. Both de-
signers won an IDSA Award in 2004,
are university lecturers, and are try-
ing to encourage new generations of
designers.

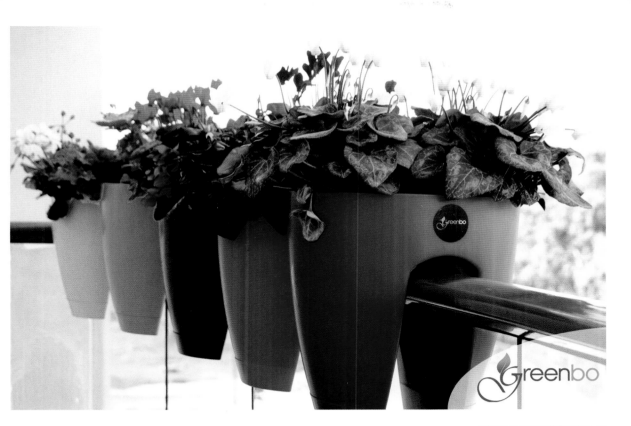

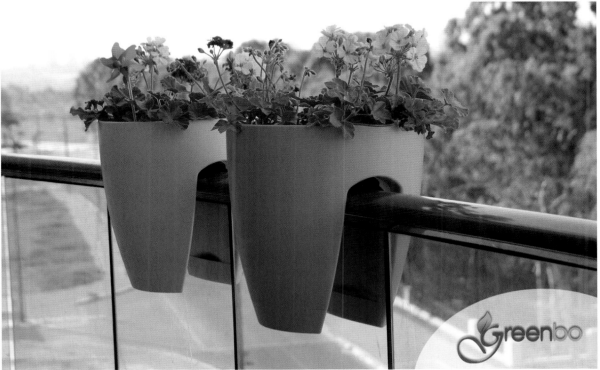

Greenbo is a pot made of recycled materials. Its design allows it to be affixed to almost all kinds of railings without screws or other tools. As you can see, it incorporates a drainage and water recycling system, and it is also easy to clean.

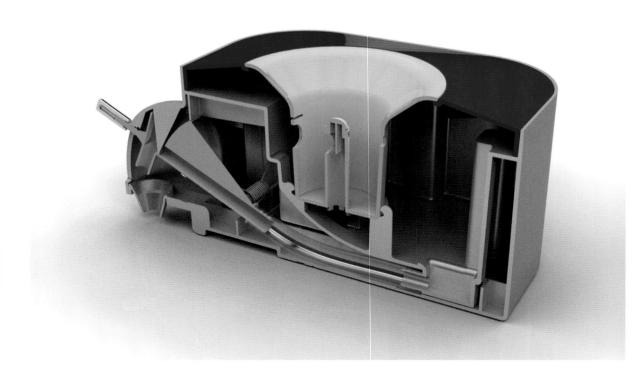

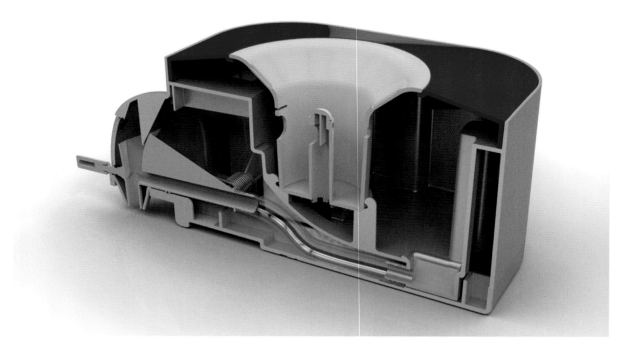

The MEY EDEN Easy-Bar is a water dispenser that operates without electricity or mechanical taps. It is easy to use, and the flow depends on the amount of fluid contained in the bottle. This rendering shows its operation in detail.

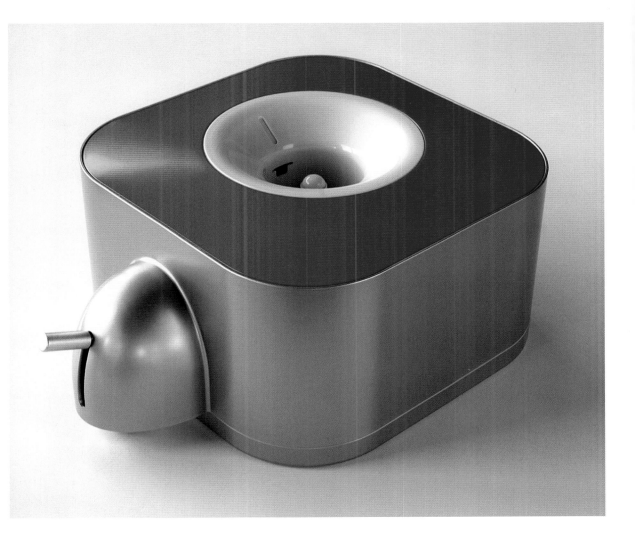

JÄRVI & RUOHO

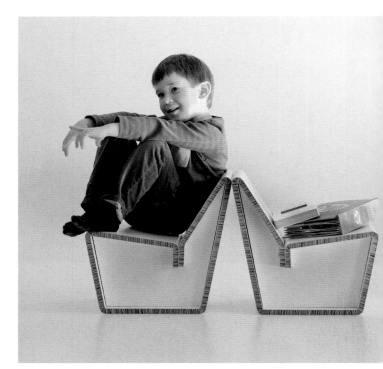

Helsinki, Finland
www.jarvi-ruoho.com

"Observe the life of an object: how to use it and for what, how it is made, and how it can be improved. Form is only one of the parts that make up an object. The final product must exceed the sum of its parts." This is how Teemu Järvi and Heikki Ruoho describe the creative process. They both studied at the Helsinki University of Art and Design. They established their studio in 2003 and won the Ornamo Design Award in 2008.

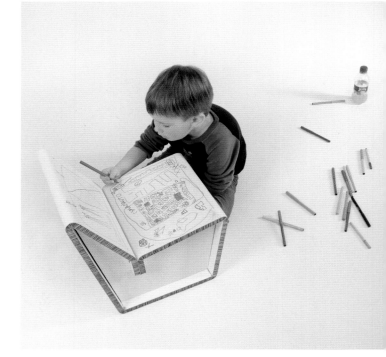

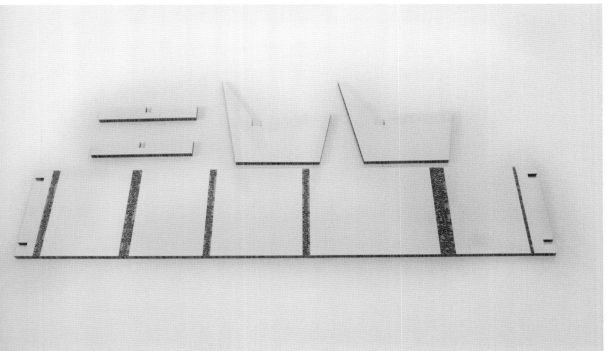

The Kenno Cardboard child's chair, made of corrugated cardboard, is stout and can be assembled without glue or other tools. It can be decorated by its little owner until he or she is too old to use it.

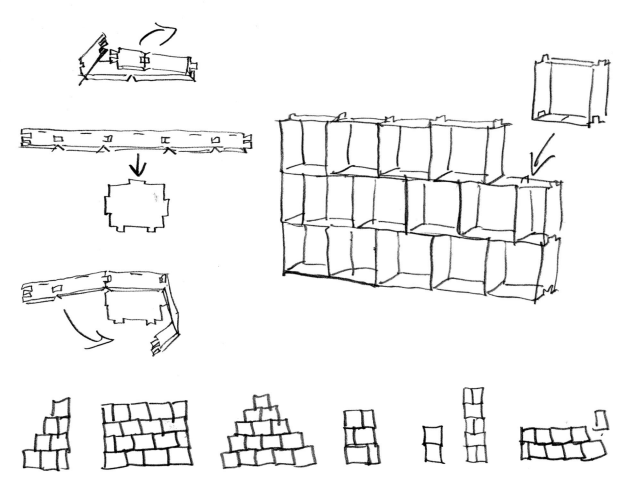

The Kasaa Cardboard shelving unit is made of thick, stackable cardboard modules that can be arranged in many combinations. Each unit can be assembled without glue or other tools. The material is recyclable.

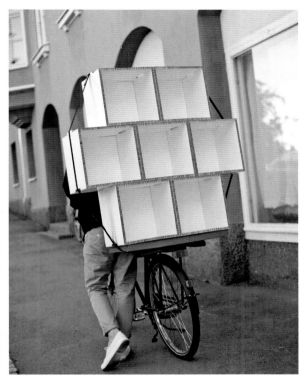

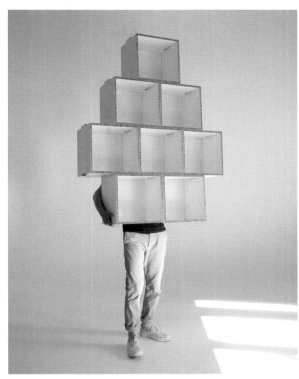

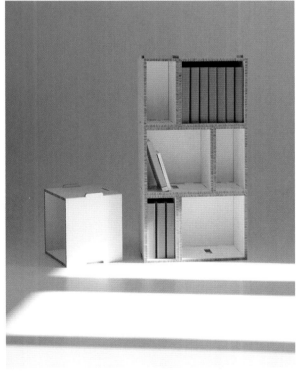

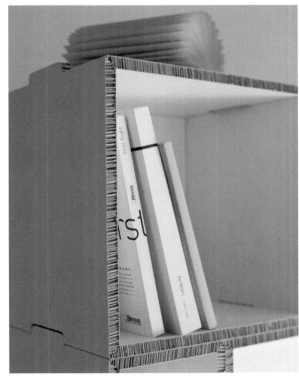

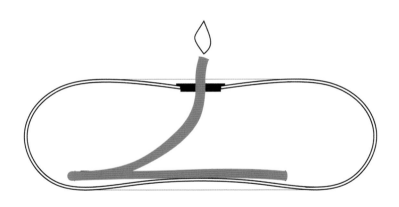

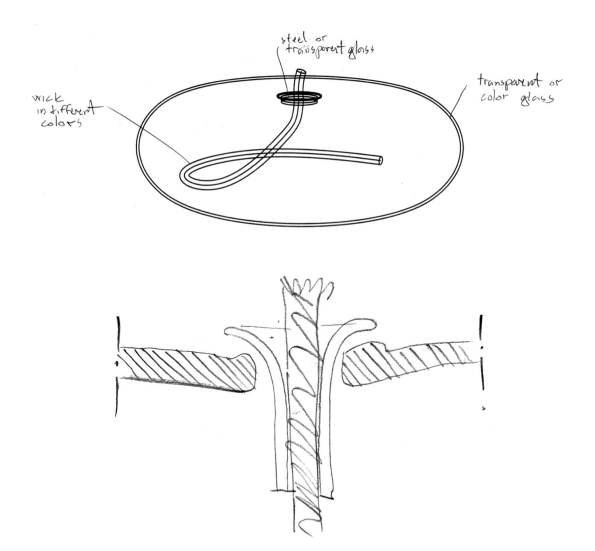

steel or
transparent glass

transparent or
color glass

wick
in different
colors

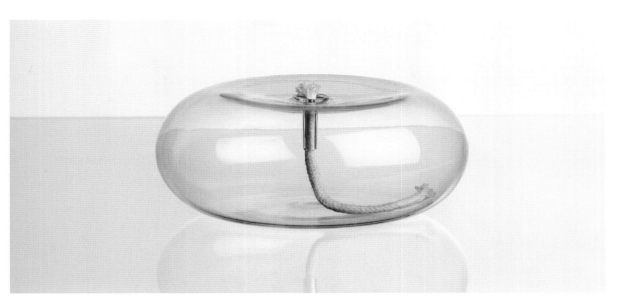

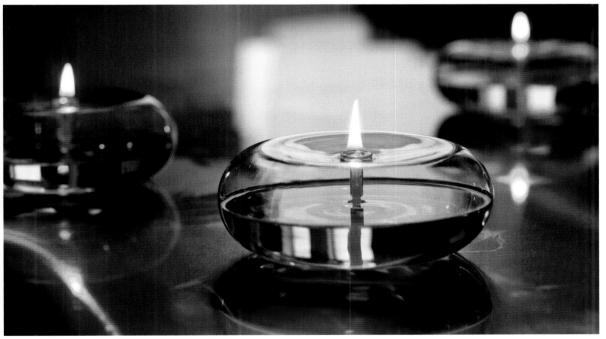

With its rounded shapes, the Pumpkin Lamp positions the candle flame right in the center. Its light is warm and welcoming.

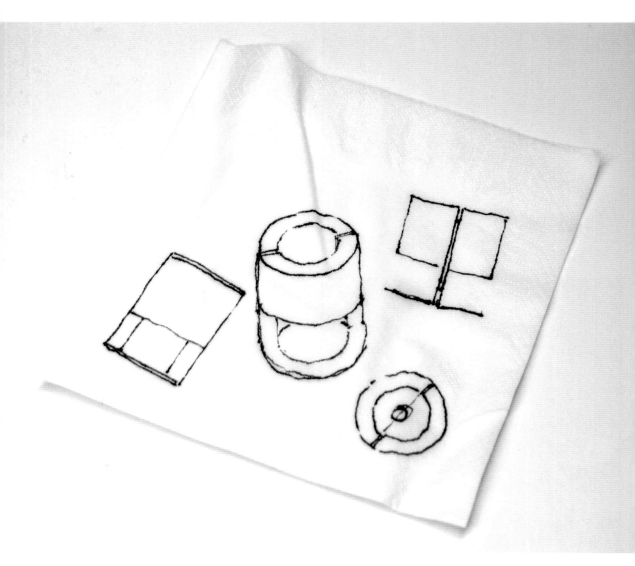

The Side Lamp for the bedside provides an evocative light with a transparent acrylic shade. The profile is both classic and, from the front, original.

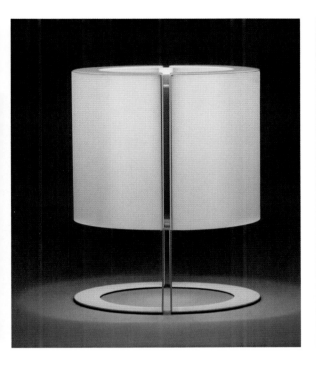

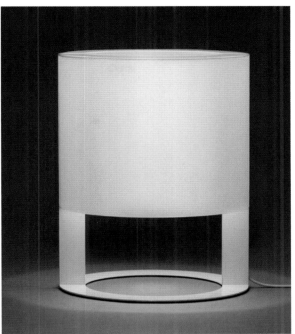

London, UK
www.jibds.com

In English, the word *jib* refers to the metal structure that is used during filming to cover angles that cannot be reached from the ground. With this metaphor as a basis for their studio, JiB designers' mission is to make things more accessible. Their portfolio includes furniture and product designs. The company works with three central elements: composition, proportion, and materials.

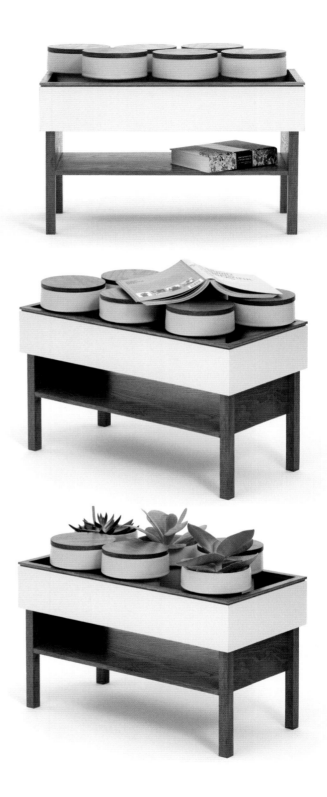

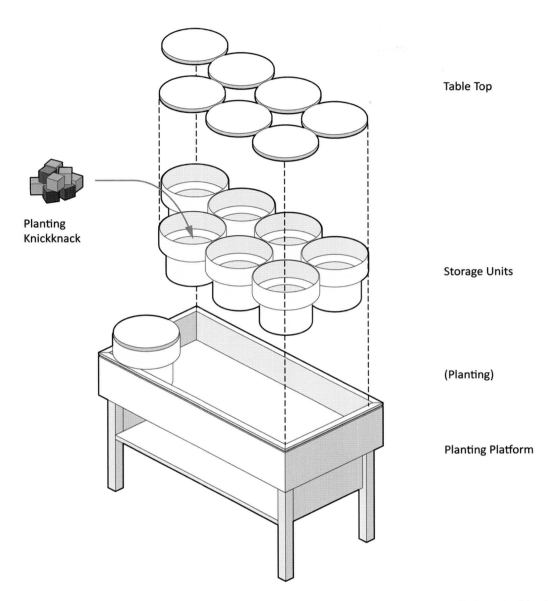

Table Top

Storage Units

Planting
Knickknack

(Planting)

Planting Platform

The O Collection was designed to create furniture with space for plants, books, and other objects that are kept in view. Console O is a center table where ceramic containers form the surface and, at the same time, can be used for storage.

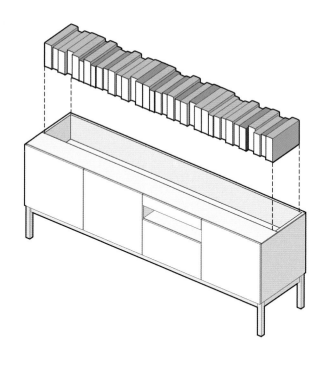

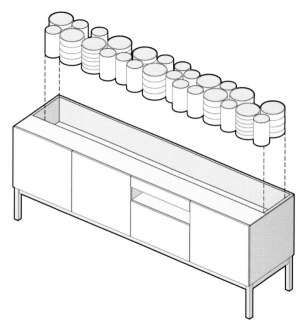

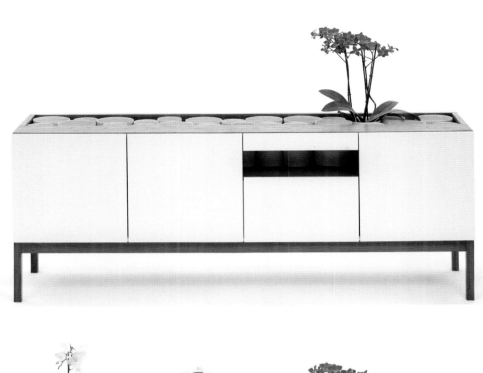

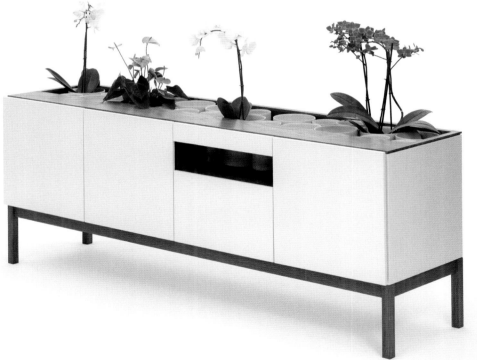

Credenza O can be experienced from different viewpoints. Viewed from a standing position, the circular ceramic containers form a pattern. From the front, the gaze is drawn by the various holes.

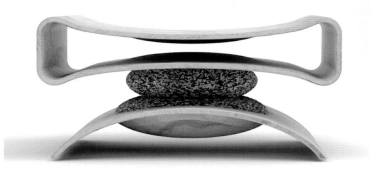

RYAN JONGWOO CHOI

Ryan Jongwoo Choi
London, UK
www.ryan-j.com

Ryan Jongwoo Choi is still study-ing at the prestigious Central Saint Martins College of Art and Design in London, but his name already appears on the lists of winners of internation-ally recognized prizes such as the iF Design Award, the Electrolux Design Award, the IDEA Design Award, and the Spark Design Award. This young designer has also worked for Design Mu and Rock Galpin. He believes in the magic of design and likes to think he can help others through his work.

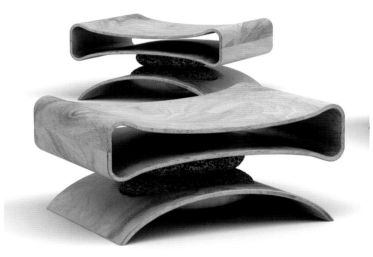

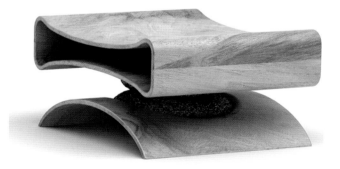

Co-existence is inspired by natural materials such as rock. The combination of granite and wood is natural, as is the strange feeling of instability provided by this seat.

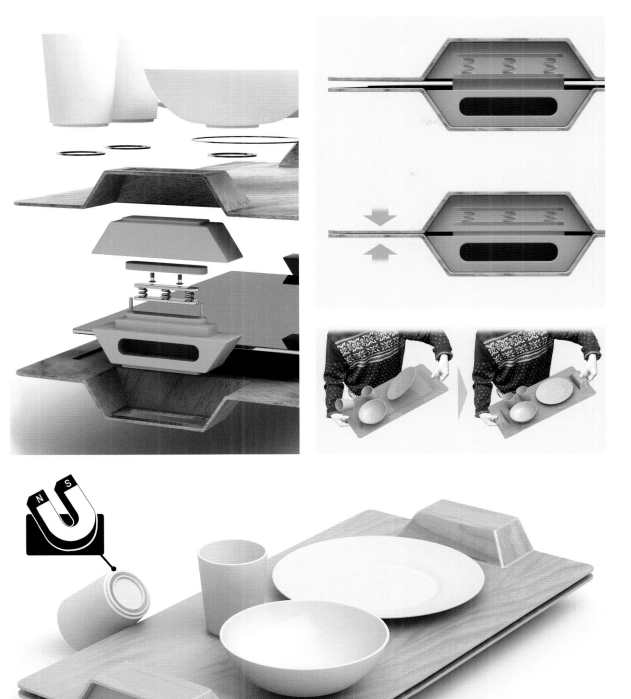

The Magic Tray is designed so that whatever is carried on it cannot be dropped or spilled. It consists of two sheets joined by magnets, which also hold objects in place. When you release the handle, the sheets separate.

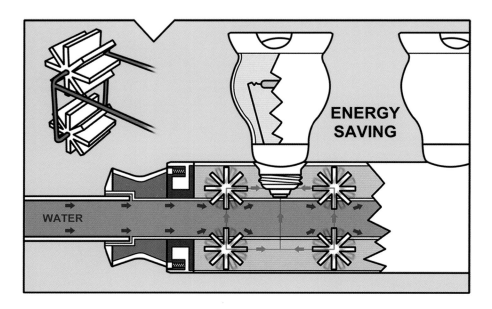

ENERGY
SAVING

WATER

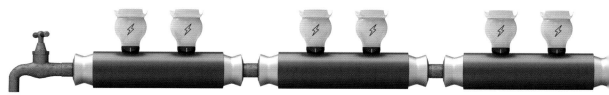

①
Rubber

Separate the water pipe and connect it with the ES pipe

②
Connect the bulb to the ES pipe

③
Use the water - Energy saving

④
Accumulated energy can be used for the light

Light can be controlled by turning the button

Inside the ES Pipe is a hydraulic wheel
that converts the flow of water into
electricity, which powers an artificial light.

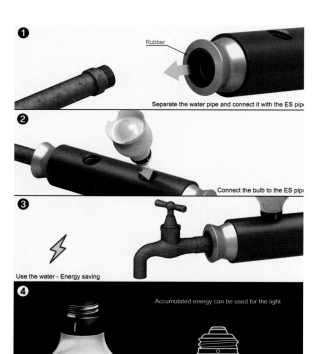

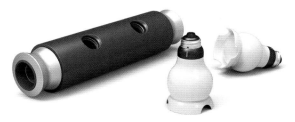

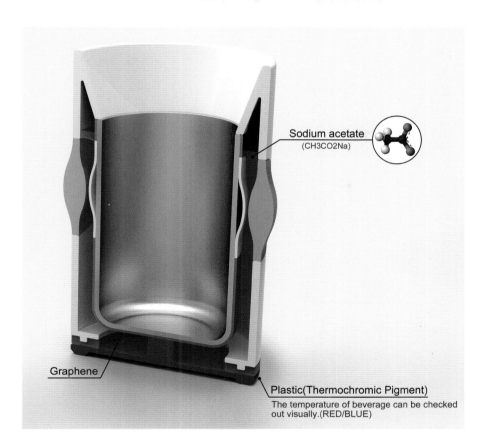

Sodium acetate
(CH3CO2Na)

Graphene

Plastic(Thermochromic Pigment)
The temperature of beverage can be checked
out visually.(RED/BLUE)

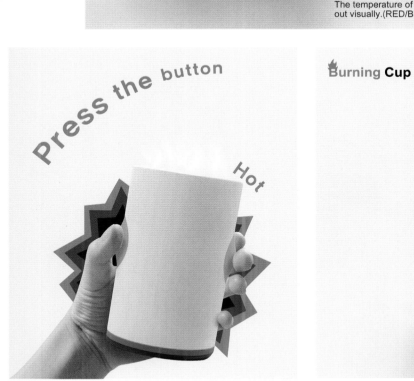

Press the button

Hot

Burning **Cup**

This cup maintains the temperature of the liquid in it. The solid-state sodium acetate inside generates heat with slight pressure from the fingers. The heat of the drink melts the sodium acetate, which returns to its original state when it cools down.

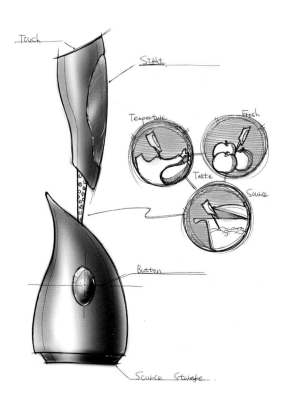

Touch

Sight

Tempertue

Fresh

Taste

Source

Button

Source Storage

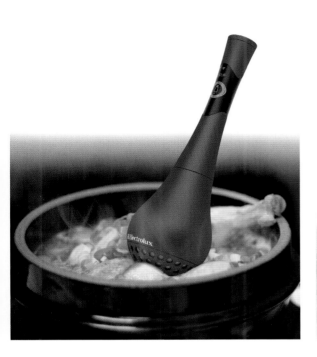

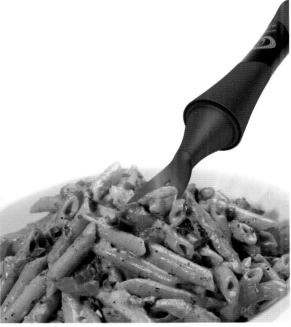

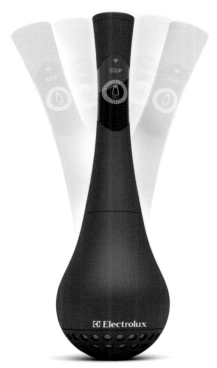

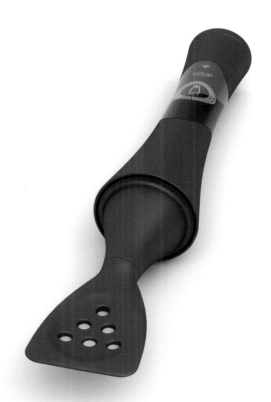

Inspired by a spectrograph, the Ingresure is a new kind of ladle that lets you see if you have used the correct amounts of ingredients. It has a small display screen and various sensors.

MEREL KARHOF

London, UK
www.merelkarhof.nl

Merel Karhof was born in the Netherlands in 1978. She traveled around Europe from an early age and lived in different places for relatively long periods, soaking up culture. Karhof studied design at the Eindhoven Design Academy, then founded Collective Circus Design with some of her colleagues after finishing her studies. Her designs combine art, science, and craft.

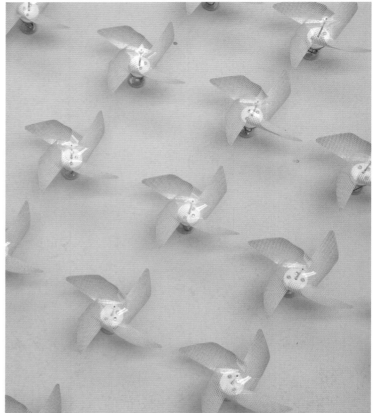

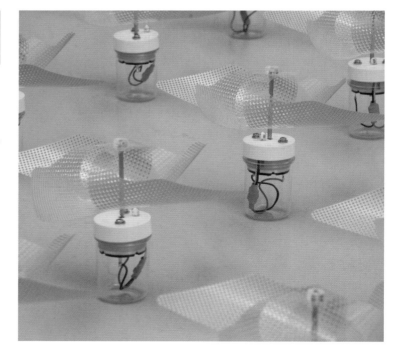

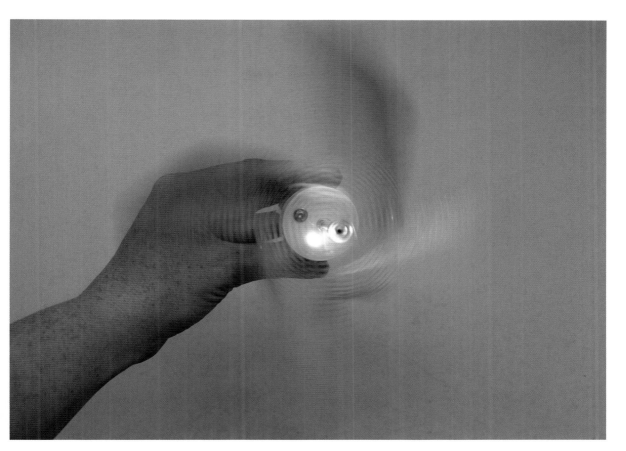

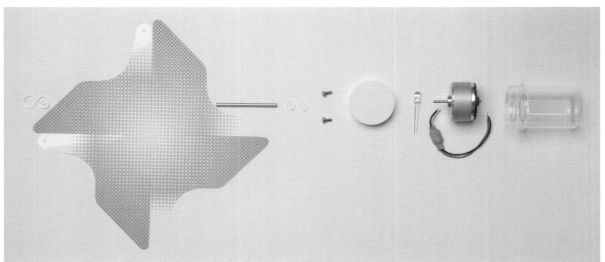

The Energy Harvester IV is a wind-powered LED lamp that is part of a product line designed to educate consumers about this type of energy and how to obtain it.

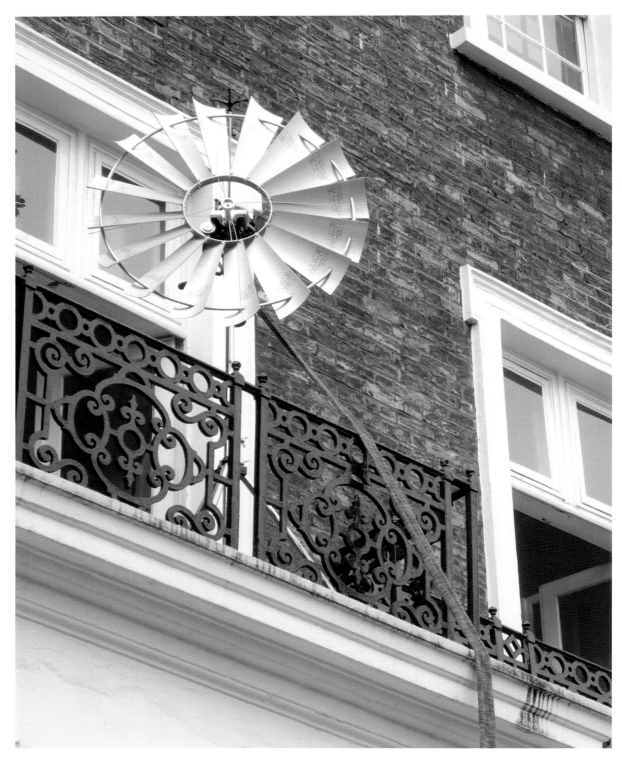

The Wind Knitting Factory is a sustainable production system. Attached to buildings' facades, it produces knitted fabric, which feeds into the building through a window.

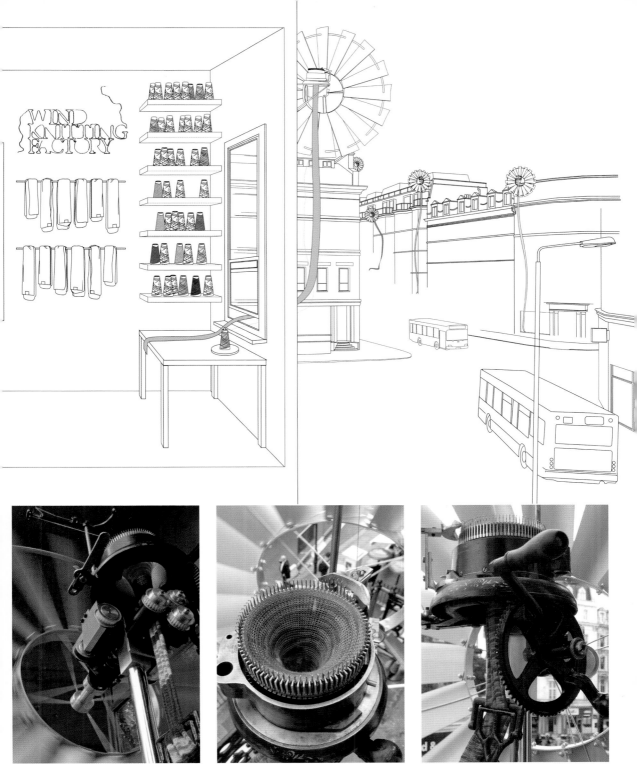

WIND KNITTING FACTORY

The blades are more than 3 feet (91.44 centimeters) in diameter; the drum where the wool is threaded is next to them.

KARTEN DESIGN

Marina del Rey, CA, USA
www.kartendesign.com

This small studio was founded by four designers: Jeff Bentzler, Jonathan Abarbanel, Rick Blanchard, and Paul Cash. This team's goal is to create positive experiences between products and consumers. The company has twenty-five designers who specialize in medical technology, household items, and industrial transport. The studio has received awards from IDEA, iF, Good Design, and Red Dot Design.

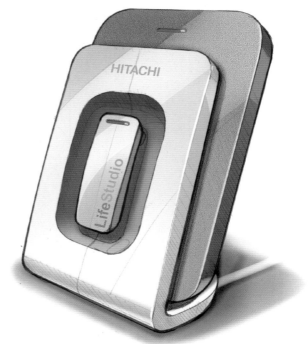

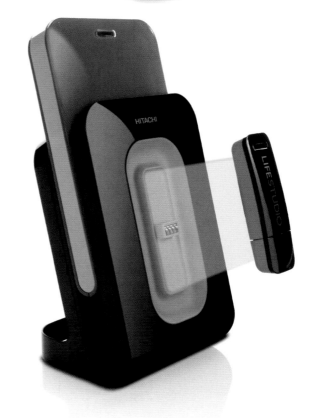

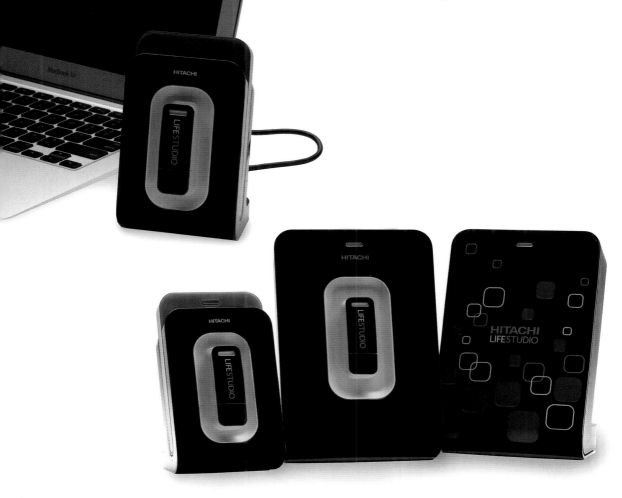

This family of external hard drives from Hitachi GST was designed to be light and easy to carry. The hard drive has a built-in USB memory.

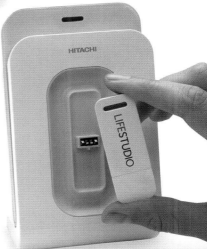

ZONE A

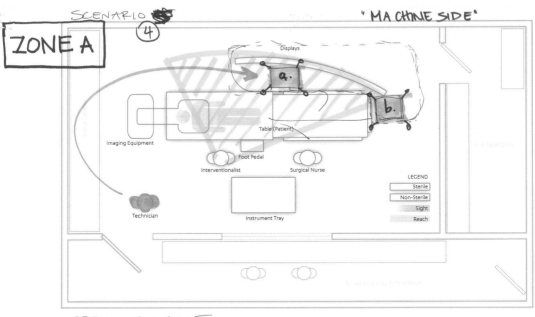

Displays

a.

b.

Table (Patient)

Imaging Equipment

Foot Pedal

Interventionalist

Surgical Nurse

Technician

Instrument Tray

LEGEND

Sterile	
Non-Sterile	
Sight	
Reach	

- OPTIMAL FOR SIGHT
- OPERATOR: **NON-STERILE** PERSON
- LOCATION: OUT OF STERILE FIELD
- REQUIRES: 3RD PERSON, POLE CART

PRIMARY

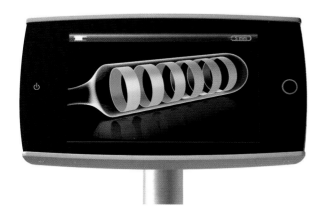

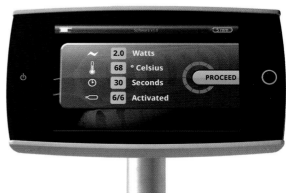

~	2.0	Watts
🌡	68	° Celsius
⏱	30	Seconds
⬯	6/6	Activated

PROCEED

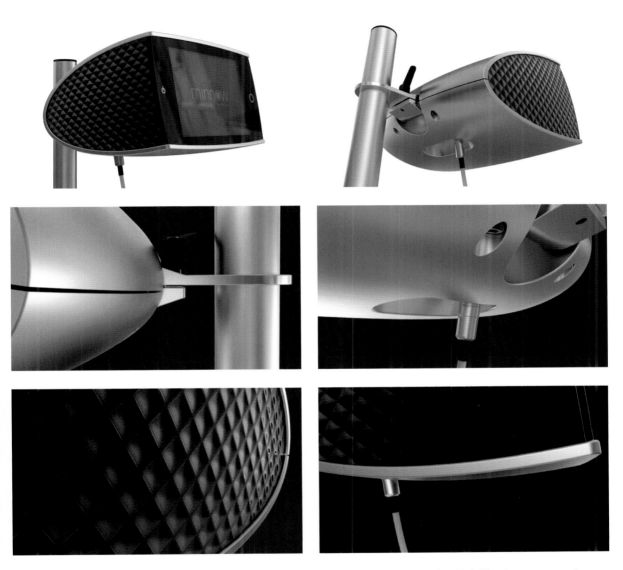

With a full-color display and a simple, practical user interface, this machine for treating high blood pressure and circulation problems is sixty times faster than its competitors and also introduces an innovative treatment.

KATAPULT DESIGN

Suffolk Park, NSW, Australia
www.katapultdesign.com

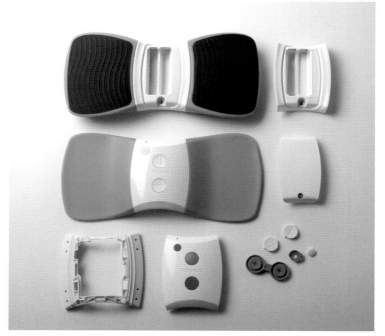

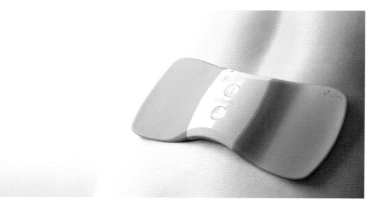

The Katapult Design team observes without prejudice, thinks about the users of their creations, and understands the work as an ongoing challenge to overcome. It is this way of seeing design that has led to the company spending more than twenty years involved in innovation, providing products with the latest technology to help their clients become competitive. Katapult Design has won numerous awards, including the Chicago Athenaeum Good Design Award and the Australian Design Mark.

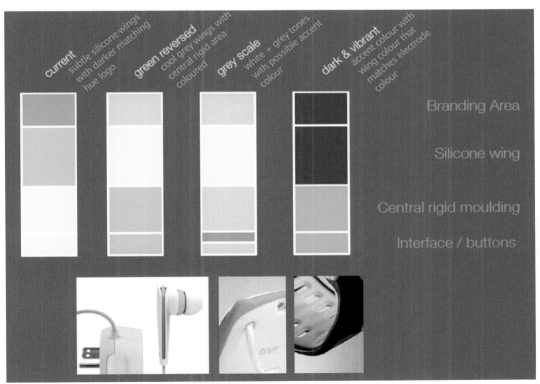

current
subtle silicone wings
with darker matching
hue logo

green reversed
cool grey wings with
central rigid area
coloured

grey scale
white + grey tones
with possible accent
colour

dark & vibrant
accent colour with
wing colour that
matches electrode
colour

Branding Area

Silicone wing

Central rigid moulding

Interface / buttons

The WiTouch Pro is designed to relieve pain in the lumbar area. The appliance is wireless, can be used at home, and works by stimulating muscle fibers with electrodes to reduce back pain.

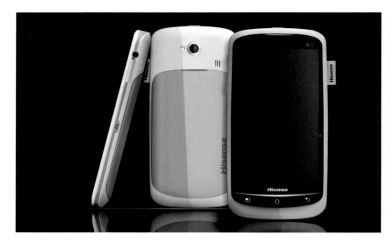

ARTHUR KENZO

San Francisco, CA, USA
www.arthurkenzo.com

The mission of Arthur Kenzo, a French designer living in the United States, is to use design to make the world a better place and change the way we live. He is fascinated by human behavior, technology, and the interaction between the two. Kenzo works for the studio Fuseproject, whose creations include furniture, electronics, medical devices, and sustainable products.

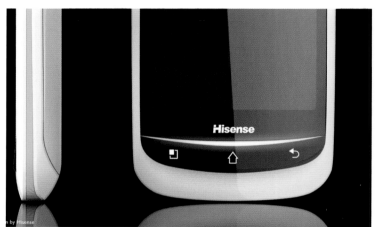

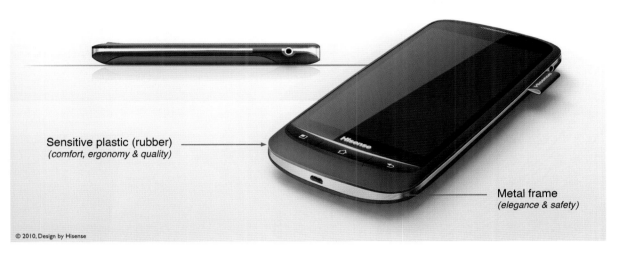

Sensitive plastic (rubber)
(comfort, ergonomy & quality)

Metal frame
(elegance & safety)

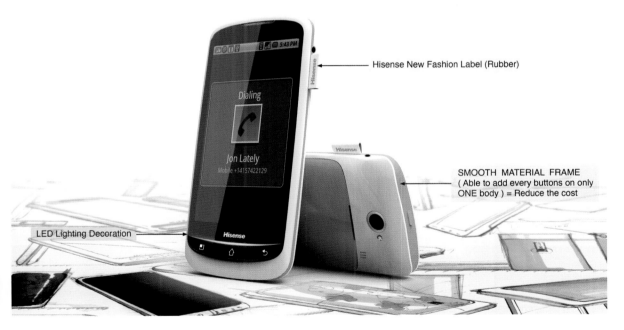

Hisense New Fashion Label (Rubber)

SMOOTH MATERIAL FRAME
(Able to add every buttons on only
ONE body) = Reduce the cost

LED Lighting Decoration

Sliceo is a smartphone designed for Hisense. This phone has a sophisticated appearance to justify its high price. It is very slender and modern, suitable for corporate businesspeople.

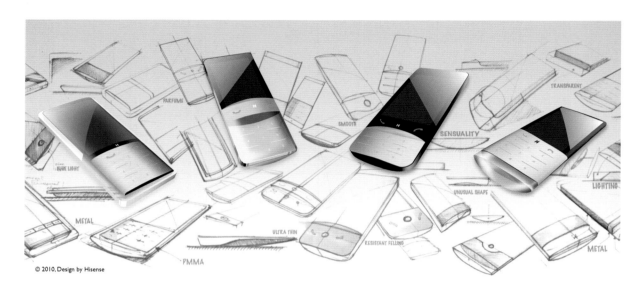

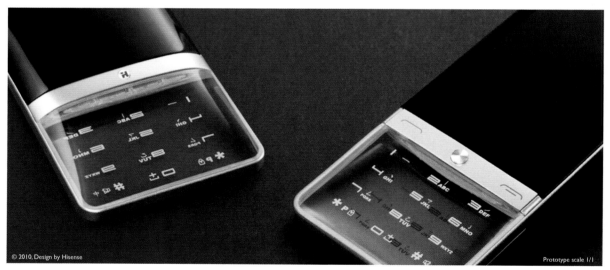

Prototype scale 1/1

The Clarity is a simple mobile phone with elegant and sophisticated lines and a transparent number pad. It was designed for Hisense for the female consumer.

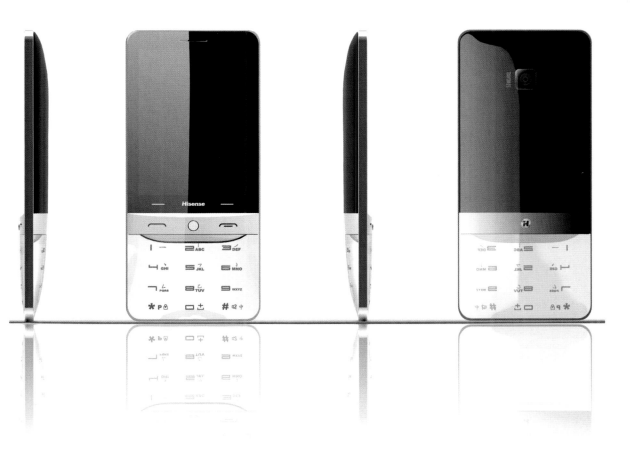

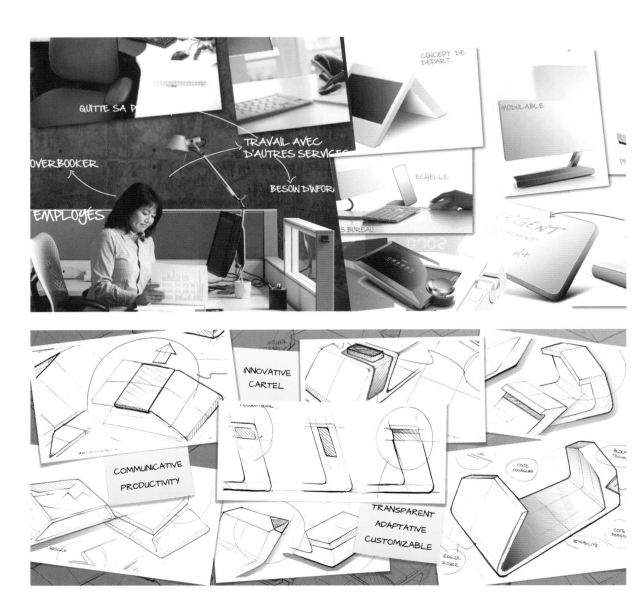

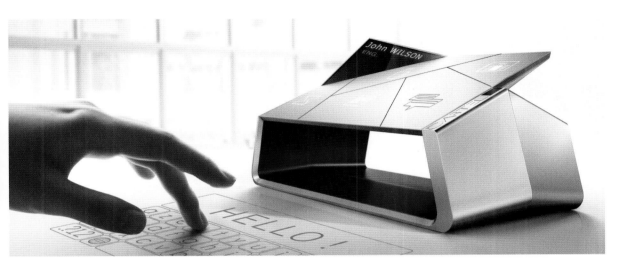

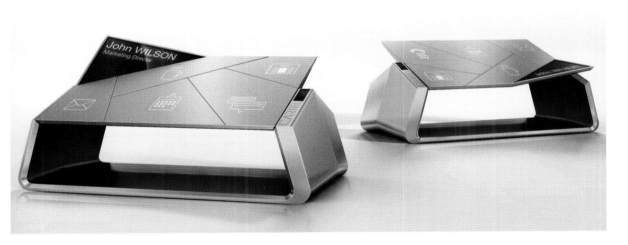

The Cartel is a digital office notepad. It promotes relationships in the workplace and helps organize tasks and allows to record every missed visit at your office, when you weren't available at your desk or during a short absence.

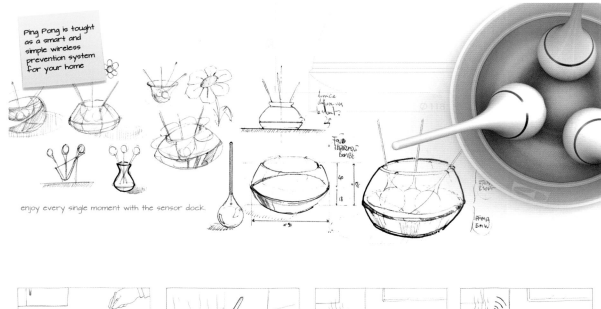

Ping Pong is tought as a smart and simple wireless prevention system for your home

enjoy every single moment with the sensor dock

Marc takes one of the Ping sensors
from his dock

He clips it to the pan he's using,
the Ping sensor is using heat as energy

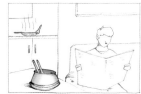

Marc takes the dock with him and
enjoy his living room

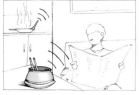

As the sensor is reporting a problem,
the dock is alerting Marc

Ping Pong is a wireless kitchen assistant that allows the user to send commands from another room. Sensors detect when temperatures are too high, or when a pan of water boils over.

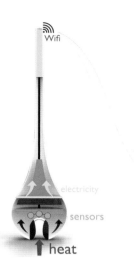

Wifi

electricity

sensors

↑heat

As a communicating and mobile device, Ping-Pong is equiped with current technology. In order to optimize energetic consumption, Ping transforms the heat emited from the cookware to recharge its batteries.

Furthermore, Ping is designed to send automatically wifi informations to the dock : Pong, which is used to transform these virtual informations to lights and sounds signals.

USERS

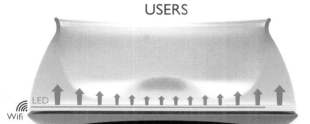

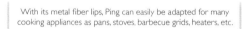

LED

Wifi

With its metal fiber lips, Ping can easily be adapted for many cooking appliances as pans, stoves, barbecue grids, heaters, etc.

Translucent Glass to diffuse LED lighting

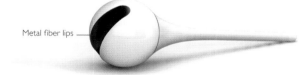

Metal fiber lips

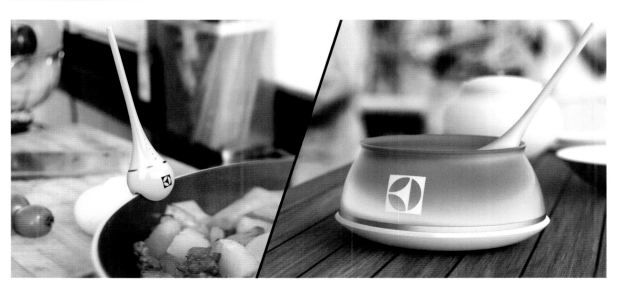

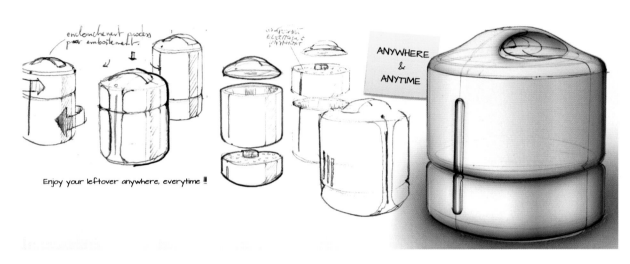

enclenchement process
par emboitement.

ANYWHERE
&
ANYTIME

Enjoy your leftover anywhere, everytime !!!

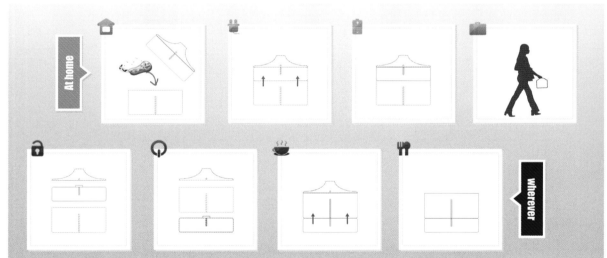

At home

wherever

164

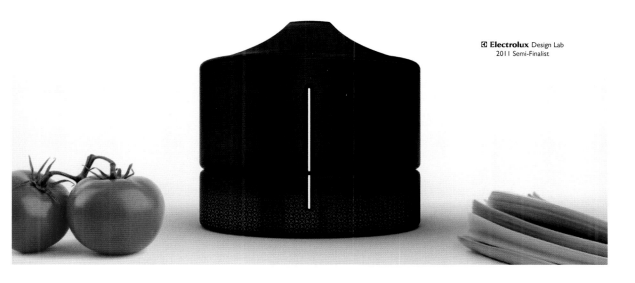

◩ **Electrolux** Design Lab
2011 Semi-Finalist

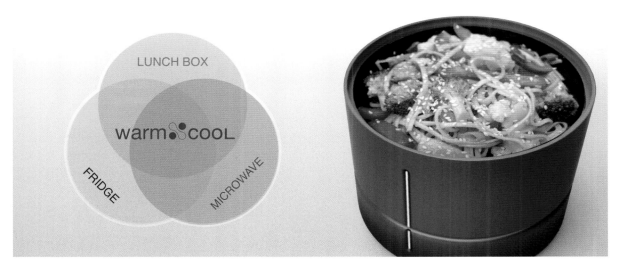

The Warm N'Cool is a container for storing leftovers and heating them up later. The container works like a refrigerator; the energy generated during refrigeration charges thermal batteries for later use.

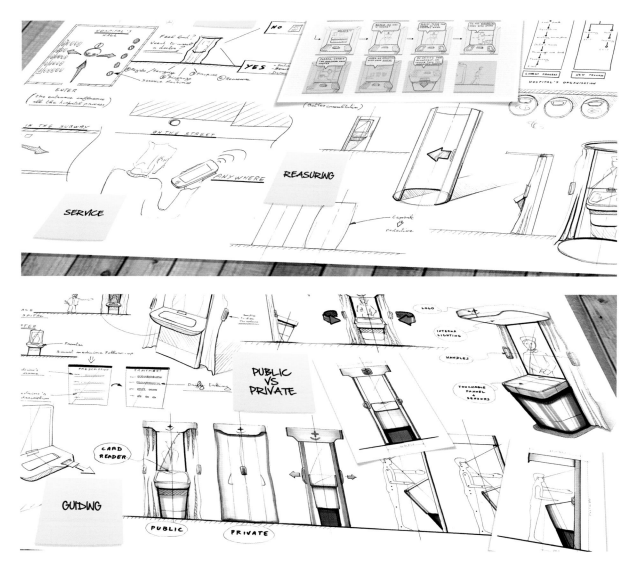

The Smart Consulting Service is a robot designed to improve the flow of patients in hospitals. The machine is responsible for recording patients' data when they arrive. After a preliminary virtual assessment, the robot makes an appointment with the appropriate specialist.

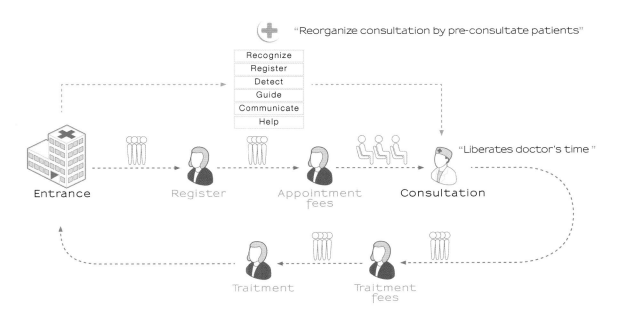

"Reorganize consultation by pre-consultate patients"

Recognize
Register
Detect
Guide
Communicate
Help

Entrance

Register

Appointment fees

Consultation

"Liberates doctor's time"

Traitment

Traitment fees

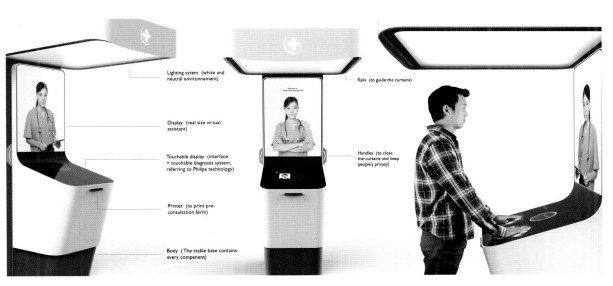

Lighting sytem (white and neutral environnement)

Display (real size virtual assistant)

Touchable display (interface + touchable diagnosis system, referring to Philips technology)

Printer (to print pre-consultation form)

Body (The stable base contains every compenent)

Rails (to guide the curtains)

Handles (to close the curtains and keep people's privacy)

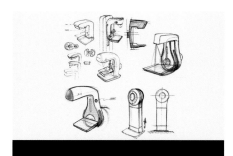

JEONG KIHYUN

Gyeonggi-do, South Korea
www.motifdesign.co.kr

Korean-born Jeong Kihyun studied automotive engineering and industrial design at Seoul National University of Technology and since then has worked as a designer for various companies. He has experience in creating medical equipment, mobile telephony, and multimedia interfaces. He has won the Korea Good Design Award on several occasions, most recently in 2012. He has also participated in exhibitions such as the Atelier Project.

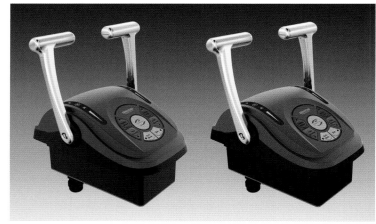

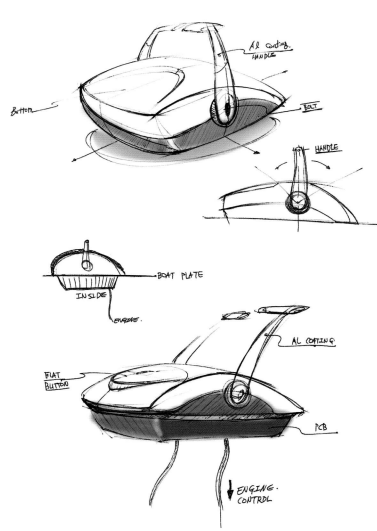

The Boat Controller was designed for RIQ; it controls almost any boat and can operate two motors at the same time. This robust yet elegant machine provides the user with intuitive and unique usability.

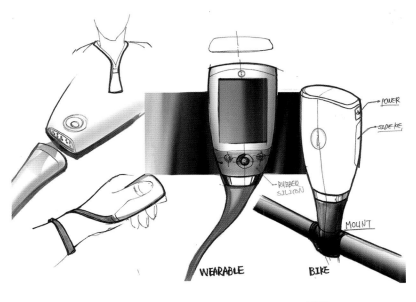

WEARABLE BIKE

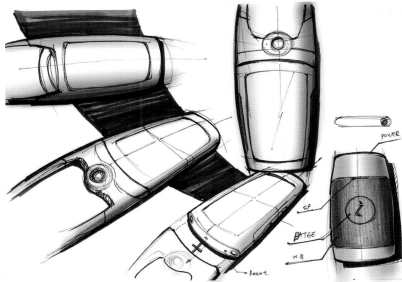

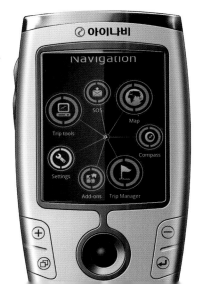

This waterproof outdoor navigator and designed for Thinkware allows the user to see the maps in 3D. Its small size, rounded shape and smooth surface make it extremely portable and easy to handle.

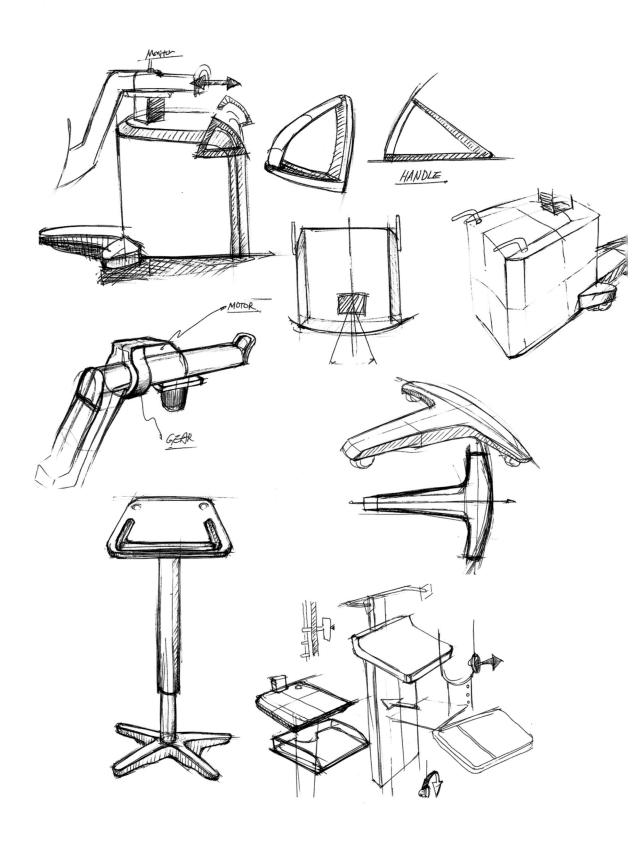

Moniter

HANDLE

MOTOR

GEAR

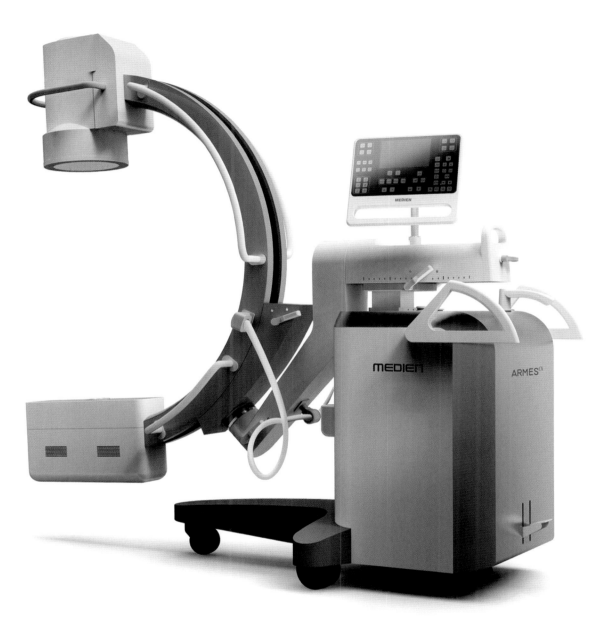

C-Arm was designed for Medien and is used to perform angiographs. Unlike conventional machines, its mobile structure allows you to analyze any area of the body with ease. Its flexibility means that all angles can be covered.

Designed for Thinkware, Cassiopea is a sleek and compact GPS. The user interface is quick and convenient to use.

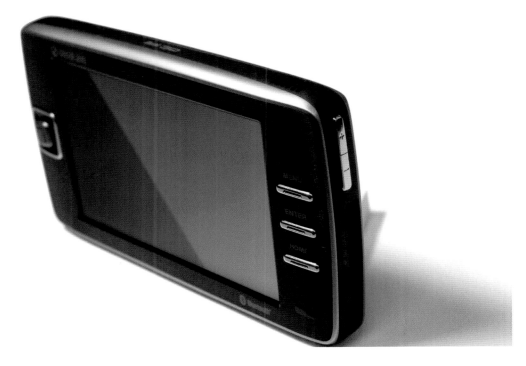

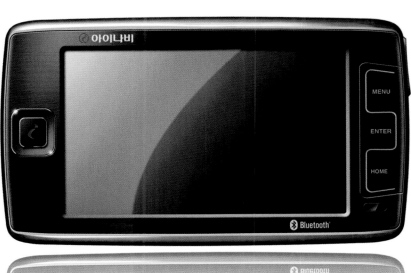

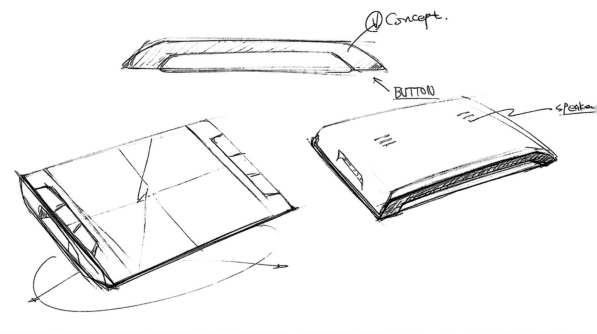

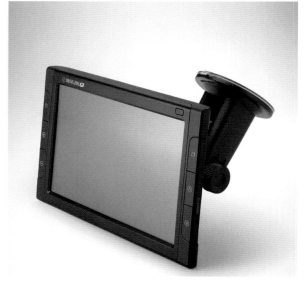

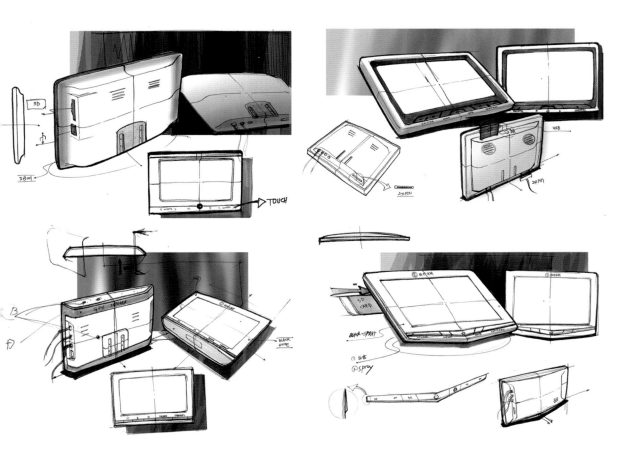

The Navi G1 GPS was designed for luxury automobiles. With a 7-inch screen, the device provides all the necessary information for traveling in Europe, including a television receiver with PiP function.

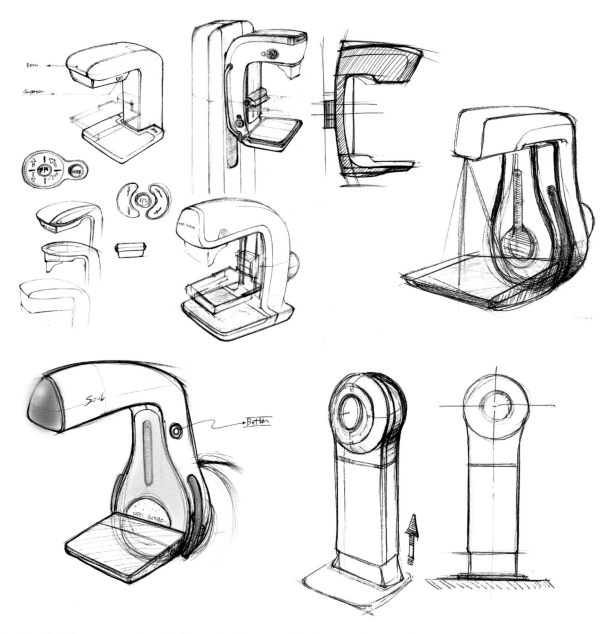

Soul is a digital mammography unit with excellent image quality. Designed for Medi-Future, it is intuitive and the controls are easy to understand. The parts that are in contact with the breast have rounded edges to ensure maximum comfort.

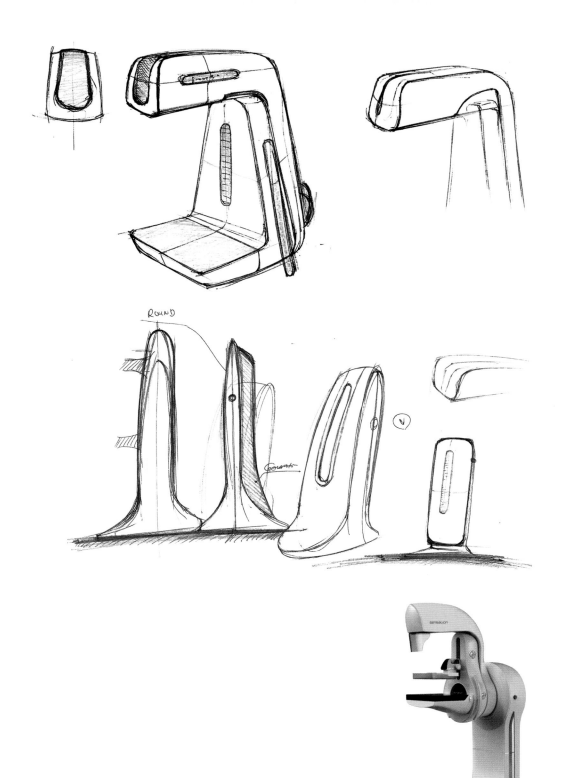

ROUND

KIMEBA DESIGN STUDIO

Gyeonggi-do, South Korea
www.kimeba.com

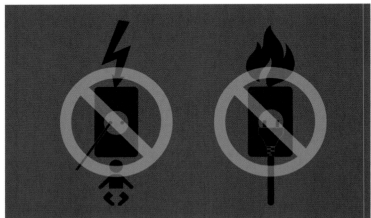

Yongjim Kim is the founder of this young and original studio, which defines its creations as "harmony between form and function." Inspired by fine arts and aesthetic balance, the company creates objects that fulfill their function naturally. Kim observes the functionality of daily objects and then adds a dash of intuition and a lot of color. Kimeba won the Concept Design Award in 2010.

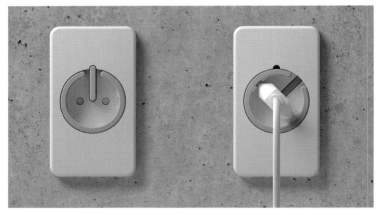

Switch is a socket with a joyful, practical design. The outlet is turned on and off by turning the plug, so that it does not have to be unplugged every time. It also prevents electrical accidents.

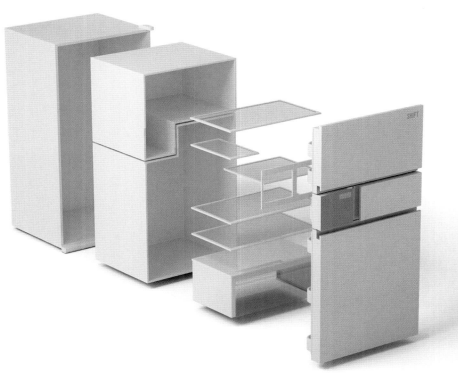

The Shift is a refrigerator with three compartments: fridge, freezer, and minifridge. The latter is for storing frequently used items so that when the door is opened, less cold escapes, saving energy.

This file is for notes. It is also designed to hold a notepad and pen.

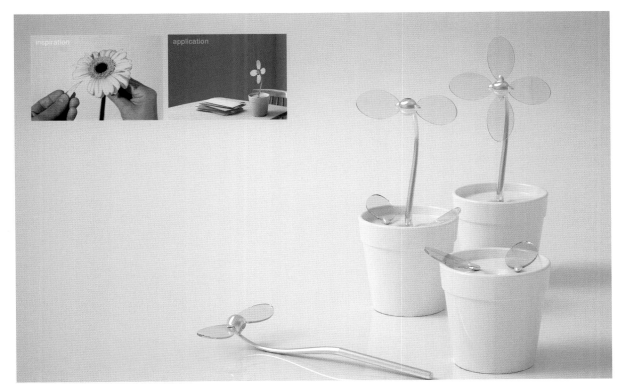

The Flower Pot is an original set of magnifying lenses. Imitating old eyeglasses, the lenses are in the shape of flower petals and would decorate any desk.

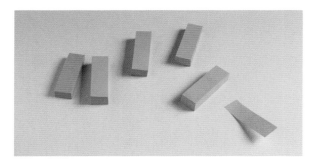

SHINOBU KOIZUMI

Tokyo, Japan
www.shinobu-koizumi.com

Shinobu Koizumi graduated from Tokyo Zokei University with a degree in design and fine arts and began work for a construction company as a commercial space designer. He explains that, for him, designing products is not synonymous with making objects. He believes that the most important thing is that his creations communicate something, that they awake memories of the past in their users.

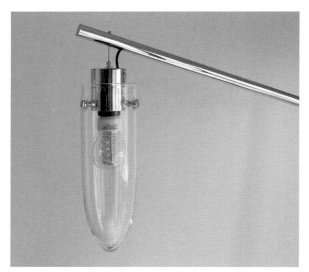

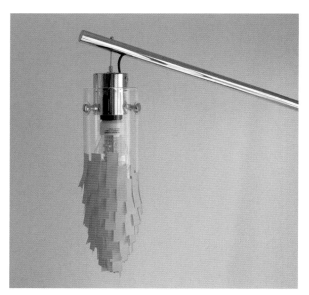

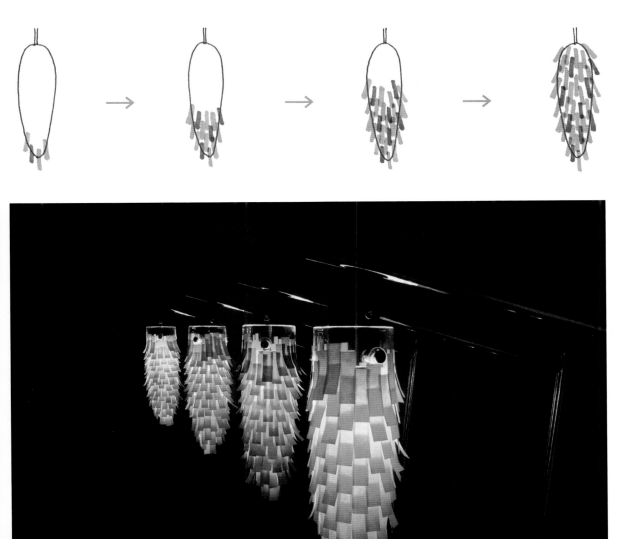

The Bagworm lamp is decorated with sticky notes of various colors. The curious lampshade resembles a cocoon and allows the user to create color and light combinations with surprising ease.

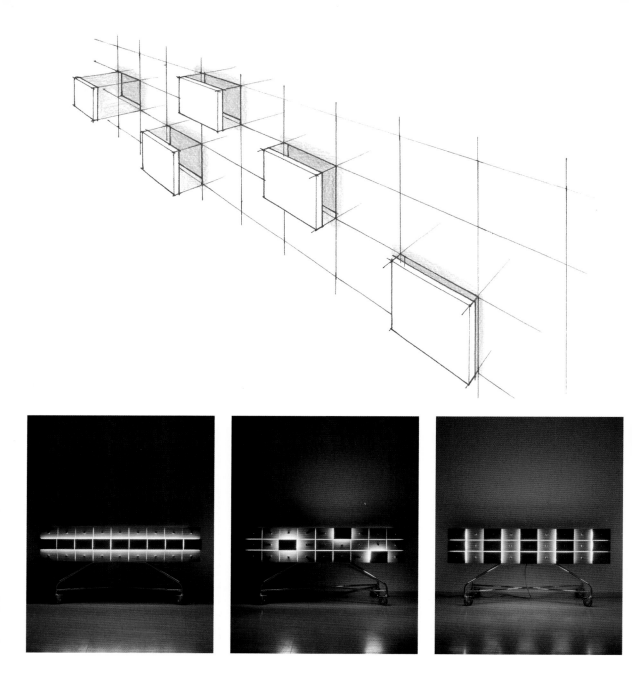

The Light in Drawer chest has small drawers with a lighting system at the back. It was inspired by magical stories in which treasures are hidden in mysterious light-filled places.

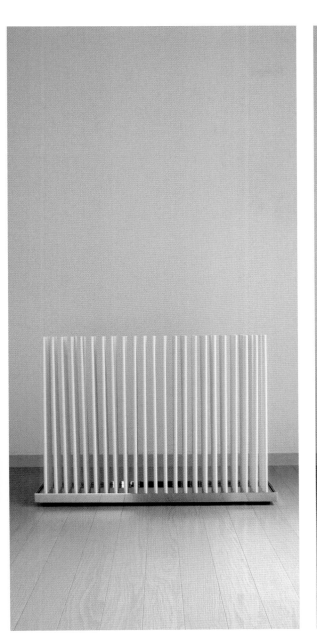
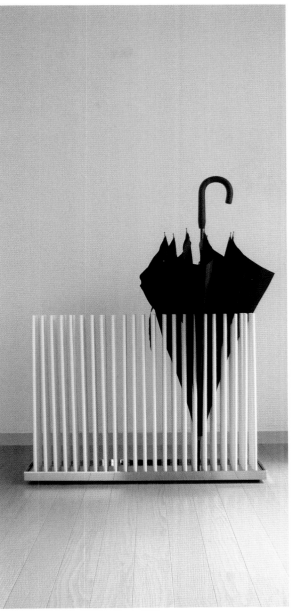

The Umbrella in Reed wooden stand has a metal tray-shaped base and vertical slats to hold the umbrellas. Drops of water run along the slats and collect in the tray.

The Moment table is inspired by the idea that time stands still during a coffee break. It is manufactured from rough-textured epoxy resin, and the color fades in the center of the base, reinforcing a sense of the passage of time.

The CD on Strings is ideal for storing and organizing CDs. It consists of a large square structure in which the CDs are held between thin tensioned cords, creating a floating effect.

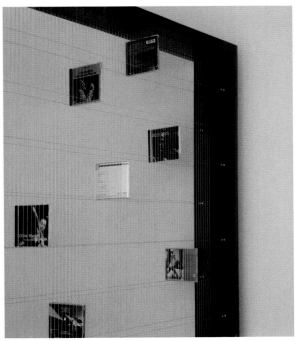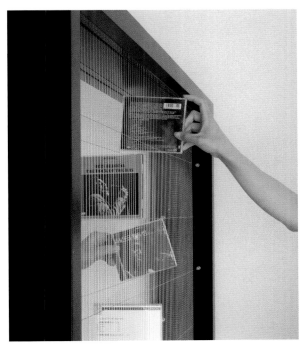

PO-CHIH LAI

London, UK
www.pochihlai.com

Po-Chih Lai was born in Taiwan and graduated with a degree in product design from the Royal College of Art in London in 2012. An enthusiastic entrepreneur with knowledge of engineering and design, he explores the intersection where a product's beauty, functionality, and creativity meet. He believes that utility should not be less important than self-expression and that design is a communication tool.

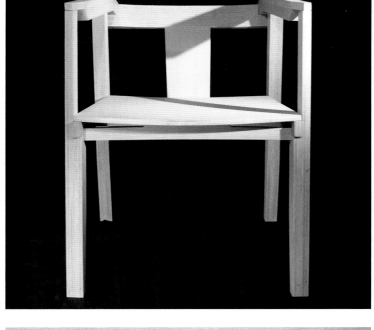

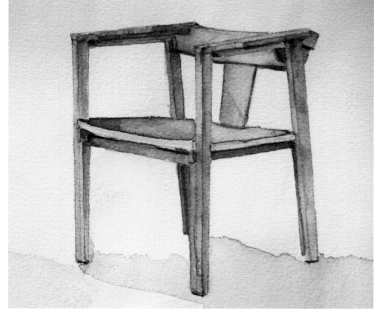

The Ming dynasty is known for its humanist spirit and functional rationality and is often compared to the Renaissance. The Ming-El chair embodies this combination of maturity and culture in a piece of furniture.

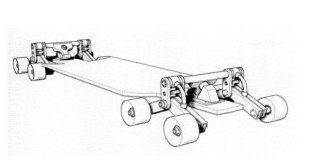

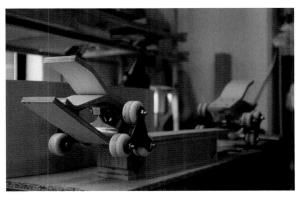

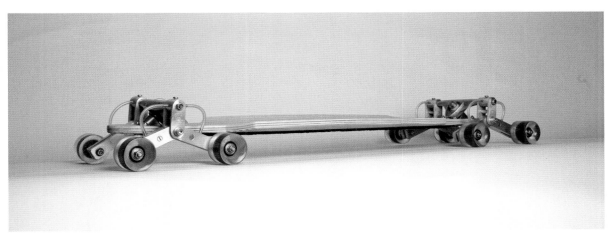

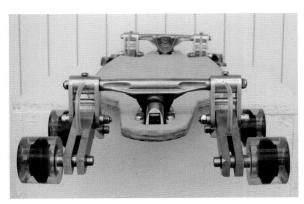

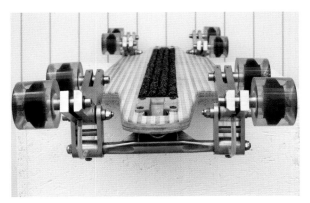

The Stair Rover skateboard is made for skating down stairs. The board has eight wheels and a Y-shaped aluminum frame that can grip each step and slide: stairs become a new means of transport.

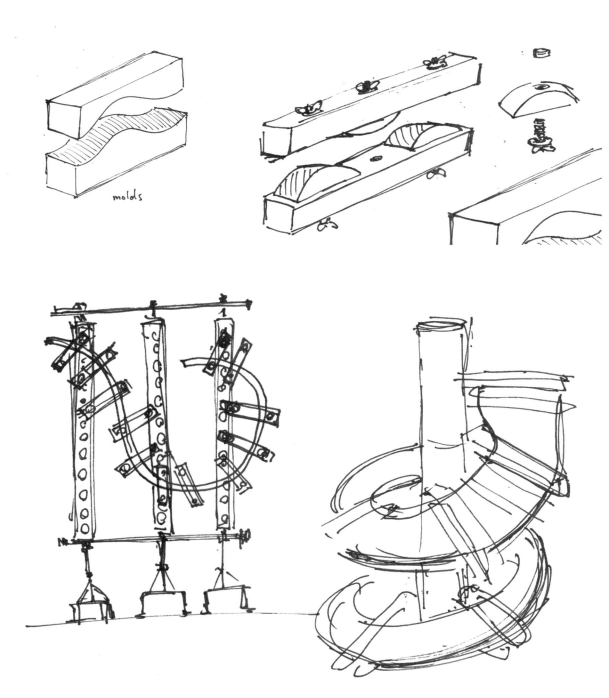

molds

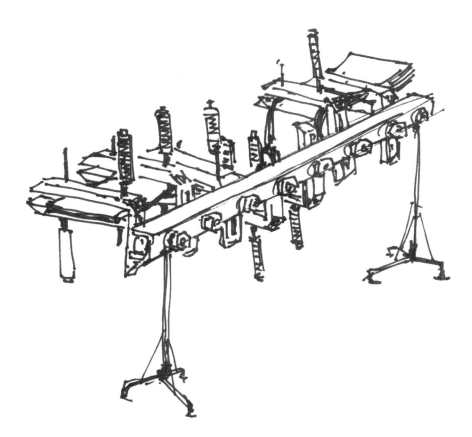

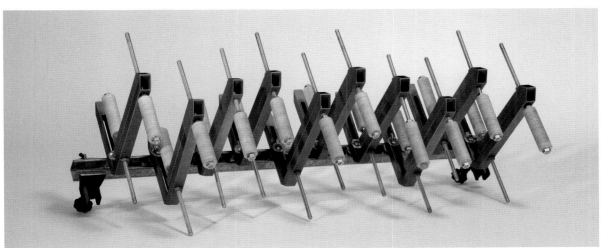

The Rapid Laminator was meant to facilitate the prototype design process. It laminates materials without the need for molds and can be adjusted to different shapes. The clamps can be moved horizontally and vertically, and their length and angles can be altered.

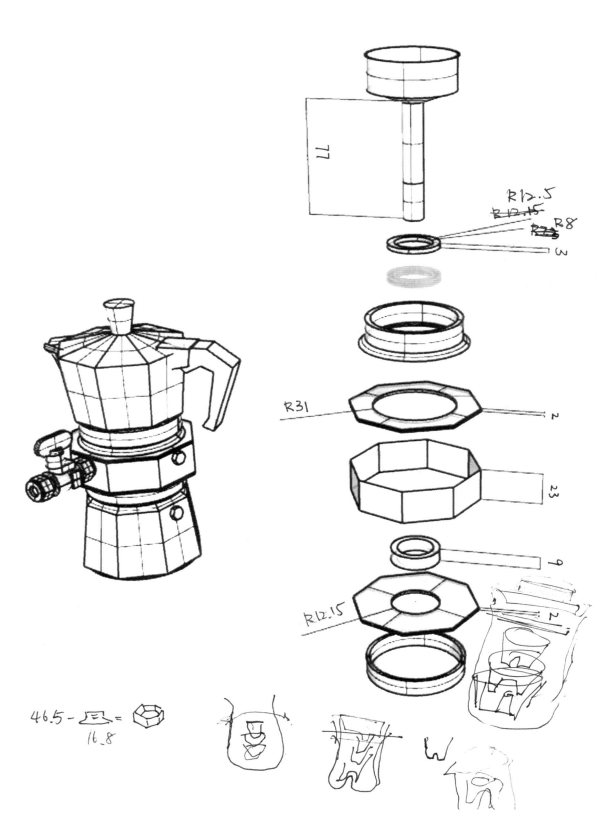

77

R12.5
R12.15
R8
R13
3

R31 2

23

9

2

R12.15

46.5 − ⊟ = ⬡
16.8

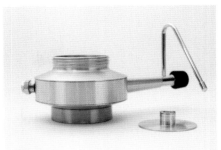

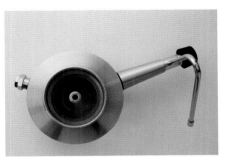

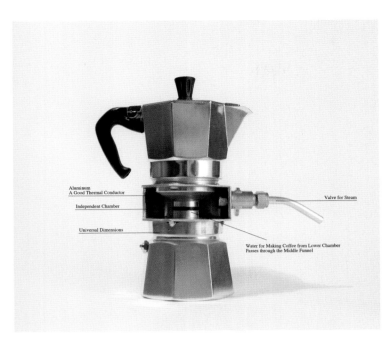

Aluminum
A Good Thermal Conductor

Independent Chamber

Universal Dimensions

Valve for Steam

Water for Making Coffee from Lower Chamber
Passes through the Middle Funnel

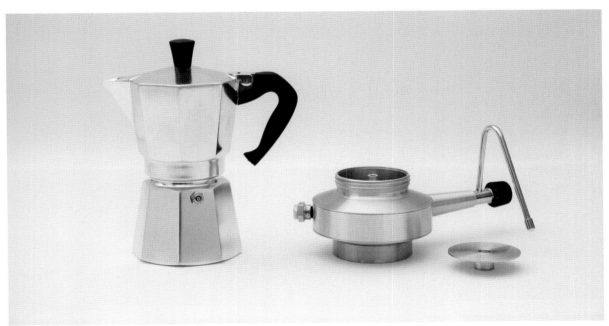

The Milk Brother emulsifier was inspired by the Moka Express pot (patented by Luigi De Ponti in 1933). This small invention creates froth in hot milk with a central valve. The steam from the coffee pot is stored in a separate compartment and then used to froth the milk.

LES M DESIGN STUDIO

Rennes, France
Luxembourg, Luxembourg
www.lesm-designstudio.com

The Les M studio was established in 2008 by French designers Céline Merhand and Anaïs Morel. The two young people met at the Rennes School of Fine Arts, from which they graduated in 2007. The mission of Les M is to change small things in daily routines with their creations, choosing materials that are particularly pleasing to touch and that invite consumers to interact with the object. The studio works for companies such as Casamania and Super-ette.

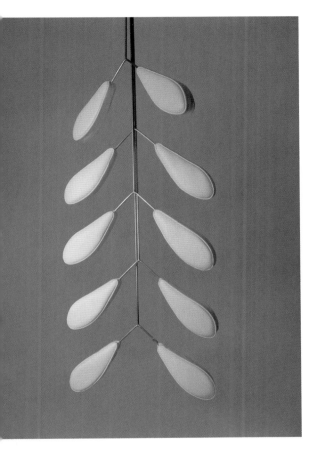 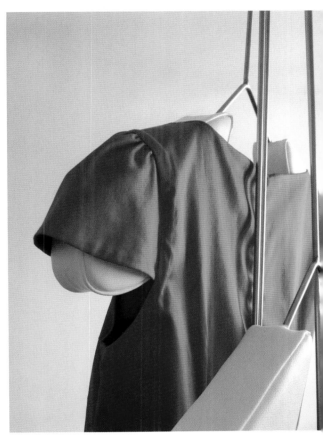

Leaves from trees are incorporated into the design of the Effeuillage hanger, which is torso-shaped to keep the garment in good condition.

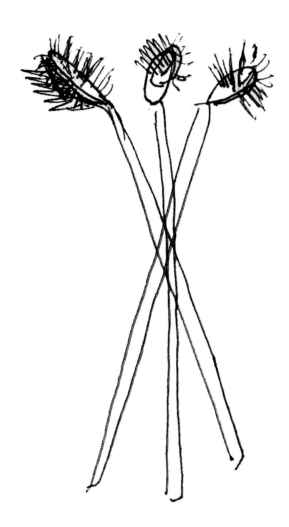
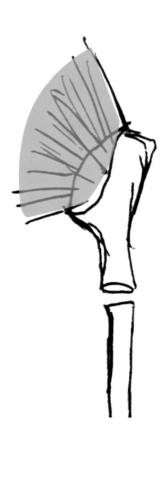

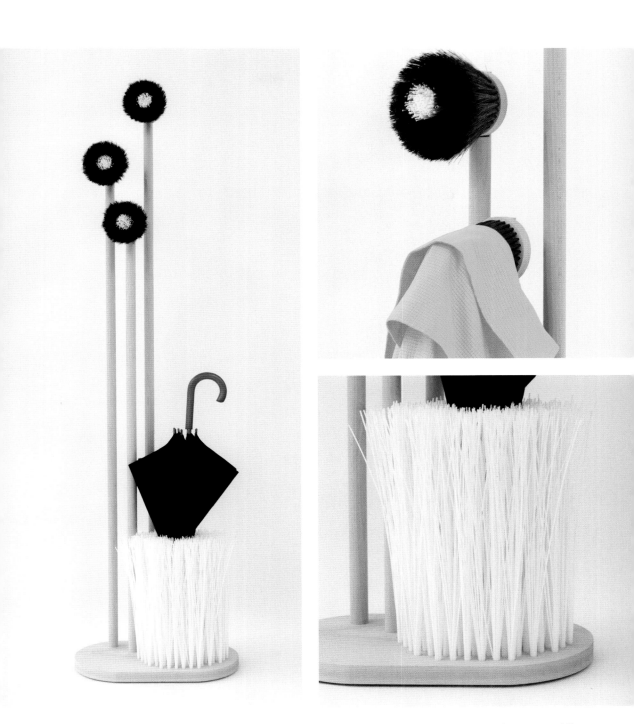

The Heli is a coat rack with umbrella stand. The three bars and the base are beechwood, and the hangers and the umbrella area are made from fibers.

The Precious mirror has colored side drawers for storing jewelry and other small accessories. It also has a removable bar with hooks for hanging necklaces.

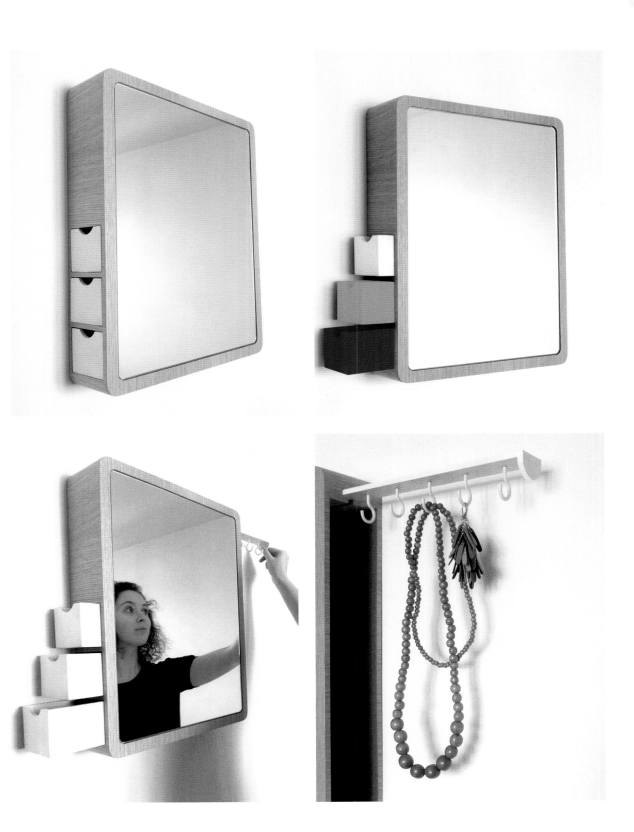

The Sensorium is a set of artistic pieces designed to stimulate the five senses. Great care was taken in the choice of materials, which are appealing to the touch. Each area is focused on one of the five senses.

The project was exhibited in the Mudam (Musee d'Art Moderne Grand-Duc Jean de Luxembourg) for one month, during which visitors could interact with the various pieces.

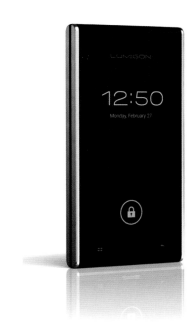

Copenhagen, Denmark
http://lumigon.com

Lumigon focuses on creating luxury technology products with unique, original, innovative, and functional designs. T2 was designed by two members of the studio's creative team: Line Thomsen and Ai Mitsufuji. Thomsen is an industrial designer whose creations are sophisticated and user-friendly. Mitsufuji has a master's degree in architecture and draws inspiration from her roots to refine her products, adding details and practical features.

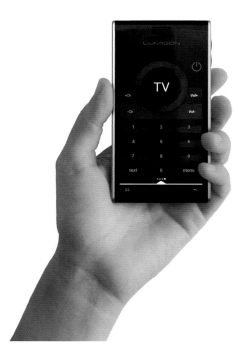

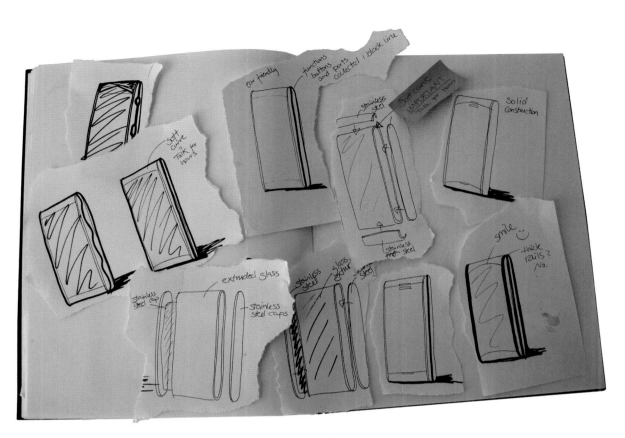

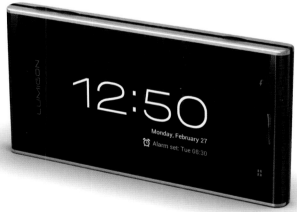

The T2 is a new smartphone from Lumigon. Simple, elegant, and functional, it offers a compact stainless steel design and a very strong screen with extremely high resolution. It also incorporates a remote control system for different devices.

JESSICA MA

Montreal, Canada
www.coroflot.com/majessica

The young designer Jessica Ma began by studying architecture; then, after graduating, she decided to study for a degree in industrial design at Montreal University. This second course allowed her to explore and satisfy her curiosity about objects and our ways of interacting with them. Ma's main interest is in consumer products that are both functional and indispensable. One of her projects has appeared in *The Gazette*.

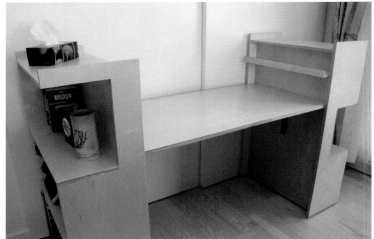

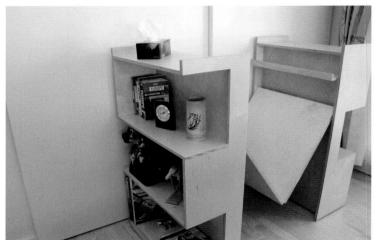

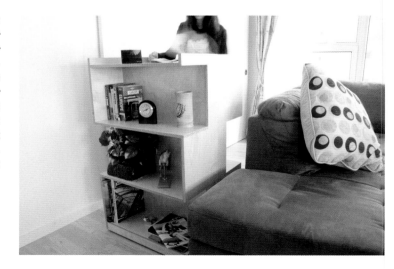

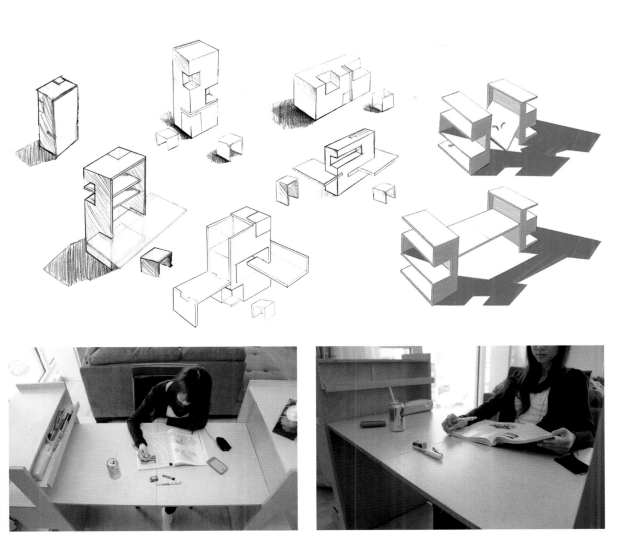

The STaTion has a dual function: closed, it is a bookshelf with storage capacity on both sides; it can also be opened to reveal a worktable. This piece would easily fit into a small apartment.

LUBO MAJER

Bratislava, Slovakia
http://lubomajer.com

Lubo Majer began his professional career before completing his studies. He opened his first studio with a fellow student, leaving years later to seek new adventures. These and other experiences, such as working for Marín Ballendat, were at least as important as his academic studies, in Majer's opinion. Majer interprets design as a way to improve not only the objects that surround us but also society, the environment, and the future.

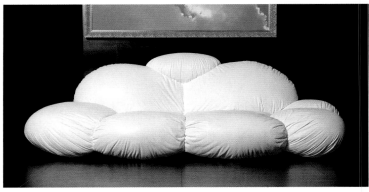

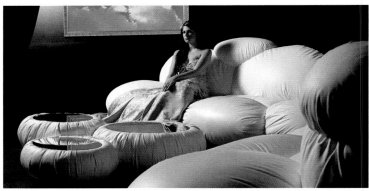

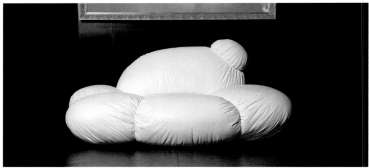

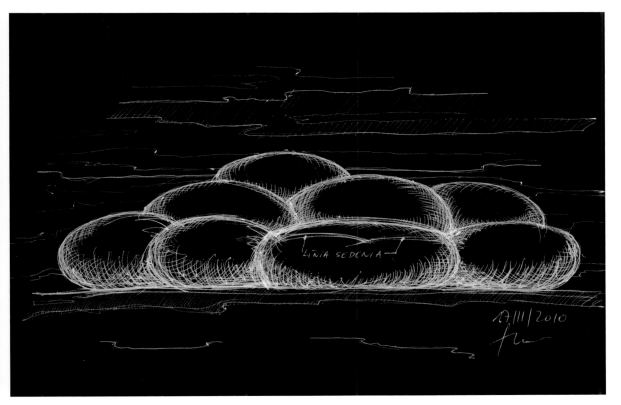

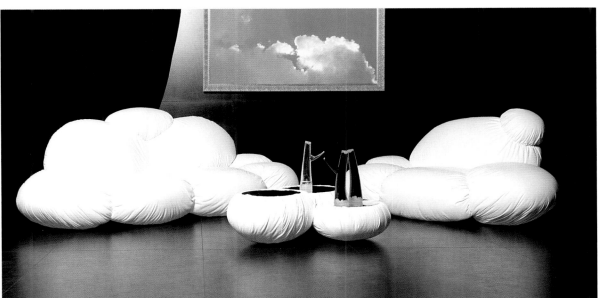

The designer of the Cirrus was inspired by clouds. Its construction is rigorous, and the structure is robust without compromising comfort, originality, or sophistication.

MALAGANA

Bogota, Colombia
www.malaganadesign.com

Alejandro Gomez Stubbs is the founder of the small studio Malagana. After receiving his degree in architecture in 2003 and completing a master's degree in industrial design in 2007, Stubbs went to work for Clodagh Design, where he carried out projects for clients such as W Hotels Worldwide. In 2008, he won the Design+Modern+Function Award, and in 2009 he opened Malagana Design, which launched the successful EQUILIBRIUM line in 2012, capturing the attention of the international design community.

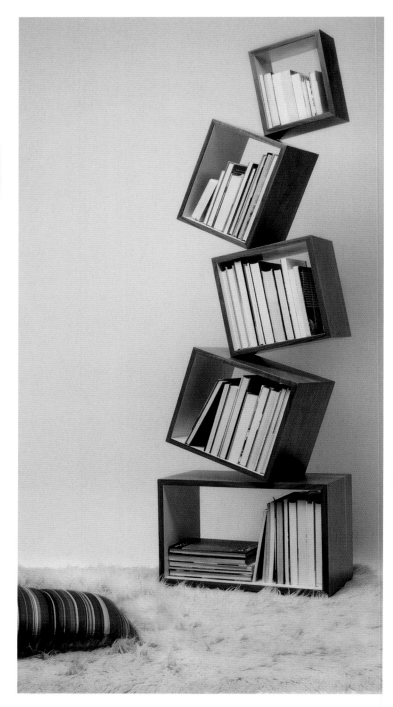

Concepts final #2

The Equilibrium bookshelf comprises various modules stacked in an original way: each block is supported on just one corner, as if it were floating. The walnut bookshelf can support up to 158.7 pounds (72 kilograms) and measures almost 6.56 feet (2 meters) in height.

DARIO MARTONE

Castellammare di Stabia, Italy
www.dariomartone.it

Dario Martone has been attracted to art since childhood, so it was no surprise when he decided to enroll in an art college in Rome and graduated with a degree in industrial design. He believes that designers are capable of changing lives with products that educate people and teach them to respect themselves, the community, and the environment. Martone is studying for a master's degree at Iuav University in Venice.

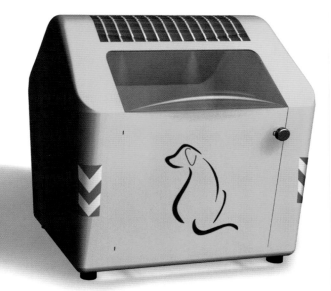

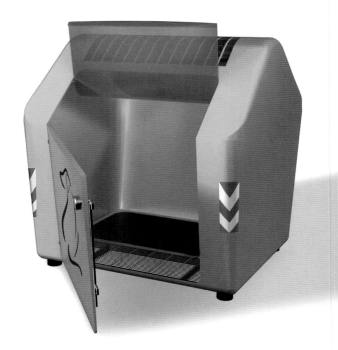

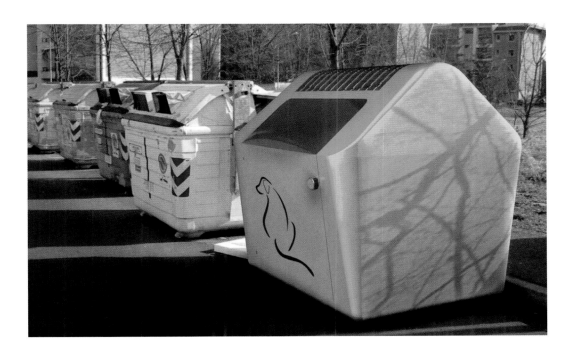

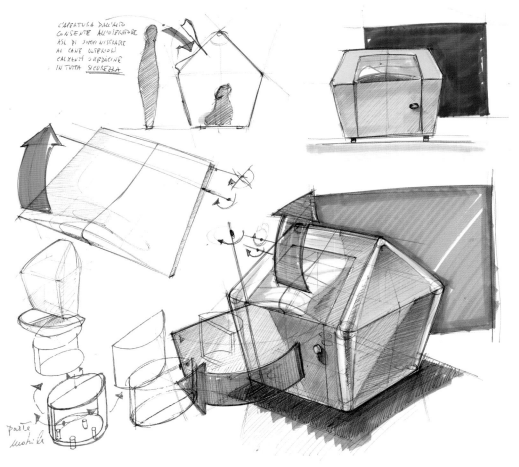

Designed by Gabriele Natale and Luis Enrique Pisfil, Chance offers a second chance to abandoned dogs.

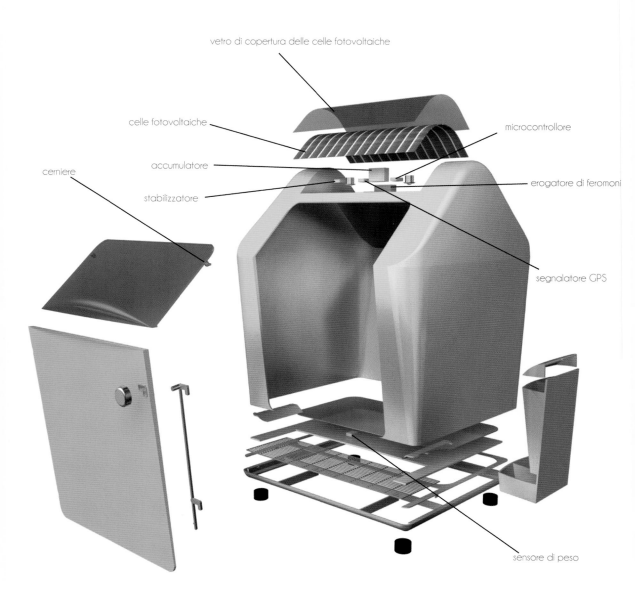

vetro di copertura delle celle fotovoltaiche

celle fotovoltaiche

microcontrollore

cerniere

accumulatore

erogatore di feromoni

stabilizzatore

segnalatore GPS

sensore di peso

In the shape of a container, this large kennel has a GPS device that alerts the appropriate authorities when an animal is inside. The solar-powered container dispenses a ration of food and water for the dog.

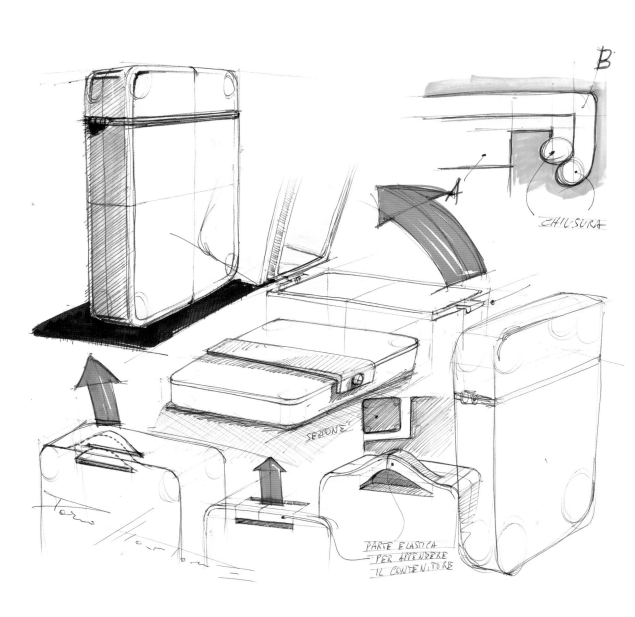

B

A

CHIUSURA

SEZIONE

PARTE ELASTICA
PER APPENDERE
IL CONTENITORE

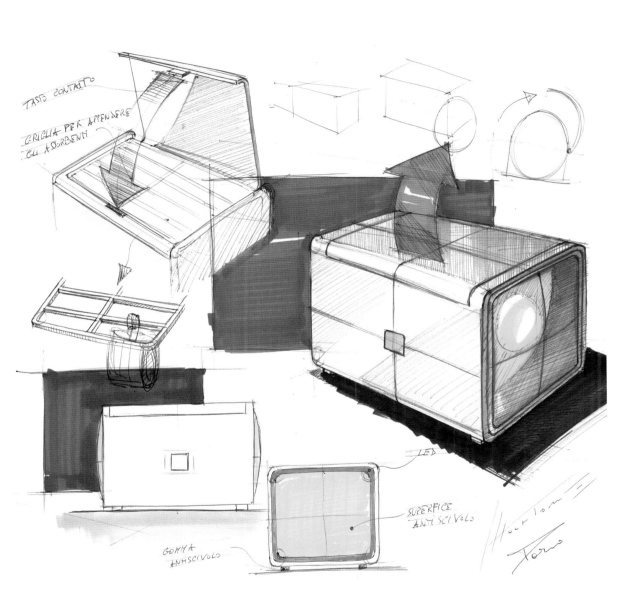

TASTO CONTATTO

GRIGLIA PER APPENDERE
GLI ASSORBENTI

LED

SUPERFICE
ANTISCIVOLO

GOMMA
ANTISCIVOLO

The Nature is a small device designed to wash reusable sanitary towels. It is made of silicone and ABS polymer.

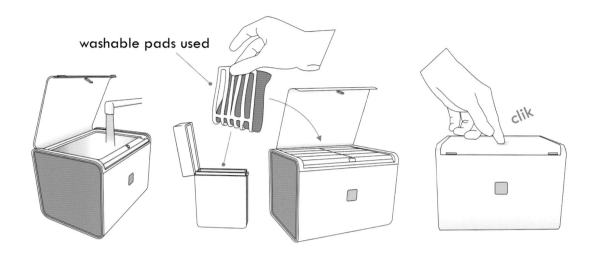

washable pads used

clik

1. Put the water inside the Base

2. take the pads used and then put it in the base using inner band

3. close the cover

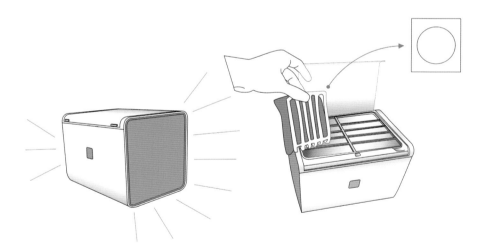

3. first step:
- soaking.
second step:
- disinfection.

3. take the pads from Base, and put it in the washing machine

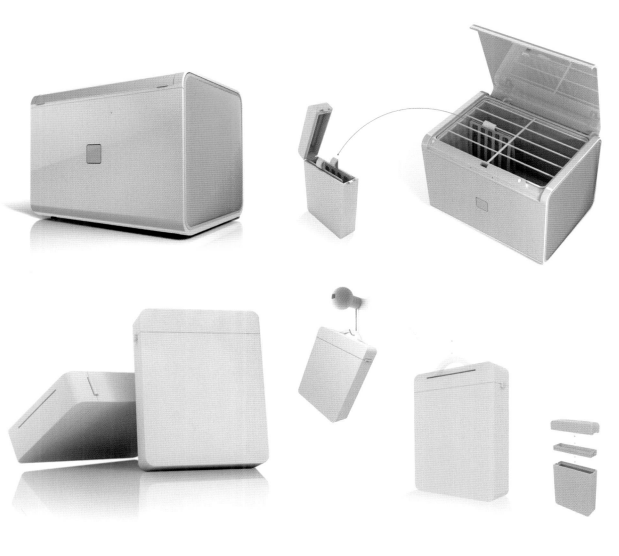

UV-C waves reflected inside the Base

UV-C waves

Lamp UV-C

Its high temperatures disinfect the pads, eliminating the need for the chemical products that would normally be needed to prepare them for washing in a conventional washing machine.

J. P. MEULENDIJKS

Utrecht, The Netherlands
www.n-u.nl
www.planktonstation.nl

The J. P. Meulendijks Studio, named after its founder, designs furniture, lighting systems, and industrial products for international clients. J. P. Meulendijks has also launched a brand that designs, develops, produces, and distributes its own projects under the name Nu-Collection. The studio is currently concentrating on the production of ecological and sustainable products and has designed a new biodegradable material: ecolotek.

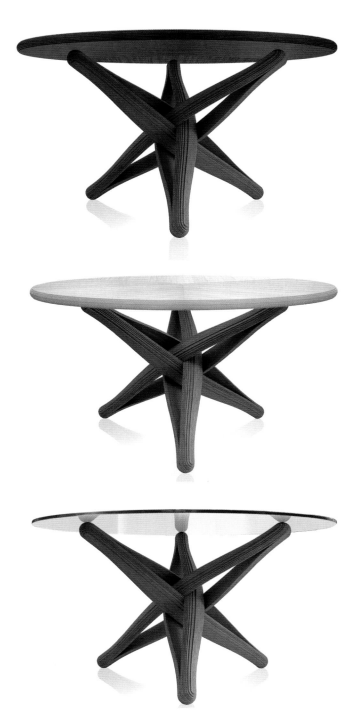

The Lock Bamboo Caramel table is manufactured from bamboo, a renewable material that is "en vogue" among contemporary designers. It reaches maturity in just three years and provides very flexible wood.

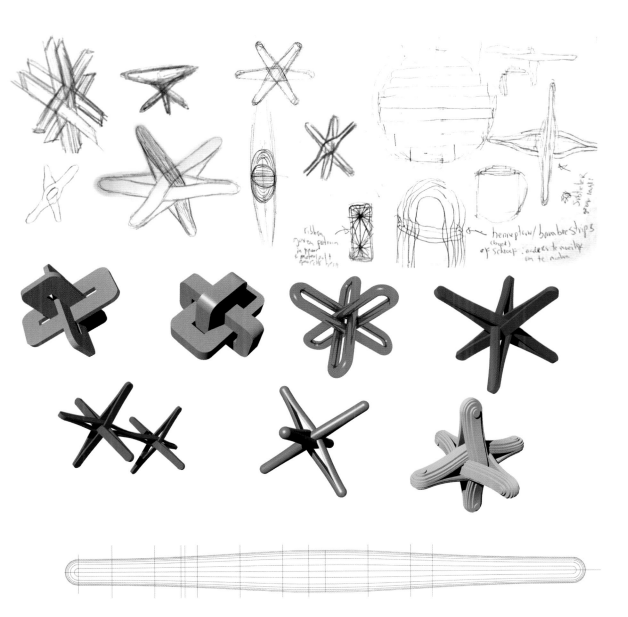

The frame consists of three pieces of bamboo inlayers joined only at the tips, giving a dome shape to the legs.

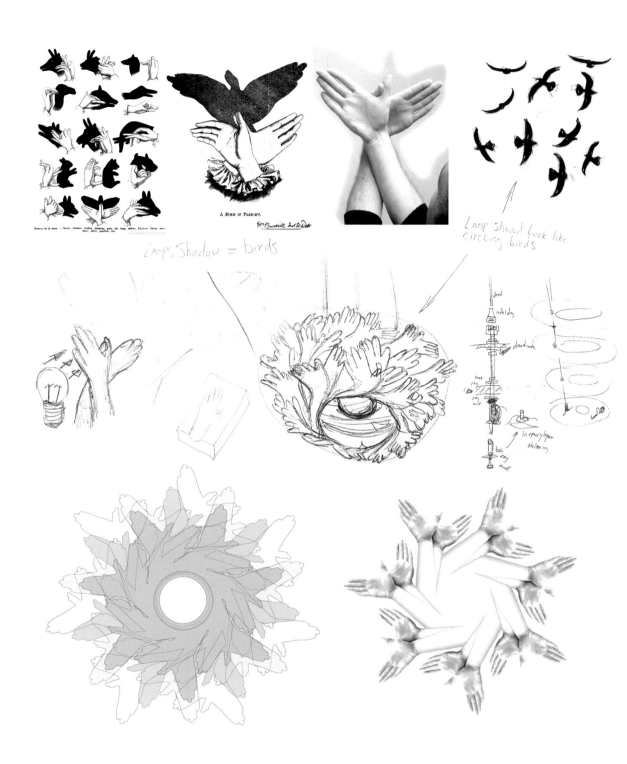

A BIRD IN FLIGHT.

Lamps Shadow = birds

Lamp should look like circling birds

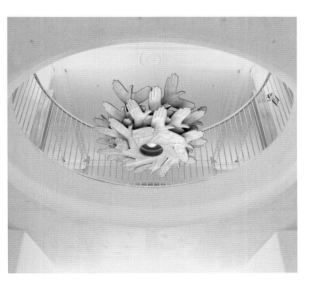

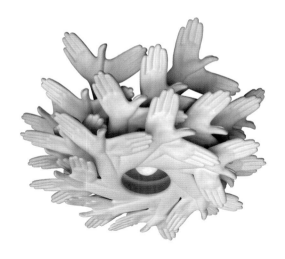

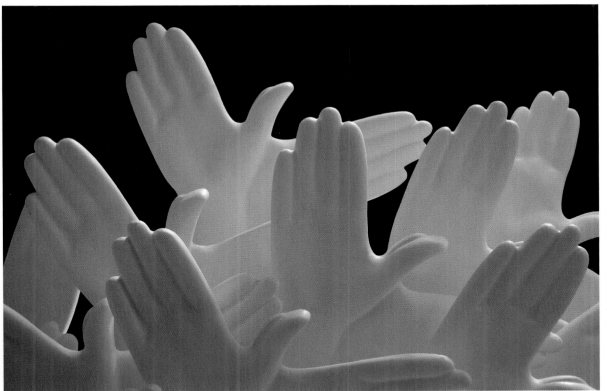

The Bird in Hand is a sculptural pendant lamp inspired by hands making a bird shape. The play of shadows creates a dove silhouette.

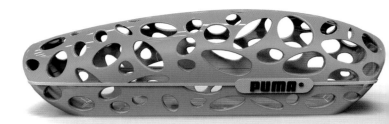

MONTDESIGN

Caracas, Venezuela
www.montdesigns.com

MONTdesign is a multidisciplinary dynamic freelance group that offers its clients knowledge and experience, adding extra qualities to the products they need. Its designers understand their work as a constantly evolving art that is part of our everyday lives and that makes us grow and improve. Each product poses new challenges, and procedures are adapted to the needs of each project.

The design of this glasses case takes into account visual attraction, industrial production factors, and the use of new manufacturing materials.

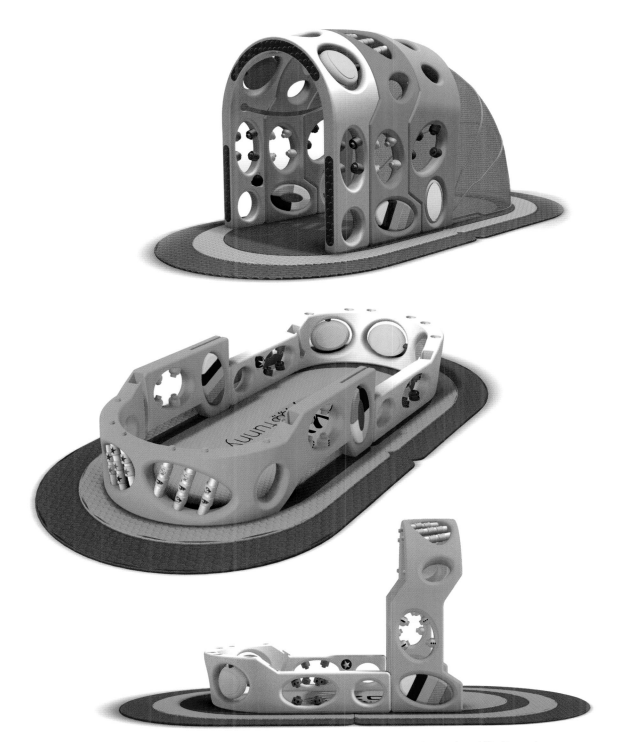

This children's game station is aimed at one- to four-year-old children. It helps develop motor skills through sensory games. Each module covers one stage of childhood.

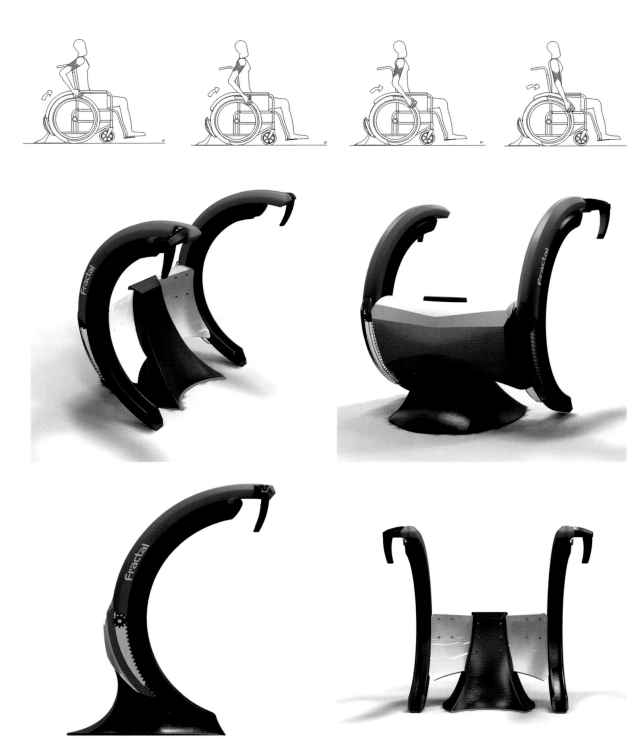

This aerobic and anaerobic exercise machine is for people who need a wheelchair. The machine can be used for rehabilitation therapy, as it develops strength and muscle tone.

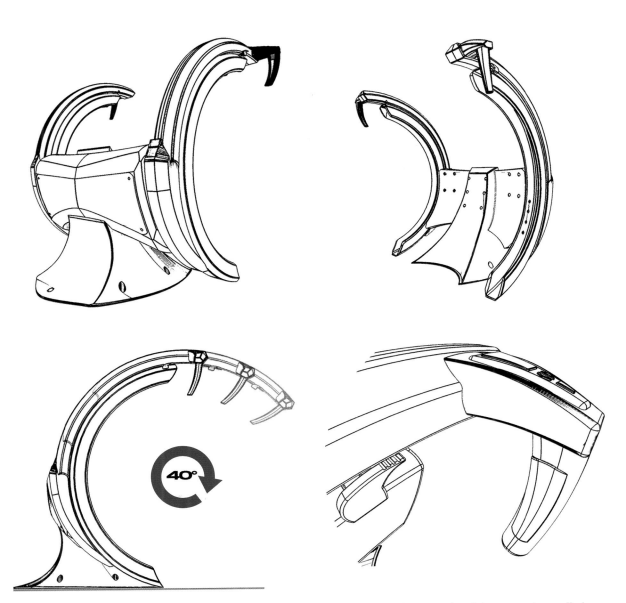

The apparatus simulates a wheelchair, and as shown in the sketch, different degrees of resistance can be applied.

GABRIEL NIGRO

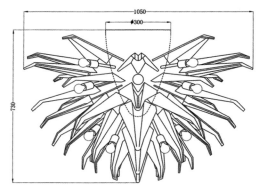

Copenhagen, Denmark
www.gabrielnigro.com

Born in Uruguay in 1974, Gabriel Ni-
gro travelled in Argentina and Brazil
and ended up settling in Denmark.
This long journey and mixture of cul-
tures formed his vision of the art of
design. "Imagination is stronger than
knowledge," he says, and he plans his
designs well before putting them into
practice. He was nominated for the
Cooper-Hewitt, National Design Mu-
seum, People's Design Award in 2007.

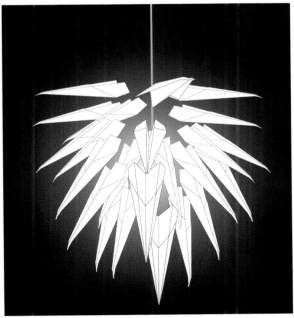

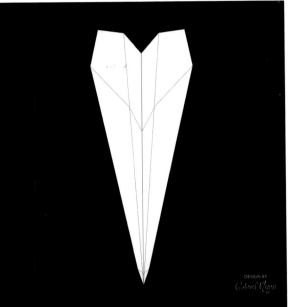

DESIGN BY
Gabriel Vigro

Inspired by children's paper airplanes, the Concorde is an original lamp design. In the same way that real aircraft circle the globe, this lamp's aircraft revolve around the bulb.

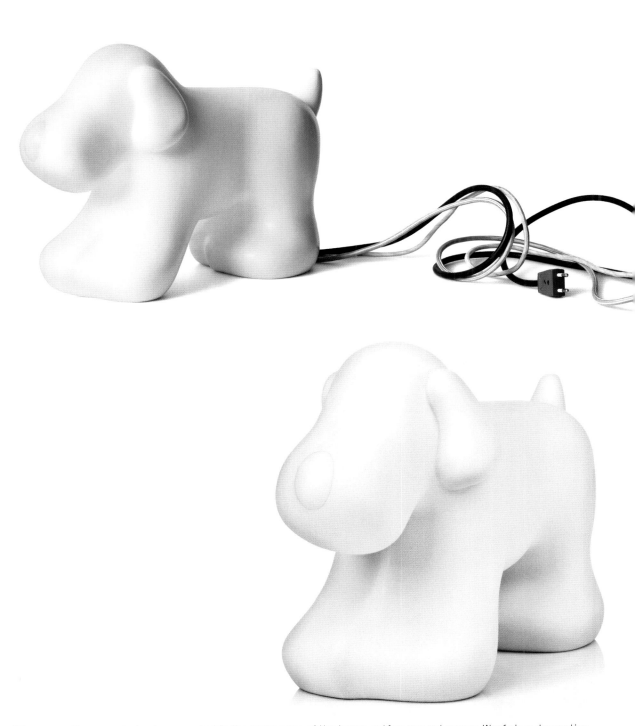

When more than one device is connected in the same area of the home, cables can get messy. Woofy is a decorative dog-shaped object that can be used to hide those cables inside.

NORM

Copenhagen, Denmark
www.normcph.com

Jonas Bjerre-Poulsen and Kasper Rønn met at the Royal Danish Academy of Fine Arts, drink at the fountain of Scandinavian design tradition, and form a complete professional duo. They founded NORM in 2008, and their products, inspired by Nordic bird life, are made with natural, long-lasting materials. Their designs are beautiful, minimalist, and functional, with an extra serving of spontaneity that makes their products stand out.

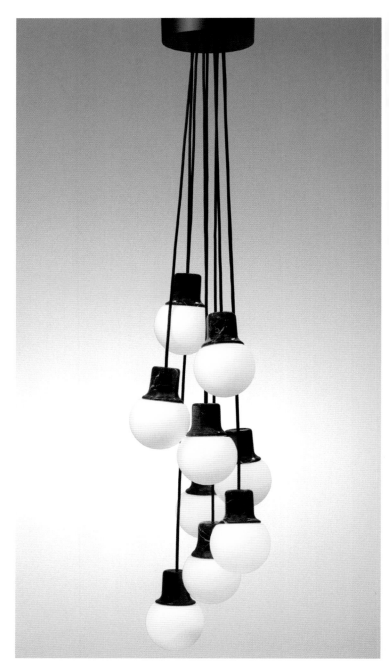

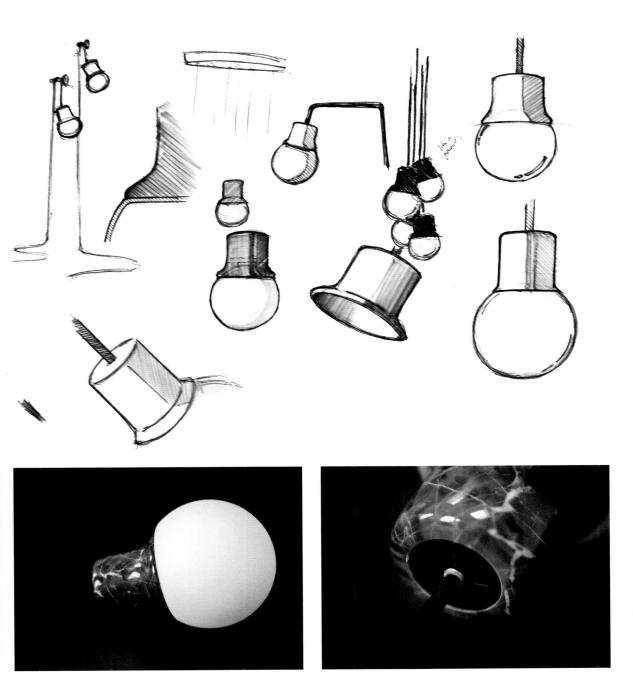

The Mass Light was inspired by the streetlights of Paris, Barcelona, and New York. Manufactured from brown marble and glass, this ceiling light, with its simple lines and strong construction, illuminates large spaces and withstands the test of time.

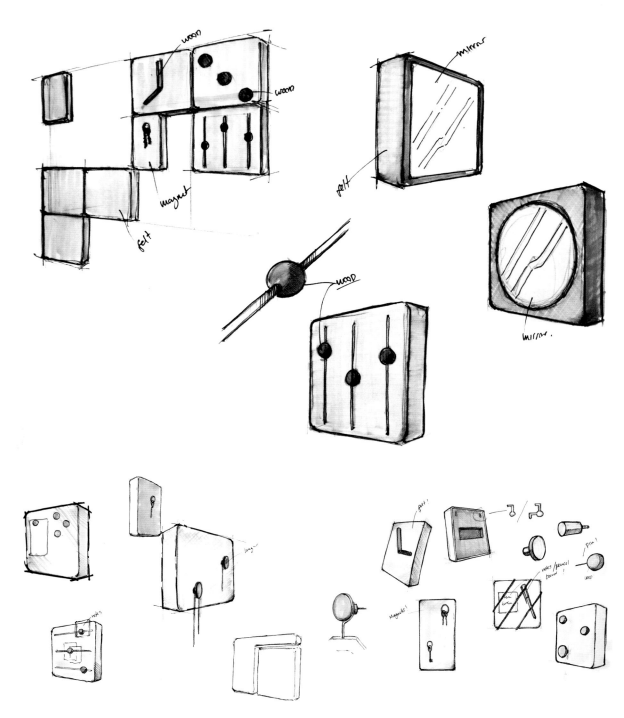

In the modular felt Wall Panels set, all the panels are the same shape and size but have different functions: clock, mirror, and pin board.

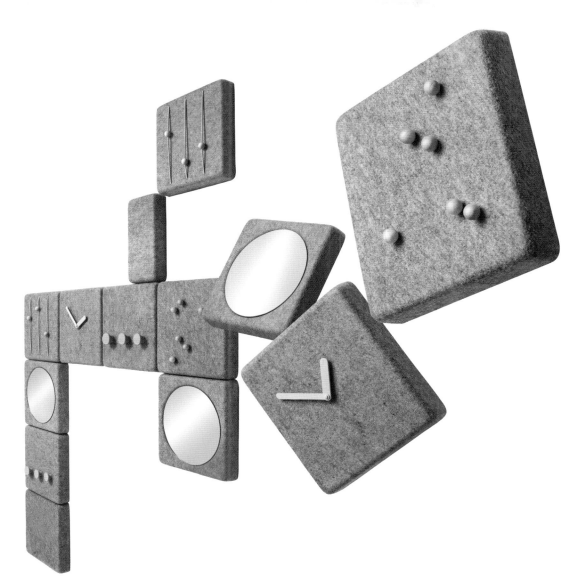

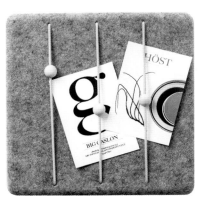

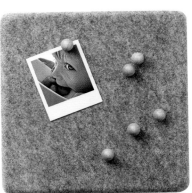

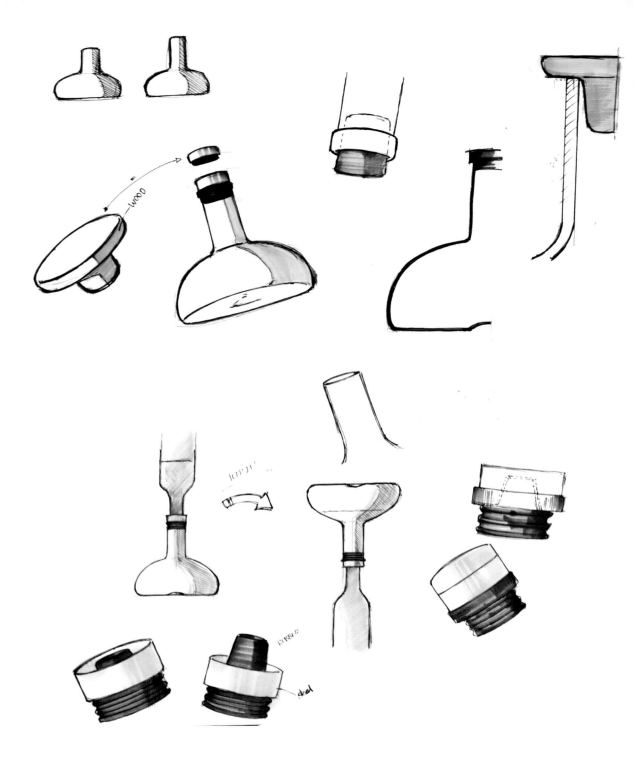

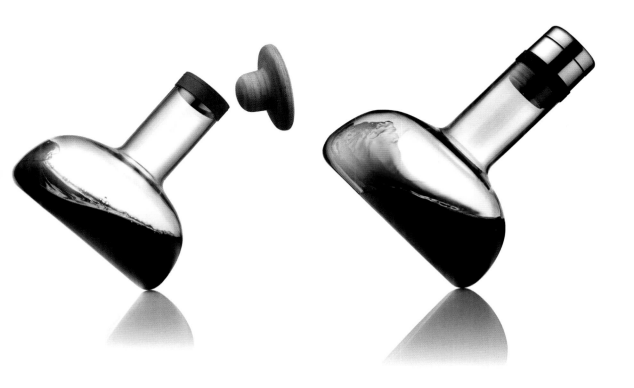

The Wine Breather is a wine decanter and container. Wine can be served directly from the decanter; the wooden stopper keeps it in good condition.

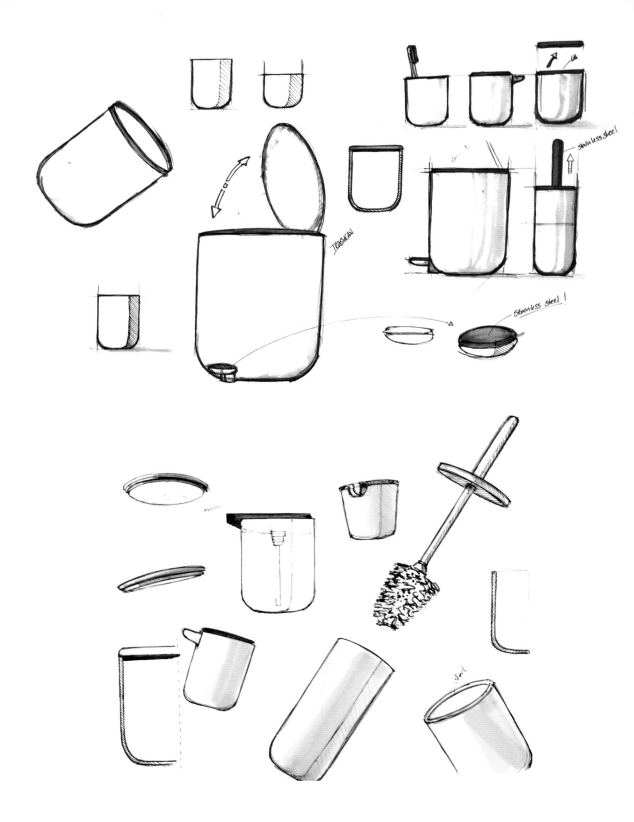

IROSKAN

stainless steel

Stainless steel!

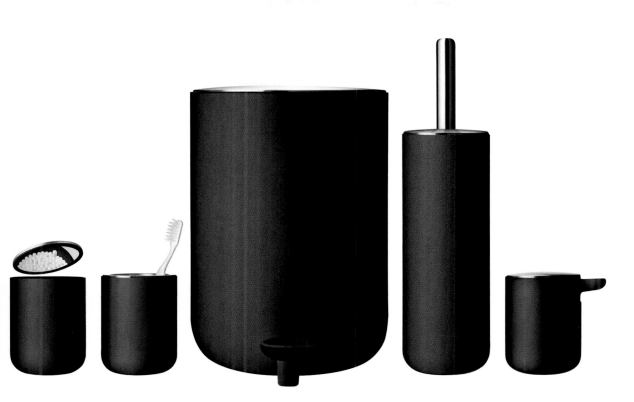

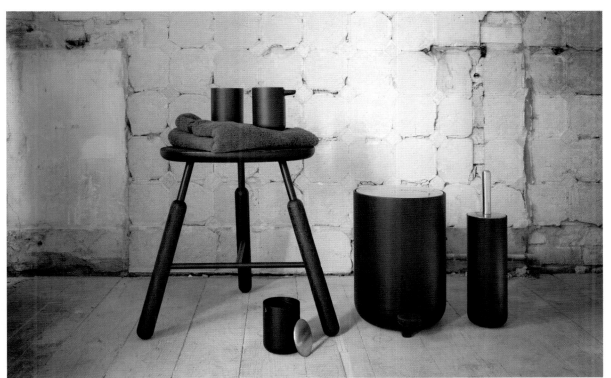

This brush and container, part of the Nordic Bath collection, are lightweight with simple lines. This traditional Swedish design is easy to clean. The series includes a wastebin, soap dish, toothbrush holder, and a small box with a mirror.

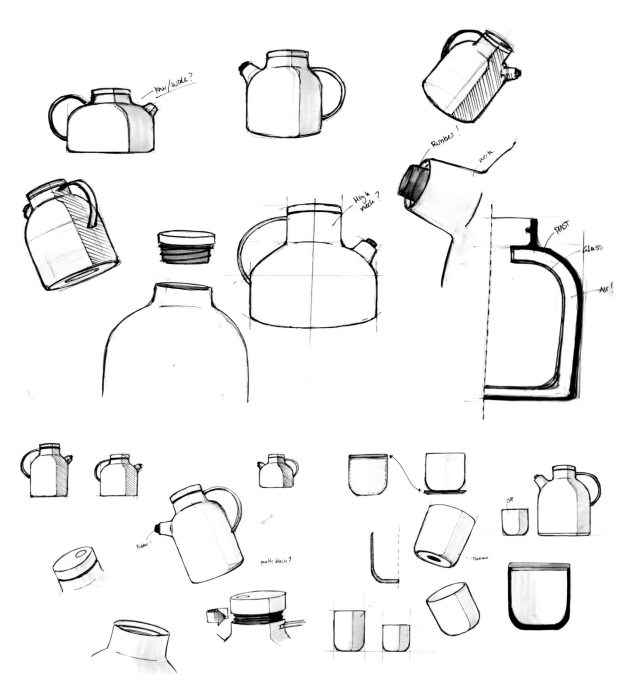

The Glass Kettle Teapot is a fusion of Zen philosophy and contemporary Swedish design. The tea strainer is in the center, and the glass walls allow you to see the tea brewing. The silicon cord allows you to remove and clean the strainer.

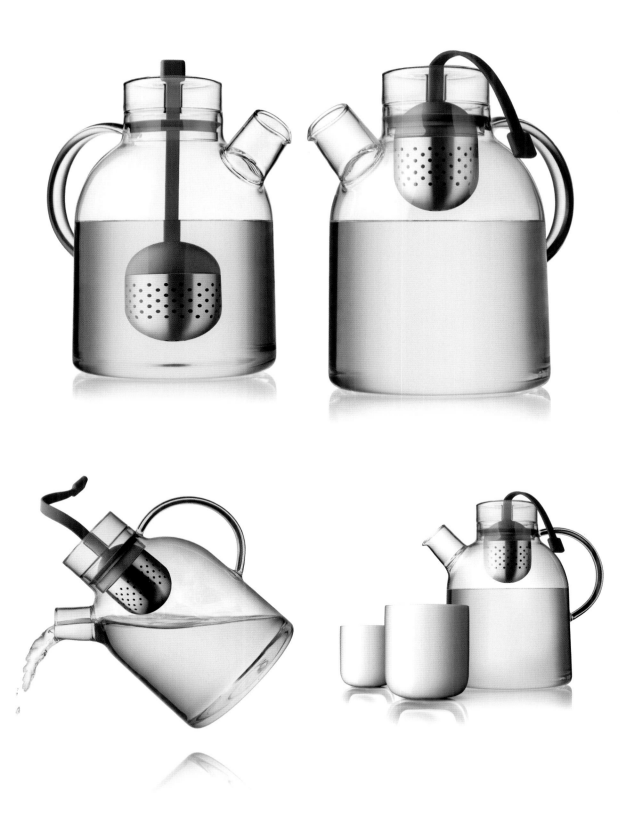

PAPERCLIP DESIGN
LIMITED

Kowloon, Hong Kong, China
www.paperclipdesign.hk

Designer James Lee, who loves air-
planes, earned a degree in mechani-
cal engineering from Hong Kong Uni-
versity and then a master's degree
in aeronautics and astronautics. His
diverse experience in the airline in-
dustry enabled him to understand the
commercial as well as the operative
aspect of the sector. Lee founded his
studio in 2012, and his first product,
the Paperclip Armrest, has won sev-
eral international prizes.

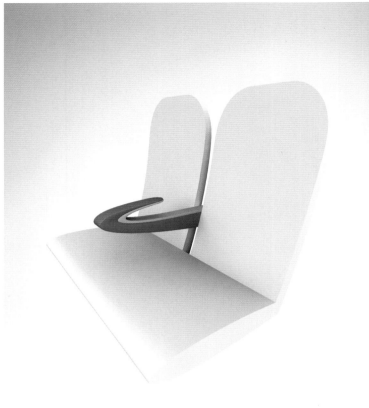

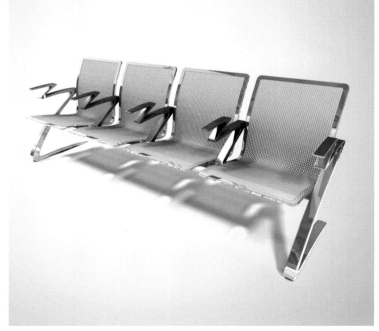

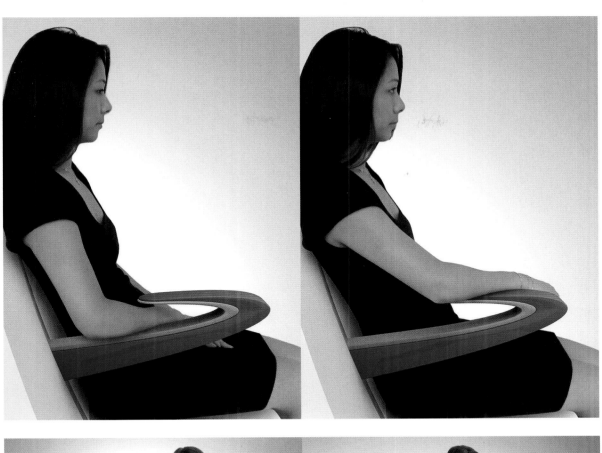

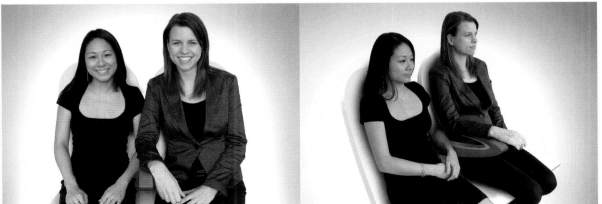

This armrest allows two people sitting next to each other to share the same area without touching. The arms are situated one above the other.

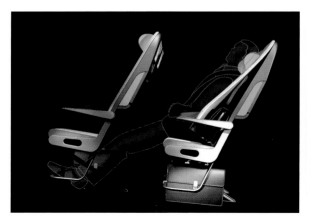

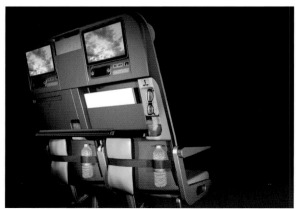

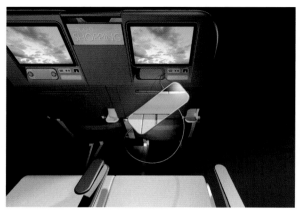

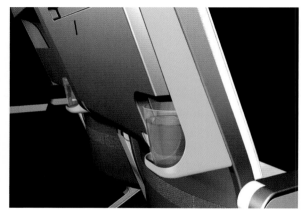

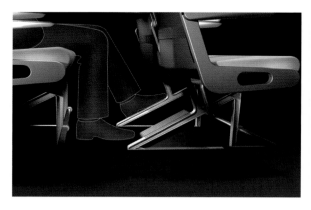

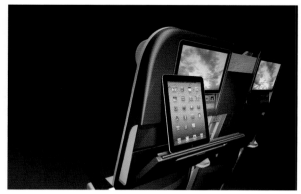

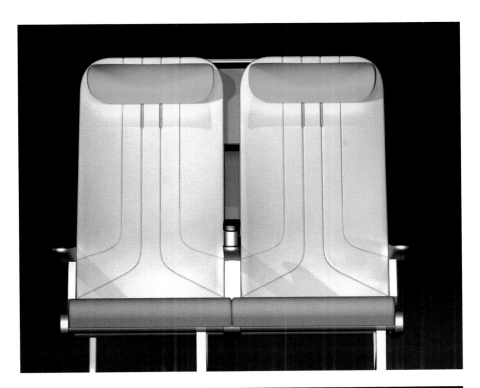

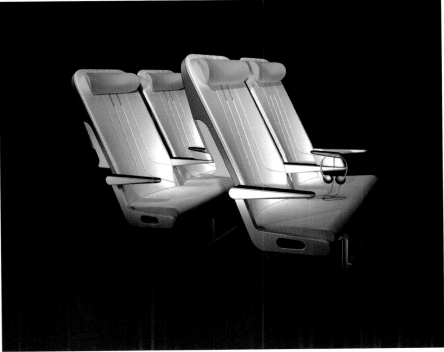

This is a seating concept for economy-class sections on long flights. The prototype has more comfortable seats, high-tech devices, and a shared magazine rack to liven up the journey without adding weight to the aircraft.

PAPERNOMAD

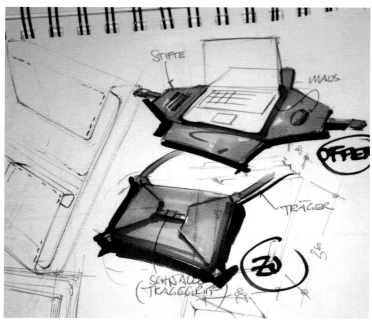

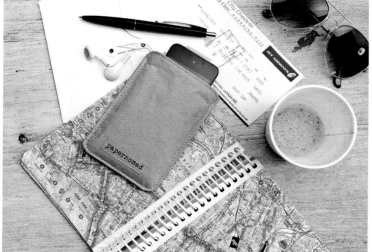

Vienna, Austria
www.papernomad.com

The founders of Papernomad combined their different areas of knowledge and skills to reach what they were striving for: success. Benjamin Kwitek looks after everything related to intellectual property, and Mario Bauer handles marketing strategies and administration. Cristoph Rochna is the designer behind the Papernomad project. The company won the Red Dot Award in 2012 and the German Design Award in 2013.

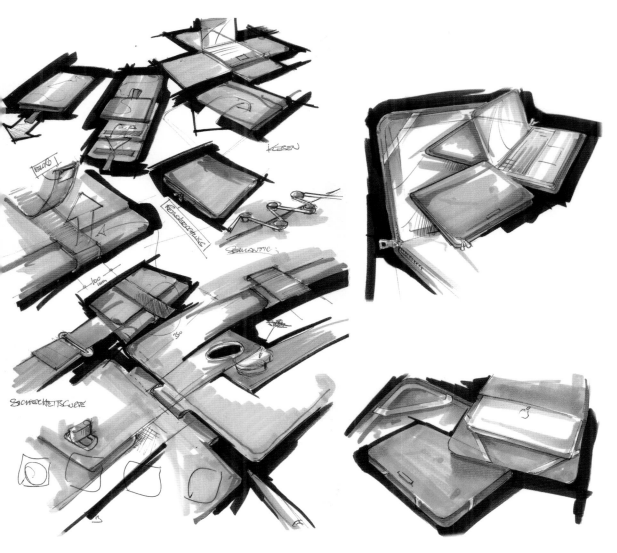

The Papernomad is a pouch to protect mobile devices such as smartphones and tablets. It is made from a recycled paper composite that is biodegradable and resistant to water and tearing. It can also be personalized with craft decorations.

ILSA PARRY

Liverpool, UK
www.ilsaparry.com

Ilsa Parry graduated from Manchester Metropolitan University in 2003 and founded REthinkings in 2009 with the conviction that too many products lack emotion and personality. She seeks to fill a gap in the market by discovering and developing alternative projects. Her studio produces household objects with the objective of designing products that demonstrate imagination, ambition, and creative design.

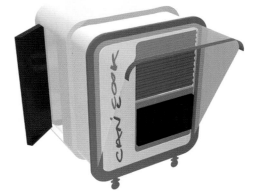

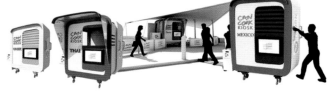

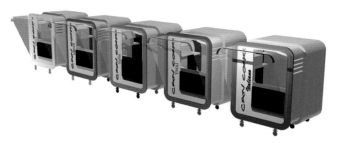

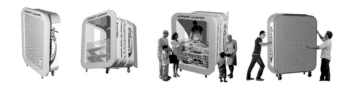

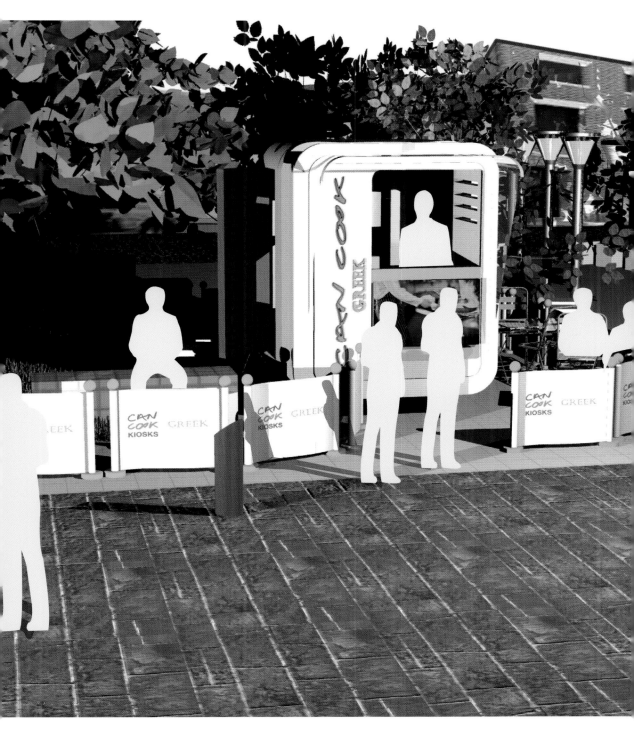

Versatile, light, highly functional, mobile, and complete with a kitchen, the Mobile Street Vending Kiosk is designed to help paroled prisoners and recovering substance abusers re-enter society and rehabilitate themselves through cooking and food.

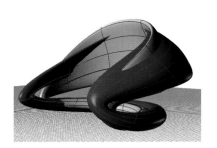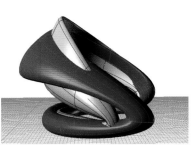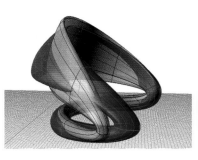

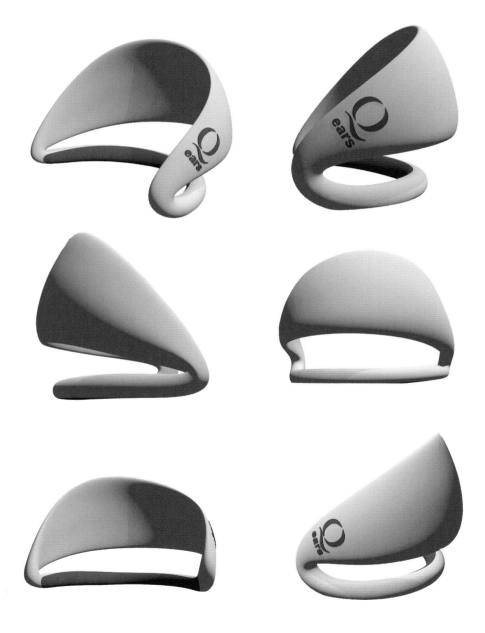

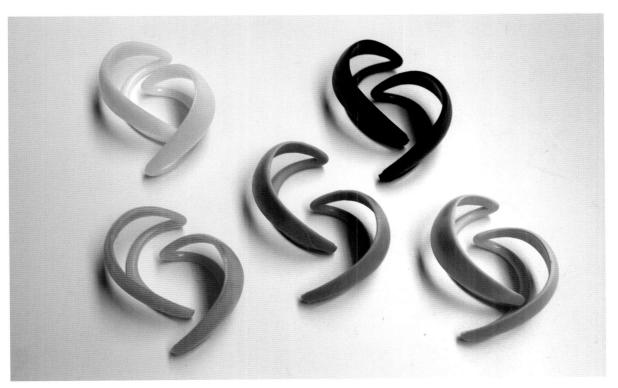

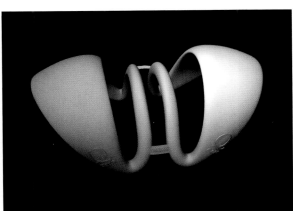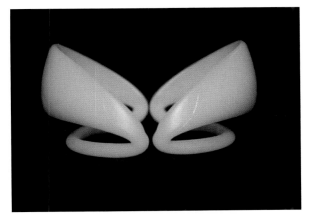

The Q'ears is a hearing aid for less acute hearing loss, designed to work at specific times. The devices are disposable, and rather than using digital technology, rely on their shape to amplify sound waves.

BEN PAWLE

London, UK
www.benpawle.co.uk

Benjamin Pawle studied at the Glasgow School of Art, where he discovered a passion for product design. Pawle has worked on personal projects that highlight his interest in helping people on an emotional level, and for large design companies in Glasgow and Barcelona. He currently works in Designit's London offices.

Transformation Game is a game for children with hemiplegia. It promotes the development of motor skills, such as buttoning. The smooth differently colored thick felt pieces can be folded and are connected with buttons.

This game consists of a robot costume for children to practice buttoning and unbuttoning clothing while having fun.

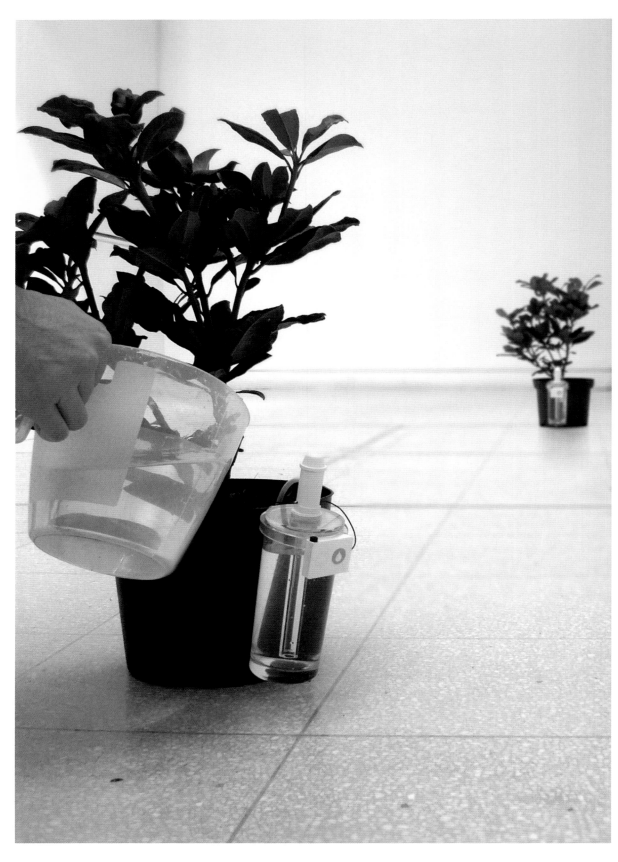

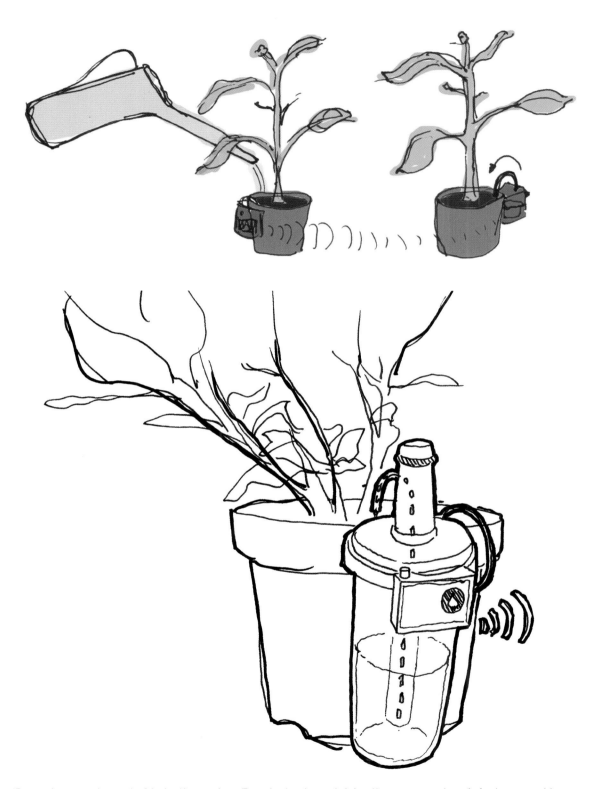

Home Grown is a remote-control irrigation system. Two plant pots containing the same species of plant are used to monitor soil moisture; when one pot is watered, the irrigator for the next pot starts and waters the other plant.

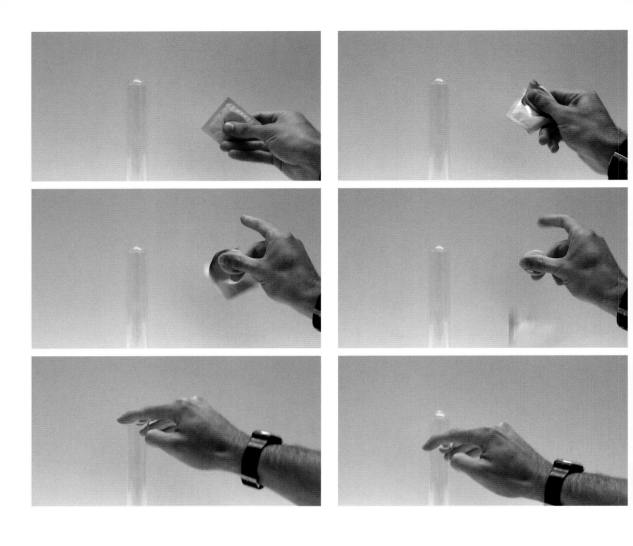

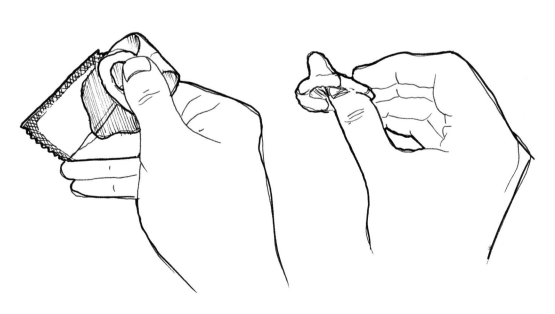

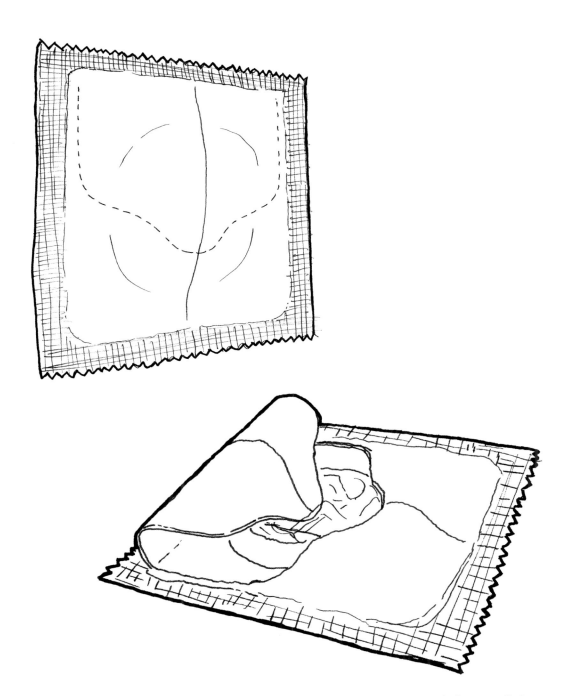

The One Handed Condom is a condom wrapper designed for people with restricted motor function in the upper limbs. It can be opened with one hand with a simple finger movement.

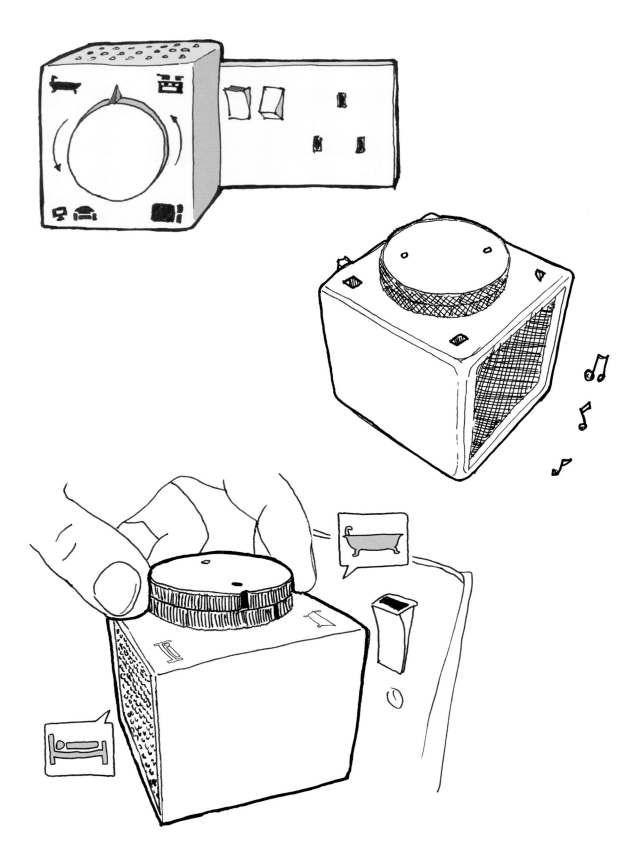

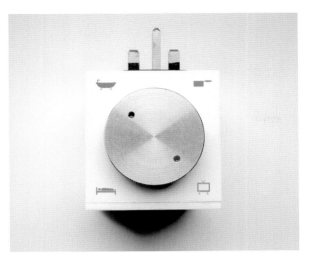

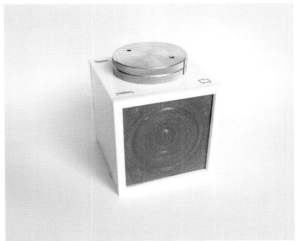

The Noise Box records background noise made by the inhabitants of the house. This soundtrack can be played back to reduce the feeling of loneliness when no one else is in.

VINH PHO

San Francisco, CA, USA
www.vphodesign.com

Vinh Pho graduated from the Art Center College of Design in Pasadena, California, and took part in an international exchange with a French university. He focuses on industrial design, paying special attention to thought and strategic design, brand development, and design functionality. He has won the Bronze IDEA and was a regional finalist in the James Dyson Awards and a finalist in the 2012 IDSA.

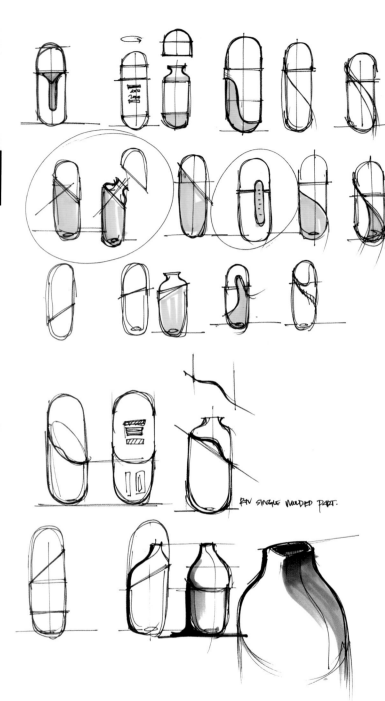

Auto Zone is a collection of car care products. The designs breathe new life into the brand by indicating the products' uses through contrasting colors and a simple yet original shape.

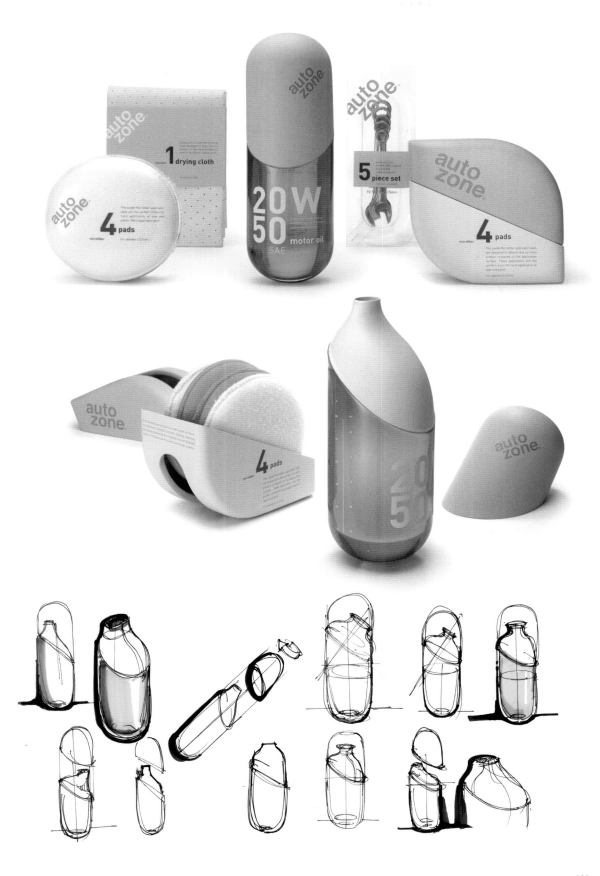

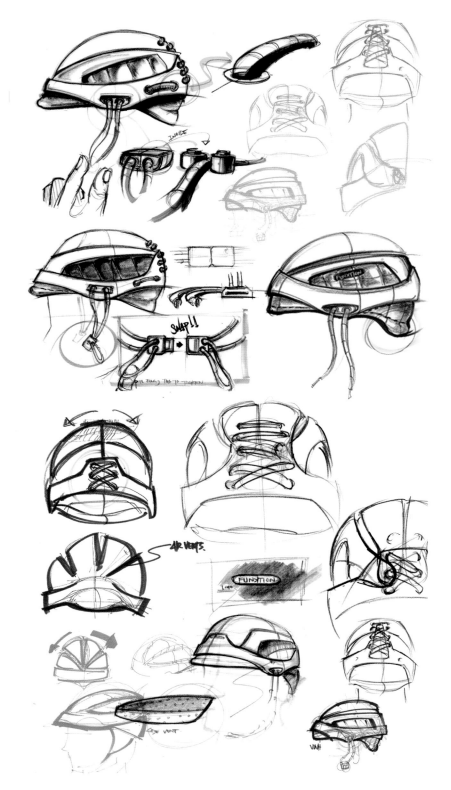

The FunKtion is a helmet designed for skaters and skateboarders to meet the specific requirements of their sports and their particular style. The designers studied different materials and successfully reduced the weight and volume of the helmets.

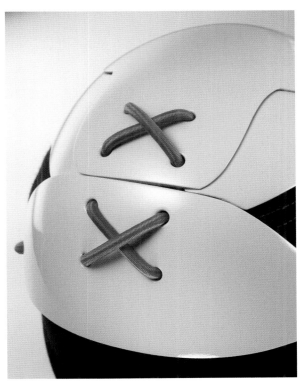

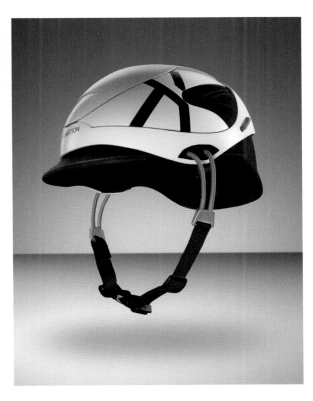

The helmet's internal Skydex impact protection layer and Gore-Tex pads, as well as the external locking plates, make it more portable and improves protection.

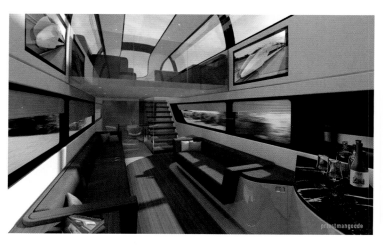

PRIESTMANGOODE

London, UK
www.priestmangoode.com

Priestmangoode is a multidisciplinary studio that works on marketing, branding, product design, and transport engineering projects. The studio strives to improve product design and efficiency. Priestmangoode has created market-changing products such as the world's most profitable hotel room. The Mercury high-speed train and Waterpebble are original creations.

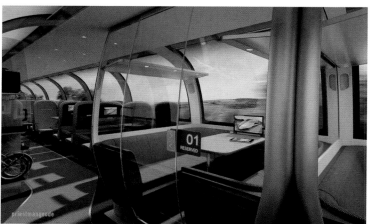

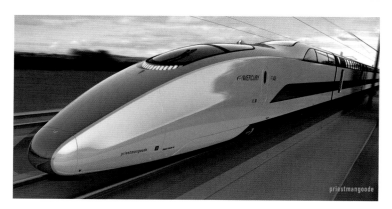

The Mercury Train is designed to compete with other means of transport. The train of the future operates with low levels of carbon, has an aerodynamic head, and is very fast, reaching 224.9 miles (362 kilometers) per hour. The interior design is spectacular.

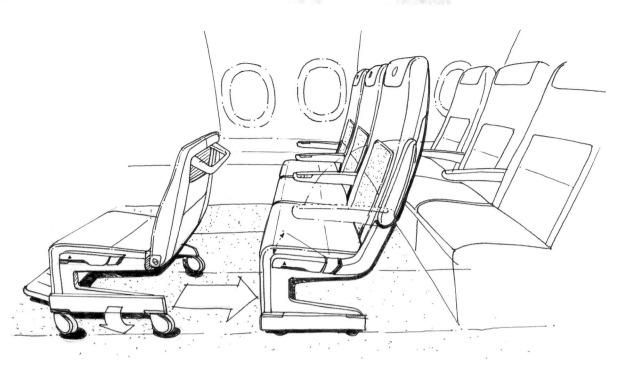

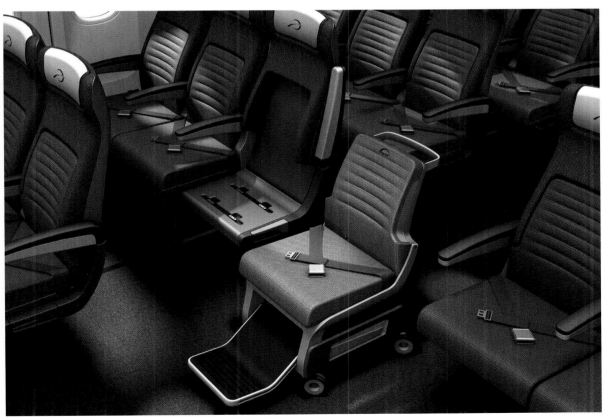

The Air Access airplane seat is a concept designed for people with reduced mobility. It consists of two parts: a wheelchair to help passengers in and out of the plane, and an area in the plane where the chair is secured. It can be installed facing the aisle.

This modem has been designed for BT Broadband. Thanks to its elegant design, the Home Hub has become a device that consumers remember and that fits in with other furniture in the home.

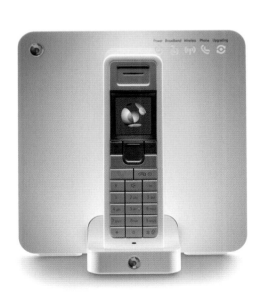

CABLE/STORAGE.
TIDY.

SPEAKER
CONTROLS

CABLE
MANAGEMENT
@ BACK.

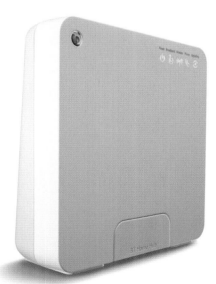

JASON PUTRA

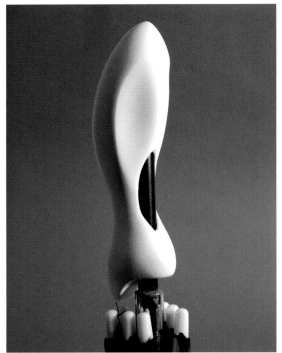

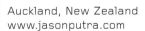

Auckland, New Zealand
www.jasonputra.com

Born in Jakarta, Indonesia, in 1991,
the young Jason Putra is studying
product design at Auckland Univer-
sity in New Zealand. He has shown
a passion for design since childhood,
along with an intense curiosity about
how the objects that surround him
work. He loves helping others "like a
superhero," and he strives for excel-
lent consumer experiences, the use of
renewable materials, and a simple and
modern look.

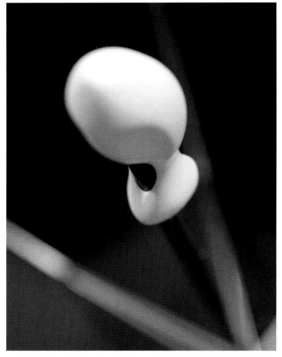

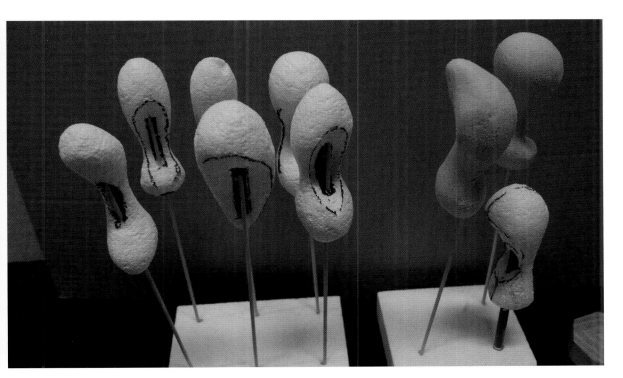

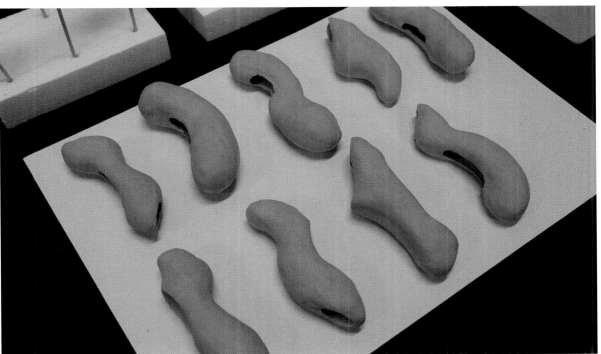

The Handle, for umbrellas, has an ergonomic design that adjusts to the hand. Its shapes create a visual play that can be seen from all angles.

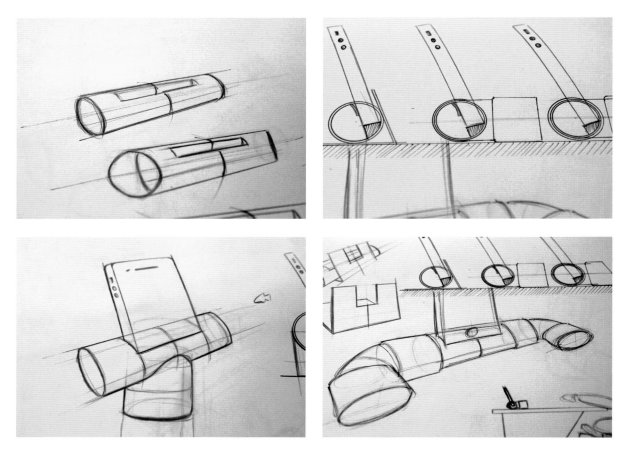

The Recycling Project is a design for iPhone® holders that is made with recycled materials such as cork and PVC tubes. It provides good support for the mobile phone and amplifies sound through the ends of the tubes.

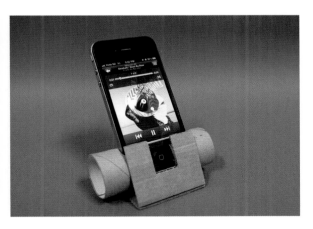

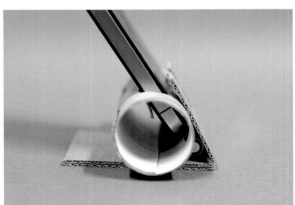

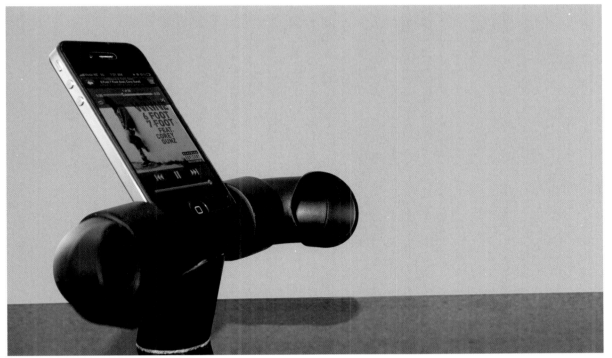

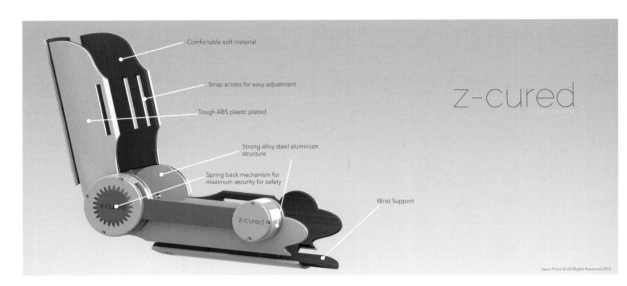

Comfortable soft material

Strap access for easy adjustment

Tough ABS plastic plated

Strong alloy steel aluminium structure

Spring back mechanism for maximum security for safety

Wrist Support

z-cured

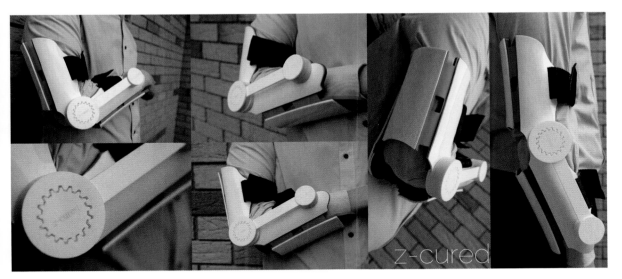

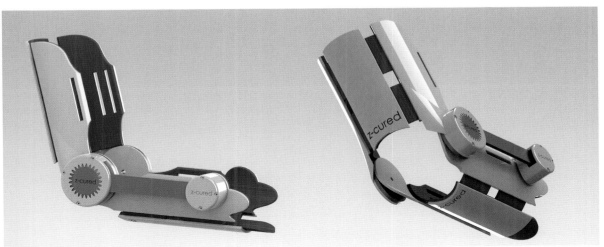

The Z-Cured is an alternative to the traditional sling, eliminating the need for straps around the neck and allowing the angle to be adjusted. The exterior is made of ABS plastic and the interior of a soft, breathable material. It is light, flexible, and strong.

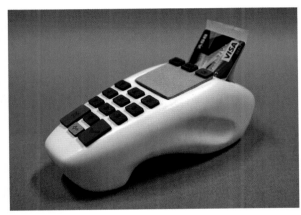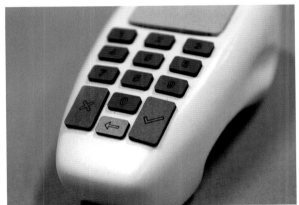

The Incremental Design dataphone aims to improve the software development process. The casing makes the interaction between software and user easier.

RKS

Thousand Oaks, CA, USA
www.rksdesign.com

The large team that forms the RKS studio, established in 1980, follows what it calls the "Psycho-Aesthetics®" method to design its products. RKS is responsible for developing strategies and creating brand images for clients and, at the same time, for discovering users' needs in order to meet them with innovative products that make day-to-day life easier. Clients include Unilever, PepsiCo, LG, and Medtronic.

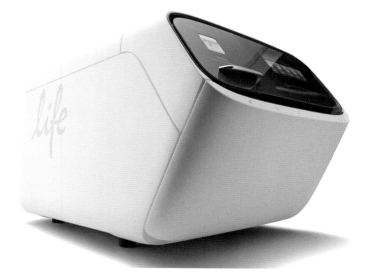

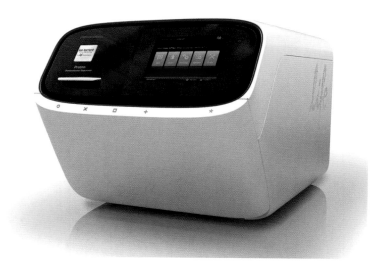

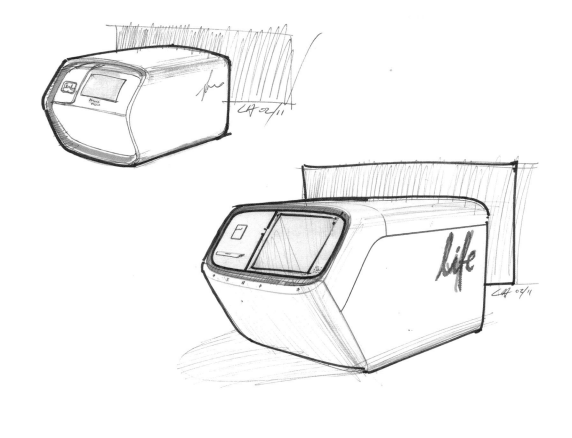

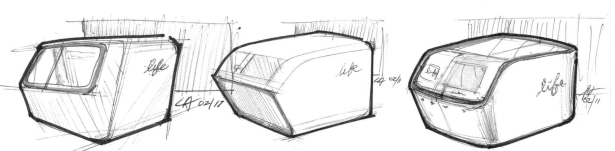

The Ion Proton™ is a DNA sequencer that analyzes human, animal, and vegetable genomes in a matter of hours. At a relatively affordable price—$1,000—this device makes the study of genetics and hereditary diseases much more widely accessible.

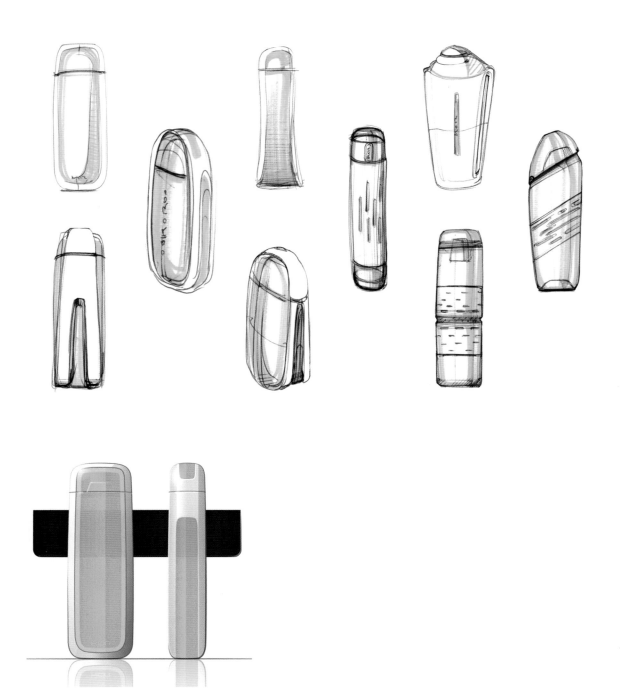

The Kor One is a water bottle designed to reduce the use of polluting plastic. The reusable bottle is opened by lifting a cap; the walls look like glass, providing a clear view of the water.

 GW Global Water Crisis

 WP Watershed Protection

 OP Ocean Protection

 CR Container Recycling

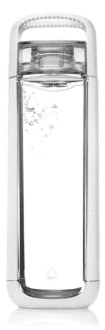 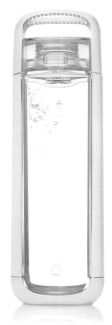 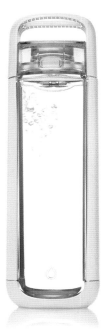 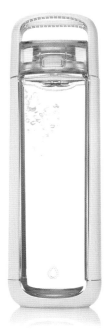

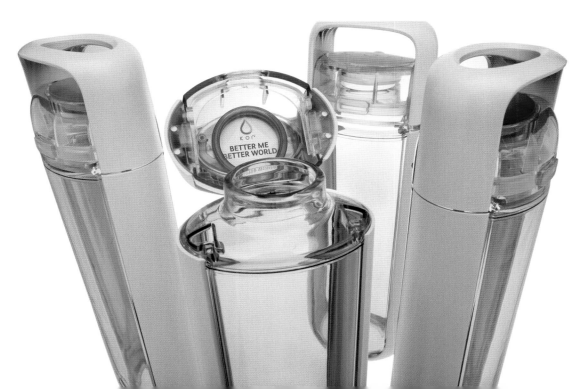

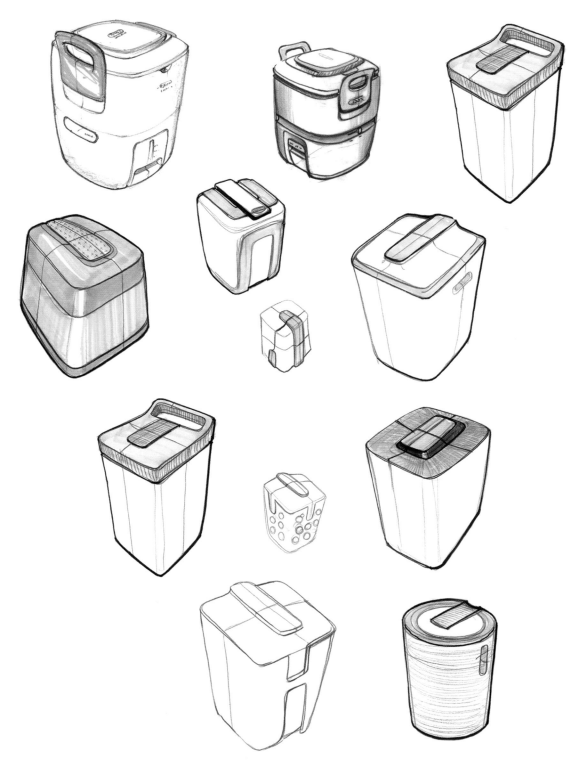

The Laundry Pod is a small portable washing machine for washing delicate items of clothing. It saves energy while treating your delicates more gently than a conventional washer.

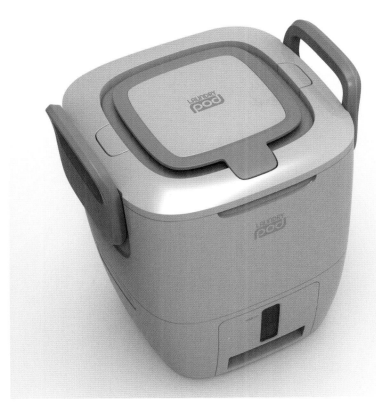

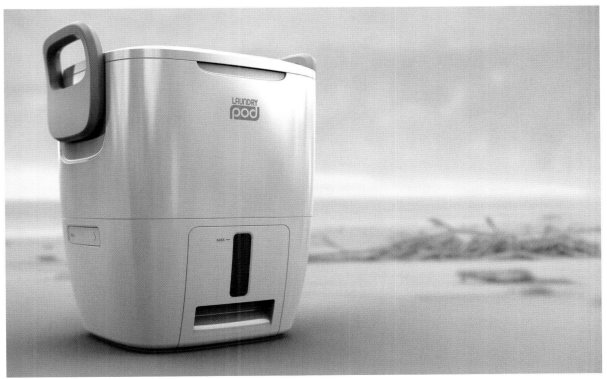

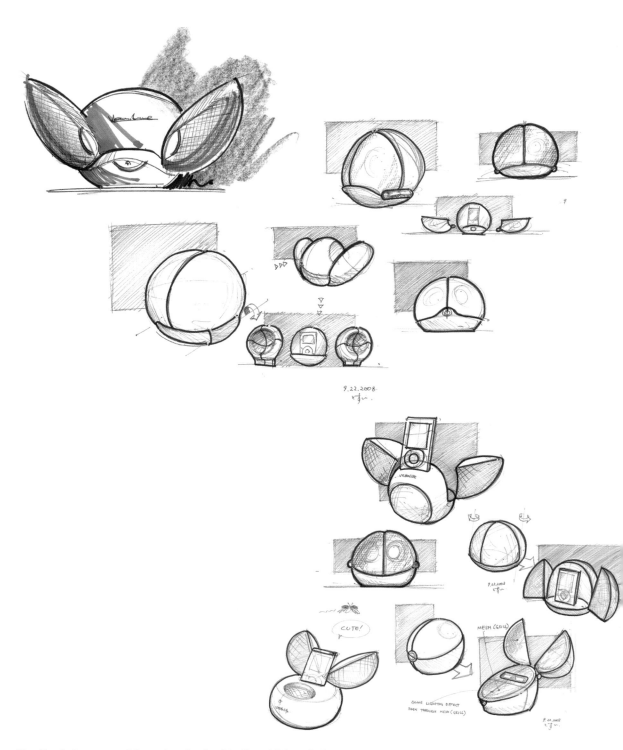

The Firefly is a powerful speaker for the iPod® and iPhone®. Its organic lines give it a unique character, and its folding wings hide a powerful digital amplifier and touch-sensitive controls.

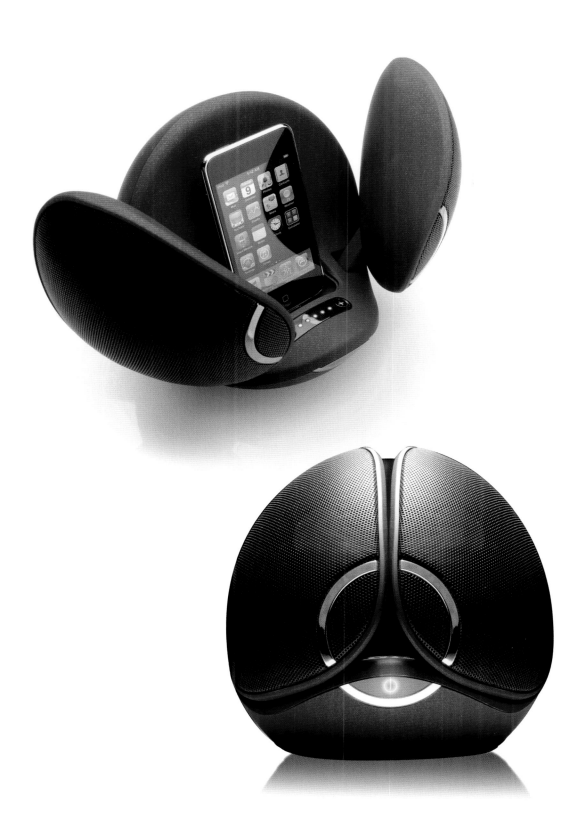

RYAN FRANK STUDIO

London, UK
Barcelona, Spain
www.ryanfrank.net

Born in South Africa, Ryan Frank is a furniture designer with offices in London and Barcelona. He is known for his modern crafted creations and has become one of the greatest European ecological designers. His designs are distinctive, and his use of unusual materials has won several prizes, including the Green Dot Award in 2008, the Most Sustainable Product in 2007, and the Most Environmentally Conscious Company in 2009 at the Hidden Arts Annual Awards ceremony.

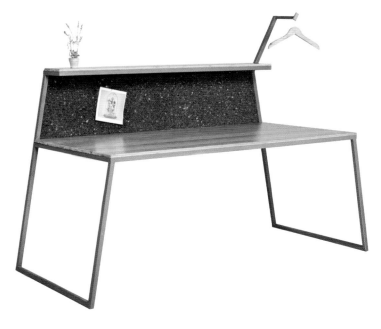

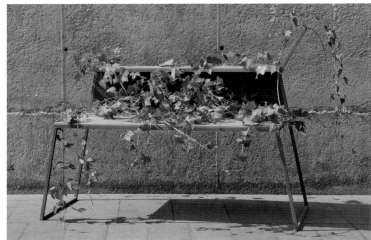

The Glitch is a furniture collection that includes a desk and bookcase made with renewable materials such as bamboo and cork. Both the bureau and the sideboard have space-maximizing side hangers.

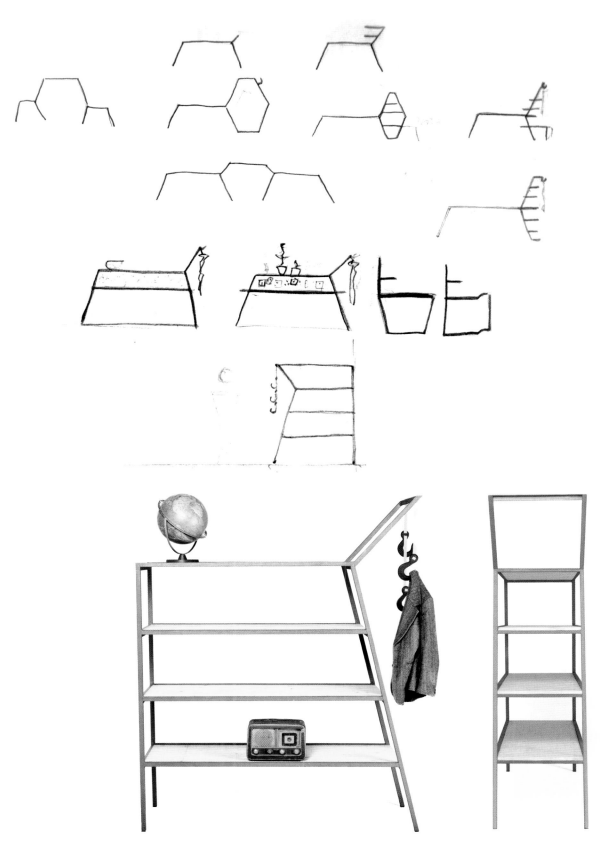

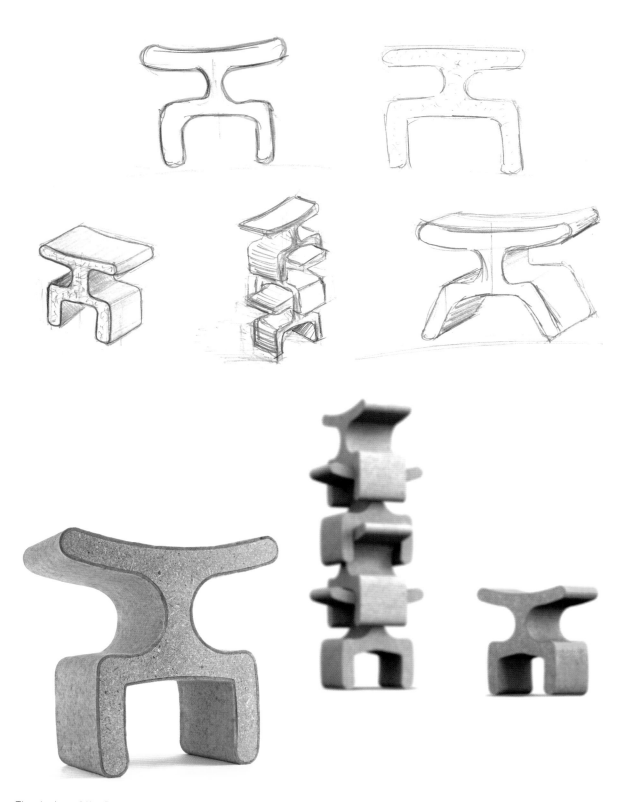

The design of the Isabella & Enzo stools was inspired by Native American totem poles. Isabella is made of felt-lined chipboard, while Enzo is made with Scandinavian spruce.

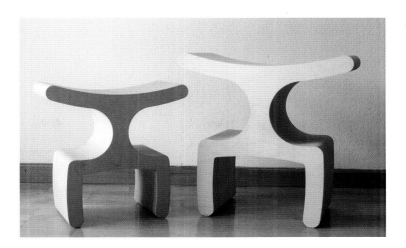

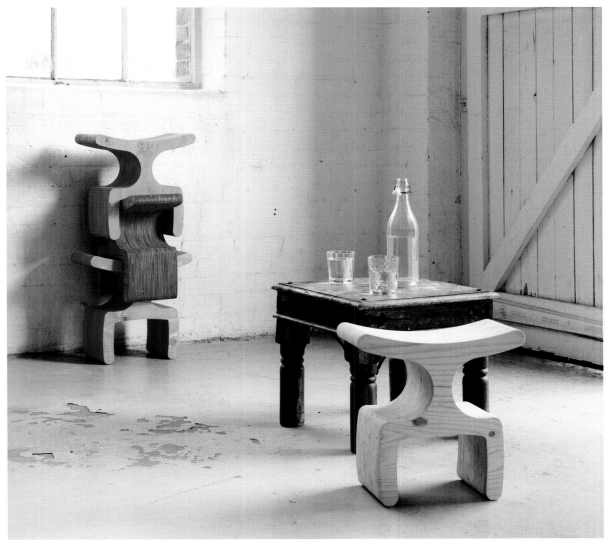

The sustainability of their production system, the variety of colors available, and stackability are all remarkable.

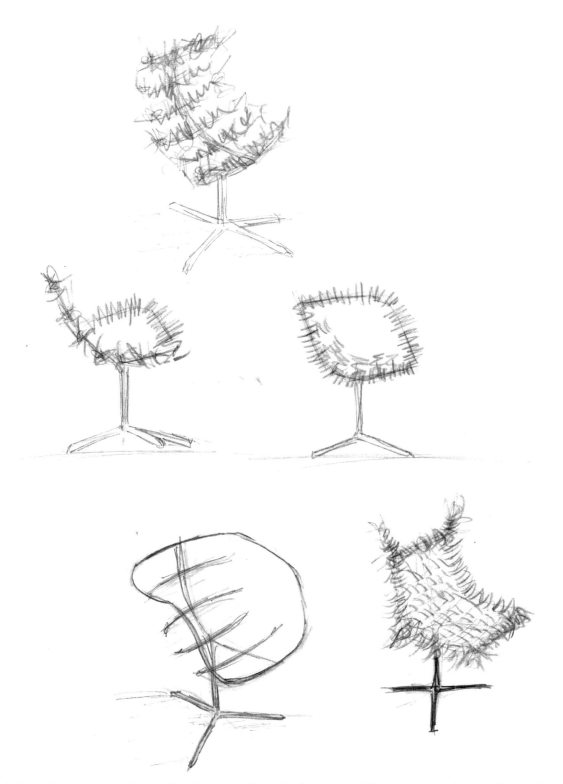

The design of the Inkuku was inspired by chickens, reflected by the texture of its original structure and its upholstery, which is made of recycled materials such as used shopping bags and surplus fabric.

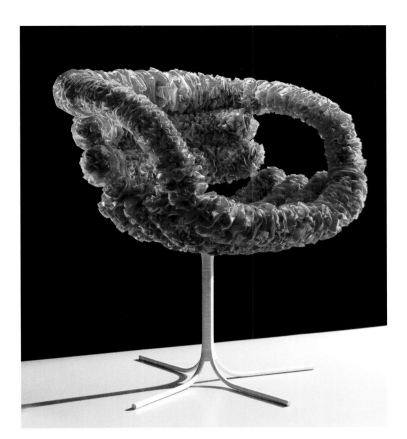

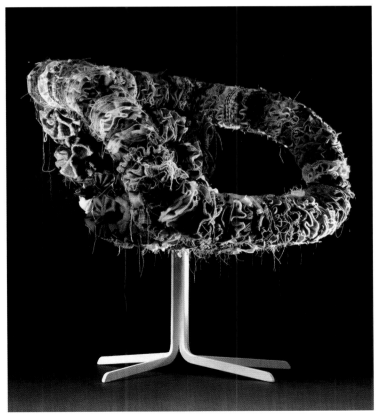

VINCENT SÄLL

Lulea, Sweden
www.vincentsall.com

Vincent Säll is still studying industrial design, but his portfolio indicates a talent for planning and sketching and paying attention to forms and detail. Säll's professional training is evolving from his artistic experience and is being made complete by his academic learning. Music, photography, and painting, he says, are those beautiful corners from which you can see everything.

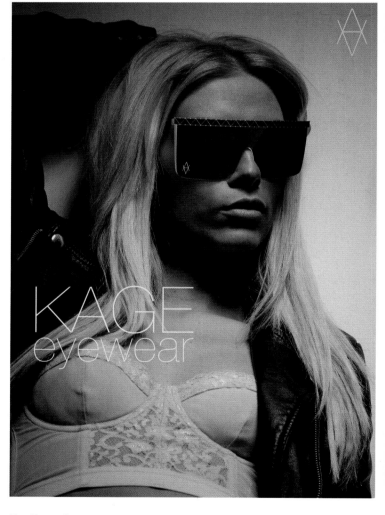

The Kage glasses cover so much of the face that people have to guess what lies beneath. With an original and exaggerated design, the Kage is protective and at the same time provides an air of mystery.

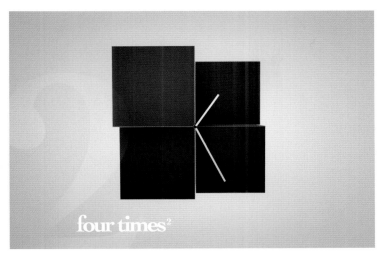

four times²

The Four Times is a concept for a watch made of four square modules of various sizes and thicknesses. Each module is a quarter of the watch, and the differences in thickness symbolize the passing of time, the first being the most slender and the last the thickest.

simplified

center axis

golden section

simplified

big city top view

symmetric formation

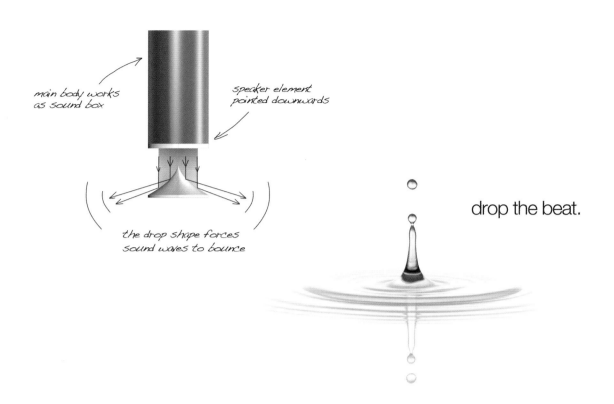

main body works as sound box

speaker element pointed downwards

the drop shape forces sound waves to bounce

drop the beat.

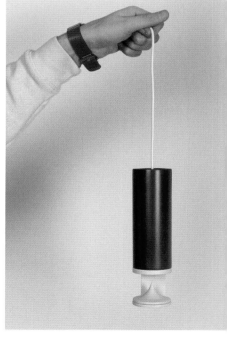

The wireless Drop the Beat speaker was inspired by the ripples that form when a stone falls into water. It is designed for use with Apple products.

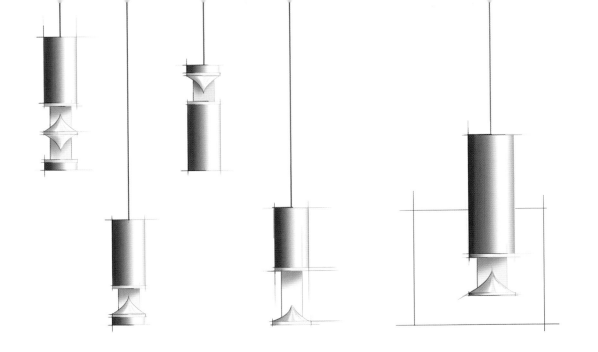

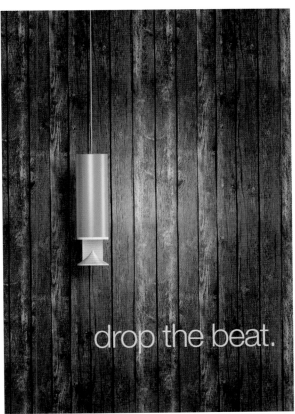

drop the beat.

As shown in the renderings, the speakers are cylindrical with a cone at the end that directs the sound around its own axis. The device has a rechargeable battery.

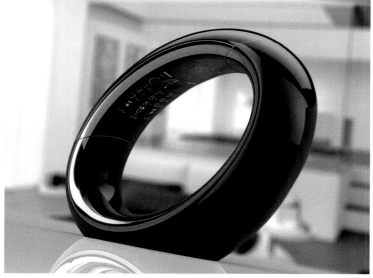

SEBASTIEN SAUVAGE

Hong Kong, China
www.coroflot.com/sebsauv

Born in Brest, France, industrial designer Sebastien Sauvage was raised in Paris and now lives in Hong Kong. He specializes in product design, having completed a master's degree at the Birmingham Institute of Art and Design in England. He uses the complex combination of cultures that he is acquainted with to create innovative products and take on new challenges. He has designed for multinationals such as Electrolux, Motorola, and Bosch, and has received awards and appeared in international publications.

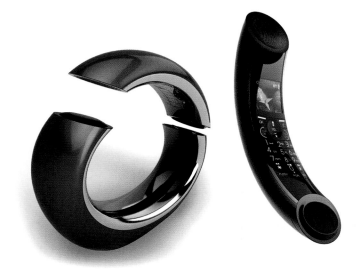

The Eclipse is a cordless telephone with a base station. Both parts have the same elliptical shape, so when fitted together they form a perfect circle. With a backlit keyboard and a high-shine finish, this telephone is elegant, modern, and timeless.

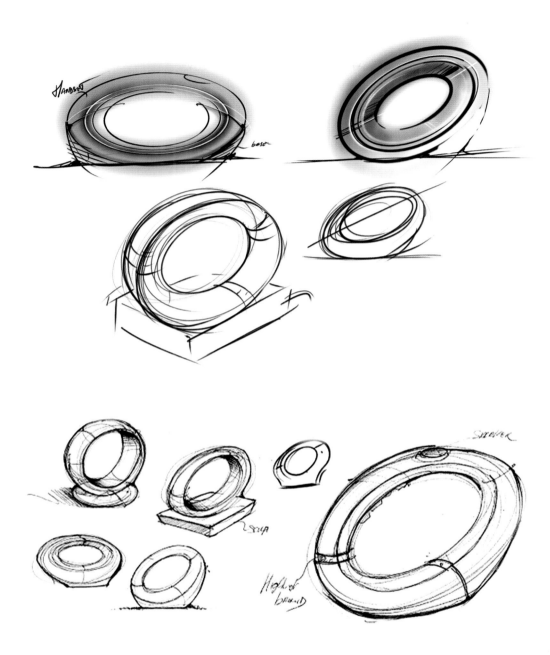

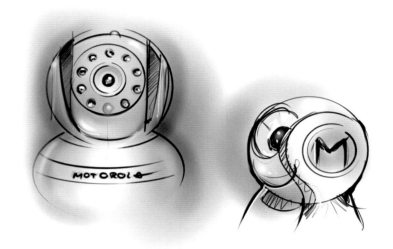

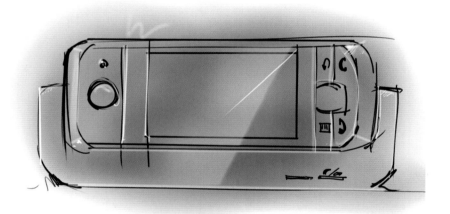

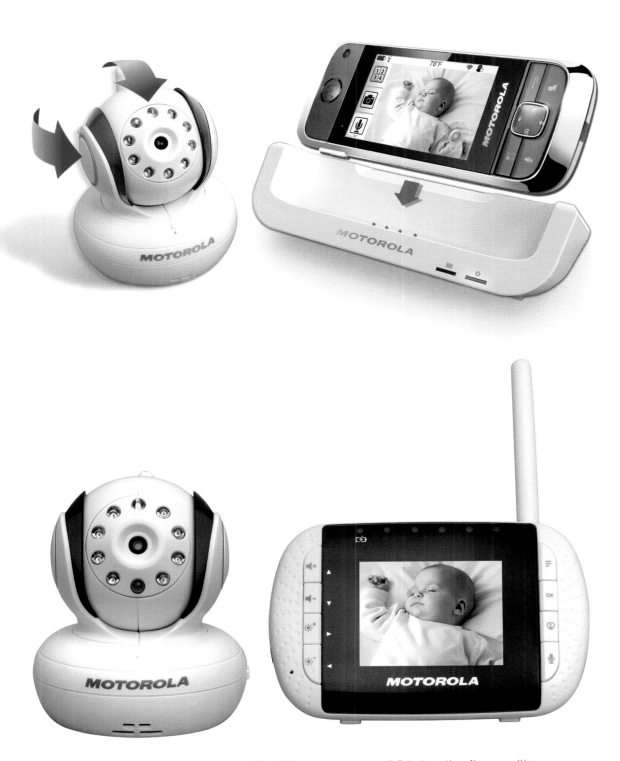

The MBP36 is an audio and video baby monitor. The LCD screen measures 3.5 inches, the ultra-sensitive microphone transmits all of the little one's movements and grunts, and the infrared camera works in the dark. It functions from a distance of 656 feet (200 meters).

SENZ° UMBRELLAS

Delft, The Netherlands
www.senzumbrellas.com

Gerwin Hoogendoorn, Gerard Kool, and Philip Hess could not have imagined how far they would go with the production and launch of their first prototype, a concept that Hoogendoorn devised for his final degree project. When the new product, the Senz° Storm Umbrella, was launched in the international press, sales rocketed, reaching ten thousand in just ten days. The studio won the Red Dot Award in 2007 and the iF Award in 2009.

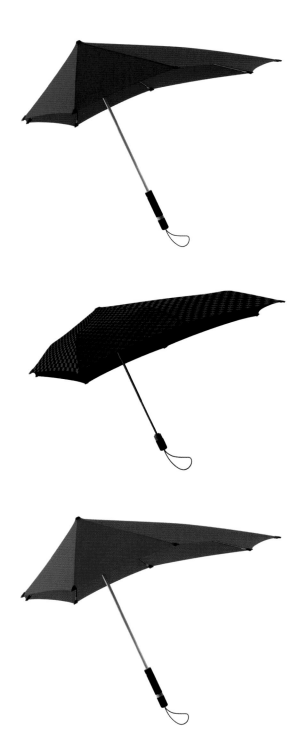

The Senz° is an aerodynamically designed umbrella that can withstand winds of up to 62 miles (100 kilometers) per hour without turning inside out or breaking. Thanks to its innovative frame, the umbrella moves against the force that is pushing it instead of being defeated by the pressure.

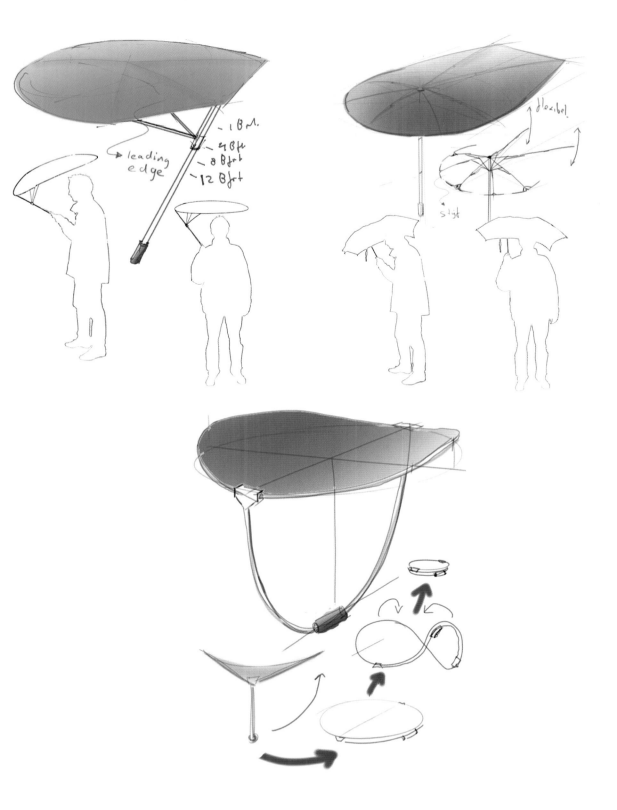

leading edge

- 1 Bft.
- 4 Bft
- 8 Bft
- 12 Bft

flexibel

stijf

MIKE SERAFIN

Downers Grove, IL, USA
www.memikeserafin.com

After spending his childhood assembling and taking apart toys and other gadgets, Mike Serafin decided to use his talent to transform objects into something useful and productive. He earned a degree in industrial design and is currently combining his work for the Vessel branding and packaging agency with his personal projects. Serafin has designed for companies such as SRAM/Rock Shox, Wave Sport Kayaks, and *Bike* magazine, among others.

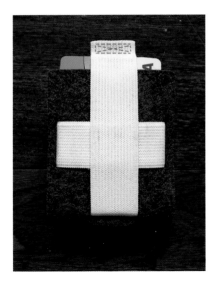

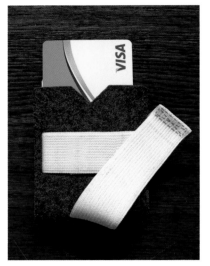

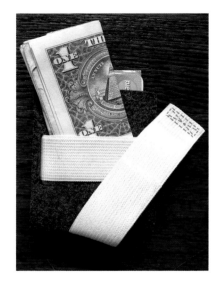

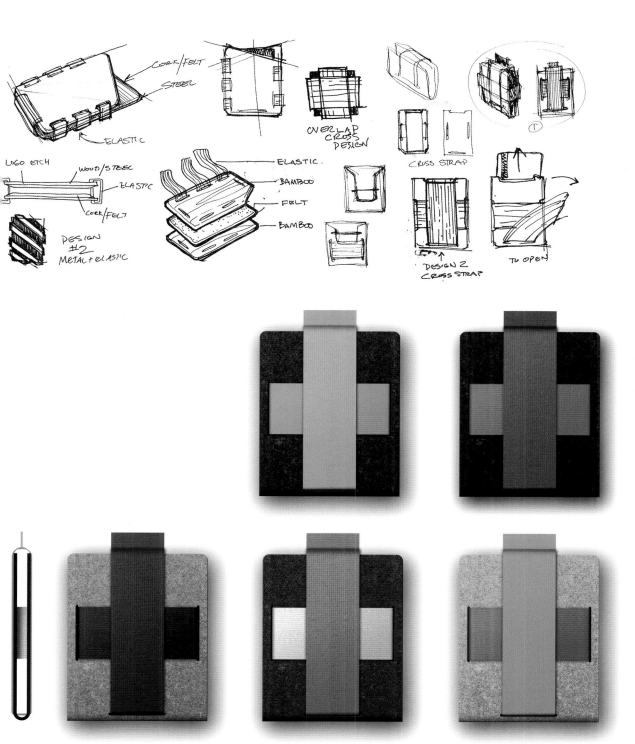

The Woolet is a simple minimalist wallet that allows the user to keep everything well organized.

The Bent consists of two stainless steel soap dishes with original structures that are minimalist, sturdy, and practical.

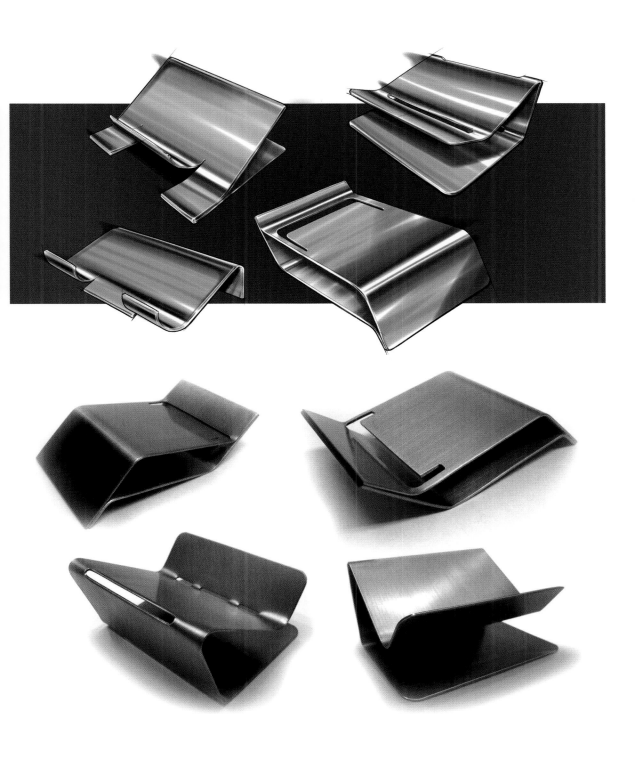

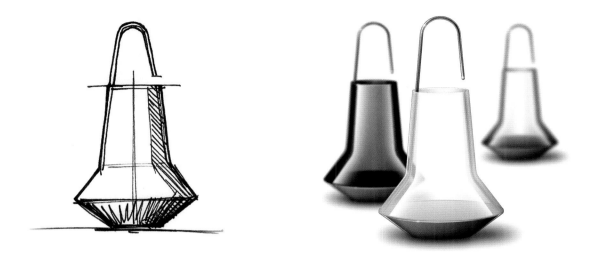

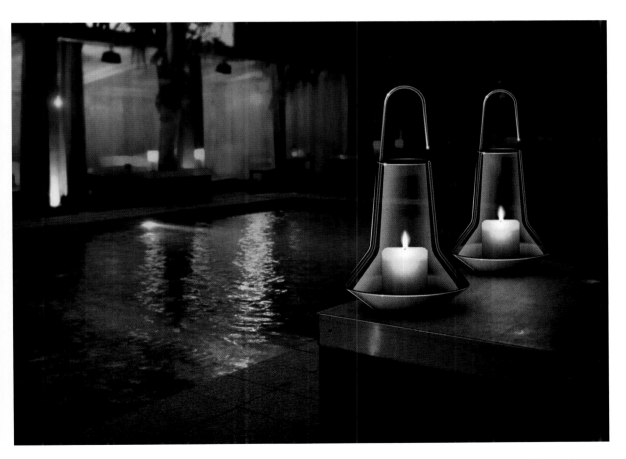

The Hurricane Lanterns lamp is specially designed for extreme situations in which electricity is unavailable, such as hurricanes or earthquakes. The candle is protected from the wind by the walls of the lantern, which can be hung up.

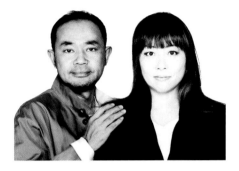

SETSU & SHINOBU ITO DESIGN STUDIO

Milan, Italy
www.studioito.com

Mixing Eastern and Western traditions, the Setsu & Shinobu Ito Design Studio benefits from its creators' experience in different fields of design. Born from the Itos' marriage, the studio's mission is to explore the interaction between humans, products, and their surroundings; their designs are based on the observation of behavior. Setsu and Shinobu's projects have curvilinear and unlimited forms, creating a visual connection with the object and adding all-around value.

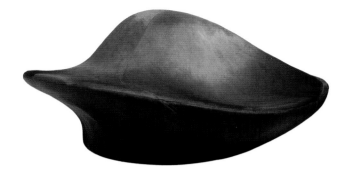

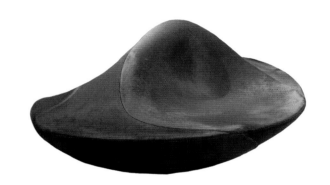

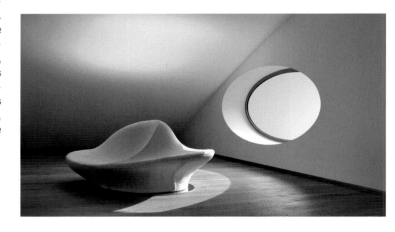

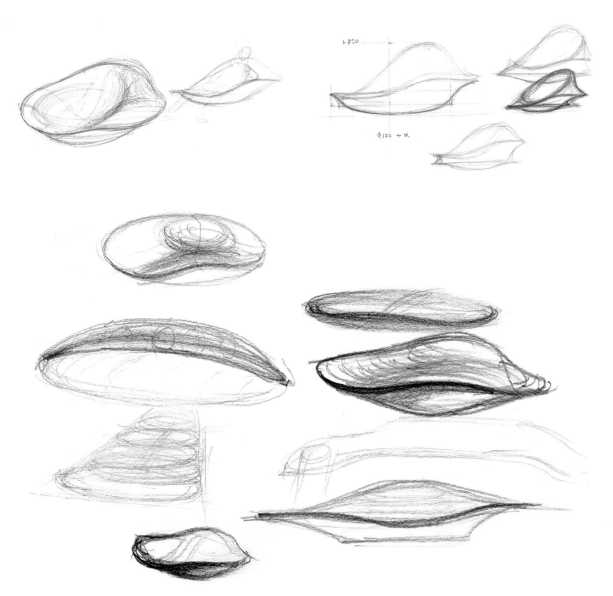

The Fuller, designed for Sawaya & Moroni, is a sculptural sofa that provides seating on all of its surfaces. Placed in the center of a room, this object becomes a source of natural energy.

lounge

7600

160

420
|
430

The Swa Cell is an outdoor chair in a wooden frame, with an awning that can be lowered to provide privacy and tranquility. It was designed for Fornasarig.

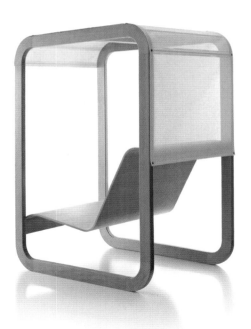

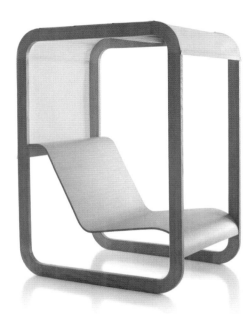

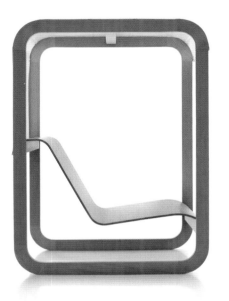

大きいひだ

PASSANI panaceite

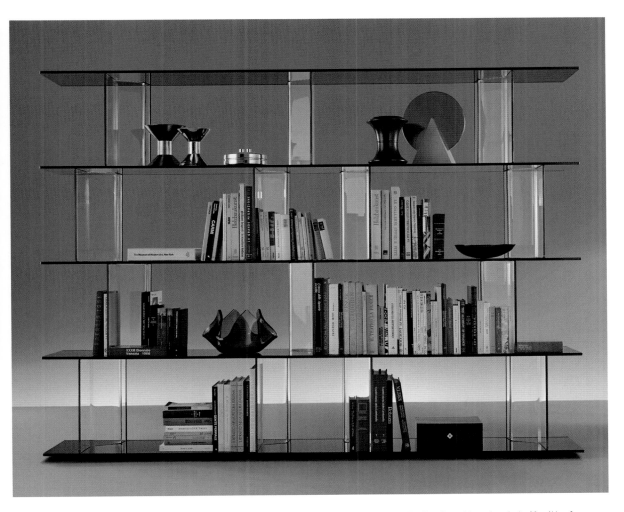

Inspired by the vertical *inori* Japanese prayer position and designed for FIAM Italia, Inori is a bookshelf with glass cubicles for storing treasured possessions. The multifunctional shelves can be freely arranged.

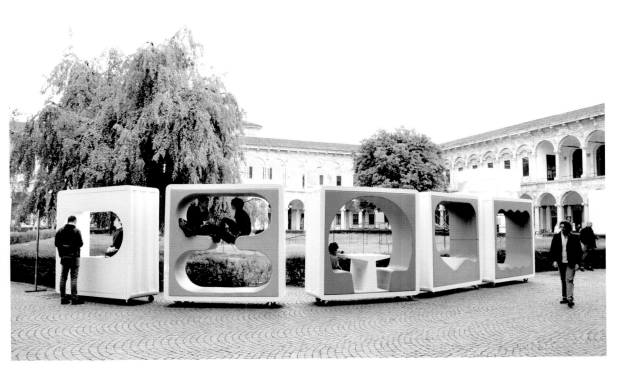

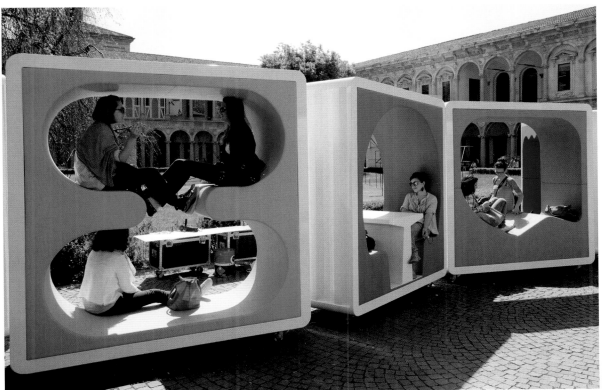

Lib(e)ro is a set of urban modular space separators that incorporate different functions. Made from discarded shipping containers, this system can be used to create independent microenvironments.

AVIHAI SHURIN

Lehavim, Israel
www.avihaishurin.com

The studio founded by the young Avihai Shurin specializes in designing original, fun, and surprising products for everyday use. He believes in spontaneity and wants to extract smiles from the least expected moments. The company also offers consultancy services, product assistance, and idea and creative product development. In 2011, the studio took part in the "The TOY" exhibition in Tel Aviv, Israel.

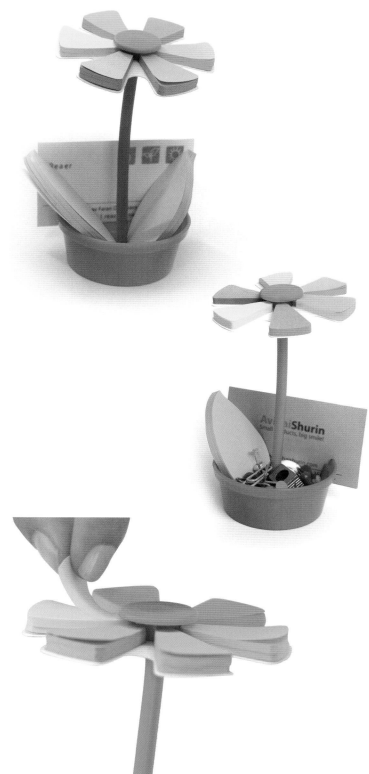

The Desk Flower is a flower-shaped sticky note pad. The design can incorporate pieces of paper of various sizes and colors, making it ideal for marketing. It also includes a pencil holder.

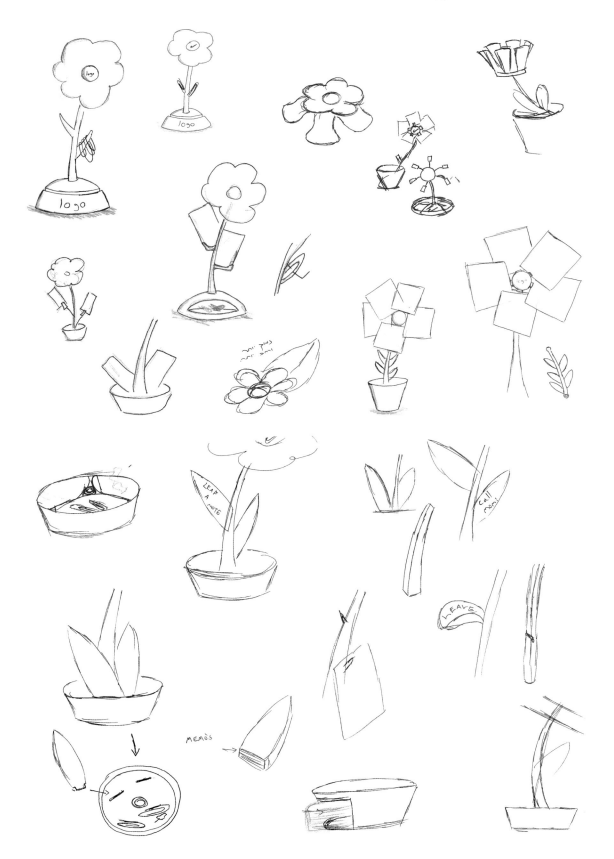

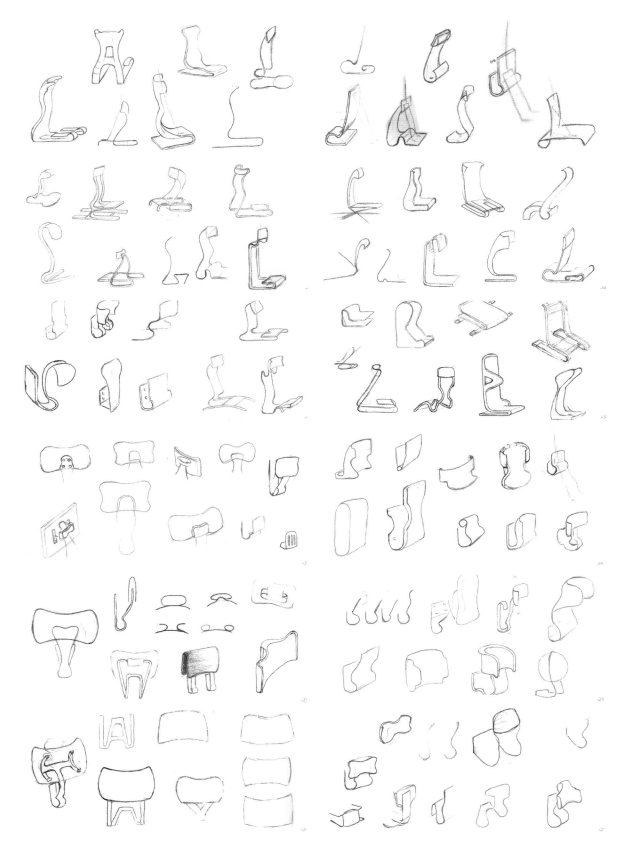

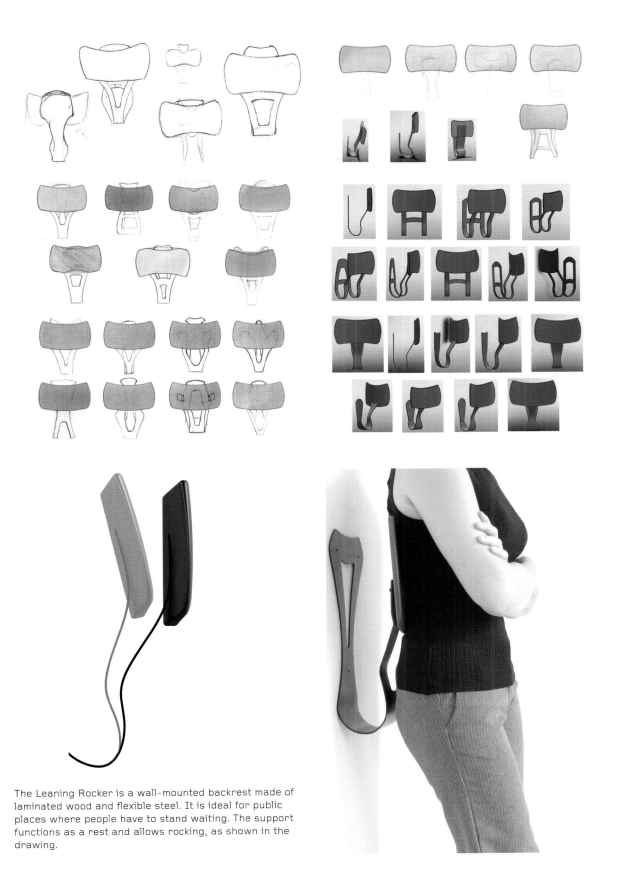

The Leaning Rocker is a wall-mounted backrest made of laminated wood and flexible steel. It is ideal for public places where people have to stand waiting. The support functions as a rest and allows rocking, as shown in the drawing.

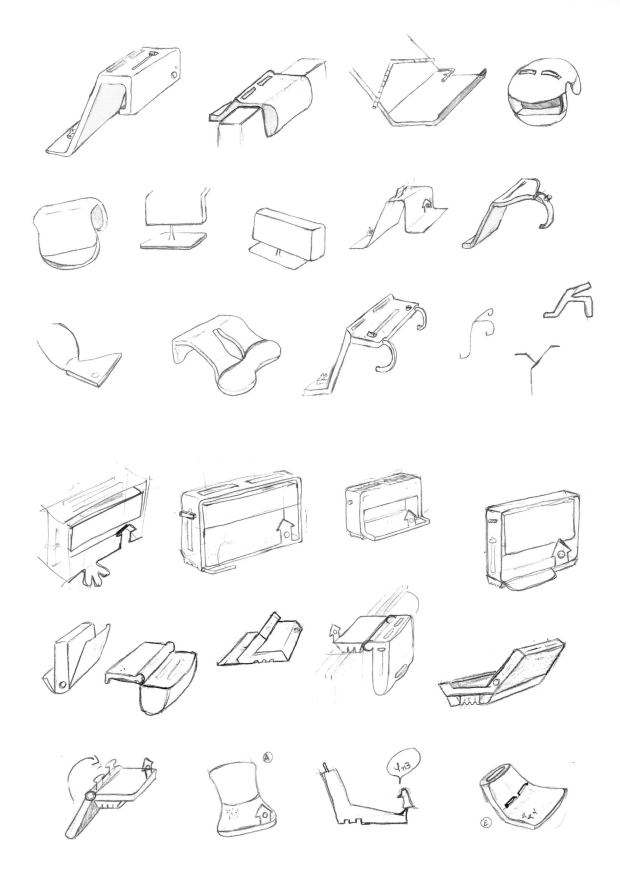

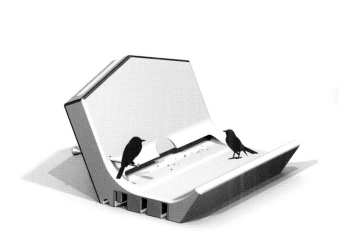

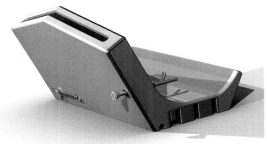

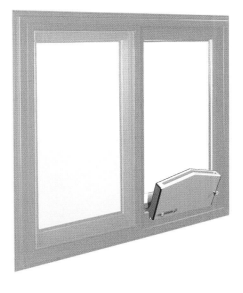

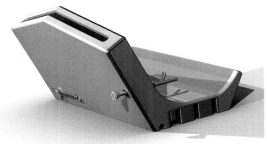

1. start:
 pull the button
 bread goes down

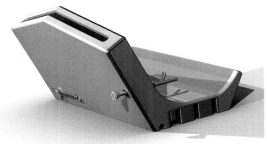

2. toasting bread..........

3. ready!!!
 toast pop up.
 crumbs pop down...

HOW IT WORKS

The Me & You Toaster is a toaster with a bird feeder. Placed on the windowsill, the inside part serves as the toaster, while on the other side, the crumbs are freely available to birds.

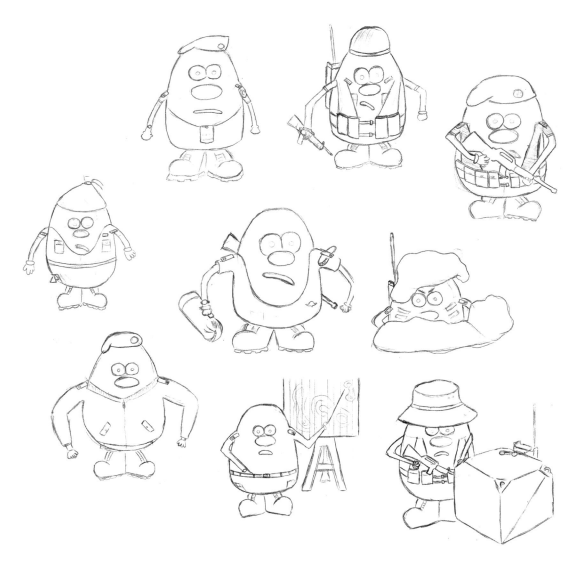

Mr. Potato Head in the Army reinterprets the original toy by dressing the character in military clothing. With the collaboration of Objet Geometries, the studio designed this toy to raise awareness about child soldiers.

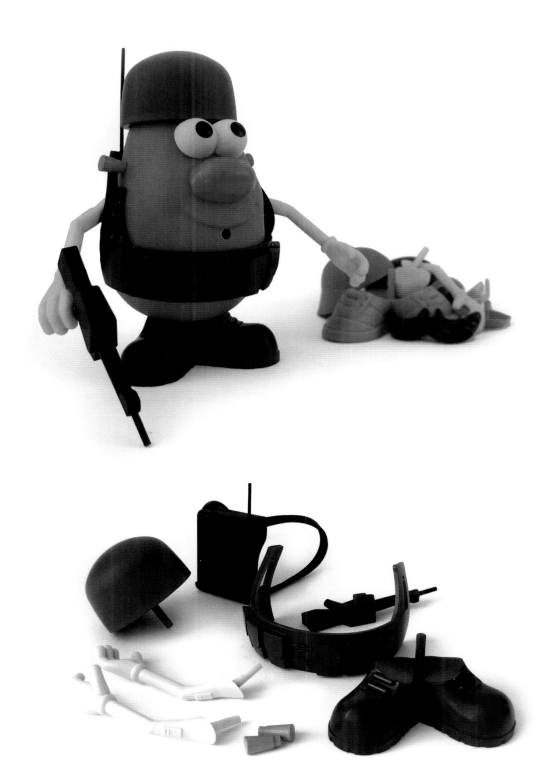

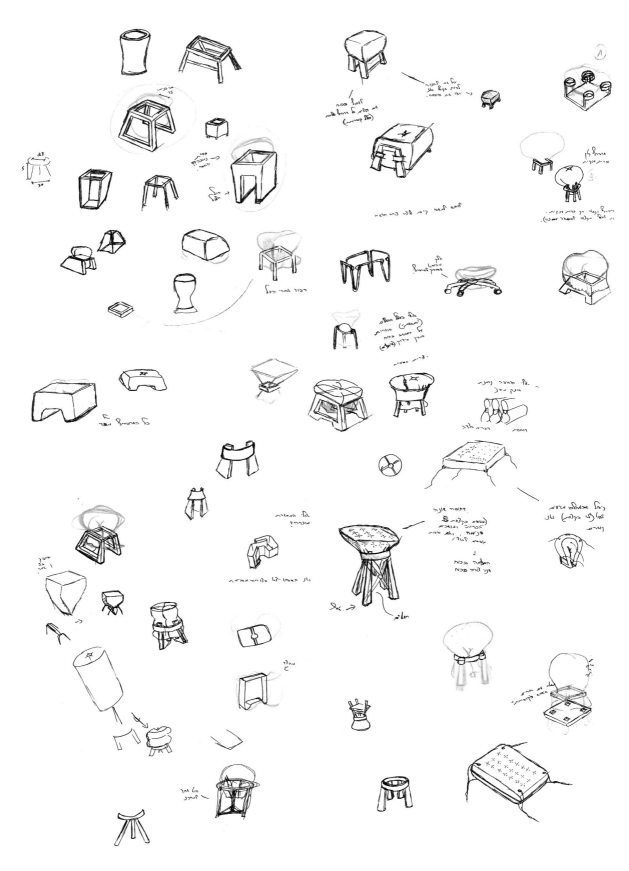

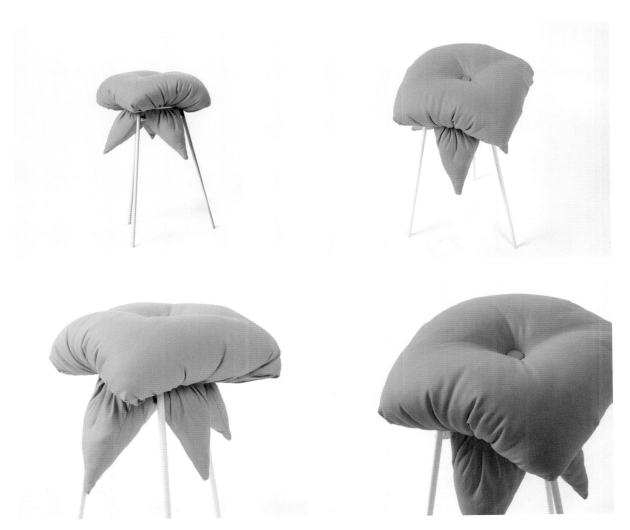

The Too Tight Stool was inspired by the story of Cinderella. The cushion is inserted in the center of the structure and is pushed down, giving the impression that it does not fit.

SIESTA STUDIO

Warsaw, Poland
www.siestastudio.com

Zuzanna Malinowska and Marcin Wroń-
ski form an interesting team. She stud-
ied design in Warsaw while he studied
political science in the same city. Mal-
inowska founded her own studio after
collaborating with other companies,
and Wroński decided to join her after a
stint working in public relations. Siesta
Studio is the fusion of two very differ-
ent but equally creative minds and pur-
sues a minimalist aesthetic because
the designers believe that "the more
you have, the more limited you are."

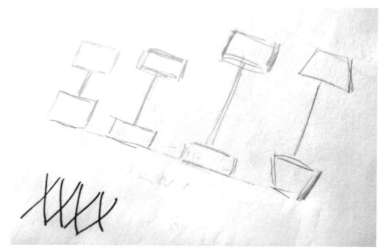

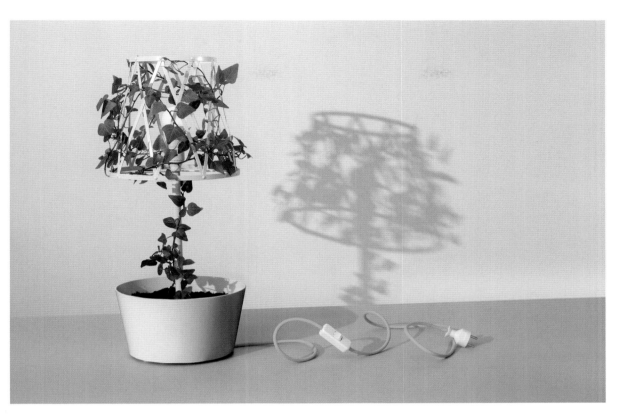

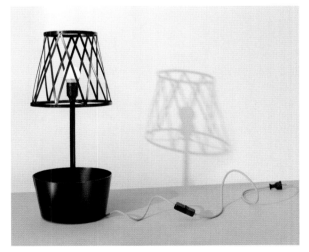

The Green Lamp has an interesting metal structure that acts as a support for the plant that grows from the base, which is also a plant pot. The play of light and shadows evolves as the plant grows.

SNAPP DESIGN

Edenvale, South Africa
www.snappdesign.com

Jonathan Fundudis and Renko Nie-
man decided to establish Snapp De-
sign with the goal of making subtle
changes to human culture by creating
simple and efficient products. Time-
less design is important and can evoke
emotions that contribute to a sense of
well-being. The team has been nomi-
nated for the German Design Award
2013 and won the Good Design Award
in 2011.

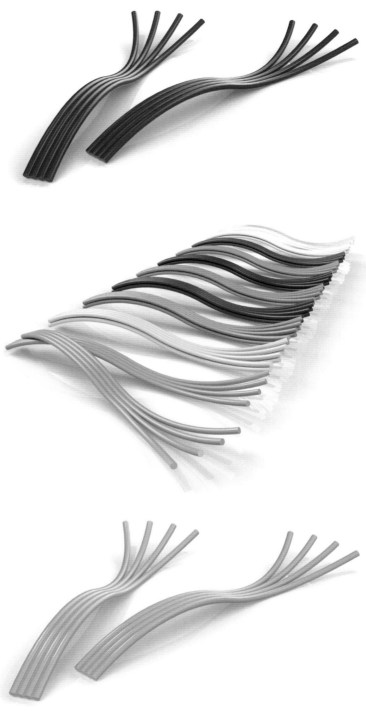

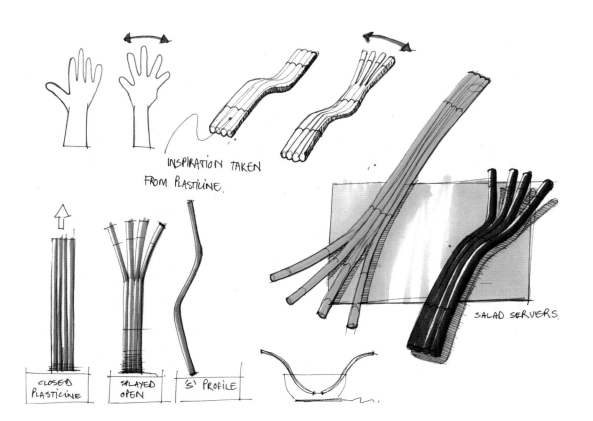

INSPIRATION TAKEN FROM PLASTICINE.

SALAD SERVERS.

CLOSED PLASTICINE

SPLAYED OPEN

'S' PROFILE

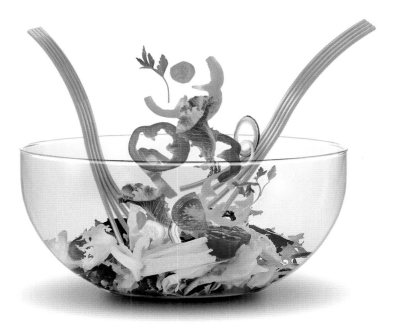

The Splay Salad Server is made of a flexible material similar to plastic. The gently curved fingers at the end form a fork.

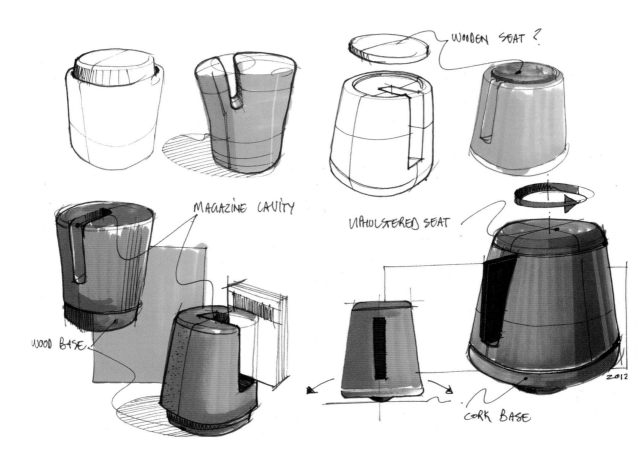

WOODEN SEAT ?

UPHOLSTERED SEAT

MAGAZINE CAVITY

WOOD BASE

CORK BASE

2012

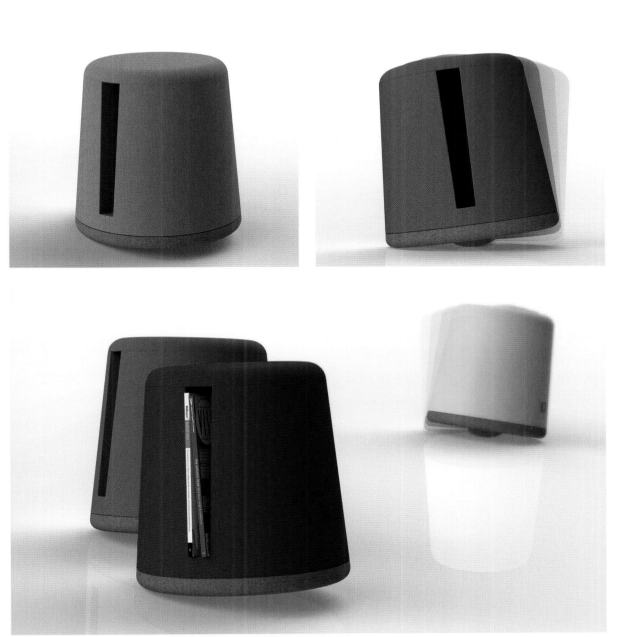

The fiberglass Orbit stool was inspired by a spinning top. The cork base cushions the weight of the person on the stool and allows rotation on the same axis. The side slot can be used to hold magazines.

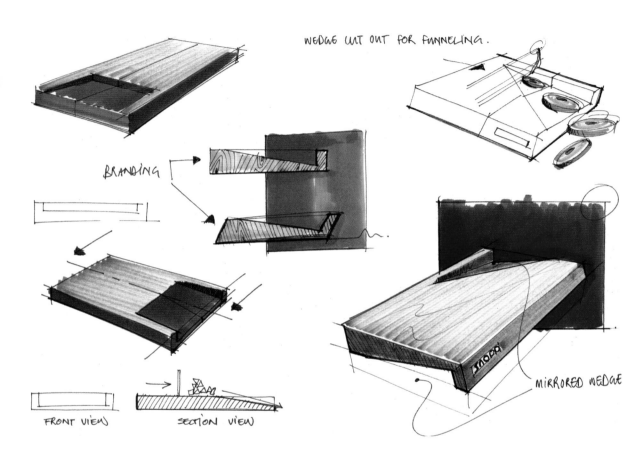

WEDGE CUT OUT FOR FUNNELING.

BRANDING

FRONT VIEW

SECTION VIEW

MIRRORED WEDGE

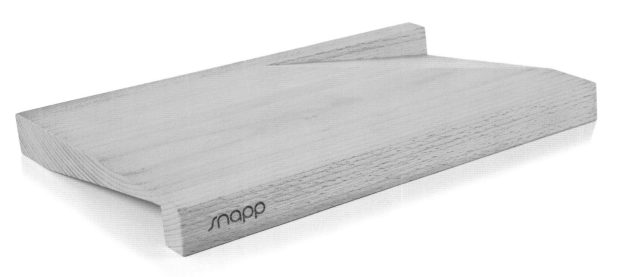

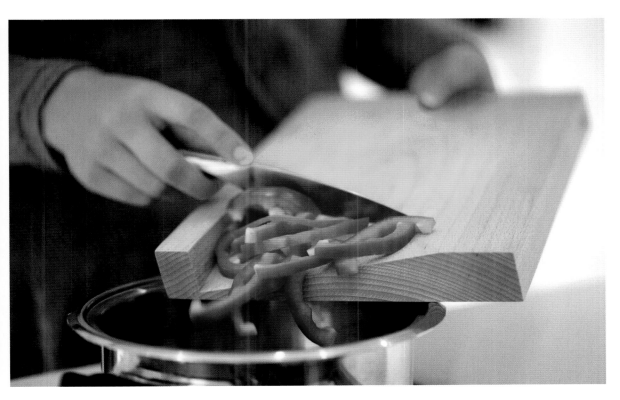

The wooden Slice Cutting Board, with wedge-shaped gaps at each end, makes it easier to transfer the food after it has been cut.

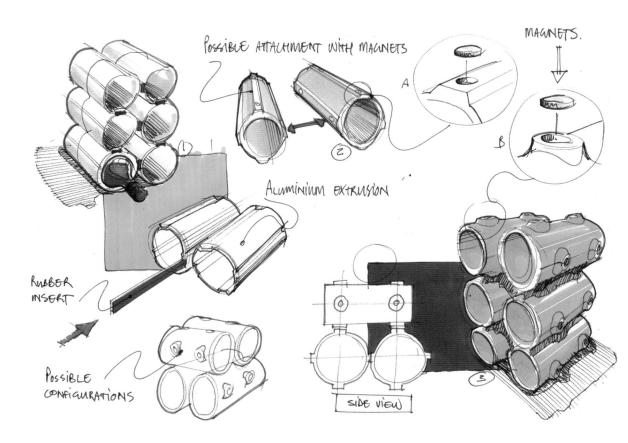

POSSIBLE ATTACHMENT WITH MAGNETS

MAGNETS.

A

B

ALUMINIUM EXTRUSION

RUBBER INSERT

POSSIBLE CONFIGURATIONS

SIDE VIEW

The Engage Wine Rack Imitates a LEGO set. The individual cylinders can be stacked in multiple ways and, being magnetic, they remain joined and stable.

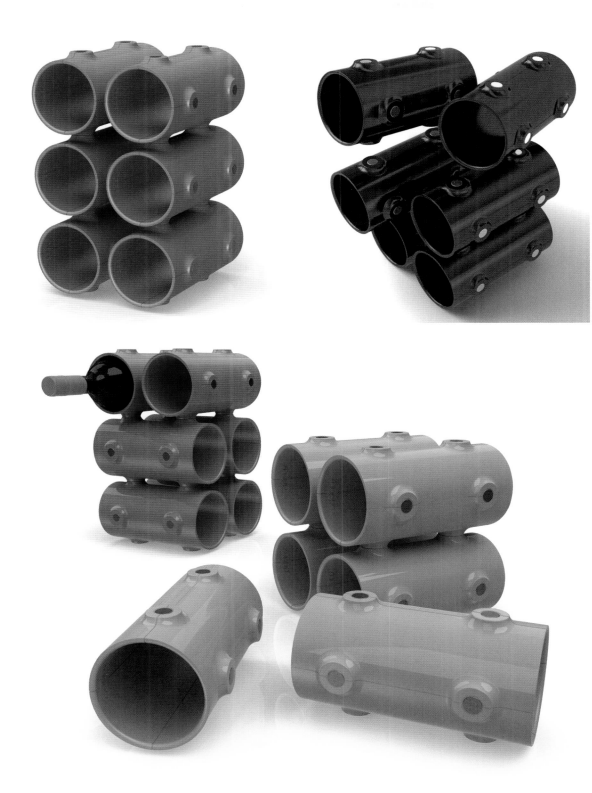

337

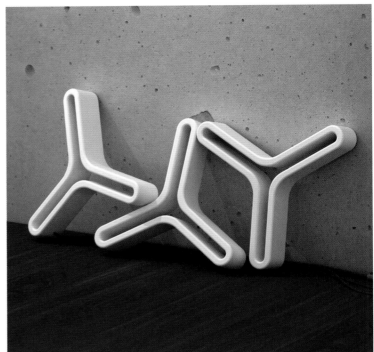

SOLOVYOV DESIGN

Minsk, Belarus
www.solovyovdesign.by

Maria and Igor Solovyov are industrial designers whose objective is to invent useful, evocative, and beautiful products, give them added value, and produce them with the purest craftsmanship. The team designs furniture, lighting, electronics, and accessories and sells its patents to clients in Russia, France, the United States, and China.

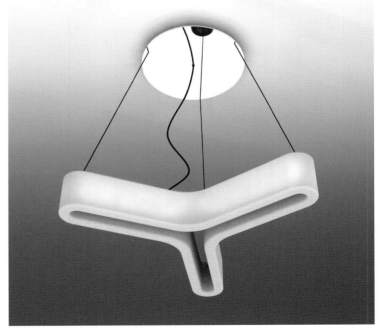

Axis lamps can be used indoors and out. They feature LED bulbs and a semitransparent body.

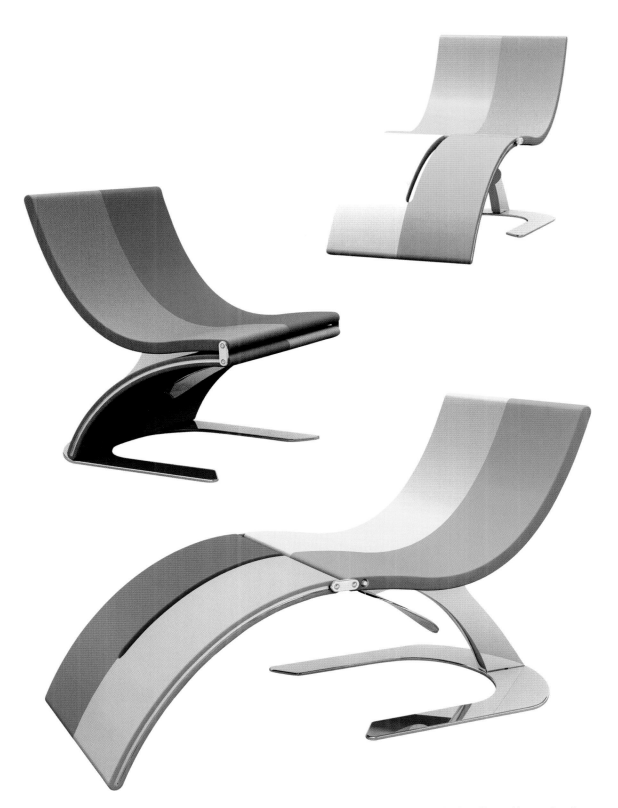

Hypnosis chairs, designed in collaboration with Dzmitry Samal, recline and can be lengthened by moving the lower part, for different modes of use. Their base and lever are metallic and the upholstery is divided into four differently colored parts.

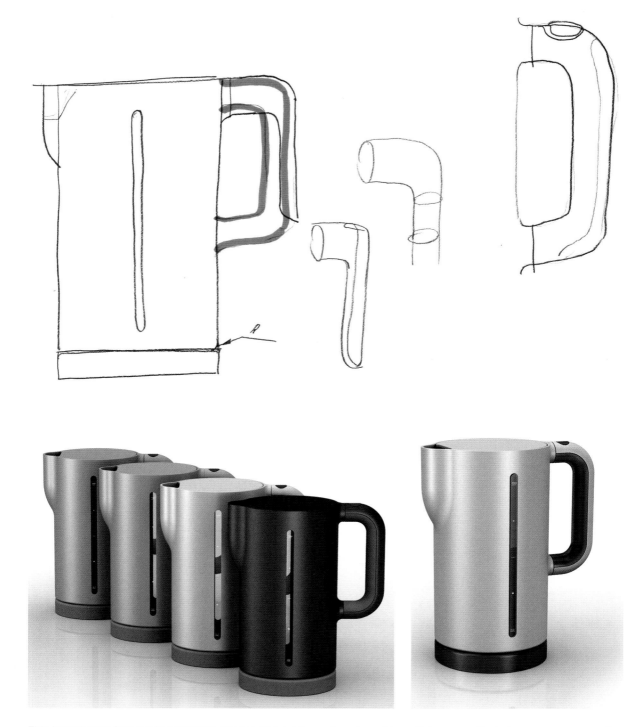

This teapot uses four basic geometric shapes and subtle surface transitions. It has a small window so you can see the liquid inside.

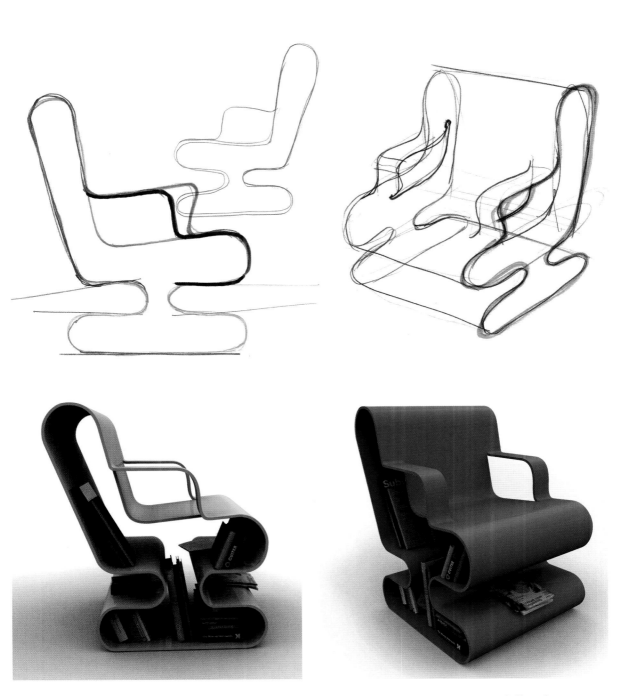

The Ofo chair has a double function. The front area serves as a seat with armrests while its organic lines form a storage space.

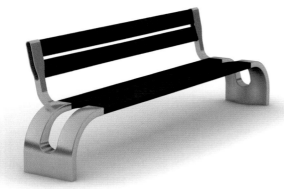
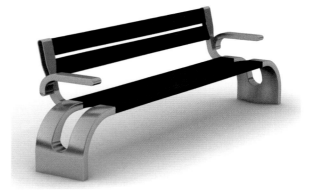

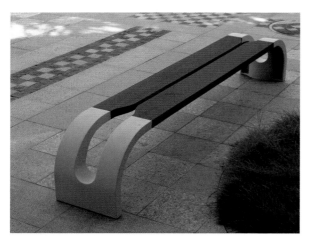

The Melbourne furniture collection, manufactured of cast aluminum and wood, comprises three different designs: a bench with no back or armrests, a bench with a back but no armrests, and a bench with both. It was designed for Simplicity.

Geo is an aluminum and wood line of urban furniture shaped in silhouettes of maps of the United States, Latvia, and Lithuania. They have a perforated surface to prevent water pooling. They were designed for Simplicity.

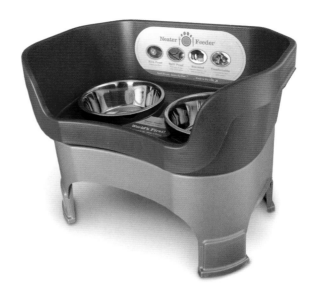

Ontario, Canada
www.sparkinnovations.com

With more than twenty years of experience and 145 U.S. patents, Spark Innovations has become Canada's most prolific design company. Spark Innovations creations range from consumer electronics to medical devices and industrial equipment. The group's mission is to meet the needs of clients and consumers alike.

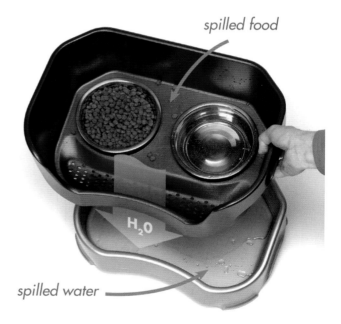

spilled food

spilled water

The Neater Feeder, for pets, keeps the containers of food and water full and separated into two bowls. Water percolates through the holes and does not get the floor dirty.

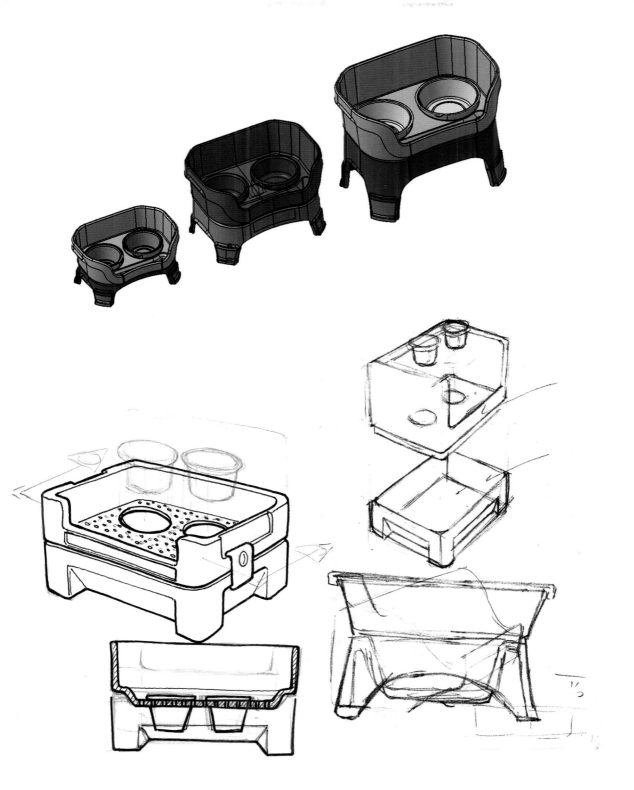

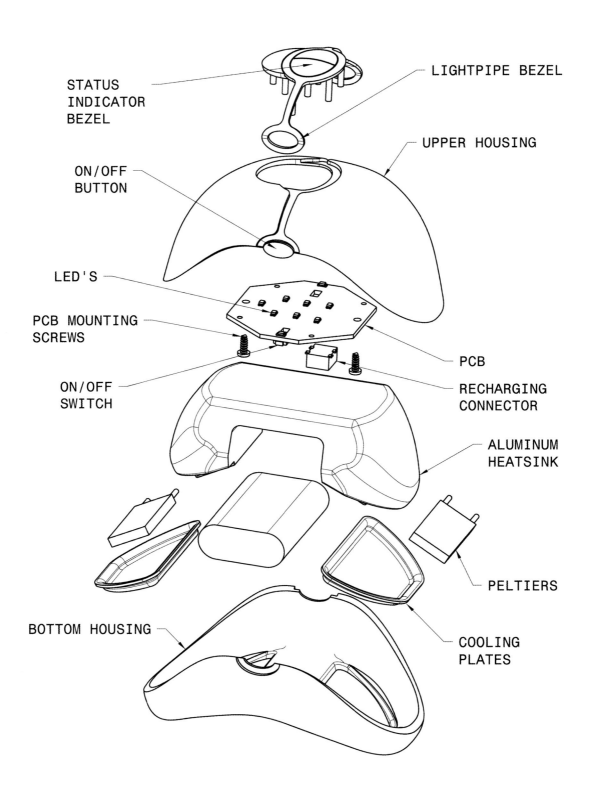

STATUS INDICATOR BEZEL

LIGHTPIPE BEZEL

UPPER HOUSING

ON/OFF BUTTON

LED'S

PCB MOUNTING SCREWS

PCB

ON/OFF SWITCH

RECHARGING CONNECTOR

ALUMINUM HEATSINK

PELTIERS

BOTTOM HOUSING

COOLING PLATES

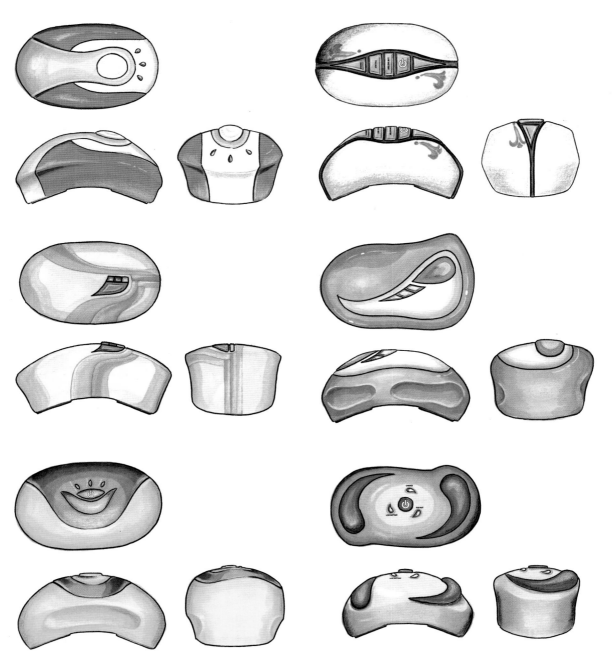

The Meno Pod is designed to control the hot flashes associated with menopause. The product is chilled and applied to the skin of the neck, the forehead, or the wrists.

The Drywall Axe is a multipurpose tool with a utility knife, a tape measure, and a pencil. Adam Pauze had the idea for this after having trouble cutting large sheets of plasterboard.

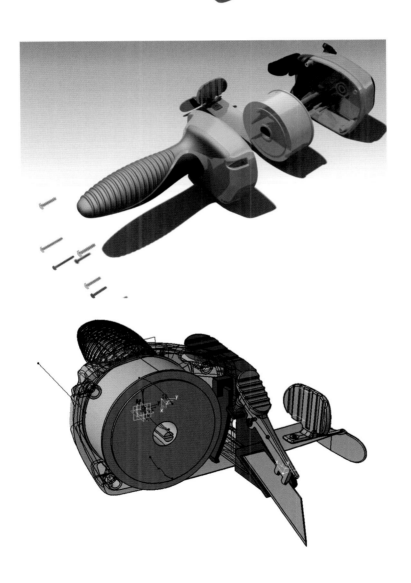

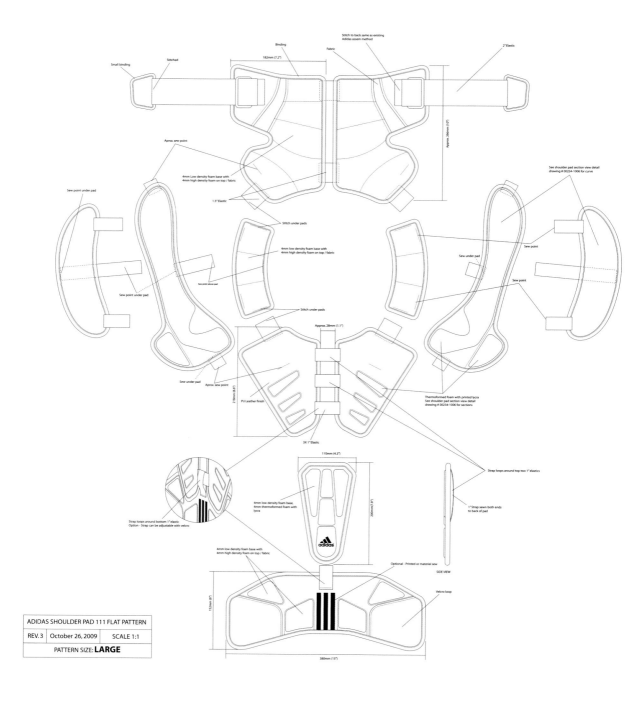

Stitch to back same as existing
Adidas assem method

Binding

Fabric

2" Elastic

182mm (7.2")

Small binding

Stitched

Approx 266mm (10")

Aprox. sew point

See shoulder pad section view detail
drawing # 00234-1006 for curve

Sew point under pad

4mm Low density foam base with
4mm high density foam on top / fabric

1.3" Elastic

Stitch under pads

4mm low density foam base with
4mm high density foam on top / fabric

Sew point

Sew under pad

Sew point

Sew point under pad

Sew point above pad

Sew under pad

Sew point

Stitch under pads

Approx. 28mm (1.1")

Sew under pad

Aprox. sew point

219mm (8.6")

Thermoformed foam with printed lycra
See shoulder pad section view detail
drawing # 00234-1006 for sections

PU Leather finish

3X 1" Elastic

Strap loops around top two 1" elastics

110mm (4.3")

4mm low density foam base,
4mm thermoformed foam with
lycra

200mm (7.8")

1" Strap sewn both ends
to back of pad

Strap loops around bottom 1" elastic;
Option - Strap can be adjustable with velcro

4mm low density foam base with
4mm high density foam on top / fabric

adidas

Optional - Printed or material sew

SIDE VIEW

Velcro loop

152mm (6")

380mm (15")

ADIDAS SHOULDER PAD 111 FLAT PATTERN		
REV. 3	October 26, 2009	SCALE 1:1
PATTERN SIZE: **LARGE**		

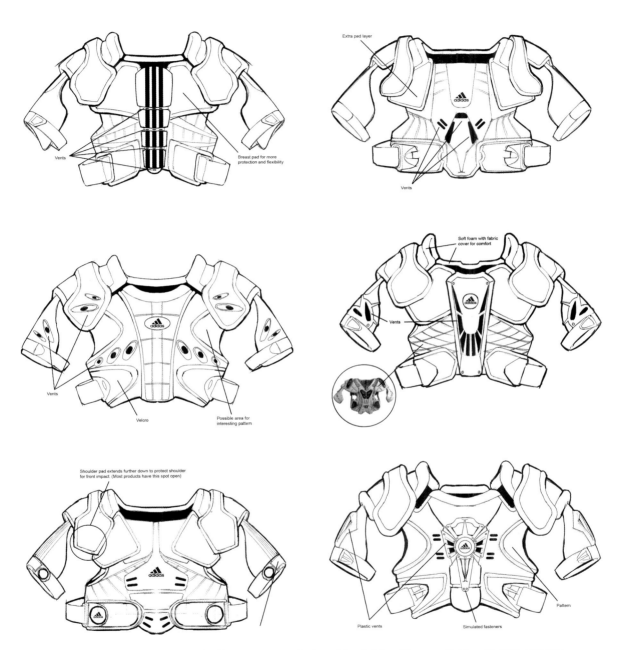

Extra pad layer

Breast pad for more
protection and flexibility

Vents

Vents

Soft foam with fabric
cover for comfort

Vents

Vents

Velcro

Possible area for
interesting pattern

Shoulder pad extends further down to protect shoulder
for front impact. (Most products have this spot open)

Pattern

Plastic vents

Simulated fasteners

These various items of lacrosse protective gear were designed for Adidas. They are light, with high-density padding that reduces the impact of blows without adding bulk. The adjustable rubber joint bands allow comfortable movement.

Vents

Matt on gloss

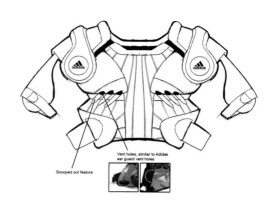

Vent holes, similar to Adidas
ear guard vent holes

Scooped out feature

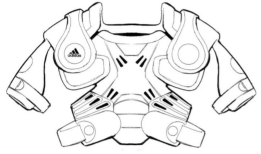

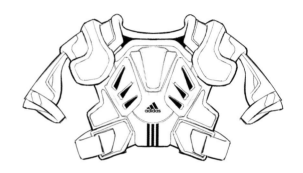

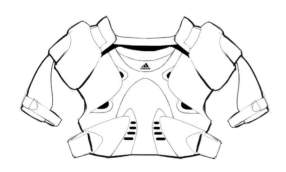

Front

Back

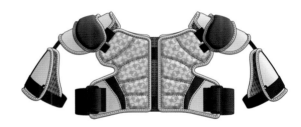

Front

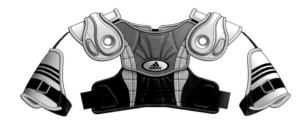

Back

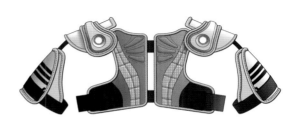

Front

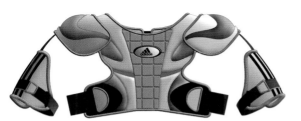

Back

The Adidas 211 uses Adidas ClimaLite fabrics, which repel moisture and provide coolness and comfort. The upper front section is independent, giving the player freedom to make extreme moves.

VOODOO HENGE

The Talon is a lacrosse stick. The tilted, gradual design ends in a head with thirty-two string holes, which allows you to customize the mesh. The decorative engravings allude to the Iroquois nation, which invented the sport.

STUDIO DVANDIRK

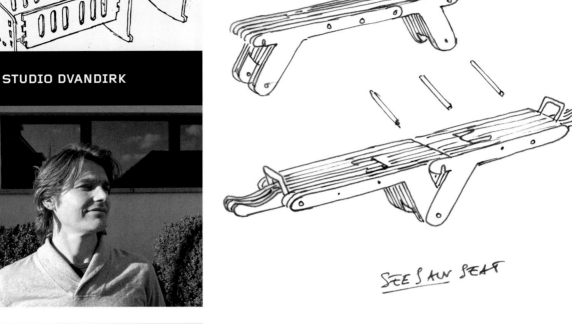

SEE SAW SEAT

SEE SAW SEAT

Maastricht, The Netherlands
www.dvandirk.nl

In an era when the mechanisms that move objects are hidden, DvanDirk has launched a series of products where double function and transparency are essential to their identity. The studio works to ensure that the end user understands how the object that he or she is interacting with works and how to make the most of it. Its creations are made with durable materials to be more ecologically sound.

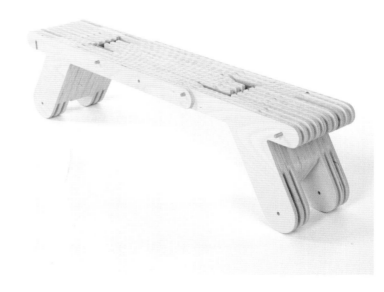

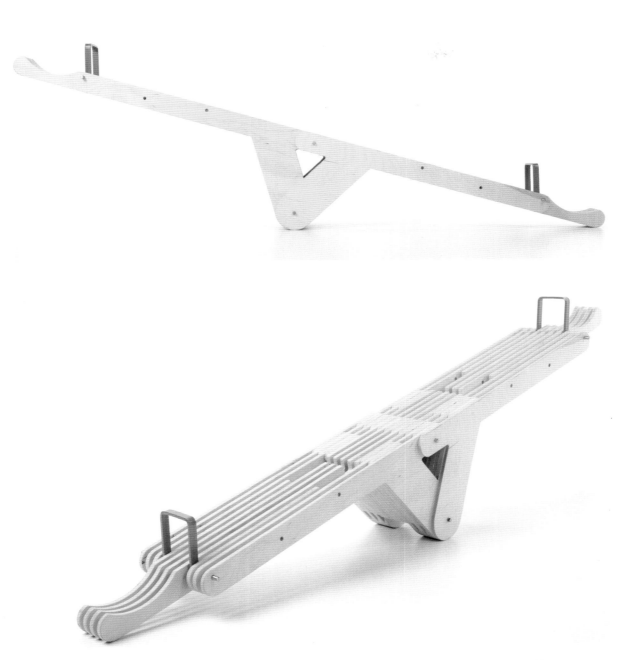

The SeesawSEAT is a small bench that becomes a seesaw or swing for children. The piece is sturdy and is transformed by sliding the surface inward or outward and securing the structure with three long nails.

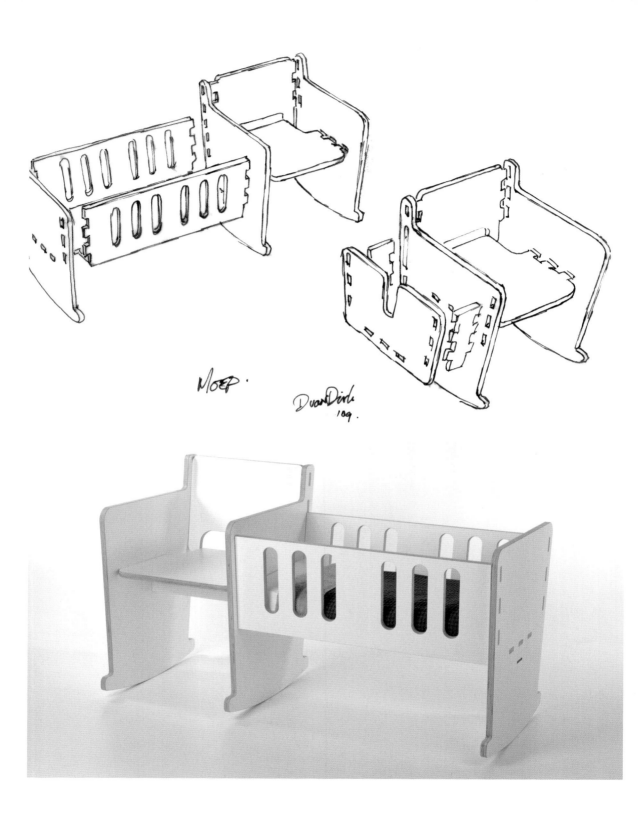

MOEP.

DvanDirk
189.

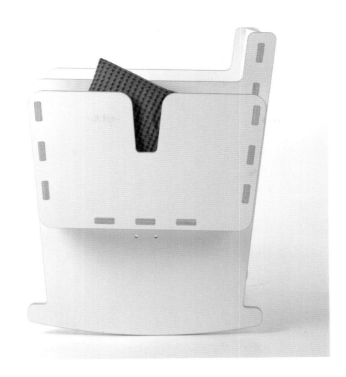

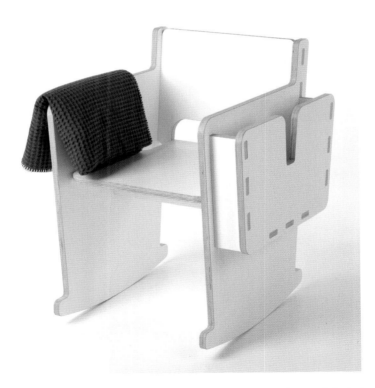

The MOEP symbolizes the bond between parents and children: the design connects an adult chair with a baby's cradle. The parts are joined like a puzzle, and when the cradle is no longer needed, it can become a shelf for children's books. Both pieces can rock.

STUDIO KLASS

Milan, Italy
www.studioklass.com

In 2009, Marco Maturo and Alessio Roscini created Studio Klass, which focuses primarily on product design. Their methods are based on observing and analyzing existing products in order to improve them, or, more directly, developing new products to solve the original problems. Studio Klass collaborates with companies such as Artsana Group (Chicco), Mercedes Home, and Busso, and its founders have been teaching at the Milan European Design Institute since 2009.

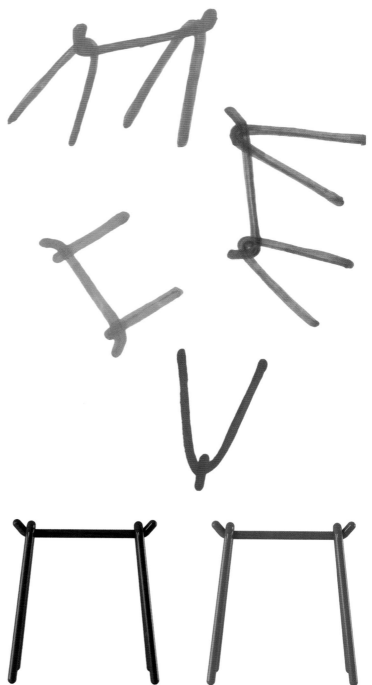

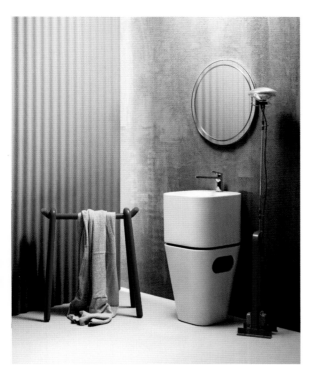

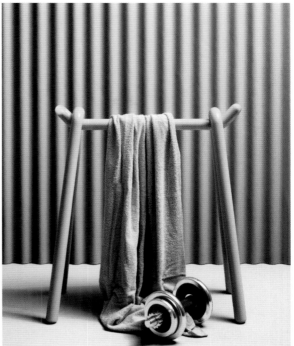

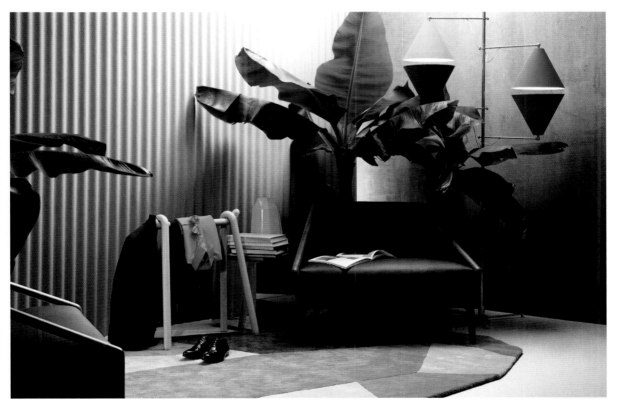

Inspired by the classic suit valet, the Balloon is ideal for any space. It can be used to hang clothes or towels on.

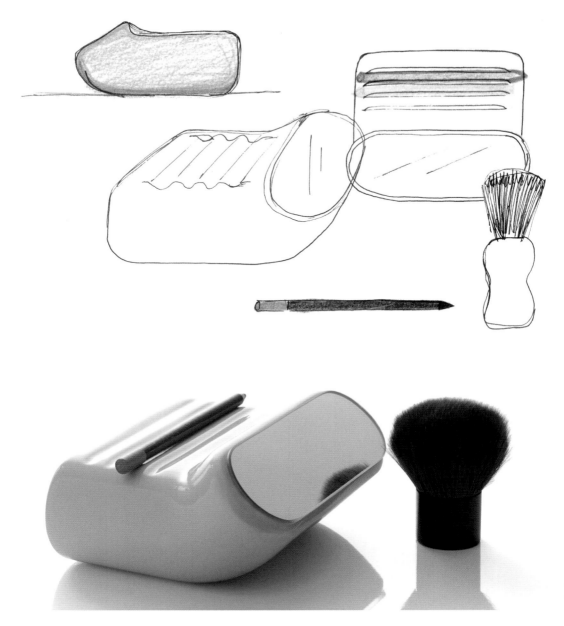

The design of the Moment, a mirror, makes it easy to use on a flat surface. Its surface is grooved to hold makeup tools.

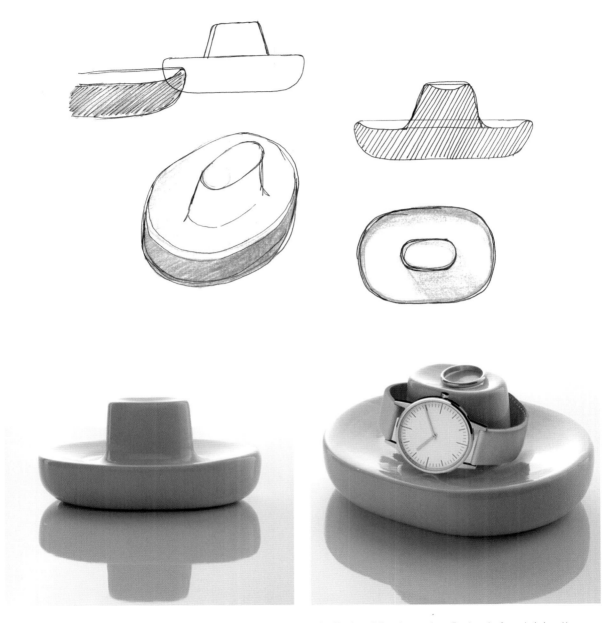

The Baia reinvents the bathroom container for holding personal effects while showering. Instead of containing them, the Baia is surrounded by the objects.

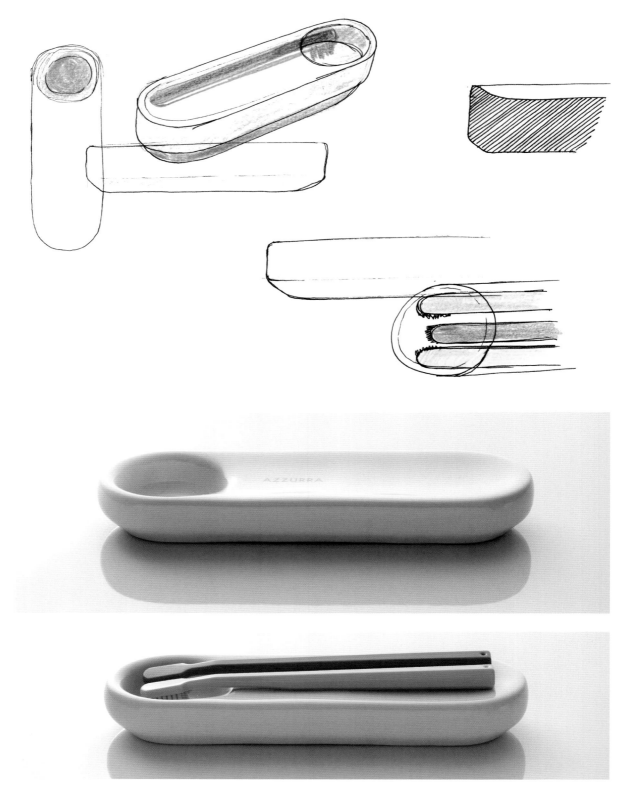

The Pinolo is a ceramic horizontal toothbrush holder. Its design renders it more hygienic than others by encouraging water flow to prevent stagnation.

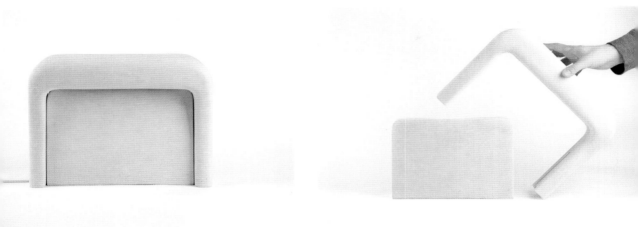

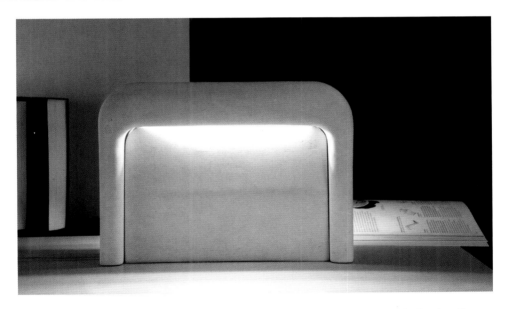

The Petra is a monolithic bedside lamp inspired by the eponymous monument in Jordan. It consists of two parts: a main body that houses the light source and an upper section that redirects the light toward the sides.

STUDIOMAMA

London, UK
www.studiomama.com

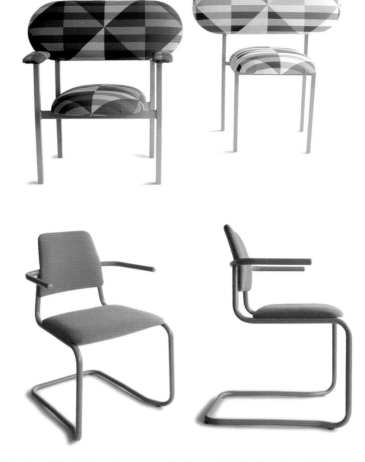

Studiomama was established in 2000 by a married couple of designers: Nina Tolstrup and Jack Mama. Besides being multidisciplinary, their work is timeless, honest, fun, and unpretentious. Studiomama is a pioneer in the use of recycled materials that extend product life and also in challenging conventional business and distribution methods. Tolstrup, observant and curious, studied at Les Ateliers school of industrial design in Paris and earned a degree in marketing from the Copenhagen Business School.

Using traditional structures as a starting point, Re-Imagined chairs allow you to adjust the backrest and seat to create different angles. They are upholstered with exclusive fabrics from Arthur David Design.

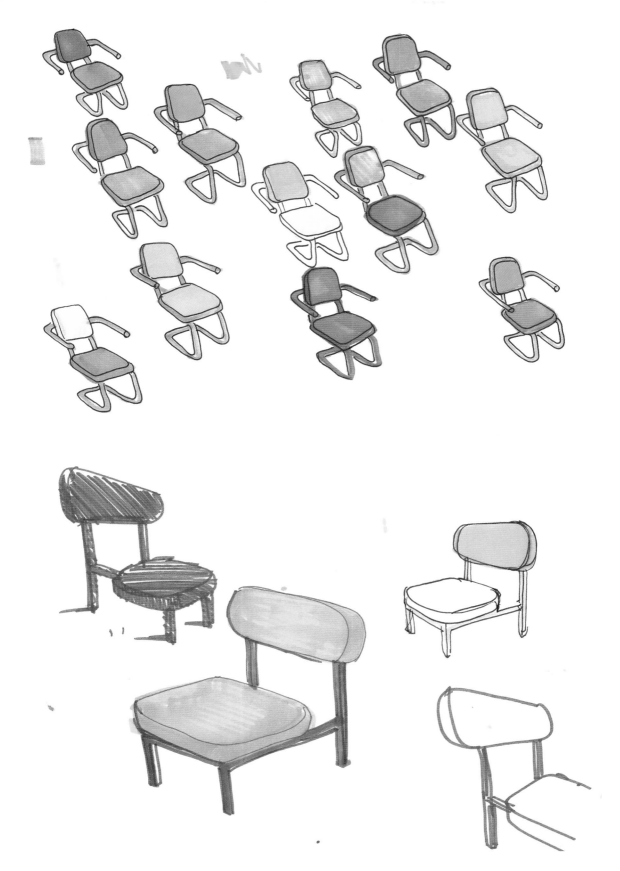

MODULE A WITH LCD, CONTROLS AND BATTERY COMPARTMENT
SLIDES INTO CLEAR CASING B AND IS FIXED PERMANANTLY

135,922

37

PLAN VIEW

78,831

37

TIME SET BUTTONS

ALARM SET BUTTONS

NOTE: PLUS MINUS SYMBOLS ON
BUTTONS TO BE RECESSED IN
MOULD

BACK VIEW

BATTERY COMPARTMENT
SLIDE OUT DOOR

TIP ALARM CLOCK
GENERAL ASSEMBLY DRAWING
© STUDIOMAMA 2005
DATE: 12-06-05

The ON/OFF Alarm Clock was designed for Lexon. The alarm is switched off by turning the clock on its side.

The Reveal Cabinet is made of recycled floorboards, which contrast with its shape. The hollows provide wardrobe and shelving areas, supplying an original negative space.

SYBARITE

London, UK
www.syb.co.uk

Torquil McIntosh and Simon Mitchell share the same studio: Sybarite. The company, which specializes in product design and architecture, takes inspiration from both nature and new technologies. As a result, their creations are distinctive, fluid, and timeless. There are more than three hundred projects in the studio's portfolio, including the design for a Bellefontaine Switzerland shop in Moscow.

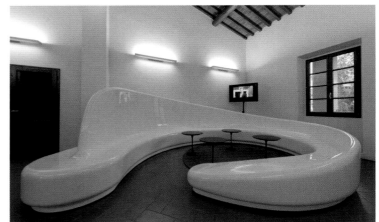

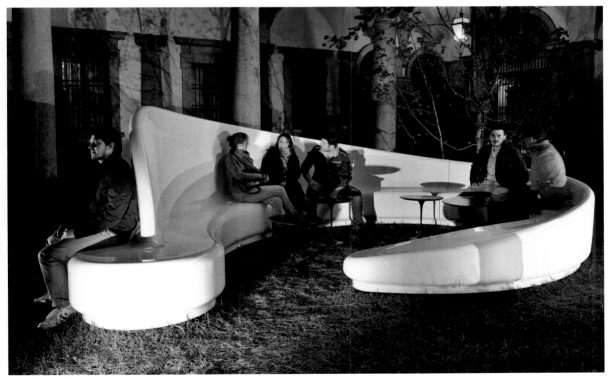

Archetto, designed for Marzorati Ronchetti, is a large modular sofa, ideal for public spaces or meeting rooms. Its forms are fluid, flexible, beautiful, and functional. Linear continuity is preserved by the rounded ends, which lead to the seats at the back.

SLIMANE TOUBAL

Pontoise, France
www.slimanetoubal.com

Slimane Toubal has more than twenty years of experience in car design. He began as a modeler and took part in the creation of prototypes in France for brands such as BMW, Renault, Citroën, Peugeot, and Lamborghini. At the same time, as a freelancer, Toubal was responsible for producing 3D models for multinationals such as Audi, Honda, and Volkswagen. He currently develops car prototypes in different sizes.

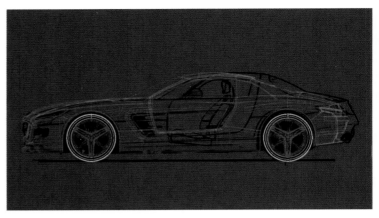

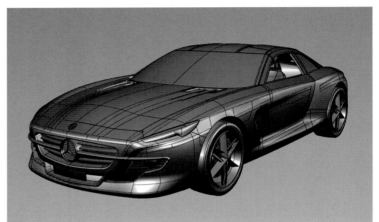

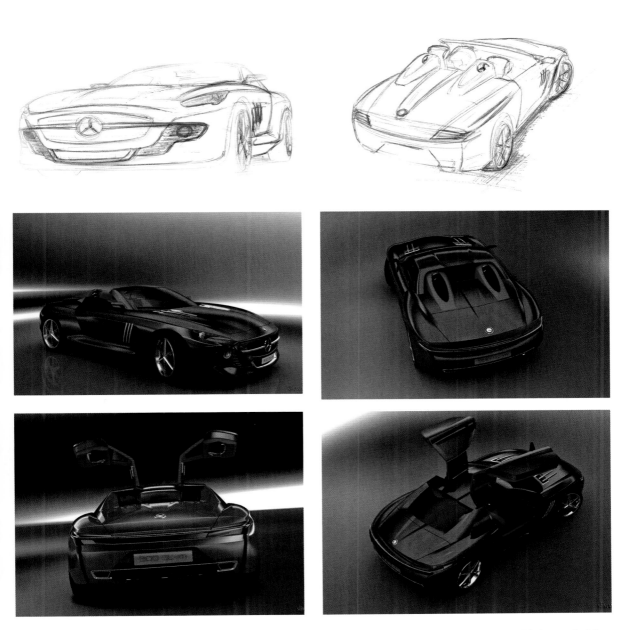

This is a reinterpretation of the Mercedes-Benz 300 SL Gullwing. Its curves are sinuous and the roof is lower, but it still has the classic "gullwing" doors.

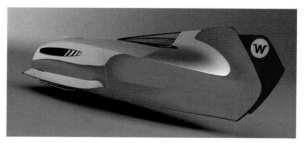

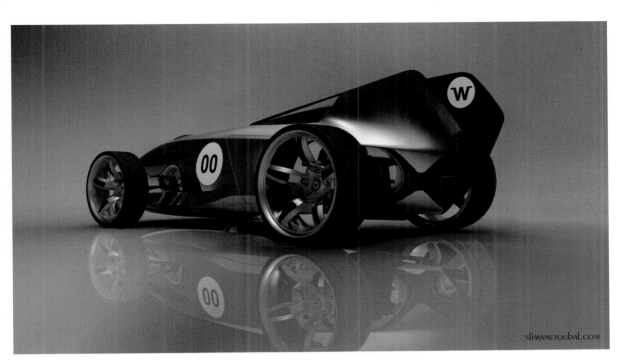

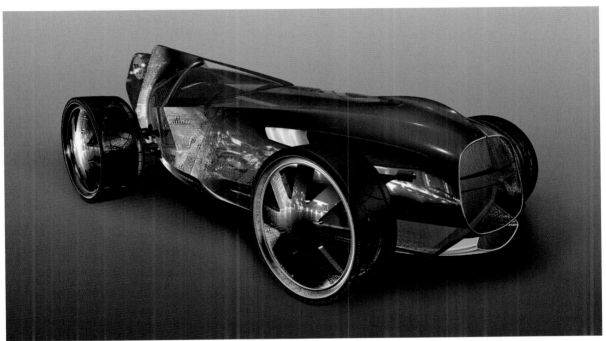

W 00 is a Formula 1 concept whose main body was designed in collaboration with Jean Semeriva. With a tubular front, the shape continuously varies, ending in the rear vertical ailerons that emphasize its aerodynamic structure.

MICHEL VANDAMME

Tourcoing, France
michel.vandamme@gmail.com

After studying graphic design and specializing in 3-D and visual effects in the Supinfocom School of Valenciennes, France, Michel Vandamme began his professional career in Lemoine SA as a product designer. He collaborated with different companies until becoming Kingfisher's head of design and development in 2009. Vandamme takes graphic and product design, which complement each other, and uses them to round off his creations.

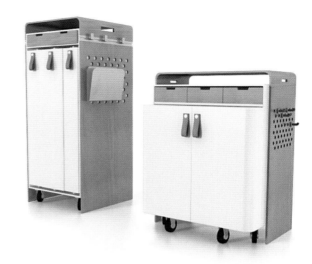

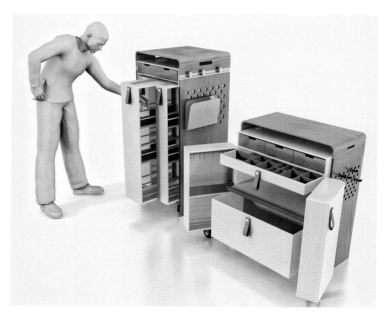

Box & Kit office storage furniture offers different organization solutions with a compartment rotation and movement system, which saves space and is reminiscent of multipurpose pocket knives.

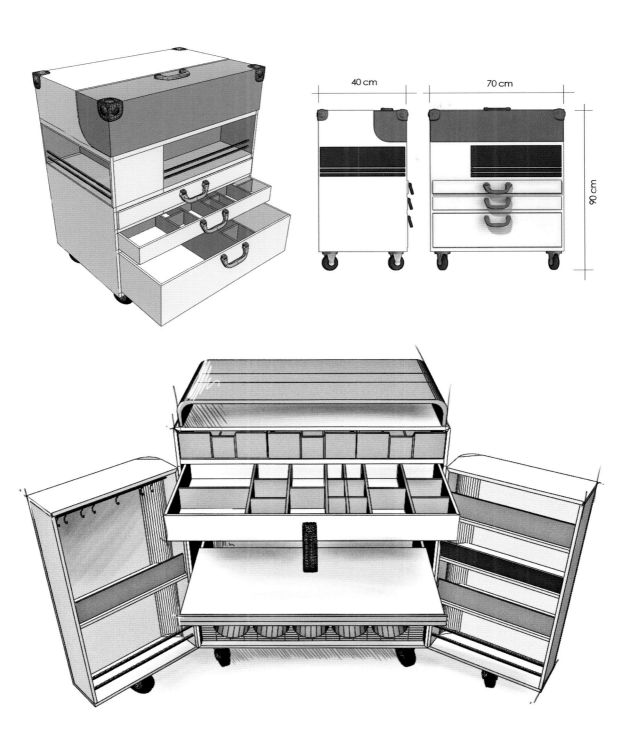

40 cm

70 cm

90 cm

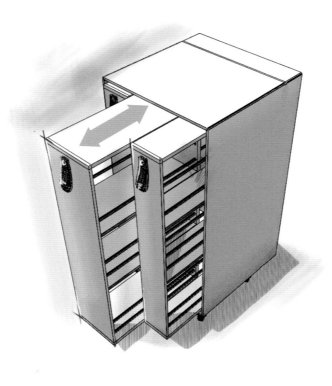

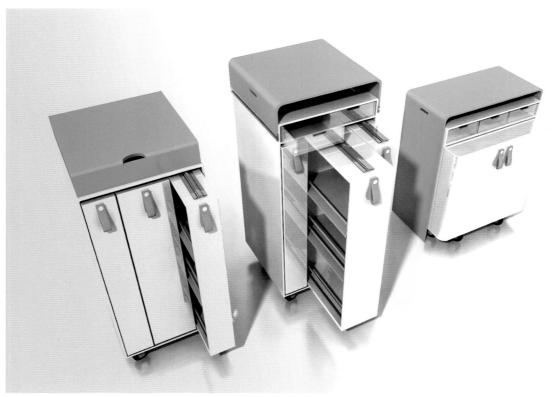

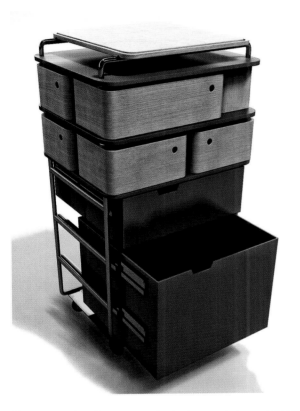
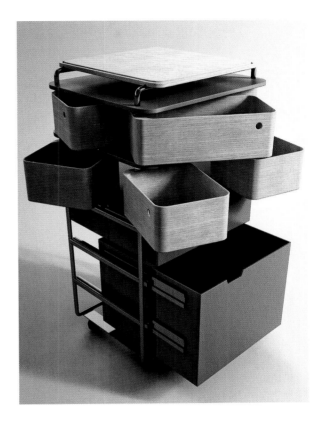

The new system turns every inch of space into useful storage area.

ALBERTO VASQUEZ

Budapest, Hungary
www.alberto.hu

Born to a Colombian father and a Hungarian mother, Alberto Vasquez is inspired by two completely different cultures: European and South American. He is fascinated by nature, and his way of understanding design is influenced by the Amazonian Indians' way of thinking. Vasquez graduated from Moholy-Nagy University of Art and Design, in Budapest, in 2010. He is interested in ecological, cultural, and social problems, and he has received several awards for his Flow Lamp.

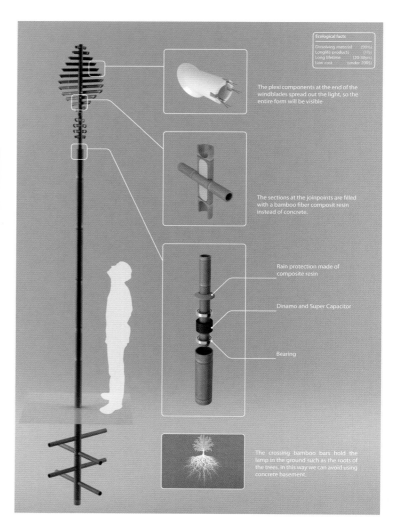

Ecological facts
Dissolving material (99%)
Longlife products (1%)
Long lifetime (20-30yrs)
Low cost (under 200$)

The plexi components at the end of the windblades spread out the light, so the entire form will be visible

The sections at the joinpoints are filled with a bamboo fiber composit resin instead of concrete.

Rain protection made of composite resin

Dinamo and Super Capacitor

Bearing

The crossing bamboo bars hold the lamp in the ground such as the roots of the trees. In this way we can avoid using concrete basement.

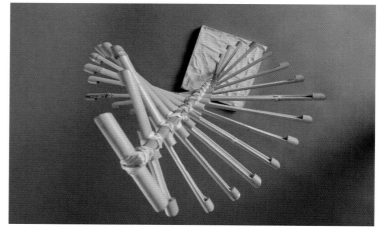

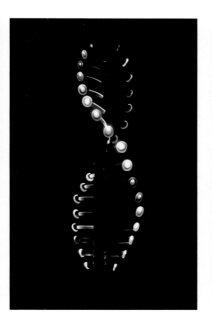
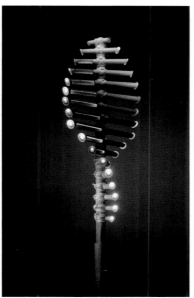
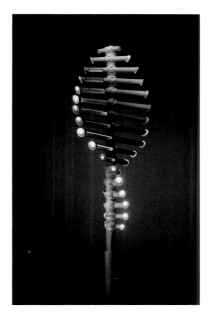

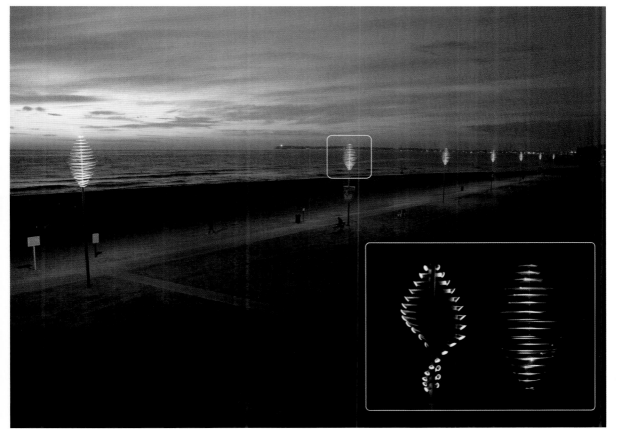

The Flow is a lamp that functions on the same principle as a vertical wind turbine. Its spiral design receives wind from all directions. The Flow is made of bamboo and is easy to produce.

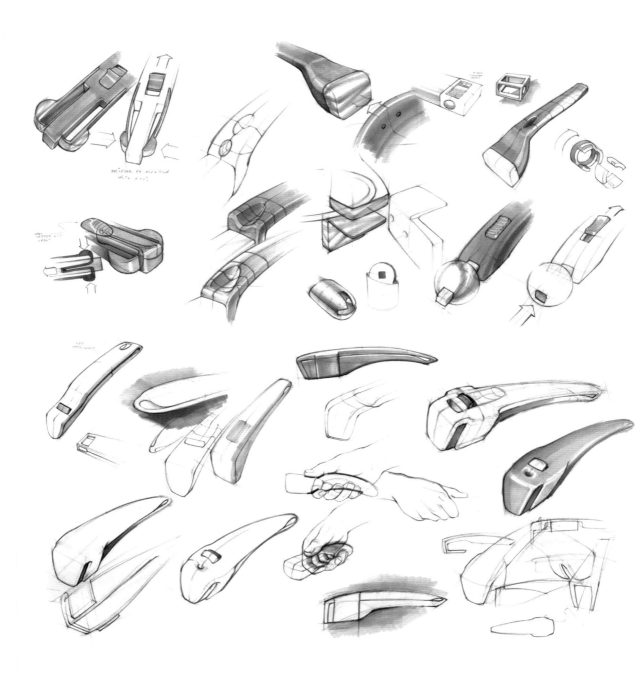

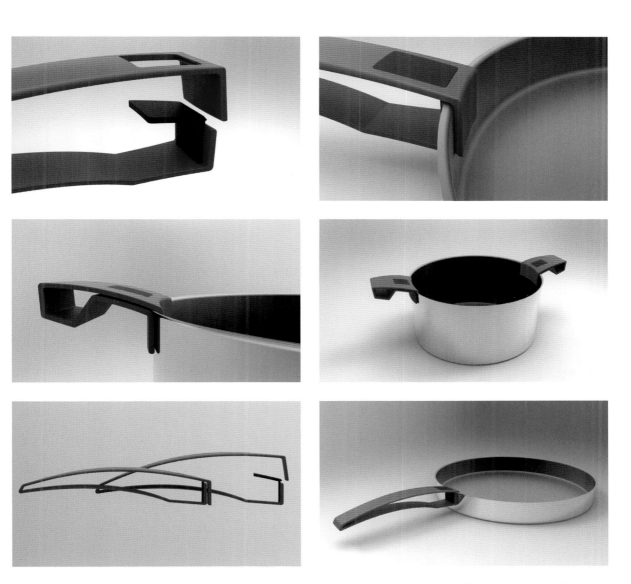

When these removable pot and pan handles are grasped, two magnets come into contact with the metal container and remain attached until the grip on the handles is released.

VITA JEHS + LAUB

Stuttgart, Germany
www.jehs-laub.com

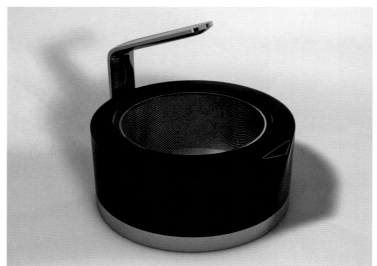

Markus Jehs and Jürgen Laub met at the University of Design of Schwäbisch Gmünd while studying industrial design. They graduated in 1992 and founded their studio in 1994. Since then they have spent more than fifteen years designing furniture and lights for Italian companies such as Cassina and Nemo, and every year sees the expansion of their international client base, which includes Authentics, Brunner, and Fritz Hansen.

The design of the Stelton Potter teapot centers on the process of preparing tea. A large strainer spreads and brews the tea, and the double wall keeps the drink hot. The handle helps to pour the tea easily.

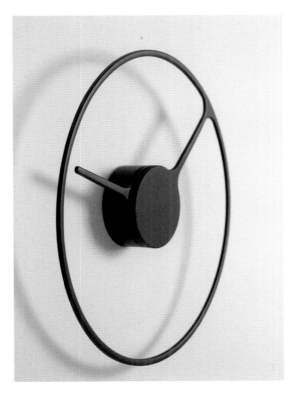

The Stelton Time Clock is a wall clock whose frame indicates the time. The outer ring marks the hours, the internal ring the minutes.

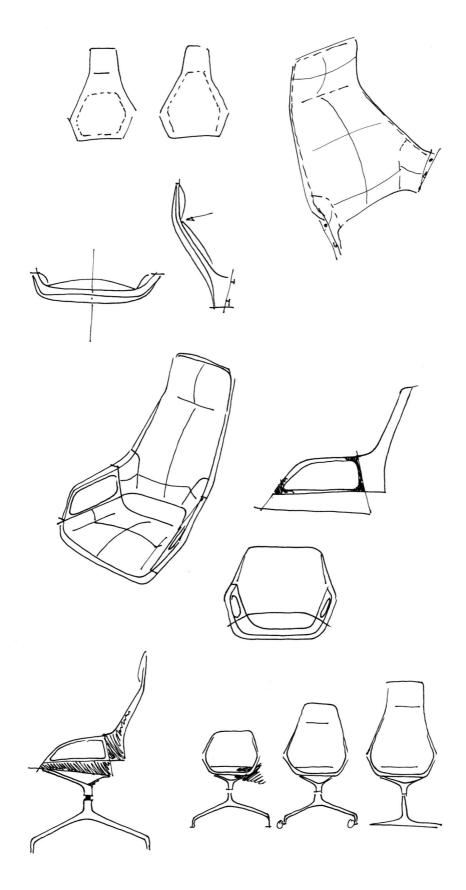

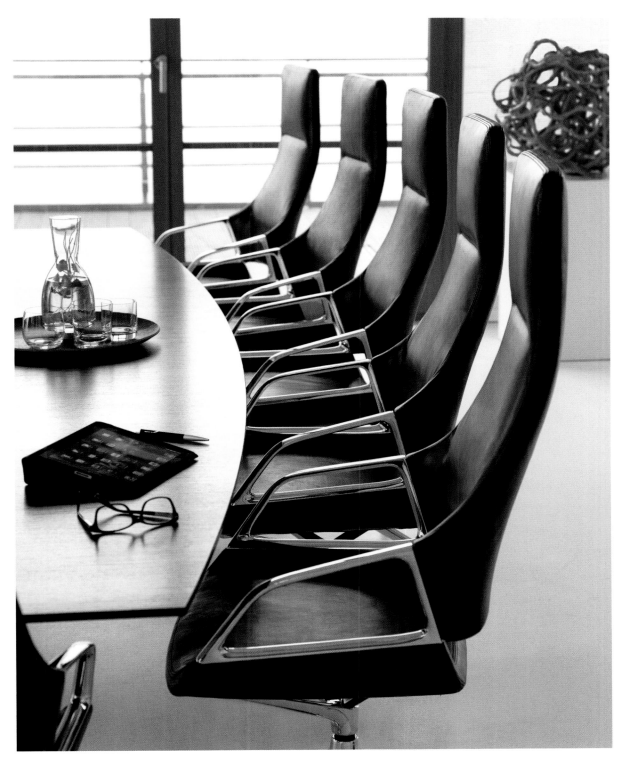

Graph is a high-end range of conference chairs designed for Wilkhahn. The seat shell can be divided and reassembled in numerous configurations thanks to the armrests being the main link between seat and backrest. Different models can be derived from a single basic concept.

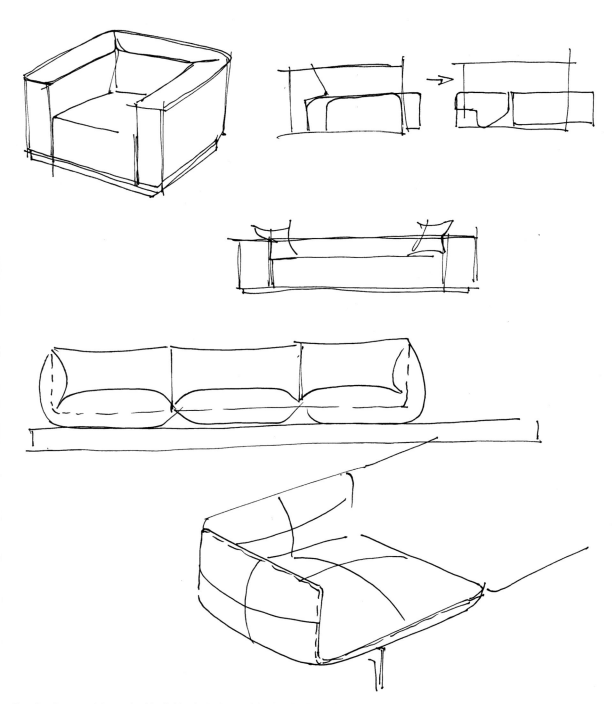

The Cor is a modular set of individual chairs and tables that can be arranged according to space.

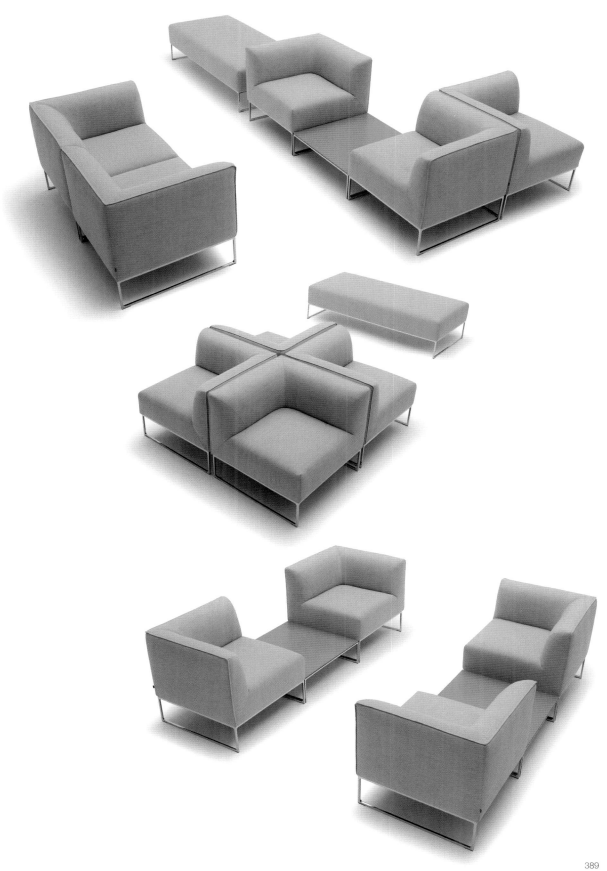

Stockholm, Sweden
www.jonaswagell.se

"Generous minimalism" is the philosophy of the Swedish designer Jonas Wagell, who specializes in graphic design, marketing, product design, and architecture. Wagell prefers to create objects that are functional rather than artistic and likes to think that his products are part of people's everyday lives. For him, emotions are more important than exclusivity, and so he tries to add a personal and expressive element to all of his work.

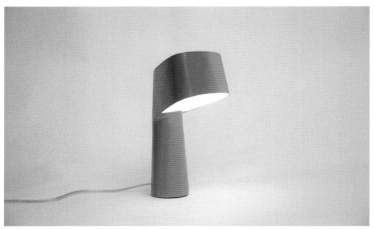

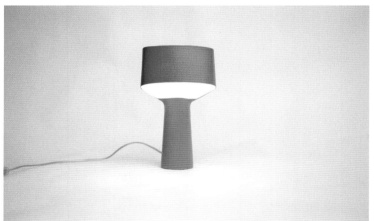

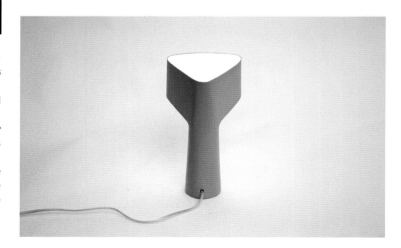

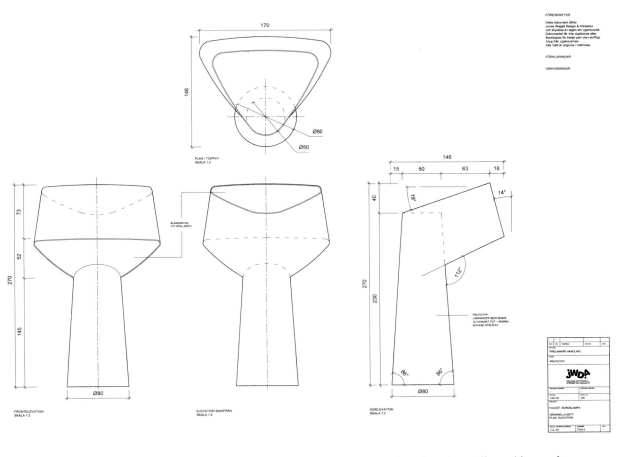

FÖRESKRIFTER

Detta dokument tillhör
Jonas Wagell Design & Arkitektur
och skyddas av lagen om upphovsrätt.
Dokumentet får inte dupliceras eller
återskapas för tredje part utan skriftligt
intyg från upphovsman.
Alla mått är angivna i millimeter

FÖRKLARINGAR

HÄNVISNINGAR

PLAN / TOPPVY
SKALA 1:2

Ø80
Ø50

170
146

BLÄNDSKYDD
VIT OPAL AKRYL

FRONTELEVATION
SKALA 1:2

ELEVATION BAKIFRÅN
SKALA 1:2

SIDELEVATION
SKALA 1:2

Ø80

73
52
270
145

146
15 50 63 18
40
270
230
14°
112°
86° 86°

PROTOTYP:
LAMPKROPP BESTÅENDE
AV KONISKT FOT + SKÄRM I
BOCKAD STÅLPLÅT

PRELIMINÄR HANDLING
PROTOTYP

jWDA

120116 JW

FAUGET, BORDSLAMPA

GENERELLA MÅTT
PLAN, ELEVATION

1:2, A3 FAU-2

Light Works is a collection of lamps whose purpose is not to illuminate but rather to enhance the ambience of a room.
The different designs were developed with the aim of being both economical and of good quality.

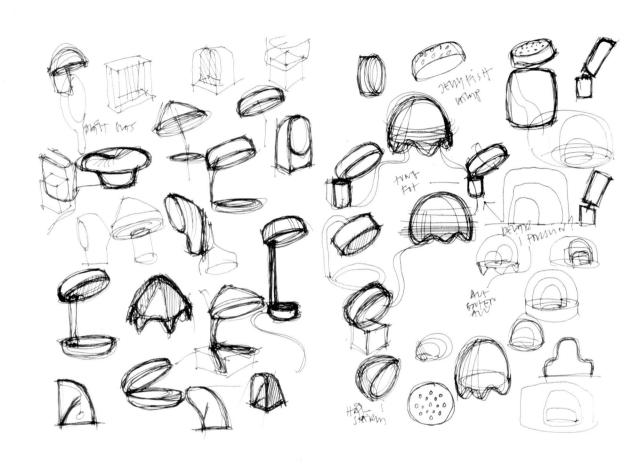

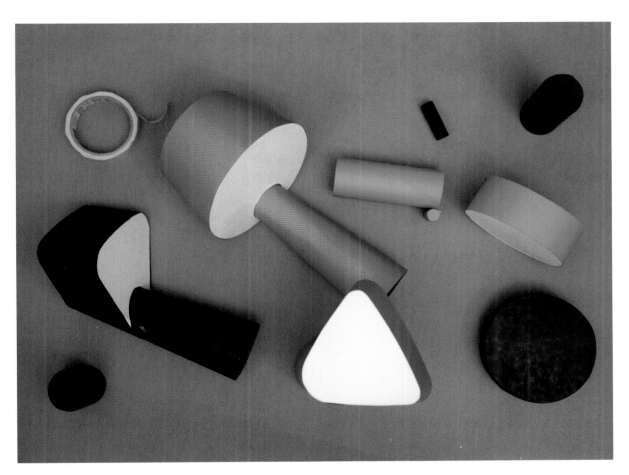

The Wedge is a triangular bedside lamp that is ideal for sideboards, corridors, and corners. The Disc is small but provides a lot of light. Its steel base allows it to be positioned in any manner without tipping. It is ideal for desks and shelves.

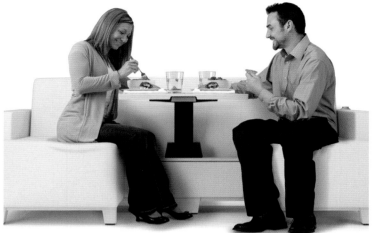

BLAIR WIELAND

Grabill, IN, USA
www.saudermfg.com

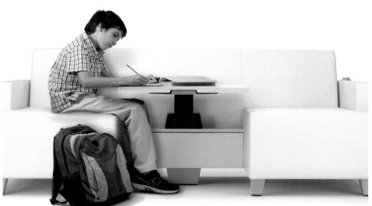

The sleepToo™ is a compact furniture suite designed to meet the needs of those accompanying hospital patients.

Having studied design at the University of Michigan, Blair Wieland completed an MBA at Notre Dame. He is one of the founders of Wieland Furniture, and during the past twelve years he has managed the development of a multitude of products for Wieland Healthcare and Sauder Manufacturing. He has won eleven Addy Awards, two Nightingale Awards, four NeoCon Awards, and a Gold IDEA in the scientific and medical product category.

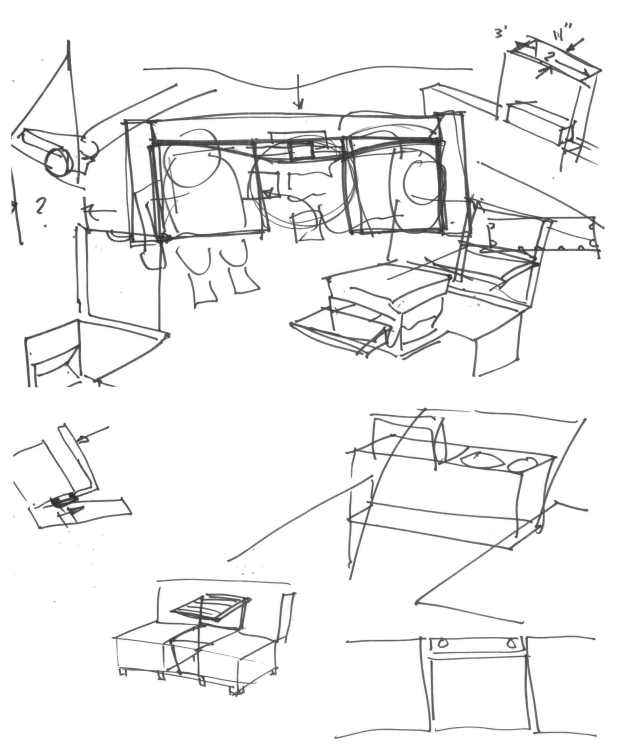

3'

2

2

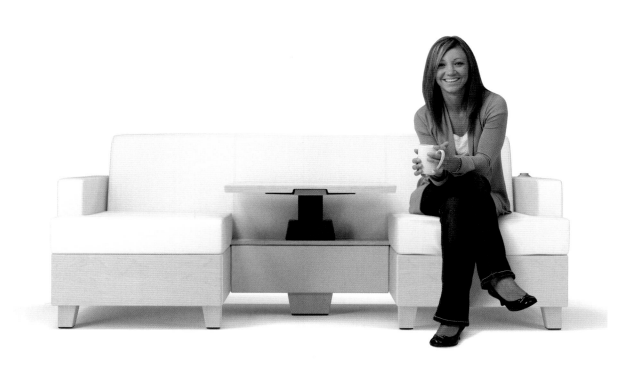

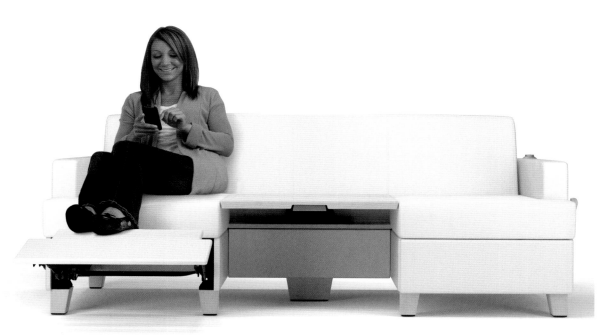

THE NEXT SLEEPER SYSTEM

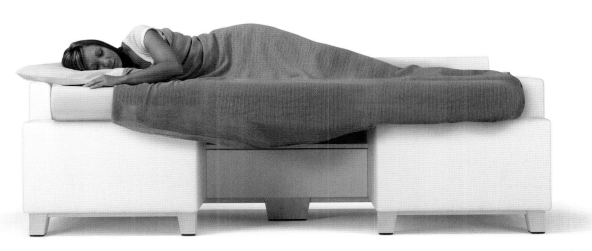

TABLE EXTENDS FOR
EATING, CARDS ETC

DROPS DOWN
TO MAKE
Sleeping surface

The suite allows you to set up a bed and a dining/work table, and it occupies only 18 square feet (1.67 square meters).

TIM WIELAND

Solingen, Germany
www.coroflot.com/timw

Tim Wieland not only likes to imagine and create, but he is also a great lover of sport, cooking, and literature. He started working as an intern in various studios in 2008 and he earned a degree in industrial design from the University of Wuppertal in 2012. He then took up the post of design engineer at TECSAFE GmbH, a company that specializes in designing and manufacturing foam products.

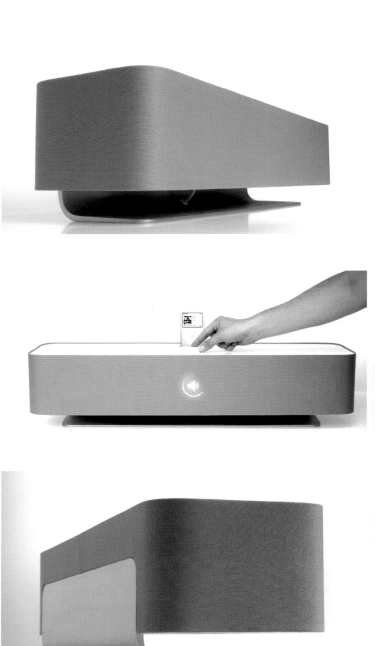

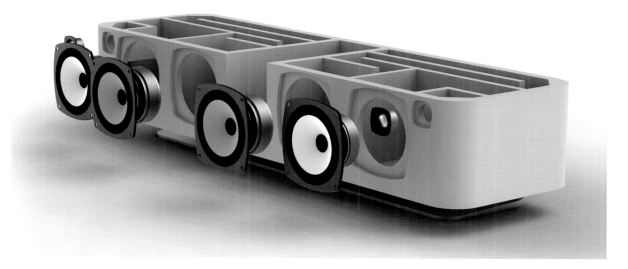

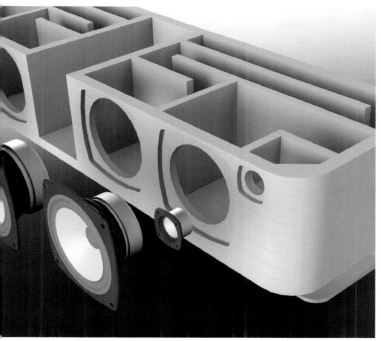

This high-fidelity stereo system is compatible with new digital technologies. Unlike the majority of portable speakers on the market, this equipment prioritizes high quality of sound, with faithful bass playback and a wide sound range.

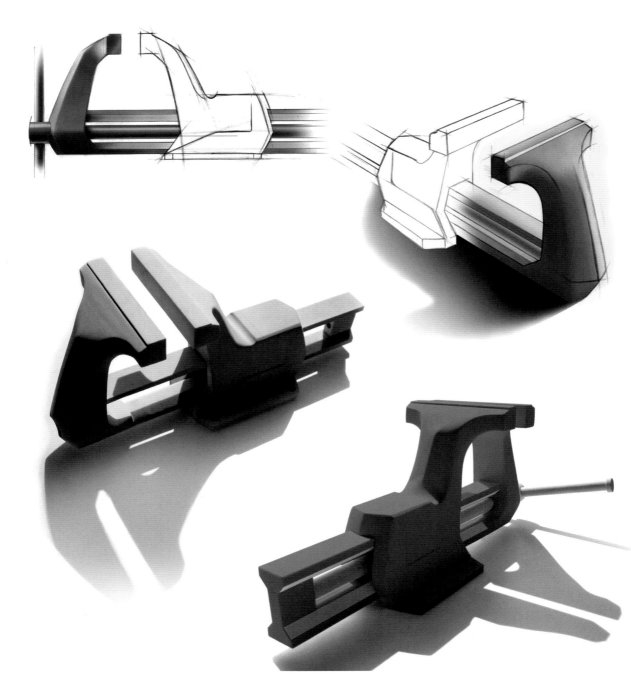

This is a redesign of the classic vise. Its shape reflects the strength of the tool and its precision.

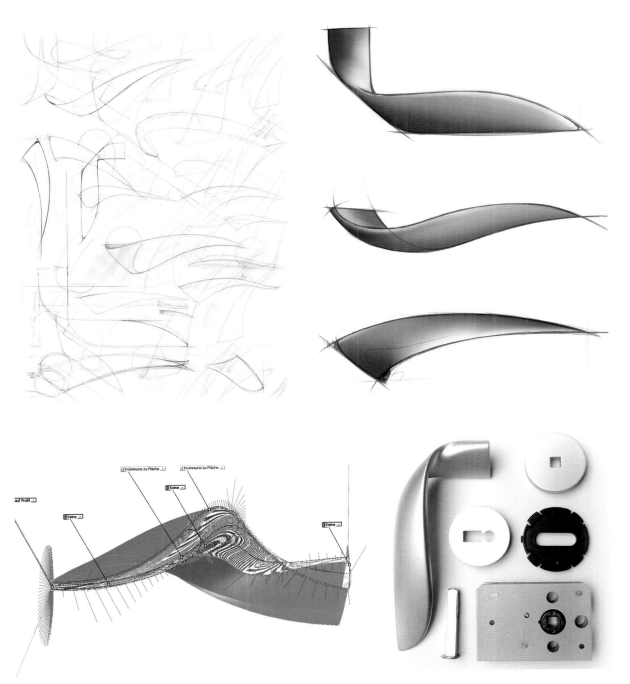

Despite the slenderness of this handle, its form is thick enough and sufficiently ergonomic to fit in the hand perfectly.

MIT WASSER BEFÜLLEN

1.

AUF SOCKEL STELLEN

2.

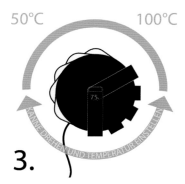

50°C 100°C

KANNE DREHEN UND TEMPERATUR EINSTELLEN

3.

MIT KNOPF STARTEN

4.

SIGNAL ABWARTEN

5.

TEE AUFGIESSEN

6.

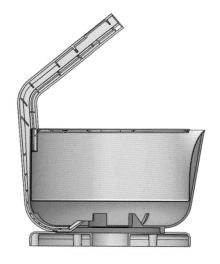

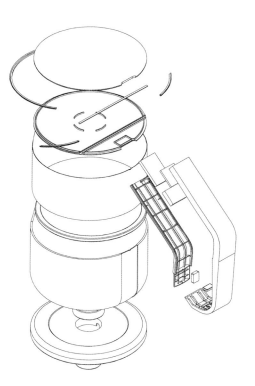

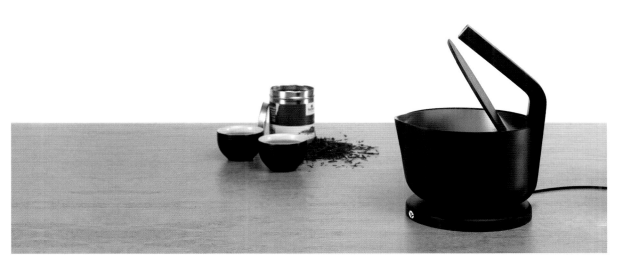

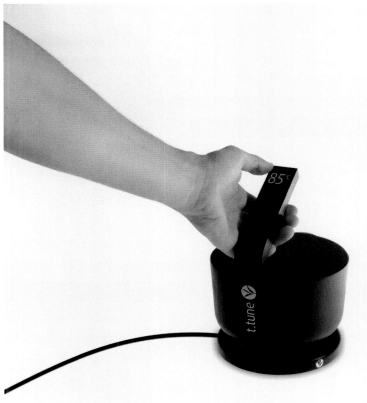

T.Tune is an adjustable teapot. The temperature and heating time are set at the beginning, making tea preparation easy and perfect.

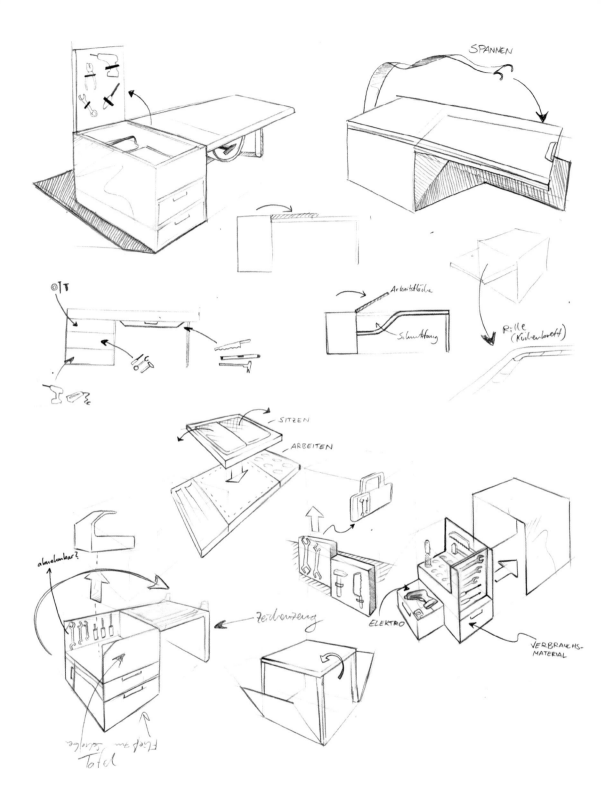

SPANNEN

Arbeitsfläche

Schnittfang

Rille
(Küchenbrett)

SITZEN

ARBEITEN

abnehmbar?

Werkzeug

ELEKTRO

VERBRAUCHS-
MATERIAL

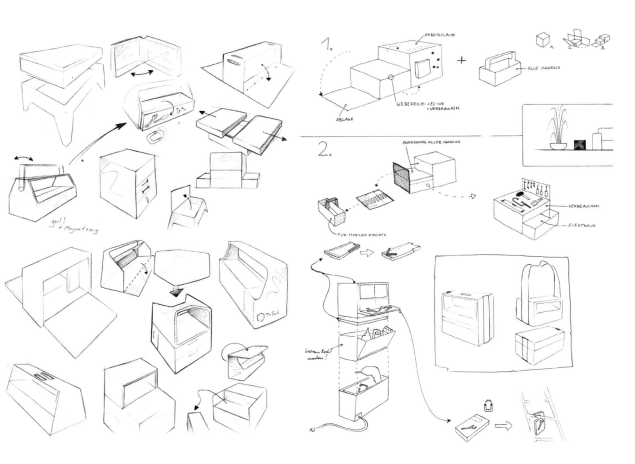

The Tragwerk is an aluminum toolbox hidden beneath a wooden stool. The product allows you to have all tools close at hand and keeps them out of the way when not needed.

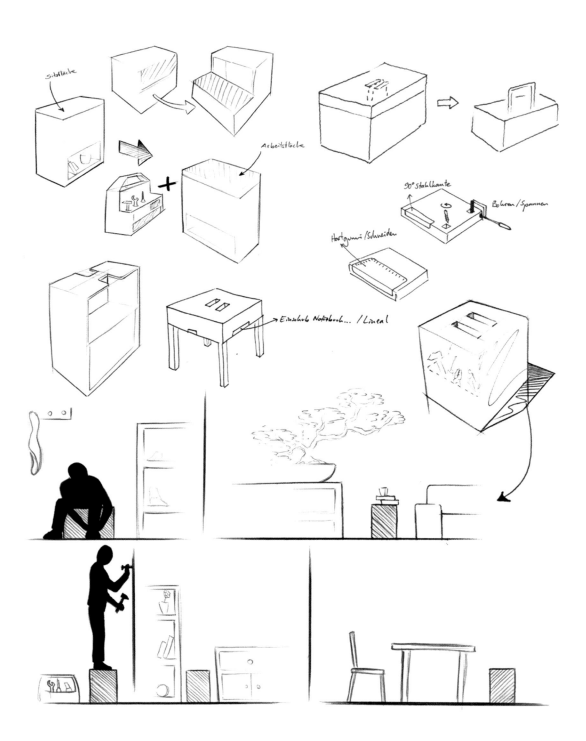

Sitzfläche

Arbeitsfläche

90° Stahlkante

Bohren / Spannen

Hartgummi / Schneiden

→ Einschub Notizbuch... / Lineal

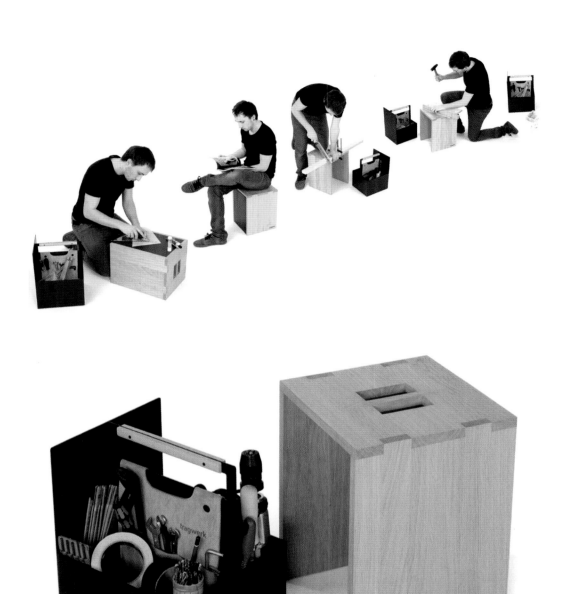

The resulting stool is strong and supports the weight of an adult, who can use it to reach the highest corners.

MAGNET EMBEDED
STEEL ROD
STEEL
HIDDE
SHAVING BRUSH WITH A STAND
SECTION

YANG RIPOL DESIGN STUDIO

London, UK
www.yangripol.com

In 2011, Yeonju Yang and Claudio Ripol, two design graduates of the Royal College of Art in London, established the Yang Ripol Design Studio, a multidisciplinary consultancy. Before that, Yang spent six years working for AB Rogers Design, and Ripol worked for Christoph Behling and Solarlab on projects for companies such as Dior and Nokia. They are currently designing for international clients and developing products and spaces.

STRING

FOR PACKAGING

POWDER COATED STEEL TUBE OR DIP MOULDED RUBBER FINISH.

TOWEL RACK FLEXIBLE LENGTH.

Diabolo is a distinctive toilet roll holder. The flexibility of the cord allows multiple combinations, and the length can be adapted to fit the available space.

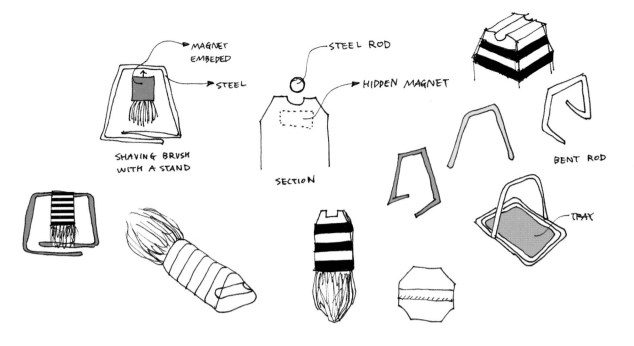

MAGNET EMBEDED

STEEL

SHAVING BRUSH WITH A STAND

STEEL ROD

HIDDEN MAGNET

SECTION

BENT ROD

TRAY

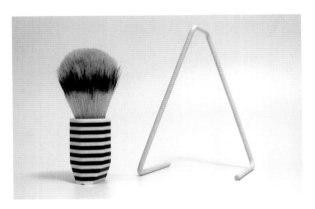

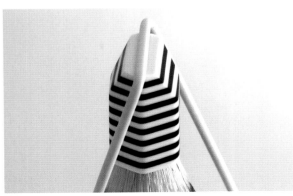

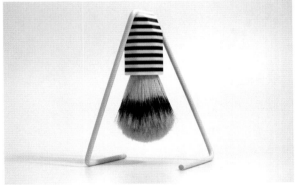

The Shaving Brush is made by traditional methods combined with laser cutting and manual machining. The sleeve contains magnets that attach to the steel rods, ensuring that the brush dries properly to prolong its life.

The wooden Flat Zoo game consists of five pieces printed on both sides. These can be combined in pairs to create different animals, including an elephant.

ZINNOBERGRUEN

Düsseldorf, Germany
www.zinnobergruen.de

Zinnobergruen was founded in 2001 by Bärbel Muhlack and Tobias Schwarzer, two German designers born in the late sixties. The company, with a team of just six employees, has been featured in more than twenty international publications, and its creations have been exhibited in a multitude of cities, including New York (2011) and Berlin (2008). In 2012 the studio won the Red Dot Design Award, thanks to Miniki.

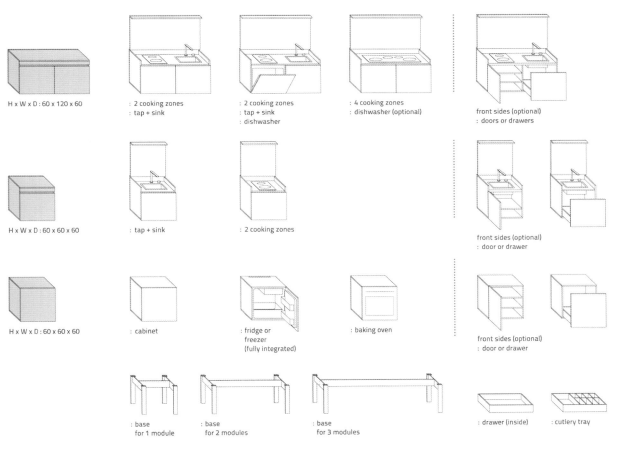

H x W x D : 60 x 120 x 60

: 2 cooking zones
: tap + sink

: 2 cooking zones
: tap + sink
: dishwasher

: 4 cooking zones
: dishwasher (optional)

front sides (optional)
: doors or drawers

H x W x D : 60 x 60 x 60

: tap + sink

: 2 cooking zones

front sides (optional)
: door or drawer

H x W x D : 60 x 60 x 60

: cabinet

: fridge or
freezer
(fully integrated)

: baking oven

front sides (optional)
: door or drawer

: base
for 1 module

: base
for 2 modules

: base
for 3 modules

: drawer (inside)

: cutlery tray

Miniki is a small and functional modular kitchen. Ideal for small apartments, it can be adapted to almost any space. The color combinations are endless and can be coordinated with other furnishings.

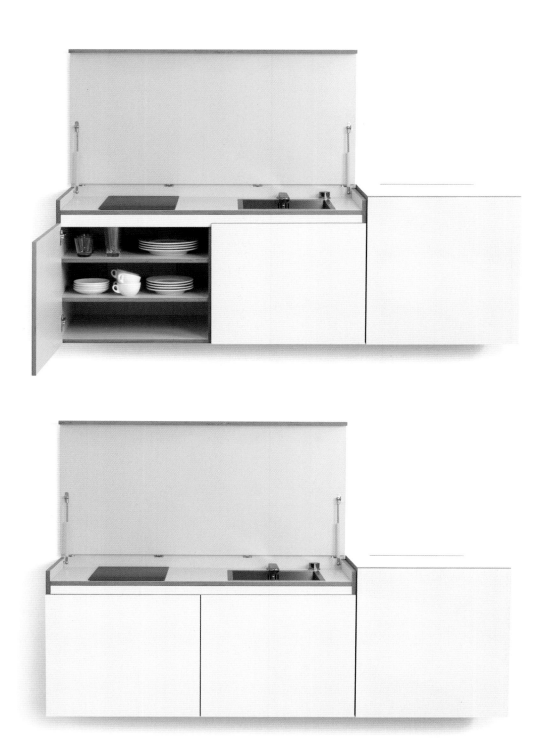

The modules are sold individually and all have a lid to convert them into a dressing table.